MAKING
AMERICAN
TASTE

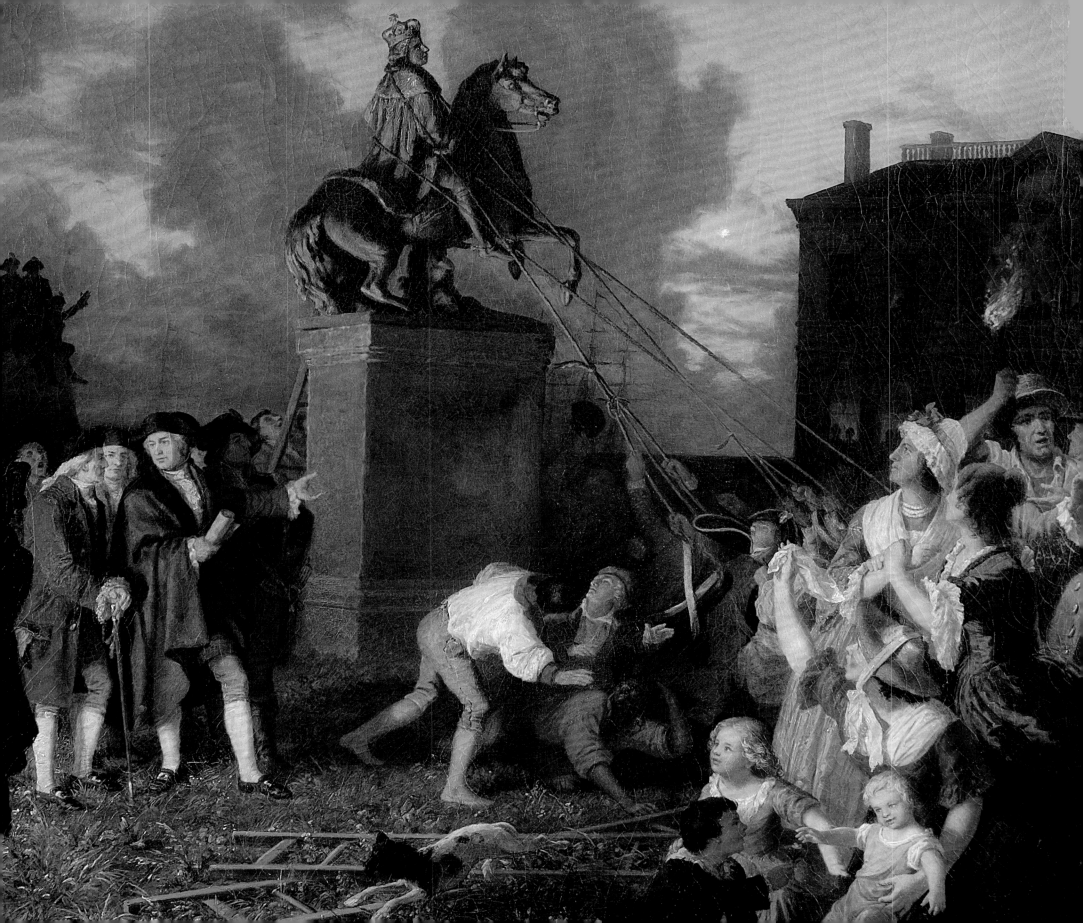

MAKING AMERICAN TASTE

Narrative Art for a New Democracy

Edited by Barbara Dayer Gallati

Contributions by
Linda S. Ferber, Ella M. Foshay, Kimberly Orcutt

THE NEW-YORK HISTORICAL SOCIETY
In association with
D GILES LIMITED, LONDON

NEW-YORK
HISTORICAL
SOCIETY
MUSEUM & LIBRARY

© 2011 The New-York Historical Society
Published by the New-York Historical Society in association with D Giles Limited, London, on the
occasion of the exhibition *Making American Taste: Narrative Art for a New Democracy* at the
New-York Historical Society (on view November 11, 2011–August 19, 2012), followed by venues
at the Taft Museum, Cincinnati, Ohio, September 20, 2013–January 12, 2014; the Taubman
Museum of Art, Roanoke, Virginia, February 13–May 19, 2014; and the Memorial Art Gallery of
the University of Rochester, Rochester, New York, October 11, 2014–January 4, 2015.

First published in 2011 by GILES
An imprint of D Giles Limited
4 Crescent Stables
139 Upper Richmond Road
London, SW15 2TN, UK
www.gilesltd.com

Softcover edition:
ISBN: 978-0-916141-17-2
ISBN: 0-916141-17-9
Hardcover edition:
ISBN: 978-1-904832-76-8

For the New-York Historical Society:
Project Curator: Linda S. Ferber
Project Editor: Fronia W. Simpson
Photography of all objects in the N-YHS collections by Glenn Castellano.

For D Giles Limited:
Copy-edited and proofread by Sarah Kane
Designed by Helen Swansbourne
Produced by GILES, an imprint of D Giles Limited, London
Printed and bound in China

All measurements are in inches and centimeters.

ILLUSTRATIONS
Front cover: Richard Caton Woodville (1825–1855). *The Cavalier's Return*, 1847, detail (CAT. 54)
Back cover: William Sidney Mount (1807–1868). *Farmers Bargaining* (later known as *Bargaining
for a Horse*), 1835, detail (CAT. 31)
Frontispiece: Johannes Adam Simon Oertel (1823–1909). *Pulling Down the Statue of King
George III, New York City*, 1852–53, detail (CAT. 34)
Copyright page: Daniel Huntington (1816–1906). *Sowing the Word*, 1868, detail (CAT. 23)

Contents

Foreword

IT SEEMS ENTIRELY appropriate to celebrate the reopening of a renovated and reinvigorated New-York Historical Society with *Making American Taste: Narrative Art for a New Democracy*. This landmark exhibition drawn from the Society's own deep art collections introduces us to a marvelous corpus of paintings and sculptures that will be new to many viewers. This volume also expands our understanding of the tastes of those who built these collections as well as their aspirations and agendas. This exhibition will also tour as part of Sharing a National Treasure: The Traveling Exhibition Program of the New-York Historical Society, our ongoing campaign to bring our collections to the attention of national audiences. Our partners are the Taft Museum of Art in Cincinnati, Ohio, the Taubman Museum of Art in Roanoke, Virginia, and the Memorial Art Gallery of the University of Rochester, Rochester, New York.

Thanks are due to a great curatorial team. Guest Curator Barbara Dayer Gallati selected the works and developed the ideas and themes that drive the exhibition. Her partner on-site was Senior Art Historian, Linda S. Ferber. Dr. Gallati is the volume editor and major contributor to this publication, which also includes essays by Dr. Ferber and Dr. Ella M. Foshay. Dr. Kimberly Orcutt, Curator of American Art, contributed many of the entries that further enrich the volume.

For their generous support we thank Michael Reslan, the National Endowment for the Arts through the American Recovery & Reinvestment Act, the Walter and Lucille Rubin Foundation, the Raymond and Margaret Horowitz Foundation, Richard Gilder and Lois Chiles, the New York Community Trust Joanne Witty and Eugene Keilin Fund, Larry K. Clark, the Barrie A. and Deedee Wigmore Foundation, J. Joe Ricketts, the PJ Callahan Foundation, Inc., the Diane and Thomas Jacobsen Foundation, and Irma R. Rappaport.

LOUISE MIRRER
President and C.E.O.

OPPOSITE: Eastman Johnson (1824–1906). *Sunday Morning*, 1866, detail (CAT. 25)

Preface and Acknowledgments

Making American Taste: Narrative Art for a New Democracy should serve as an immediate standard reference source on two important counts. First, this volume publishes many important paintings and sculptures in the oldest public art collection in New York City; among them are a number of icons. However, apart from the information contained in Richard Koke's pioneering collection catalogue of 1982, most of these works are largely unknown to the scholarly and museumgoing community. The catalogue entries and artists' biographies presented here bring us up to date on core information and scholarship, paving the way for further research. Moreover, many of the works have recently been conserved and are illustrated in color, looking their best. Second, and equally important, are the thoughtful essays that accompany and interpret this corpus of works, most of which have been outside the canon of what is thought and taught in the history of American art and culture. This volume, therefore, will make a significant contribution to deepening our understanding of American taste and collecting. These practices are considered here in the complex cultural and social context of the nineteenth century. The fact that a number of the artists, collectors, and critics discussed were also members of the New-York Historical Society adds to the rich texture and historical significance of the volume.

Many members of the Society's museum and library staff have contributed to this project, including Sarah Armstrong, Maurita Baldock, Mary Beth Cadmus, Miguel Colon, Marybeth De Filippis, Joseph Ditta, Stephen Edidin, Roy R. Eddey, Elizabeth Fiorentino, Eleanor Gillers, Marcela Gonzalez, Kira Hwang, Susan Kriete, Brianne Muscente, Angela Nacol, Heidi Nakashima, Jillian Pazereckas, Eric Robinson, Daniel Santiago, Ione Saroyan, Miriam Touba, Laura Washington, Scott Wixon, and Heidi Wirth. Glenn Castellano deserves our special thanks for his splendid photography. Critical research support was provided by Christina Charuhas, Sophie Lynford, Alexandra Polemis, Sarah B. Snook, and Lori Zabar. The skills of Kenneth M. Moser and Eduardo Larreo revived both paintings and frames. The Williamstown Regional Conservation Center resurrected Louis Lang's great history painting, *The Return of the 69th (Irish Regiment)* of 1862, while Eli Wilner & Company created a historical replica of its long-lost frame. We thank Fronia W. Simpson for her expert and thoughtful editing. We are grateful to Dan Giles as a great publishing partner, and to Helen Swansbourne for her beautiful book design.

LINDA S. FERBER
Vice President and Senior Art Historian

Note to the Reader

Authors of Entries

BDG Barbara Dayer Gallati

KPO Kimberly Orcutt

Barbara Dayer Gallati wrote all of the artists' biographies.

Abbreviations

AAA Archives of American Art, Smithsonian Institution, Washington, D.C.

N-YHS New-York Historical Society

LW *Literary World*

NYDT *New York Daily Tribune*

NYEP *New York Evening Post*

NYH *New York Herald*

NYM *New York Mirror*

NYT *New York Times*

Dearinger 2004

Dearinger, David B., ed. *Paintings and Sculpture in the Collection of the National Academy of Design, Volume 1, 1826–1925.* Manchester, Vt.: Hudson Hills Press, for the National Academy of Design, 2004.

Dunlap 1834

Dunlap, William. *A History of the Rise and Progress of the Arts of Design in the United States.* 2 vols. New York: George P. Scott and Co., 1834.

Foshay 1990

Foshay, Ella M. *Mr. Luman Reed's Picture Gallery: A Pioneer Collection of American Art.* New York: Harry N. Abrams, in association with the New-York Historical Society, 1990.

Johns 1991

Johns, Elizabeth. *American Genre Paintings: The Politics of Everyday Life.* New Haven: Yale University Press, 1991.

Koke 1982

Koke, Richard J. *American Landscape and Genre Painting in the New-York Historical Society: A Catalogue of the Collection, Including Historical, Narrative and Marine Art.* 3 vols. New York: New-York Historical Society, in association with G. K. Hall & Co., 1982.

Tuckerman 1867

Tuckerman, Henry T. *Book of the Artists.* New York: G. P. Putnam and Son, 1867.

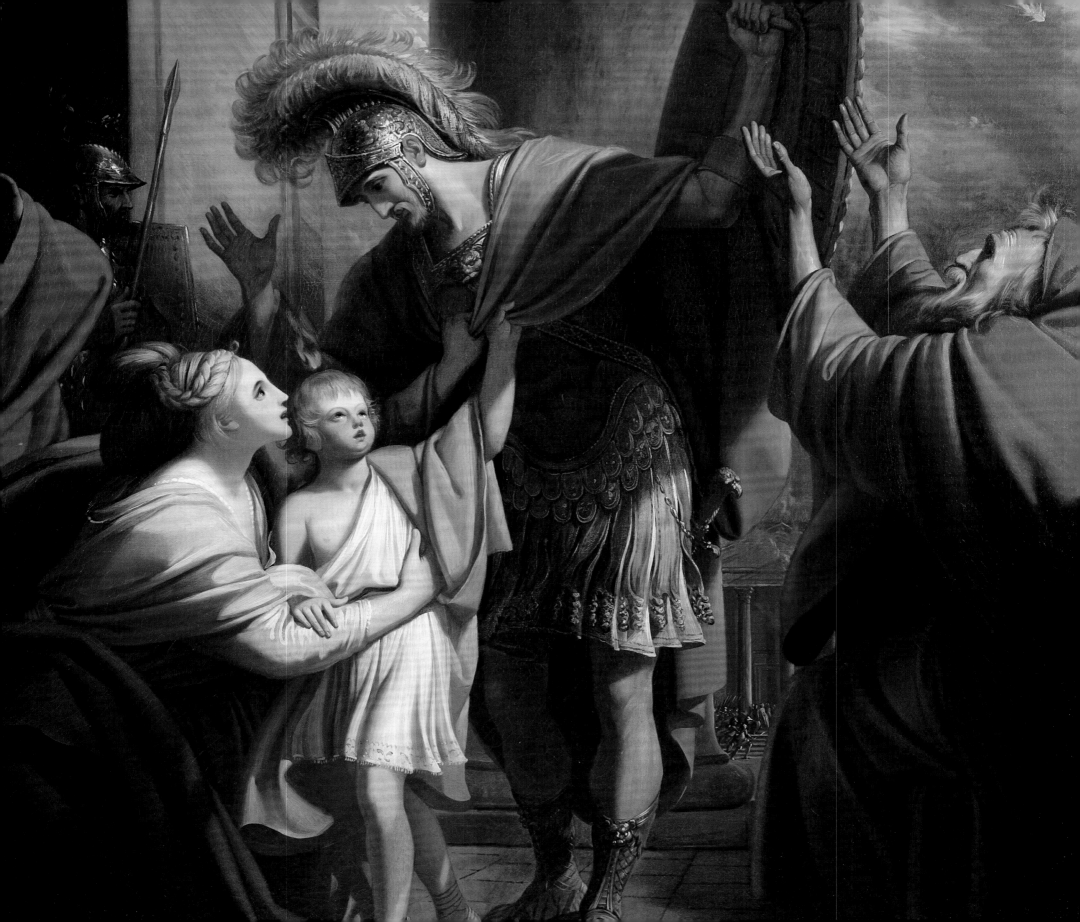

Taste, Art, and Cultural Power in Nineteenth-Century America

BARBARA DAYER GALLATI

JENNY: *I'm still trying to work out what makes good things good. It's hard isn't it?*
DANNY: *The thing is, Jenny, you know, without necessarily being able to explain*
why. You see, you have taste. That's not half the battle, that's the whole war.

—AN EDUCATION

A relish for the higher excellencies of art is an acquired taste, which no man ever
possessed without long cultivation, and great labour and attention.

—SIR JOSHUA REYNOLDS

The Question of Taste

The epigraphs to this essay represent opposite ends of an old and unresolved argument about the nature of taste. The first is dialogue from a recent film in which the sixteen-year-old protagonist Jenny learns difficult life lessons during her affair with an older man. Naïve and hungry for experience, Jenny is insecure about her ability to judge art and is reassured by her lover's friend that she already has taste, thus voicing one side of the debate that posits that taste is inborn, or at least passively acquired. The second, a statement by the eighteenth-century English painter Sir Joshua Reynolds (1723–1792), patently asserts that taste is something

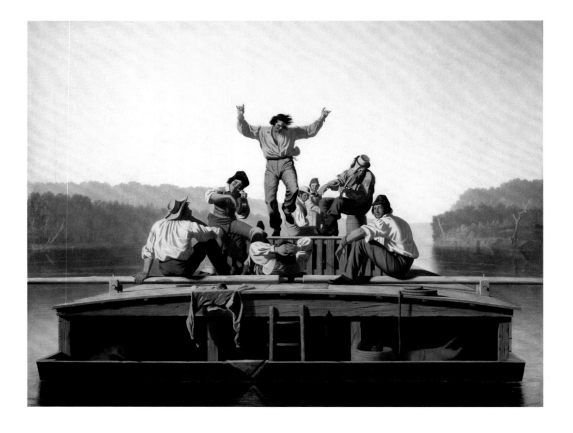

FIG. 1. George Caleb Bingham (1811–1879). *The Jolly Flatboatmen*, 1846. Oil on canvas, 38½ × 48½ in. (96.8 × 123.3 cm). Private collection, on loan to the National Gallery of Art, Washington. Image courtesy National Gallery of Art, Washington

to be learned and that it can only be attained over time and with effort. During the centuries separating Reynolds's pronouncement and the film, preferences for certain styles and themes have changed, but the problem of defining or quantifying taste has not been solved. This essay introduces the reader to these polarities of taste and why they arose in the context of antebellum American art. Emphasis is placed on New York—not only because the city was, by 1825, the nation's art center but also because the present exhibition is drawn exclusively from the collection of the New-York Historical Society, a repository that has reflected the taste of the city's cultural leaders since the institution was founded in 1804.

Atoning for Vulgarity

In 1847 a writer for the *Literary World* bemoaned the American Art-Union's decision to engrave George Caleb Bingham's *The Jolly Flatboatmen* (fig. 1) for distribution to its subscribers in 1846. Declaring that the painting dealt "a death blow to all one's preconceived notions of 'High Art,'" the anonymous columnist also expressed relief, stating that Daniel Huntington's *A Sibyl* (cat. 21), which the Art-Union also distributed in engraved form that year, would "amply atone for all that the other may lack."[1] Months later the same opinions were lodged again, presumably by the same author, who expanded his views, saying that Bingham's

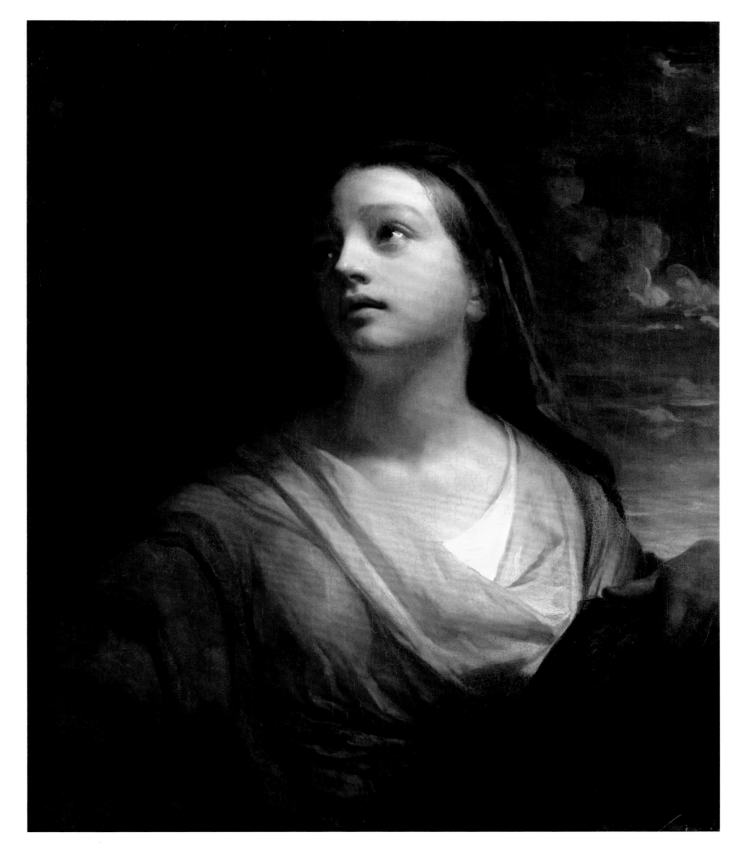

CAT. 21. Daniel Huntington (1816–1906).
A Sibyl, 1839

painting was a "vulgar subject, vulgarly treated . . . [and] were it not somewhat redeemed by the engraving of Huntington's Sybil, we should feel great commiseration for the members, that to the possibility of drawing some of the bad pictures was added the certainty of getting a print of so low a character."[2] The differences between the two paintings are manifold. Not only do they reveal dissimilar techniques but also—and what is more relevant here—Bingham's image of rough, masculine American frontier life was a decided contrast to the idealized feminine spirituality embodied in Huntington's *A Sibyl*.

The vehemence with which the *Literary World*'s critic vented his opinion might be unexpected, especially since the Bingham has achieved iconic status in the canon of American art history, whereas the once highly admired Huntington is now virtually ignored. The matter could be easily dismissed as being simply a question of taste. However, once considered, the issue of taste looms large as an unwieldy but crucial element of American cultural life. Indeed, "taste" was a primary component in critical discourse throughout the eighteenth and nineteenth centuries. Loosely defined as the "power of receiving pleasure from the beauties of nature and of art," taste was a dynamic factor in the formation of refined society.[3] And, as witnessed by the following extract, the concept was a fundamental concern at the time the *Literary World*'s critic was writing about Huntington's *A Sibyl* in 1847:

> A taste for the more elevated productions of painting and sculpture is rapidly increasing amongst us, and day after day brings new evidence of artistic genius, that will eventually raise this country to a level in this respect with any of the nations of Europe. . . . There are many persons of highly cultivated taste in this country, who find, in the noblest efforts of the chisel and pencil, the congenial embodiment of their own refined and glowing conceptions; but this is not sufficient for the interests of painting and sculpture. The fame and fate of artists depend even still more upon the verdict of the people at large; and until true ideas of art are more generally diffused, and the demand becomes greater for works of a high order, it cannot be expected that men of genius will devote the utmost powers of their minds to produce fine compositions.[4]

This passage introduces key ideas attached to the faculty of taste. The author acknowledges the existence and growth of "elevated" or high art and assumes that, with the proliferation of "elevated productions," the United States would attain parity with European nations in the realm of the arts. Cultural nationalism, however, was beset by conflicting demands: American artists had only a negligible history of their own and few opportunities for training. Short of developing a new, unique language of art, many artists had neither choice nor desire to do other than perpetuate European aesthetic models. Those models, however, were based on academic hierarchies of subject matter, media, and facture, rankings that recalled their origins in monarchical institutions and therefore conceptually contradicted the egalitarian precepts of the new democracy. Similarly, the notion of a group of "persons of highly cultivated taste" and another of the "people at large" also relied on a tendency to classify the population hierarchically, placing a small and refined social group possessed of superior taste in opposition to the broader mass of the populace, who were deemed incapable of appreciating the efforts of American artists. This concept, too, was antithetical to democratic attitudes because it presupposes the necessity for a privileged class that controls and disseminates valuable cultural currency.

To explore the ideology of taste as it developed in the United States, selected paintings and sculptures depicting genre, history, literary, and religious subjects are examined here. For the most part, the works discussed were well known to contemporaneous audiences, having been exhibited publicly, reproduced in print form, and/or written about in the press. Linked by their reliance on narrative imagery, these works are nonetheless separated by radically different aesthetics (in terms of both form and content) and are powerful material signs of the ideas that fueled debates about the promotion of populist or elitist taste.[5] The element of narrativity is especially important in this context. As Hayden White explains, "[N]arrativity, certainly in factual storytelling and probably in fictional storytelling as well, is intimately related to, if not a function of, the impulse to moralize reality, that is, to identify it with the social system that is the source of any morality that we can imagine."[6] This statement can also be applied to the visual arts inasmuch as readily accessible, moralizing content was deemed an essential component of a work of art in the early nineteenth century. Moreover, visual narratives seem to have been discussed using the same language with

which nineteenth-century reviewers assessed novels. As Nina Baym has observed of reviews of novels, "The assumption that the phenomena named as plot, character, and the like were properly understood by studying the lexical and syntactic units of the text—in other words by reducing it to elementary particles— did not yet exist."[7] Baym also maintains that literary reviews were couched in descriptive terms and gave scant attention to symbolism or metaphor. The same observations can be applied to the language of antebellum art criticism, which described the image (i.e., explicated the narrative) rather than interpreted content or evaluated technique.

Little consideration is given here to portraiture and landscape painting. For the most part, portraiture did not figure in discussions of taste. And, although it is readily admitted that landscape imagery is often narrative in character (see Ferber's essay in this volume), this omission is intentional and is justified by ideas presented in a lengthy article from the *Christian Examiner* in 1863. There, the writer extolled the intellectualism of the late Thomas Cole's allegorical landscapes and remarked (possibly alluding to the English art critic John Ruskin's [1819–1900] influence): "The American landscape school is now developing itself almost entirely in the direction of simple naturalism. By this term we mean the imitation of the forms and phenomena of nature as they appear to the eye, regardless of any higher meaning." The columnist also regretted the rising popularity of genre painting that featured the "common elements of life in their more materialistic sense," attributing its growing appeal to the fact that such imagery was universally intelligible—that is, accessible to the majority of the public.[8] Just as the writer in 1847 pitted Bingham's "vulgar" painting against Huntington's *A Sibyl*, this author based his assessments on the existence of a perceived "high" and "low" art, each of which appealed to equivalently positioned audiences on the rungs of the ladder leading to cultivation. Whether he realized it or not, the commentator for the *Christian Examiner* subscribed to the very same hierarchical categories used by European academies, in which history and religious themes represented the noblest subjects while landscape and portraiture were anchored at the lower range of the thematic spectrum.[9]

It was generally held that the ability to distinguish "high" from "low," or the "beautiful" from the "vulgar," required a level of refinement that was the product of the personal qualities of delicacy, sensibility,

and, above all, taste. In late-eighteenth- and nineteenth-century America, these concepts were legible signposts of social and economic status as well as intellectual and spiritual character.[10] Often considered attainable only by persons of high or aristocratic rank, "refinement" became increasingly accessible to members of the middle class, whose growing desire for self-improvement was paralleled by their new capacity for material acquisition. With that, art came within the reach of a greater number of people, if not through actual ownership at least through the proliferation of public exhibitions and press coverage, both of which stimulated the emergence of the professional critic.[11] Consequently, the opportunity for applying actual, personal experience of objects whose very existence was defined by standards of taste came within the purview of both the elite and the "common" man and offered a scale against which individual ideals could be measured. Although this process was occurring in Europe as well, social and cultural attitudes in America were made more complex by democratic principles that called into question the validity of clinging to Old World values. Such issues filtered into aesthetic debates among artists, critics, and patrons, yet nearly all participants in these disputes resorted to citing the cultivation of taste as the ultimate goal.

Given that a staggering variety of narrative subjects enjoyed critical respect and public admiration simultaneously, it is suggested here that the concept of taste, although once a stable sign of refinement, became elastic, stretching to accommodate the diverse political, social, and, indeed, professional aspirations of those who invoked the word. To a degree, the state of American arts in the mid-nineteenth century was as varied and fluid as the aesthetic pluralism that emerged in the latter part of the twentieth century and still governs today. The disorderly aesthetic conditions that are now in place may be seen to have their origins in the vital nineteenth-century American cocktail of aristocratic taste as it mixed with democratic ideals. The older precepts of taste were stretched to their limits until, as James B. Twitchell has concluded, "It is not that we think it bad manners to criticize someone else's taste, as much as it is that we have lost the concept of taste as a measure of criticism."[12]

Transplanting Grand-Manner Taste

In 1814 the young Samuel F. B. Morse wrote to his parents from London, summarizing his thoughts about the state of the arts in the United States: "It is really a pleasant consideration that the palm of painting still rests with America, and is, in all probability, destined to remain with us. All we wish is a taste in the country and a little more *wealth*. . . . In order to create a taste, however, pictures, first-rate pictures, must be introduced into the country, for taste is only acquired by a close study of the merits of the old masters."[13] Written during the War of 1812, Morse's comments manifest what the art historian Paul J. Staiti has called the "evangelical nationalism" that colored the young painter's attitudes about art as well as politics.[14] Morse had arrived in England in 1811, trained under Benjamin West, and continued to benefit from the advice of Washington Allston (1779–1843), with whom he had studied in Boston before traveling with the older artist to London. Both West and Allston instilled in Morse a taste for the grand manner, but it may be argued that West exerted the greater influence, especially in light of Morse's eventual role in establishing the National Academy of Design, modeled after the London Royal Academy of Arts, which West served as president from 1792 until his death in 1820. Indeed, for Morse and many other young American artists, West's rise from humble rural beginnings in colonial Pennsylvania to the heights of art culture in the English-speaking world stood as the greatest proof that American-born painters could forge successful careers.

West had remained in England chiefly because there was insufficient American patronage for the type of art he wished to make. Yet even though he never returned to his homeland, his reputation and examples of his art carried substantial weight in the formation of taste for Morse and his generation. As William Dunlap (another former West student) would write about him in 1834, "[West's] virtues and his talents have shed a lustre around his name, and we view him by a light radiating from himself. His influence on the art he professed will never cease."[15] Dunlap positioned West as a cultural savior of sorts by endowing him with a halo of self-generated light or wisdom that would ensure his lasting authority in the art world. This, of course, was not the case. West's output was neither sui generis nor would his mark on art be eternal. Instead, he was a conduit between England and her American colonies (later, the United States) through which notions of taste were transmitted.

OPPOSITE: **Samuel Finley Breese Morse** (1791–1872). *Landscape Composition: Helicon and Aganippe (Allegorical Landscape of New York University)*, 1836, detail (CAT. 30)

When West settled in London in 1763, he entered a culture that was marked by a veritable explosion of interest in defining and analyzing taste, a pursuit that inflected every aspect of society. Seemingly countless essays had already been devoted to discussions of taste, among them Joseph Addison's seminal "Taste," which appeared in a 1712 issue of the *Spectator*, William Hogarth's *The Analysis of Beauty, Written with a View of Fixing the Fluctuating Ideas of Taste* (1753), Edmund Burke's *A Philosophical Enquiry into the Origin of Our Ideas of the Sublime and Beautiful* (first published in 1757), and David Hume's "Of the Standard of Taste" (1757). Products of the Enlightenment, most authors speculated on whether methods could be formulated whereby responses to works of art could be quantified and clear-cut aesthetic standards established.[16] Flowing through this welter of publications was the shared notion that even though everyone possessed taste, it was governed by a social hierarchy. This was spelled out clearly by the Scottish thinker Archibald Alison:

> It is only in the higher stations, accordingly, or in the liberal professions of life, that we expect to find men of either a delicate or a comprehensive taste. The inferior situations of life, by contracting the knowledge and the affections of men within very narrow limits, produce insensibly a similar contraction in their notions of the beautiful or the sublime. The finest natural taste is seldom found able to withstand that narrowness and insensibility of mind which is, perhaps, necessarily acquired by the minute and uninteresting details of the mechanical arts.[17]

It is highly unlikely that art students pored over every treatise on taste, but it can be assumed that they were familiar with some and loosely acquainted with most. So numerous and convoluted were the taste debates that a reviewer for the *Monthly* concluded in 1759: "Yet, notwithstanding this general pursuit, and the various attempts that have been made by modern writers to trace the sources, and fix a standard of *taste*, there are very few persons who have their ideas adjusted, with any degree of precision, upon this subject; and the word *taste*, though in almost every body's mouth, is used in a very loose and indeterminate sense."[18] The word "taste" was used so frequently and its meaning was so vague that it

became a source of humor, as shown by the epigraph to an American essay on the subject quoting a "Man of Taste": "True taste to me is by this touchstone known, / That's always best that's nearest to my own."[19] Although written in jest, the unknown author's attitude was symptomatic of what one scholar has concluded was Americans' preference for common sense over theory, a sensibility grounded in "an essential distrust of, or indifference toward, serious philosophical discussions of aesthetic theories."[20] Compounding the problem for American readers was the fact that, although major Scottish and English writers on the topic were referred to in American discourse, often only extracts of their essays were printed in colonial periodicals or were known only secondarily through reviews. In the end, Alison's ideas took the firmest hold in the United States and then, not until after his *Essays on the Nature and Principles of Taste* was published in Boston in 1812.

However, the most pertinent sources on art theory for those attending the Royal Academy Schools were the lectures delivered by Reynolds, Henry Fuseli (1741–1825), and West, of which Reynolds's *Discourses* enjoyed the greatest longevity. As Reynolds's successor as president of the Royal Academy, West adopted a similarly authoritative persona by delivering aesthetic decrees in essays and lectures. As it happens, neither Reynolds nor West was formally educated, and both had risen in the artistic and social ranks by dint of their inherent talent, strong personalities, unceasing drive, and the successful assimilation of the gentlemanly manner, which, by definition, encompassed taste, or the ability to distinguish objects of superior quality. At the risk of oversimplifying West's theories, his prescription for acquiring "true" taste was reduced to three principal objects of study: the antique and the works of Michelangelo and Raphael.[21] West's American students (among them Morse, Dunlap, Charles Willson Peale [1741–1827], John Trumbull [1756–1843], and Allston) returned to their homeland imbued with the ideals conveyed to them by their teacher.[22] Thus, despite the fact that relatively few of West's paintings were readily available to American audiences, his reputation functioned as a beacon for aspiring artists.

West also exerted a presence in America in the form of the numerous portraits of him executed or commissioned by his former students that advertised their exclusive foreign training and reminded viewers of America's great potential for cultural glory. A prime example of such works is Sir Thomas Lawrence's

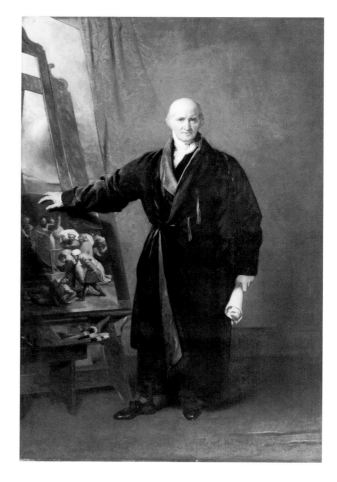

imposing full-length portrait of the aged West (fig. 2), commissioned by Trumbull in 1818 for the American Academy of the Fine Arts, in whose New York galleries the painting hung almost continuously for twenty years after its delivery in 1822.[23] Founded in 1802 by members of what can only be called New York's social old guard, the American Academy set itself the mission to provide cultural enlightenment for the local citizenry. In fact, however, the institution existed at and for the pleasure of its patrician members. It did little for American artists in terms of training them, and eventually charged admission fees that excluded the vast majority of the populace from its galleries. Nevertheless, the American Academy nominally upheld the academic standards inherited from Europe by amassing casts of classical statuary and, beginning in 1816, by organizing annual displays of art. Trumbull, the only artist to enjoy significant power within the institution over its lifetime, was himself descended from patrician Connecticut origins and, after he assumed the presidency of the academy in 1817, continued to promote the ideal of elitist art patronage on which the organization was founded.

FIG. 2. Sir Thomas Lawrence (1769–1830). *Portrait of Benjamin West*, ca. 1820–21. Oil on canvas, 107 × 69½ in. (271.8 × 176.5 cm). Wadsworth Atheneum Museum of Art, Hartford, Conn. Purchased by subscription (1855.1). Photograph © Wadsworth Atheneum Museum of Art / Art Resource, NY

This was the institutional context in which Lawrence's masterful likeness of West was first shown in New York. It endorses West's cultural authority as a painter and teacher, showing him as he delivers a lecture with his own copy of the revered Raphael's *Death of Ananias* on an easel. Trumbull had hoped to accrue additional respect for the American Academy by displaying West's portrait in its galleries, fully expecting the painting to underscore the kinship between the royal patronage of London's academy and that of the American organization.[24] However, the grand-manner ideals espoused by both institutions were not hardy enough to take strong root in American cultural soil. The Neoclassical mode in particular was little appreciated in the United States, a fact that partly accounts for the misinterpretation of West's paintings *Chryseis Returned to Her Father* and *Aeneas and Creusa* (cats. 49, 50).

By the mid-nineteenth century, West and his art were relegated to the dusty corridors of cultural memory. In 1852 one writer mentioned West as simply the source of Trumbull's history paintings, which by then were seen as "not impressive, and . . . chiefly valuable as accurately preserving the costume of the time for the use

of future artists."[25] Perhaps most damning was a series of articles entitled "West, the Monarch of Mediocrity," published in 1865, which characterized him as too willing to sacrifice his aesthetic ideals for the sake of obtaining royal attention.[26] West's role as Historical Painter to King George III had created a paradox; Americans were keen to claim (and acclaim) him, but his affiliation with the English monarchy was inimical to republican values. Thus, in the period of the country's early years as an independent nation, Lawrence's portrait of West embodied royal authority, with all the trappings of class division.

Yet class was a critical matter in the formation of an American national culture, and, as Morse had written to his parents, taste and wealth were necessary ingredients in the recipe for cultural advancement. When he returned to the United States in 1815, Morse was fired with the ambition to improve the nation's cultural condition, primarily through history painting, which he believed "would tend to elevate and refine the public feeling by turning their thoughts from sensuality and luxury to intellectual pleasures."[27] Even before he went to Europe, he was predisposed to this evangelical path by his family environment and education. Under the influence of his father, the Calvinist minister Jedidiah Morse, and his Yale mentor, Timothy Dwight, Morse adopted a utilitarian attitude that allowed him to merge his religious, political, and artistic goals in the belief that individual and national salvation could be accomplished through art.[28] Dwight's 1791 "Essay on Taste" was doubtless instrumental in shaping Morse's early notions of taste and deserves quoting at length:

> Taste may be defined, as the discernment, or the faculty by which we discern, propriety and beauty, in the objects with which we are conversant; especially the objects of imagination. Applied to the scenes of nature, and the works of art, a good taste is an aptitude to discern instinctively and clearly, the various articles, which, in those objects, are the sources of pleasure to our minds; such as beauty strictly so called grandeur, sublimity, resemblance, contrast, novelty, motion, and force. As it respects human conduct, it is a ready discernment of propriety, grace, ease, elegance, and dignity. In the imitative arts, it is a similar discernment of the justness of the imitation, and of the beauties of these means, by which it is accomplished.[29]

24

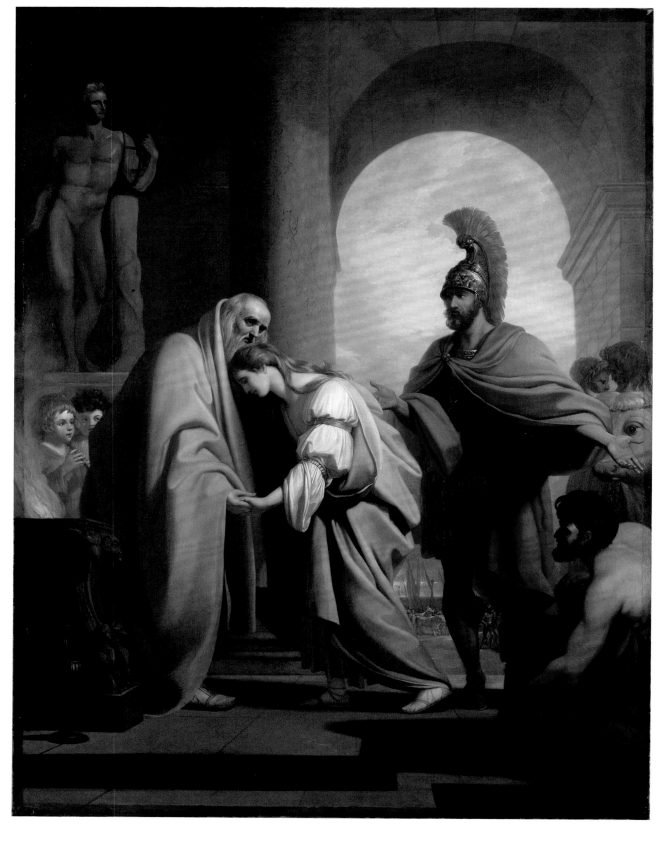

CAT. 49. Benjamin West (1738–1820).
Chryseis Returned to Her Father, ca. 1771

CAT. 50. Benjamin West (1738–1820).
Aeneas and Creusa, ca. 1771

As it had been for Trumbull, Morse's training with West was sound preparation for an aspiring history painter, and he enjoyed heartening acclaim for his *The Dying Hercules* (1812–13, Yale University Art Gallery), shown at the Royal Academy's 1813 exhibition. Buoyed by this early triumph, Morse was confident that he was ordained to bring American culture to a higher aesthetic and spiritual plane, but he returned home only to discover that the citizenry displayed "almost total want of taste."[30] His disenchantment was intensified by the poor reception given to *The Dying Hercules*, which remained unsold after showings in Boston and Philadelphia, and he had to rely on portrait painting for his livelihood over the next decade or so. After years of travel seeking portrait commissions, Morse moved to New York in 1824 and soon became associated with influential members of the city's cultural community—namely the Knickerbocker circle.[31] In 1825 he was a founder of the New York Drawing Association, which developed the following year into the National Academy of Design.

Led by Morse, the fledgling National Academy of Design limited its membership to artists and functioned as an alternative to the American Academy of the Fine Arts, the administration of which neglected the work of contemporary American artists in favor of old masters. The constellation of frictions between the two institutions is complicated, but in brief and in contrast to the older organization, the new academy initiated annual exhibitions of works by living (and primarily American) artists and provided training. For Morse, his presidency of the new academy also afforded an official platform for sounding his opinions.[32] This he did through a series of lectures fashioned after Reynolds's *Discourses* and through articles and letters printed (sometimes anonymously) in the *New York Observer*, edited by his brother Sidney.

After Andrew Jackson was elected president of the United States in 1828, Morse's rhetoric reached a fever pitch. He believed that the intellectual elite was obliged to counteract what he saw as the negative fruits of democracy, that is, a society governed by untutored masses, exemplified by Jackson, that would lead to moral decay:

> Are not the refining influences of the fine arts needed, doubly needed, in our country? Is there not
> a tendency in the democracy of our country to low and vulgar pleasures and pursuits? Does not the

FIG. 3. Samuel F. B. Morse (1791–1872). *Gallery of the Louvre*, 1831–33. Oil on canvas, 73¾ × 108 in. (187.3 × 274.3 cm). Terra Foundation for American Art, Chicago. Daniel J. Terra Collection, 1992.51. Photograph © Terra Foundation for American Art, Chicago / Art Resource, NY

contact of those more cultivated in mind and elevated in purpose with those who are less so, and to whom the former look for political favor and power, necessarily debase that cultivated mind and that elevation of purpose? When those are exalted to office who best can flatter the low appetites of the vulgar; when boorishness and ill manners are preferred to polish and refinement, . . . is there not danger that those who would otherwise encourage refinement will fear to show their favorable inclination lest those to whom they look for favor shall be displeased; and will not habit fix it, and another generation bear it as its own inherent, native character?[33]

Although Morse continued to harbor hope for the nation's cultural future, he remained disappointed. His imposing *The House of Representatives* (1822–23, Corcoran Gallery of Art, Washington, D.C.) had failed to excite viewers because it lacked narrative content, and his grand *Gallery of the Louvre* (fig. 3), which elaborated his knowledge of Europe's past masters, also failed to engage popular interest. His painting career entered the doldrums, but as *Landscape Composition: Helicon and Aganippe* (cat. 30) suggests, he maintained a utopian, albeit eccentric, vision of America's intellectual future. Cast in a visual language

derived from that of the great seventeenth-century landscapist Claude Lorrain (1600–1682), Morse's strange imagery encoded his belief that knowledge of European traditions was a requisite foundation for the coming supremacy of American civilization. He was nonetheless embittered by the lack of appreciation for his art and railed against the vulgarity of the American citizenry. The disillusioned Morse vented increasingly racist, anti-Catholic, anti-immigrant, and nativist vitriol as he continued his campaign for national improvement. Although he remained president of the National Academy until 1845, by the late 1830s he had essentially abandoned his painting career.

Like Morse, John Vanderlyn suffered acutely from America's cultural deficits, and his frustrations were augmented once he entered the European artistic milieu. With the backing of his patron, the statesman Aaron Burr, Vanderlyn first went to Europe in 1796, making the somewhat unusual decision to train in Paris, where he remained for the better part of five years. However, given Burr's Francophile leanings—he styled his Richmond Hill mansion and entertainments after French salon culture—it is understandable that Vanderlyn followed the taste of his benefactor.[34] He sailed a second time to Europe in 1803, charged with obtaining plaster casts of classical sculpture for the American Academy of the Fine Arts. In Paris once again, he embarked on what was to be the most successful period of his career, which yielded *The Death of Jane McCrea* (1804, Wadsworth Atheneum Museum of Art, Hartford, Conn.), *Caius Marius amid the Ruins of Carthage* (fig. 4), and *Ariadne Asleep on the Island of Naxos* (1809–12, Pennsylvania Academy of the Fine Arts), all of which were shown at the Paris Salon, where *Marius* was awarded a gold medal in 1808.

In addition to creating his own critically acclaimed compositions, Vanderlyn executed copies of European masterworks commissioned by American clients, one of which—*Antiope*, after Correggio (1489–1534) (fig. 5)—Dunlap recalled seeing in the home of the New Yorker John R. Murray. Dunlap recounted Murray's reaction to the painting, which, although he admired it, caused the owner consternation: "What can I do with it? It is altogether indecent. I cannot hang it up in my house, and my family reprobate it." As Dunlap explained, "The artist had consulted his own taste, and the advantage of studying such a work, more than the habits of his country, or the taste of his countrymen."[35] Although Vanderlyn was aware of the strong public resistance to images of female nudes, he persevered by displaying his *Ariadne* in an exhibition of his

FIG. 4. John Vanderlyn (1775–1852). *Caius Marius amid the Ruins of Carthage*, 1807. Oil on canvas, 87 × 68½ in. (221 × 174 cm). Fine Arts Museums of San Francisco, Gift of M. H. de Young, 49835

paintings in New York, from which the drawing instructor John Rubens Smith (1770–1849) campaigned to have the "indecent pictures" (*Ariadne* and *Antiope*) removed from public view.[36] Like some of his painter colleagues (among them Dunlap, Morse, and Rembrandt Peale), Vanderlyn sent large "exhibition" paintings on the road; *Ariadne*'s tour included showings in Montreal, Boston, Washington, D.C., Baltimore, New Orleans, Charleston, and Savannah.[37] These commercial endeavors, spurred partly by the financial panic of 1818–19, offered the possibility of financial gain and simultaneously permitted the artists to disseminate prized examples of their work to far-flung audiences in the hopes of whetting and shaping public appetite for art. Marketing art in this way appealed more to the casually curious than to connoisseurs, inasmuch as emphasis was placed on the sensational aspects of the works. In this connection, Vanderlyn may have begun

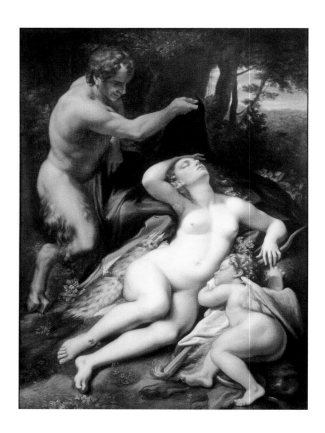

FIG. 5. John Vanderlyn (1775–1852)
after Correggio (1489–1534). *Antiope*,
1809. Oil on canvas, 70¼ × 51 in.
(178.4 × 129.5 cm). The Century
Association, New York

the replica of *Ariadne* (cat. 45) in order to have an additional version of his famous painting to send on tour.

Although *Ariadne*'s various tours resulted in financial losses, reactions to the painting varied drastically and were determined by demographic factors; for instance, the French heritage of many New Orleans viewers seems to have made them more receptive to the Neoclassical provenance of Vanderlyn's female nude. The vast differences in public reaction notwithstanding, the painting fared well with professional critics, many of whom likely sought to enhance their own standing by displaying a sophisticated level of appreciation that separated them from the culturally uninformed public. While it is doubtful that many of the reviewers were cognizant of the distinguished iconographic lineage embedded in the form of the sleeping Ariadne (a heritage that incorporated classical, Renaissance, Baroque, and Neoclassical precedents), most were quick to acknowledge the painting's particular beauty and skirted the issue of nudity. As one enthusiastic critic wrote in 1826:

> A more perfect representation of true excellence, cannot be well conceived. The richness and truth of the coloring, the grace and elegance of the figure, the ease and simplicity of the attitude, the beauty of the landscape, form a *tout ensemble* that must meet the wish of the most fastidious critic, while it enchants every beholder, and leads one for a moment to believe that some divinity of fairy creation is discovered to the sight.[38]

Except for the honor of painting one of the murals for the U.S. Capitol Rotunda, Vanderlyn's livelihood depended on portraiture for the remainder of his career. Well after the artist's death, the historian Henry T. Tuckerman recalled that Vanderlyn's long-standing bitterness was "increased by the charge of indelicacy

OPPOSITE: CAT. 45. John Vanderlyn
(1775–1852). *Ariadne Asleep on the Island
of Naxos*, ca. 1811–31

somewhat grossly urged against his works, by ignorant prudery, which, destitute of the soul to perceive the essential beauty of the creator's masterpieces, has yet the hardihood to impugn the motives of genius, and desecrate by vulgar comments, the most beautiful evidences of its truth."[39]

In contrast to West, Morse, and Vanderlyn, William Dunlap took a more pragmatic tack in constructing his career—or, rather, careers—as painter, playwright, theater impresario, art critic, and historian of American art and theater.[40] Like the others, however, he regretted the almost nonexistent market for contemporary art in America and was reduced to painting portraits when he returned to New York in 1787 from his London studies with West. Dunlap's wide-ranging interests and talents liberated him from dwelling too much on the failures of American culture; instead, he worked tirelessly at his writing and theatrical productions and painted only intermittently. His membership in the Philological Society, formed in 1788, brought him into close contact with the lexicographer and Yale graduate Noah Webster, with whom he shared a love of language. When Webster left New York, the society seems to have metamorphosed into the Friendly Club, a literary group whose roster included Dunlap's friend the novelist Charles Brockden Brown.[41] Dunlap's family connections also aided him in this social arena, especially after his marriage in 1789 to Elizabeth Woolsey, which took him into the orbit of the powerful New York mercantile Woolsey family, and made him a brother-in-law of Timothy Dwight (Morse's early mentor at Yale). Such early club associations anticipated Dunlap's place as a key figure in other organizations, including the American Academy of the Fine Arts, the Bread and Cheese Club, and the National Academy of Design.

Although most of his oeuvre consists of fairly prosaic portraits, Dunlap aspired to the grand-manner mode, as witnessed by a series of large exhibition paintings featuring the life of Christ that he sent on tour.[42] Dunlap had proudly admitted that two of the canvases, *Christ Rejected* and *Death on a Pale Horse*, were based on works by West, a claim borne out by comparing the sole surviving study for the former (fig. 6) with West's original (fig. 7).[43] The gulf between the ambitions and realities faced by aspiring American painters is illuminated in Dunlap's full-blown grand-manner conception for *Christ Rejected* and *The Artist Showing a Picture from "Hamlet" to His Parents* (cat. 8), the latter of which may be interpreted as a hopeful bid for cultivating a taste for the higher branches of art in America.

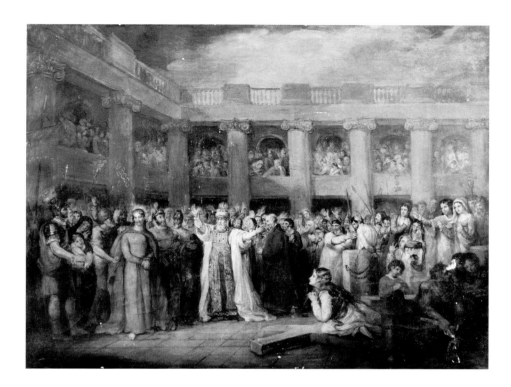

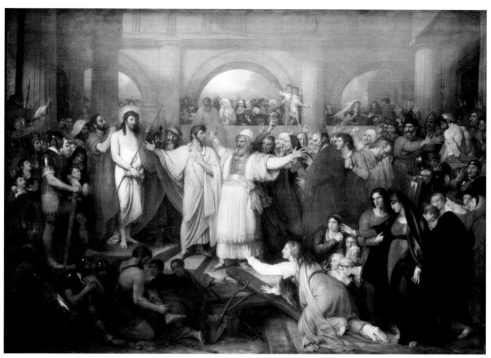

FIG. 6. William Dunlap (1766–1839) after Benjamin West (1738–1820). *Christ Rejected*, 1822. Oil on canvas, 27¾ × 35⅞ in. (70.5 × 91.2 cm). Princeton University Art Museum. Museum purchase, Caroline G. Mather Fund. Photo: Bruce M. White

FIG. 7. Benjamin West (1738–1820). *Christ Rejected*, 1814. Oil on canvas, 200 × 260 in. (5.1 × 6.6 m). Courtesy of the Pennsylvania Academy of the Fine Arts, Philadelphia. Gift of Mrs. Sarah Harrison. The Joseph Harrison, Jr. Collection

Almost without exception, the first generation of postcolonial American artists were from privileged circumstances. Dunlap had assured the readers of his history of the arts that West was "well-born" (i.e., innately refined); Dunlap himself was the son of indulgent parents who financed his training; Morse was a graduate of Yale University; Allston, a graduate of Harvard University; Vanderlyn inherited a family tradition in the arts and was also educated at the exclusive Kingston (N.Y.) Academy; and Trumbull, also a Harvard graduate, was the son of a Connecticut governor. As young men they were primed to accept European cultural hierarchies. At the same time, they felt compelled to transmit those values to a public not yet in the habit of seeing, buying, or appreciating art, the idea of which, under the sway of a Puritan heritage, remained inextricably linked with decadence and luxury. Adding to these disadvantages was the mounting distrust of connoisseurs whose knowledge of European precedents seemed to expose unpatriotic tendencies. As one writer cautioned about the typical connoisseur, "Though born in America, he has traveled long enough to fall in love with everything foreign, and despise everything belonging to his own country, excepting himself. He pretends to be a great judge of painting, but only admires those done a great way off and a great while ago."[44]

The cynicism elicited by connoisseurship was exacerbated by problems associated with gauging the authenticity of European canvases that flooded the American market. As late as 1856, the character of the "pompous connoisseur" formed the introduction to an article recommending that the American "ardor of independence" be directed to supporting American artists. The article opened with lines from a humorous poem:

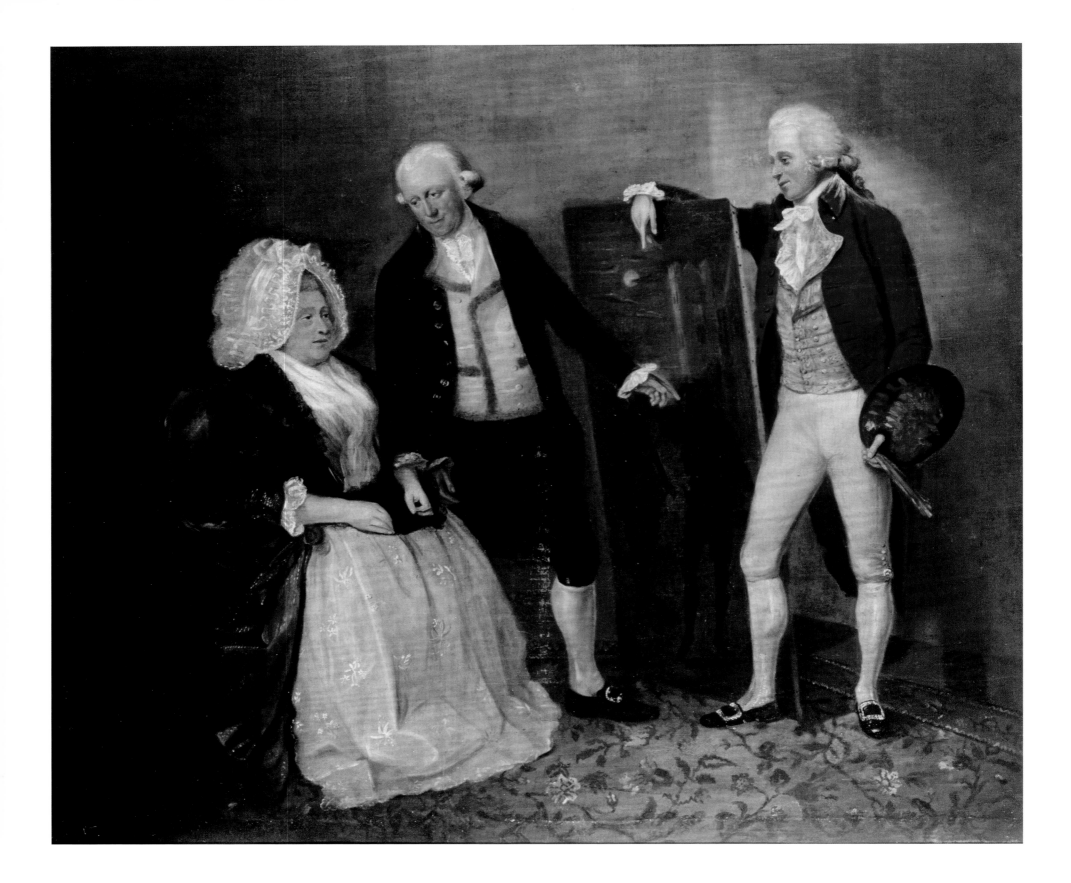

> The smiling artist paints to-day
> A picture, deeply shaded;
> Then rolls and cracks it every way
> To make it worn and faded.
> To-morrow comes the connoisseur,
> All pomp and proud decision:
> "Two thousand dollars;" no demur—
> He buys it for a Titian![45]

Essentially, popular sentiment held that the nation could not achieve complete independence until it extricated itself from the cultural grip of Europe, whether that grip was in the form of spurious works of art or in the form of undue reverence for the art of the past. This developing attitude ran counter to Morse's insistence that "taste is only acquired by a close study of the old masters."

Translating Literary Taste into Visual Experience

Dunlap's conversation piece in which he depicted himself elaborating on his painting of the ghost scene from Shakespeare's *Hamlet* underscores the unity of the arts at the end of the eighteenth century. The painting's narrative is a reminder of the interlocking relationship of the written word, theatrical performance, and the visual arts and foretells the artist's own extensive involvement with each. The painting also forecasts a general adjustment in taste away from heroic history paintings toward literary subject matter—a shift that arose from within the growing mercantile class whose discretionary funds were often spent on the ornamentation of increasingly elegant households, contributing to what has been called "parlor culture."[46] The connections between refined taste and interior decor were aptly summarized in an 1836 editorial in the *Portland Magazine*: "Perhaps there is no one thing which bespeaks the improvement of a people in good taste and intellectual endowment, as does the encouragement given to literature and the arts. Both go hand in hand; both must rise or fall together. Whenever we see a good picture in a drawing room, we are as certain

OPPOSITE: CAT. 8. William Dunlap (1766–1839). *The Artist Showing a Picture from "Hamlet" to His Parents*, 1788

that a corresponding quantity of books and periodicals are to be found in the library."[47] This sensibility persisted, and three decades later Tuckerman was making similar observations: "The analogies between literature and art are more numerous and delicate than we are apt to imagine."[48]

With the growing demand for paintings suited to domestic interiors came the requirement for subjects that would accommodate owners' desires to display their personal taste. Literary subject matter, with its emphasis on often complex compositions within which figures told a familiar, moralizing narrative, allowed artists to exercise the same talents required for history painting. In fact, these "literary" paintings were in actuality history paintings whose imagery was filtered through the fictions of such revered authors as Shakespeare, Sir Walter Scott, Washington Irving, and James Fenimore Cooper. Under the collective stimulus of the annual exhibitions staged by the National Academy of Design, the active club life in support of the literary and visual arts that sprang up in cities throughout the country, and a strong parallel trend in England for this kind of art, American painters and sculptors found a market for subject matter that pictured the familiar words of favorite authors.[49]

New York City was especially fertile ground for this type of cultural flowering, owing particularly to the 1825 opening of the Erie Canal. The canal celebrations cemented the city's dominance as the nation's economic and cultural hub, essentially announcing New York as the new center of art and publishing. Galvanized by a small but powerful group of writers, artists, publishers, and businessmen constituting the Knickerbocker circle, New York's cultural energies found focus through the symbiotic relations among such men as the novelists James Fenimore Cooper and Washington Irving, the poets William Cullen Bryant and Fitz-Greene Halleck (known as the "American Byron"), the artists Asher B. Durand, Dunlap, Morse, and Cole, and businessmen and politicians, including Luman Reed, Gulian Verplanck, and Philip Hone.[50] United by their eagerness to promote American cultural production, these men formed the practical and spiritual foundation for the development of a national vernacular in arts and letters.

Durand's *Peter Stuyvesant and the Trumpeter* (cat. 9) is a prime example of the synthetic relationship between the visual and literary arts favored by the Knickerbockers. It depicts an episode from Irving's famed satire *A History of New York, from the Beginning of the World to the End of the Dutch Dynasty*

OPPOSITE: CAT. 9. Asher B. Durand (1796–1886). *Peter Stuyvesant and the Trumpeter*, 1835

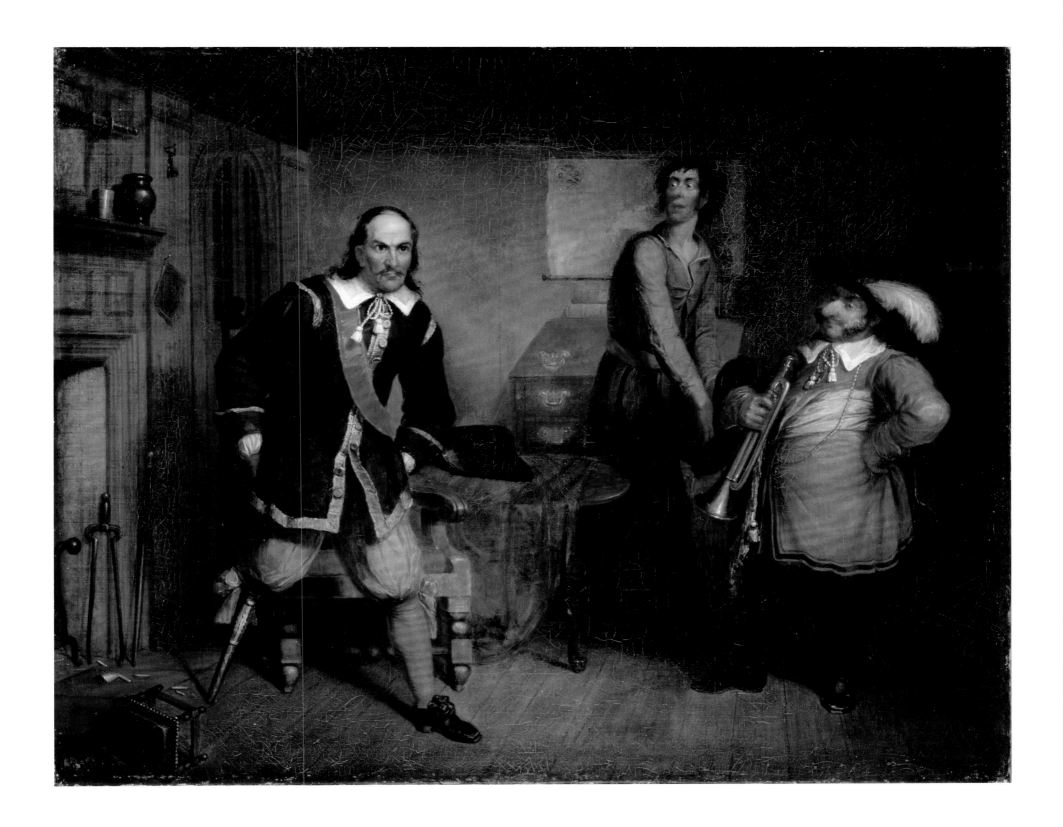

(1809). Written under the pseudonym Diedrich Knickerbocker (from which the movement, as it were, took its name), Irving's "history" has been read partly as an indictment of Jeffersonian policies. Irving was especially at odds with the Embargo Act, instituted under President Thomas Jefferson in 1807 in response to war between France and Great Britain that forbade American vessels from carrying cargo to or from foreign ports. The law, which crippled New York commerce, was repealed in 1809 during Jefferson's last week in office. Irving loosely cast Jefferson in the character of William the Testy, creating a construct in which Jefferson stood as the archetypal republican gentleman farmer, whereas the Dutch (the original colonizers of New York) embodied the merchant oligarchy that depended on and supported urban economies.[51]

In this respect, Durand's *Peter Stuyvesant and the Trumpeter* is notable, for this, his first attempt at literary genre, focuses on the early years of New York history under the mercantile rule of the Dutch. Filled with high drama that echoes the burlesque mood of Irving's text, the painting portrays New York's—or, rather, New Amsterdam's—most memorable governor. As such, the painting reflects Durand's awareness of the developing taste of the work's commissioner, Luman Reed, who had recently begun collecting the works of contemporary American artists, was an acquaintance of Irving, and perhaps appreciated content that implicitly affirmed the priority of the merchant class. Similarly, Robert W. Weir encoded the social, political, and cultural dynamics of Knickerbocker New York in his *Saint Nicholas* (cat. 48), the first version of which was offered to the lawyer, politician, author, and art collector Gulian Verplanck. Among other things, Verplanck was a partner in the gift-book publication the *Talisman*, a volume that featured poetry, prose, and engraved illustrations after paintings by Weir (including *Red Jacket*, cat. 47) and others. The *Talisman*, which lasted for just three annual issues, was only a small part of the "gift-book phenomenon" that brought together poetry, prose, and art for a target audience prepared to spend money on a minor yet nonetheless luxury item.[52]

Although Irving had spent nearly seventeen years in Europe (1815–32), his writings—especially the *Sketch Book*—continued to attract a huge American readership. First published in New York in 1819–20 under the aptly "artistic" pseudonym Geoffrey Crayon, the volume included thirty-four essays and short stories, among them "The Legend of Sleepy Hollow" and "Rip Van Winkle." Like Knickerbocker's

CAT. 48. Robert W. Weir (1803–1889).
Saint Nicholas, 1837–38

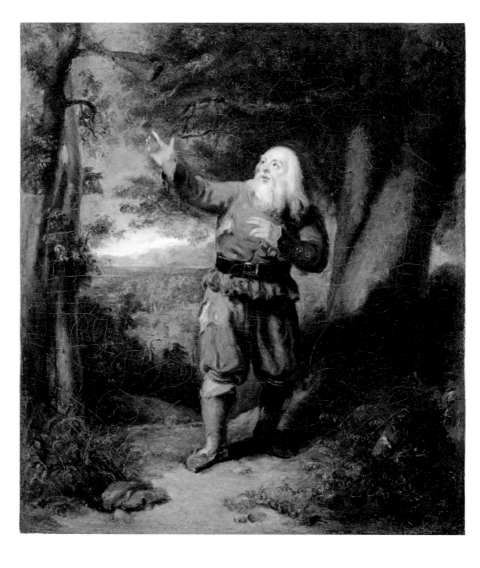

FIG. 8. Henry Inman (1801–1846). *Mr. Hackett in the Character of Rip Van Winkle*, ca. 1832. Oil on canvas, 30¼ × 25¼ in. (76.8 × 64.1 cm). National Portrait Gallery, Smithsonian Institution, Washington, D.C. Photograph © National Portrait Gallery, Smithsonian Institution / Art Resource, NY

"history," these vivid tales set in the Catskill region recalled the Dutch colonial past and satisfied artists who wanted to escape the drudgery of portraiture and desired instantly recognizable subjects of national origin that would attract patrons. When Irving returned to the United States in 1832, he was hailed as a national hero for having put American literature on the European map, an achievement that was celebrated with a flood of theatrical productions and paintings based on his writings. This intersection of literature, theater, and fine art is materially documented in Henry Inman's portrait of the actor and Reed protégé James Henry Hackett in the role of Rip Van Winkle (fig. 8). The publication of illustrated editions of Irving's oeuvre proved a veritable industry and enabled such artists as John W. Ehninger to launch their careers with Irving-derived subjects (cat. 15) and to line their pockets with receipts for book illustrations.

The works of Sir Walter Scott and James Fenimore Cooper also provided rich texts from which paintings were created. Scott's thirty-two novels and stories collectively known as the Waverley novels brought him extraordinary attention in the United States. A passage devoted to the character of the elfin page from Scott's poem "The Lay of the Last Minstrel" was the subject assigned at the March 27, 1829, gathering of the Sketch Club attended by, among others, Verplanck, Morse, Durand, Weir, Cole, and Henry Inman.[53] Not surprisingly, Cole's sketch emphasized landscape elements and reduced the figures to tiny forms in the distance. His translation of poetry into landscape signals the existence of a subgenre in American painting that can be best termed literary landscape, a fully realized example of which is his *Landscape* (cat. 7). Based on Lord Byron's "Parisina," the painting is one of several in Cole's output in which he infused landscape with familiar literary content, thus elevating landscape to a higher level in the academic scheme of subject matter. Among Cole's other literary landscapes are *Scene from "Manfred"* (after another work by Byron, 1833, Yale University Art Gallery) and pictorial adaptations of Cooper's *The Last of the Mohicans* (e.g., fig. 9). For some viewers, depictions of locales having literary associations were enough to construct a narrative. When Andrew Richardson's (1799–1876) *Dryburgh Abbey* was shown at the National Academy of Design in 1833, for instance, it was identified by one critic as the burial place of Sir Walter Scott and praised because its "[a]ssociation endears every thing connected with the author of Waverley to our understandings and our hearts."[54]

Shakespeare's plays proved the most varied and durable literary sources for artists, and, as Cooper observed, "Shakspeare is, of course, the great author of America."[55] Shakespeare's popularity was so extensive that when the Frenchman Alexis de Tocqueville toured the United States in 1831–32 he remarked, "The literary genius of Great Britain still darts its rays into the recesses of the forests of the New World. There is hardly a pioneer's hut which does not contain a few odd volumes of Shakespere."[56]

The vogue for Shakespearean imagery in the American visual arts was stimulated by the Englishman John Boydell's Shakespeare Gallery, a commercial venture through which Boydell commissioned paintings based on Shakespeare's plays for display in a purpose-built London gallery, with admission profits supplemented by the sale of prints after the works in the collection.[57] The gallery opened in 1789 and closed in 1805, when 167 of the paintings were auctioned, among them Benjamin West's *King Lear in the Storm* (to use its original title;

CAT. 7. Thomas Cole (1801–1848). *Landscape* (later known as *Moonlight*), ca. 1833–34

FIG. 9. Thomas Cole (1801–1848). *Scene from "The Last of the Mohicans," Cora Kneeling at the Feet of Tamenund,* 1827. Oil on canvas, 25⅜ × 35 1/16 in. (64.5 × 89.1 cm). Wadsworth Atheneum Museum of Art, Hartford, Conn., Bequest of Alfred Smith, 1868.3. Photograph © Wadsworth Atheneum Museum of Art / Art Resource, NY

fig. 10) and *Ophelia before the King and Queen* (1792, Cincinnati Art Museum). Purchased by West's former student Robert Fulton (1765–1815, who had by then transferred his energies from art to engineering), the two paintings were placed on loan to the Pennsylvania Academy of the Fine Arts until 1816, when they were deposited with the American Academy of the Fine Arts in New York, where they featured in its annual displays.[58] Even before the arrival of West's *Lear* and *Ophelia,* however, New Yorkers had flocked to David Longworth's Shakespeare Gallery on Park Row in 1801 to view Longworth's collection of Boydell prints, revealing what one reporter deemed "pleasing proof of the growing taste of our citizens."[59]

The young George Whiting Flagg undoubtedly consulted a Boydell print (fig. 11) for his own version of the Shakespearean *Murder of the Princes in the Tower* (cat. 16). Refined American audiences, however, generally recoiled from visual representations of such bloodcurdling scenes and inclined to more lighthearted, romantic works such as Charles Robert Leslie's *Slender, with the Assistance of Shallow, Courting Anne Page, from "The Merry Wives of Windsor" by William Shakespeare* (fig. 12), a version of which was owned by New York's future mayor Philip Hone and engraved for distribution by the American Art-Union in 1850.[60] Noted for his historical and literary paintings "in which either the beauty

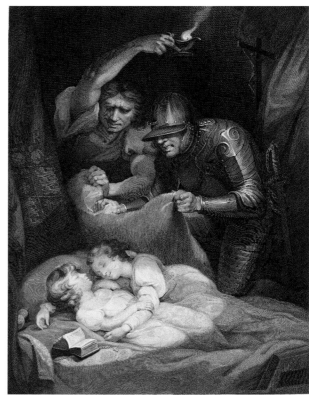

FIG. 11. Francis Legat (1755–1809) after James Northcote (1746–1831), *Shakespeare Gallery: King Richard III, Act IV, Scene III: The Murder of the Princes*, 1790. Etching and engraving on paper, 22¼ × 16 in. (56.5 × 41 cm). The Trustees of the British Museum, Prints and Drawings, Dd,6.26

FIG. 10. Benjamin West (1738–1820). *King Lear*, 1788, retouched by West, 1806. Oil on canvas, 107 × 144 in. (271.8 × 365.8 cm). Museum of Fine Arts, Boston. Henry H. and Zoe Oliver Sherman Fund, 1979.476. Photograph © 2011 Museum of Fine Arts, Boston

or the humour struck his fancy," Leslie was a favorite in the United States not only because of the picturesque pleasantries he portrayed but also because Americans could be proud of the success of this London-based American who was a Royal Academician.[61] As one American critic wrote of him in 1829, "No painter of the present day shows in his works more careful observation of nature, in her frolic moods. . . . His humor is never tinged with vulgarity, never degenerates into buffoonery; it is always delicate and refined. He is in painting what Irving is in writing."[62] In other words, Leslie's art exuded taste even though by addressing humorous episodes he risked crossing the fine line separating refinement from vulgarity.

CAT. 16. George Whiting Flagg
(1816–1897). *Murder of the Princes in
the Tower*, ca. 1833–34

FIG. 12. Charles Robert Leslie (1794–1859). *Slender, with the Assistance of Shallow, Courting Anne Page, from "The Merry Wives of Windsor" by William Shakespeare*, 1825. Oil on canvas, 26⅝ × 30½ in. (67.7 × 77.5 cm). Yale Center for British Art, New Haven, Conn. Paul Mellon Fund. Photograph © Yale Center for British Art, Paul Mellon Fund, USA / The Bridgeman Art Library

The expression of humor in art posed a knotty problem, as witnessed by critics' objections to Flagg's depiction of Falstaff (cat. 17) as a "coarse buffoon" rather than the gentleman he was by birth.[63] The roots of this attitude lay in established codes of behavior governing gentility or refinement in which civilized conduct precluded clownish or boorish behavior.[64] Fine art officialdom may not have condoned the extremes exhibited and enjoyed in the myriad burlesques of Shakespeare's plays performed in the United States, but they testified to Shakespeare's place in both the high and low cultural spheres.[65] In the visual arts, Shakespeare would remain refined, eventually whittled down to the size of such cabinet paintings as

CAT. 17. George Whiting Flagg
(1816–1897). *Falstaff Playing King*,
ca. 1834

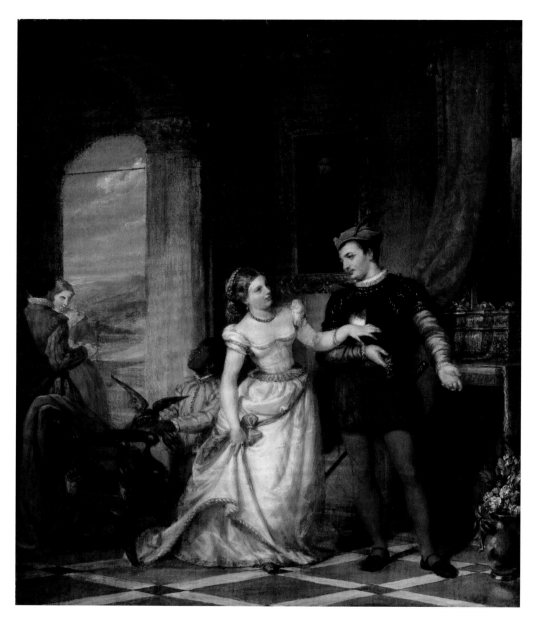

CAT. 20. Henry Peters Gray (1819–1877). *Portia and Bassanio—from "The Merchant of Venice,"* 1865

Henry Peters Gray's *Portia and Bassanio* (cat. 20). By the 1880s numerous versions of John Rogers's *"Ha! I Like Not That!"* from *Othello* (cat. 38) were likely owned by the same middle-class consumers who had relished the wonderfully parodic soliloquy from *Hamlet* in Mark Twain's *Huckleberry Finn.*[66]

Public enthusiasm for Shakespeare and Scott was part of the craze for subject matter related to English history that focused mainly on Reformation and Restoration themes.[67] The trend (which lasted from the 1840s to the mid-1860s) owed much to the avalanche of publications devoted to British history and royal biographies that were often read as monitory texts against which American values could be measured. The narrative of the mother country was, by the 1840s, something that Americans of British extraction—the majority of the population at the time—could look to with a mixture of pride and anxiety.

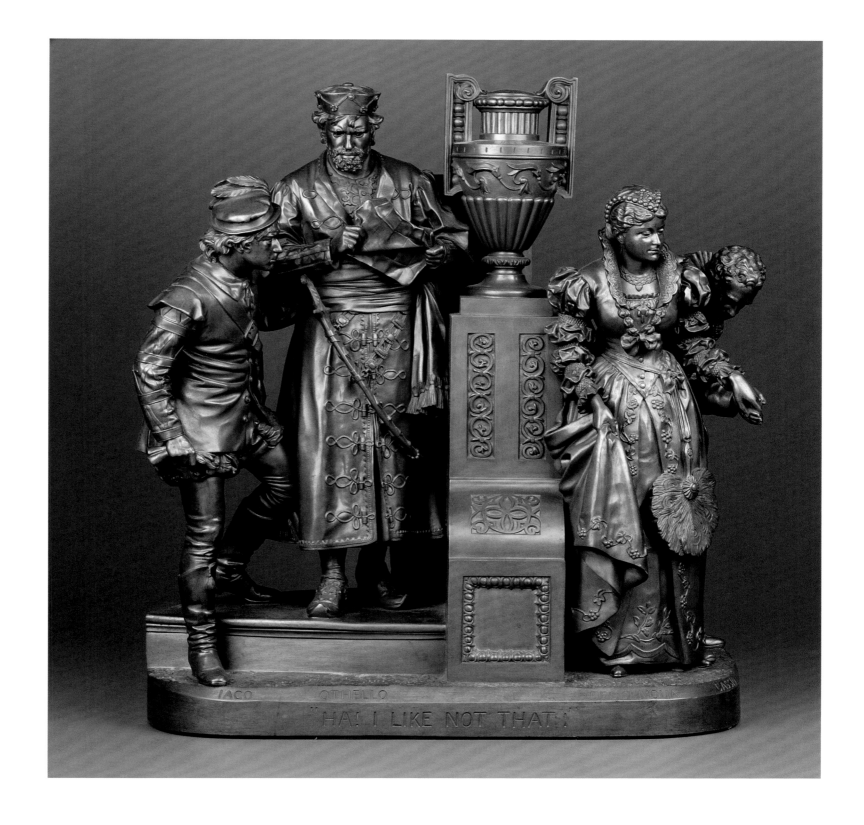

CAT. 38. John Rogers (1829–1904).
"Ha! I Like Not That!" 1882

This relationship was clearly articulated in Samuel Griswold Goodrich's introduction to his *Pictorial History of England* (1846):

> [T]he history of England is the history of our fatherland, the history of our ancestors, and of most of the institutions which belong to society in the United States. In government, religion, manners, customs, feelings, opinion, language, and descent, we are wholly or partially English. We cannot, therefore, understand ourselves or our institutions, but by a careful perusal of English history.[68]

As a consequence of this widely held view, Richard Caton Woodville's *The Cavalier's Return* (cat. 54), Emanuel Gottlieb Leutze's *Princess Elizabeth in the Tower* (cat. 28), and Louis Lang's *Mary, Queen of Scots Dividing Her Jewels* (cat. 26) functioned on multiple levels: as simulations of actual events; as fanciful costume dramas; and as typological signs that provided a gateway to comprehending contemporary religious, political, or social concerns. As such, they were evidence of the permeable boundaries between historical accounts and fiction, both of which demanded the viewer's familiarity with specific anecdotal narratives that, in turn, could be loosely construed to coincide with the viewer's personal convictions. Thus, for example, Lang's paintings featuring the doomed Mary, Queen of Scots could be read as an appeal for religious tolerance between Roman Catholics and Protestants, as a lesson on the evils of monarchy, and, in the context of the Civil War, as a tragic example of political division.[69] The tendency to interpret content in this way was commonly acknowledged. Asserting that art was "essentially a *language*," Tuckerman wrote, "Thus the moment we consider a picture as chiefly designed to *express* something instead of being a piece of clever imitation of reality, we instinctively apply to it the same principles of judgment used in illustrating the meaning and merit of a poem or a narrative."[70] The emphasis on the kinship between the visual arts and literature diminished along with the cultural currency of Stuart, Tudor, and Cromwellian themes by the late 1860s. In retrospect, however, the emergence of literary genre in the American arts provided a comfortable middle ground between the European grand manner and the nascent school of American genre painting.

OPPOSITE: CAT. 54. Richard Caton Woodville (1825–1855). *The Cavalier's Return*, 1847

CAT. 26. Louis Lang (1814–1893). *Mary, Queen of Scots Dividing Her Jewels*, 1861

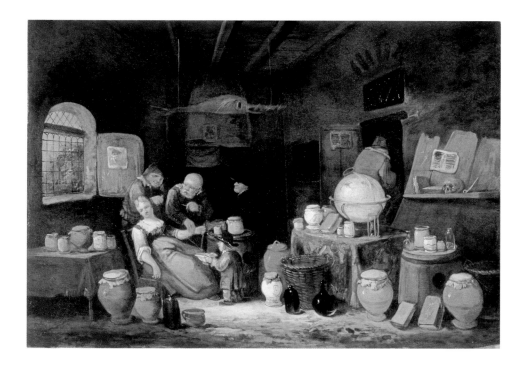

FIG. 13. Unknown artist, *Interior—Dutch Apothecary Shop*, ca. 1775–1800. Oil on wood, 18 × 24⅝ in. (45.7 × 62.5 cm). The New-York Historical Society. Gift of the New-York Gallery of the Fine Arts, 1858.24

Catering to the Average Taste

In tracing the development of genre painting in America, Tuckerman recalled the "time when almost the only specimens of humorous every-day-life-scenes . . . were the production of a Bank cashier: the subjects were homely, with a certain *naïve* literalness that commended them to the average taste."[71] The bank cashier to whom Tuckerman referred was Francis W. Edmonds, the businessman-cum-artist, whose paintings often rivaled those of his now more famous colleague William Sidney Mount. Together, the two men set the standard for what Tuckerman termed the "average taste," that is, paintings that fulfilled the growing demand for art by the "uncultivated" ranks of society whose aspirations were genuine and whose coffers were full, but whose quotient of refinement had not reached the level mandated by Morse and Vanderlyn. Such men— identified by the scholar Alan Wallach as the "functional elite," included businessmen like Luman Reed, Jonathan Sturges, Charles M. Leupp, and Robert L. Stuart, whose new wealth brought them the means and leisure to enter a cultural sphere previously occupied only by the monied gentry.[72] Earnest and eager to support the arts (and also likely equally keen to assert their new social power), this type of patron was later said by the *New York Herald* editor James Gordon Bennett to "know more about pork and molasses than . . . [he does] about art."[73]

As blunt as Bennett's statement was, it was largely true. Reed, for instance, had started his collection by purchasing European paintings, among them *Interior—Dutch Apothecary Shop* (fig. 13). However, his connoisseurship skills were weak, and he eventually concluded that buying art directly from living American

artists would prevent his being duped by unknowing or unscrupulous dealers (see Foshay's essay in this volume). Still, a vital discourse existed that decried the need for American artists to study abroad because the country could not provide adequate patronage.[74] Although lip service was still given to the high-minded ideals promoted by Morse, the handful of private collections that were amassed in New York in the 1830s and 1840s reveals that the taste of the growing mercantile class gravitated to vernacular subjects whose legibility guaranteed immediate recognition and, indeed, the pleasure of personal association with that which was pictured. Thus, it is unsurprising that Reed, Leupp, Sturges, and Stuart were attracted to genre paintings by Durand (cats. 9, 10), Mount (cat. 31), and Edmonds (cats. 12–14), given that all of them (artists included) had risen (or were rising) to the top of their respective professions by dint of hard work rather than because of educational or family privilege and, with the exception of Stuart, were born and raised in rural areas.

Subjects having particular relevance to this mercantile class—for instance, the itinerant pedlar—gained currency. Indeed, it seems most likely that Durand's awareness of Reed's rural childhood during which his father went door to door selling wares prompted the artist to address the theme in *The Pedlar* (cat. 10), the second of his genre paintings for the grocery merchant. The stock character of the pedlar was a familiar type in stage productions as well as the visual arts and persisted throughout the next half century in works by Edmonds, Ehninger, Eastman Johnson, Rogers (fig. 14), and others. If Durand's treatment of the pedlar was a source of nostalgia for Reed, it was no less so for midcentury audiences; by the 1850s the pedlar had been made all but redundant by the extensive improvements in transportation facilitating the distribution of goods.

The combination of poorly trained artists, uneducated patrons, and the fervor of cultural nationalism worked to dilute the impact of intellectualized assessments of taste. Although the word itself was in frequent use, its meaning dissolved into a generalized rubric in praise of or out of disgust for the current state of American culture. The word's loss of potency owed much to the formation of the American Art-Union, perhaps the most powerful agent for art patronage in the 1840s and a principal factor in the formation of the "average taste." In brief, the American Art-Union grew out of the Apollo Art Gallery established in 1838 in New York by James Herring (1794–1867), mainly for the purpose of displaying and selling contemporary

CAT. 13. Francis W. Edmonds (1806–1863). *Bargaining* (later known as *The Christmas Turkey*), ca. 1858

CAT. 14. Francis W. Edmonds
(1806–1863). *The Wind Mill,*
ca. 1858

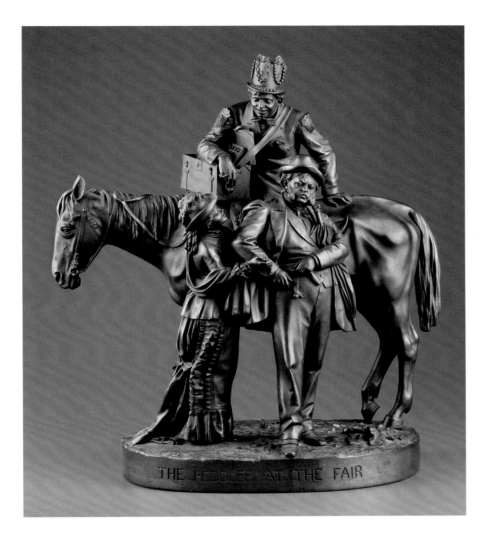

FIG. 14. John Rogers (1829–1904). *The Peddler at the Fair*, 1878. Bronze, 20¼ × 18 × 10¼ in. (51.4 × 45.7 × 26 cm). The New-York Historical Society. Purchase, 1947.145

works that had been rejected for exhibition by the National Academy of Design. Soon on the brink of financial disaster, Herring gained the support of influential businessmen to convert the organization into an art union; by 1839 the enterprise was operating as the Apollo Association for the Promotion of the Fine Arts in the United States.[75] Modeled on the template of European art unions, the organization (called the American Art-Union by 1844) was run by a board of managers who purchased art throughout the year for the purpose of dispersing it through a lottery open to subscribers who paid five dollars annually. Each year all subscribers were guaranteed the receipt of an engraved reproduction of a work chosen by the board as well as a chance to win an original work of art.

Throughout its existence, the American Art-Union was in the hands of culturally ambitious members of the business community. The major exception was Francis W. Edmonds, who balanced his activities as a

banker with his career as a painter. Other members of the Art-Union's management committee included Luman Reed's former business partner Jonathan Sturges, Philip Hone, Abraham M. Cozzens, and Charles Leupp, all of whom had private collections. Despite the committee's avowed sincerity regarding its aim to promote American art, the situation invites the suggestion that its members were enhancing the worth of their own collections by purchasing and distributing similar works through the Art-Union. The management's goals were clear-cut: to provide corporate patronage for American artists and to improve the taste of the American public mainly through the distribution of works whose nationalistic subject matter reinforced the notion that the cultural health of the United States was on the upswing. This aim, repeated throughout the organization's annual reports, is exemplified in a passage from the transactions for 1844:

> No political, commercial, or sectarian interests have brought us together. . . . Our institutions keep
> us politically and socially in a state of perpetual excitement and competition. President-making, and
> money-getting, together, stir up all that is bitter, sectional, or personal in us. We want some interests
> that are larger than purse or party, on which men cannot take sides, or breed strifes, or become
> selfish. Such an interest is Art. And no nation needs its exalting, purifying, calming influences, more
> than ours. We need it to supplant the mean, utilitarian tastes, which threaten to make us a mere
> nation of shop-keepers. We need it to soften the harsh features of political zeal, and party strife, the
> other engrossing business of this people.[76]

Patricia Hills has observed that the overriding thematic focus of the paintings purchased by the American Art-Union corresponded with political policies that promoted westward expansion and sustained the Union in the face of mounting sectionalism.[77] The developing expansionist rhetoric is borne out in Tompkins Harrison Matteson's *The Last of the Race* (cat. 29), which depicts the plight of an Indian family pushed to the westernmost edge of the continent, and John Gadsby Chapman's *George Washington in His Youth* (cat. 5), in which the nation's westward growth is implied by the illustrious founding father's early occupation with mapping the land. Other paintings such as Ehninger's *Peter Stuyvesant and the Cobbler* (cat. 15) and

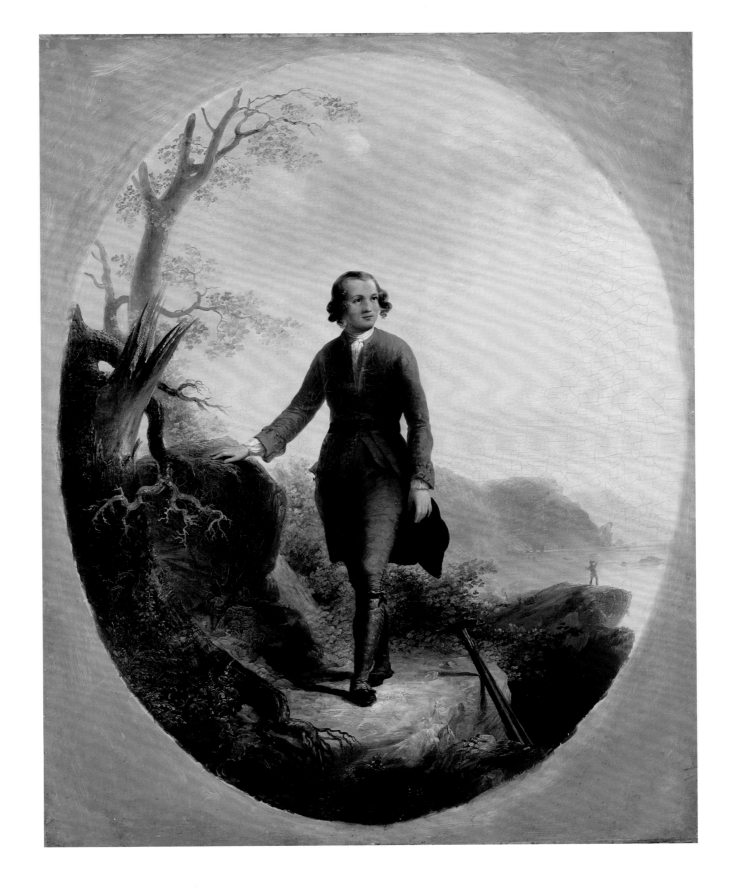

CAT. 5. John Gadsby Chapman
(1808–1889). *George Washington
in His Youth*, 1841

Mount's *Farmers Bargaining* (cat. 31) pointed to a common cultural experience established respectively in the American literary tradition forged by Washington Irving and through recognition of the specifically American "Yankee" type.[78] These and other works harmonized with and aided in the construction of a unified American narrative—whether it was expressed in terms of harvest landscapes or quaintly humorous genre scenes, subjects that were especially favored by the American Art-Union. And, despite the management's protestation that it had no political agenda, the narrative thrust of the imagery promulgated by the union coincided with conservative Whig politics (represented by Philip Hone and his circle) or the more centrist Democrats (represented by William Cullen Bryant).[79]

The high-minded, paternalistic philosophy that governed the Art-Union—that art could and would improve public virtue—also tended to dislocate traditional attitudes toward taste. Whereas taste once represented a state of studied refinement, under the auspices of the American Art-Union, the term was expanded to encompass appetite (or demand). The eighteenth-century rigors attendant on acquiring refinement, sensibility, taste, and delicacy took a back seat, as they were deemed unsuited to the new democracy, whose cultural improvement was contingent on the creation of a desire for art, even if the art that initially attracted the viewer was of inferior quality. Because it promoted common taste, the Art-Union came under especially harsh fire in 1844, stirring the management committee to present at the annual meeting headed by the group's president, William Cullen Bryant, a lengthy defense of the organization's legitimacy and its distribution of supposedly mediocre art. The committee addressed the first point with a statement to the effect that any means of encouraging art was valid. The response to the charge of mediocrity was revealing:

> Others are fearful that the system has a tendency to encourage mediocrity; as though mediocrity were a crime—or as though it were sinful to help any but the brightest geniuses, who are generally the least in need of aid from an association like this. This fear of mediocrity in Art comes with an ill grace from a community like ours, which maintains so many benevolent institutions that have for their express object the encouragement of mediocrity; no one affects to fear mediocrity in religion or learning, why should we fear it in Art? . . . Let us not, then, deny these simple delights

to those who can enjoy them, lest we send them a work of art for their solace, which, tried by the highest standard of taste, may fall a trifle short of the highest excellence. . . . Before we can have good works of art, we must feel the need of them; . . . men cannot seek to satisfy a want that they have never felt; good taste is of all things the most gradual in its development, and of all pleasures it can with most propriety be said to grow by what it feeds on.[80]

Embedded in the argument was the democratic conviction that the contemplation of art should be the province of everyone and that its capacity to instill virtue was its highest purpose. As a group, these individuals saw the common man of the streets as a threat to the peaceful conduct of the nation. By democratizing art's accessibility and leavening the rules of taste, the policy of the union promised to aid in controlling and containing the lower instincts ascribed to the masses through the simple narratives of American life, the moralizing lessons of history, and the sedative effects of landscape.

By the 1840s the devolution of taste was under way, heading toward Tuckerman's "average taste." The populist stance of the American Art-Union was ultimately billed as a corrupting influence, and the organization was increasingly charged with corroding public taste. As one writer observed in 1847, "[I]t does not tend to the elevation and perfection of Art, but to the fostering of mediocrity. . . . This is almost a necessary consequence, indeed, from the mode of its organization and operations, which always places it on the level of the popular culture, and never above it."[81] The invective aimed at the Art-Union mounted, much of it lodged by a disaffected community of artists (mainly affiliates of the National Academy of Design), who believed their careers suffered from the Art-Union's policies. Yet blame did not rest with the art-union system per se; according to one critic, fault lay with "the two or three uneducated tradesmen, who have turned it into a hobby of personal consequence, and are building themselves a throne of patronage in its Committee-room, to which nothing but mediocrity in Art can long be humble enough to kneel."[82] In addition to accusing the Art-Union committee of lowering standards of taste, many artists condemned it for depriving them of the motivation to create anything better than potboiling productions.[83]

Similar complaints were hurled at the Cosmopolitan Art-Association, another organization set up not long after the American Art-Union was dismantled in 1851, found guilty in the courts of violating gambling laws on a technicality related to its lottery system. Vilified by a writer for the *Crayon* as a "fungus . . . entirely supported by the corruptions of commercial life," the Cosmopolitan Art-Association, the author continued, "[i]n pandering to a natural love of gambling, through the principle of the organization . . . speculates upon the *money* value of the [art] prizes." The anonymous columnist concluded, "The public can realize its true character by regarding it in the same light as they do the schemes of impostors who seek to extract money under the garb of benevolence."[84] Although the American Art-Union and the Cosmopolitan Art-Association were excoriated for purveying mediocre art, it must be said that most of the artists whose works were purchased by the two organizations were members of or frequent exhibitors at the National Academy of Design. Hence, the type of work was not the primary issue; rather, the issue turned on the manner in which works were purchased and distributed.

The Veiled Taste for Reform

The language with which the *Crayon*'s writer likened the workings of the Cosmopolitan Art-Association to "the schemes of impostors who seek to extract money under the garb of benevolence" is telling. This verbal imagery, which concentrates on depravity masquerading as magnanimity, touches on a major trope in contemporaneous literature that found its roots in reform movements. Defined by the literary historian David S. Reynolds as the "benign-subversive style," this mode, as traced by Reynolds in the writings of Ralph Waldo Emerson, Henry David Thoreau, Nathaniel Hawthorne, Herman Melville, Edgar Allan Poe, and Walt Whitman, stemmed from an acute awareness of the paradoxes that permeated American reform movements.[85] In short, with the rise of reformism—as it affected religion, poverty, temperance, abolition, and labor—a type of reformer (called the "immoral reformer" by Reynolds) emerged whose manipulations revealed shocking levels of personal corruption and whose graphic descriptions of social iniquity fired the imaginations of his audience, furtively appealing to their lower natures.

The concept of the benign-subversive style as Reynolds has applied it to literary works also encompasses a group of American paintings that, although commonly catalogued as "genre," deserve to be interpreted as a distinct subcategory whose thematic parameters are defined by links with reform movements. These works—among them William Henry Burr's *The Intelligence Office* (cat. 2), James Henry Cafferty's *The Sidewalks of New York* (cat. 3), and George Henry Yewell's *Doing Nothing* (cat. 55)—are most easily identified with the benign-subversive inasmuch as urban, extradomestic settings and overt social content distinguish them from the bulk of contemporaneous genre productions. The fact that they rarely received critical comment suggests the reluctance of critics to explore content apart from the folksy scenes that glorified the wholesome simplicity of American life.[86] Indeed, they are anomalous presences in the canon of nineteenth-century American genre painting, for they are visual reminders of the darker side of American life—here with Burr's oblique reference to prostitution, Cafferty's focus on the gaping divide between rich and poor, and Yewell's implication that his errand boy is destined for a life of crime.

Although these paintings may simply be seen as general responses to the changing demography of the American population as it shifted from a rural to an urban economy, the acute social perspectives they adopt suggest their reliance on specific sources that are now lost to contemporary viewers. More needs to be learned about the lives of these particular artists before conclusions can be drawn, but isolated pieces of information recommend the validity of this tack. Burr, for example, spent most of his life working in the public sphere, and his eccentric religious and political essays point to his fascination with radical social attitudes. Cafferty seems to have engaged in some political activism—evidenced by his signature on a petition against the enactment of the Maine Liquor Law in New York, in which the signatories called for quashing the fanatical arm of the temperance movement that would "surely retard the moral movement of temperance itself, and thus increase the very evils it is intended to remedy."[87] With respect to Yewell's ominous vision of New York street life (which includes a fragment of a "Maine Law" poster), the painting likely reflects his own religious affiliation with the Church of the Covenant, to whose pastor, George Sidney Webster, he bequeathed the painting.

Reformist readings, though less explicit, can also be applied to iconography of the Indian. Weir's portrait of Red Jacket (cat. 47) inevitably evoked the stereotype of the alcohol-ravaged Indian, intermingling

OPPOSITE: CAT. 2. William Henry Burr
(1819–1908). *The Intelligence Office*, 1849

RIGHT: CAT. 3. James Henry Cafferty
(1819–1869). *The Sidewalks of New York*,
1859

CAT. 55. George Henry Yewell (1830–1923).
Doing Nothing, 1852

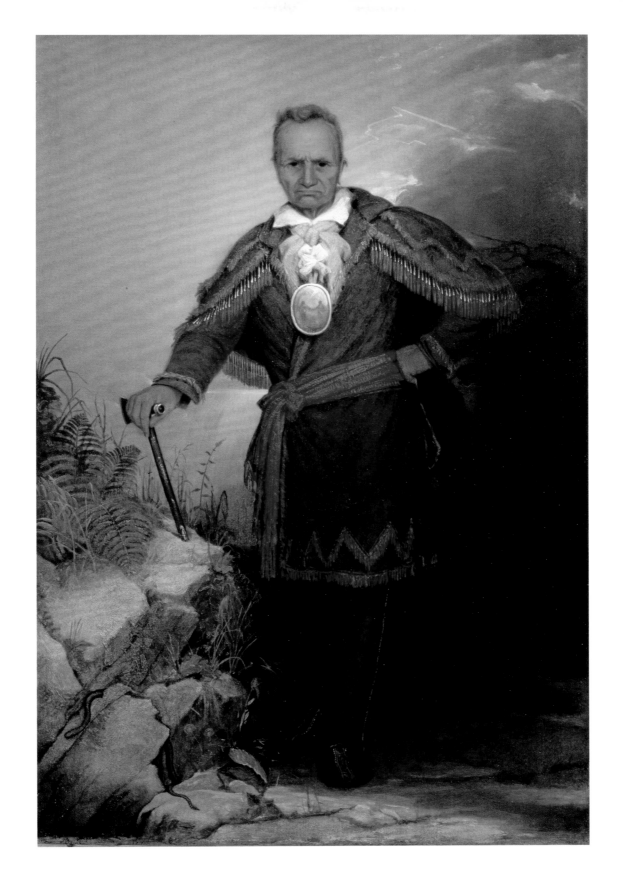

CAT. 47. Robert W. Weir (1803–1889).
Red Jacket or *Sagoyewatha*, 1828

temperance and expansionist politics. Jesse Talbot's long affiliations with the American Board of Commissioners for Foreign Missions (for which he was a financial agent) and the Presbyterian Church establish a context for his reform activity, the intensity of which is suggested by his concentration on sympathetic renderings of Native Americans (cat. 43) and religious subjects.[88] Moreover, Talbot's acquaintance with Walt Whitman (the full extent of which remains frustratingly undocumented) opens the possibility that the two found common ground within the reformist sphere. Although Whitman's stance on reform is complicated (it ranged from sardonic cynicism to fervent belief), he was deeply concerned with the moral dimensions of temperance reform, which are revealed in his novel *Franklin Evans* (1842) that includes the chapter "The Death of Wind-Foot" focusing on aboriginal (Whitman's preferred term) culture.

That Talbot's *Indian on a Cliff* was acquired by the staunch Presbyterian Robert L. Stuart is perhaps significant in light of reform rhetoric. Similar speculation arises with respect to Stuart's acquisition of paintings whose imagery featured other representatives of marginalized sectors of society—namely blacks, whose highly contested status in antebellum America propelled them from the lowest, stereotyped range of depiction to one meant to induce the viewer's compassion for them as individuals. A primary example of these contrasting approaches is found in the differences separating Mount's *Farmers Nooning* (fig. 15), in which a black man is toyed with by white boys while he sleeps, and Edmonds's *Grinding the Scythe* (cat. 12) in which a white farmer and a black farmhand work together. The shift in fine arts imagery that released the black from his status as an object of ridicule or scorn reflected a general change in the taste of the art-buying public, which was suddenly attentive to works sympathetic to the plight of the enslaved. As one writer put it in 1863, "Ten years ago no favorite artist in New York would have risked his reputation by such an attempt as this to assert the rightful freedom of an oppressed race. The President's Proclamation [the Emancipation Proclamation] . . . is breaking other chains than the slave's; for we could not help thinking . . . that while the artist was emancipating the negro, that negro, in return, was emancipating the artist."[89]

Yet, in surveying critics' responses to such works as Eastman Johnson's *Negro Life at the South* (cat. 24) or Worthington Whittredge's *The Window* (cat. 53), the narrative opacity of these and other works featuring blacks prevented a clear-cut political interpretation. Indeed, one reviewer complained that

CAT. 43. Jesse Talbot (ca. 1806–1879).
Indian on a Cliff, ca. 1840s

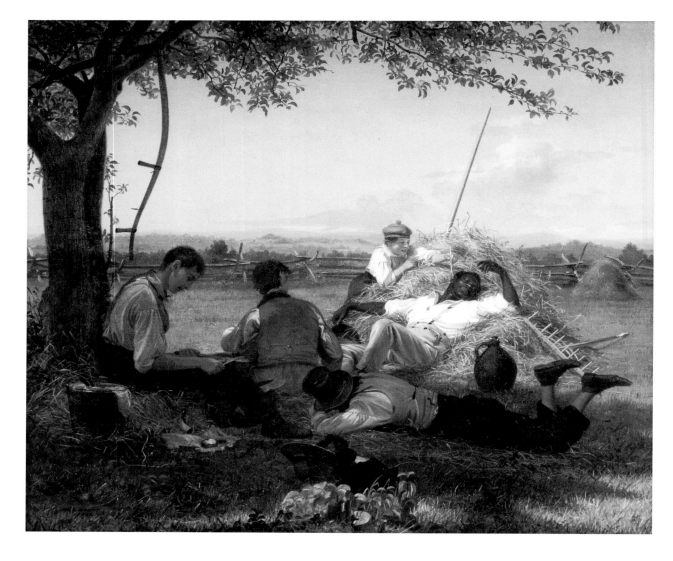

FIG. 15. William Sidney Mount (1807–1868). *Farmers Nooning*, 1836. Oil on canvas, 20¼ × 24¼ in. (51.4 × 61.6 cm). The Long Island Museum, Stony Brook, N.Y. Gift of Mr. Frederick Sturges, Jr., 1954

Johnson's painting had too many narratives: "This picture is really admirable in grace and correctness of drawing, in truthfulness of expression, and in honesty of painting. But it is somewhat wanting in unity. The interest is not sufficiently concentrated. There are four or five pictures instead of one in this composition, or combination of compositions."[90] The supposition that Johnson and Whittredge deliberately infused their paintings with narrative (and, therefore, moral) ambiguities seems valid in light of the reactions to Harriet Beecher Stowe's best-selling *Uncle Tom's Cabin* (1852). In her quest to reveal the horrors of slavery, Stowe entered the benign-subversive range of narrative, counterbalancing the angelic Eva and faithful Uncle Tom with horrific scenes of abuse. This set of extremes opened Stowe to criticism exemplified by George Frederick Holmes's commentary in the *Southern Literary Messenger* in

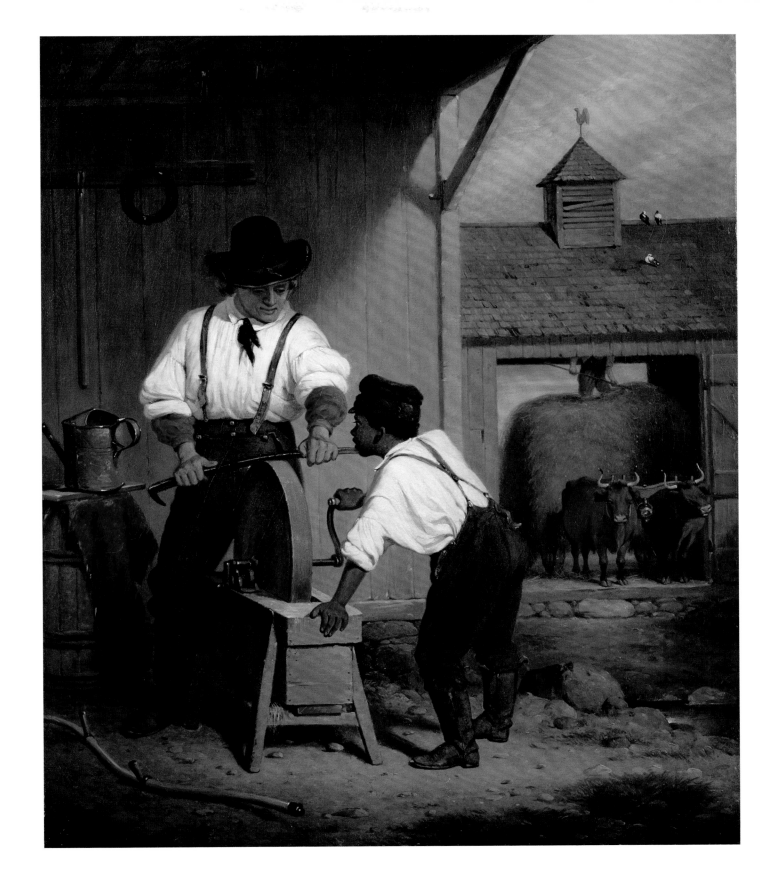

CAT. 12. Francis W. Edmonds
(1806–1863). *Grinding the
Scythe*, 1856

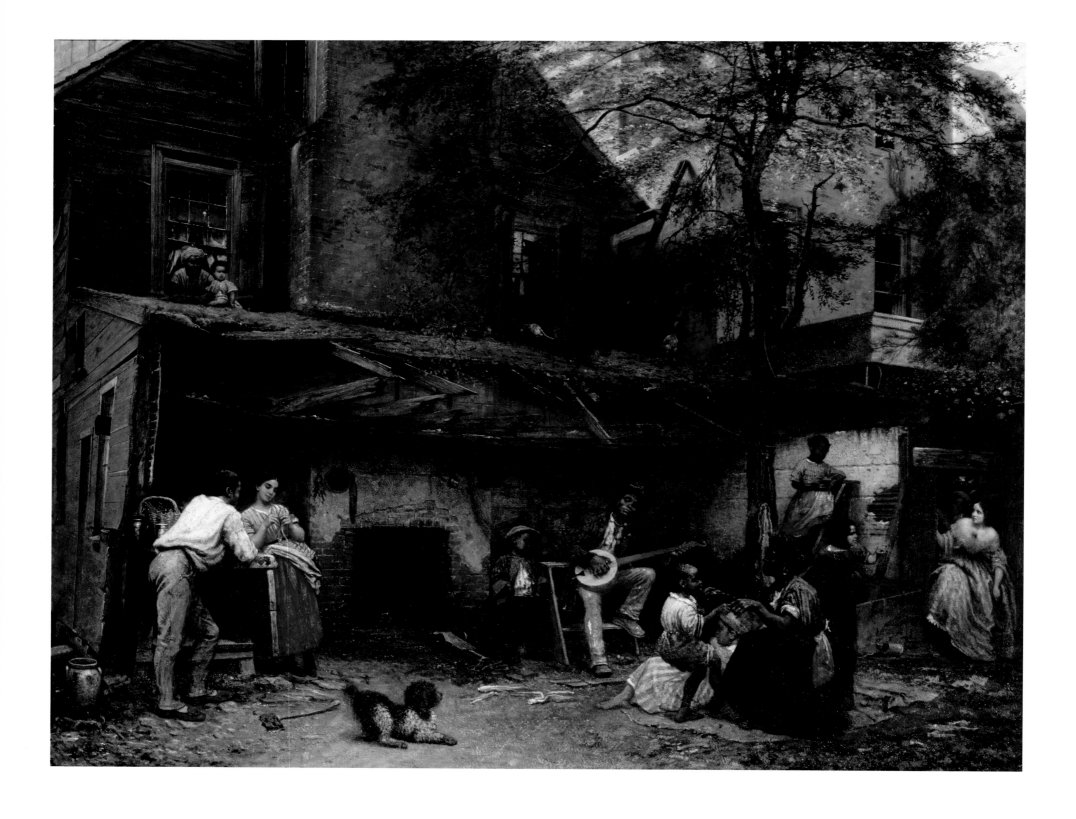

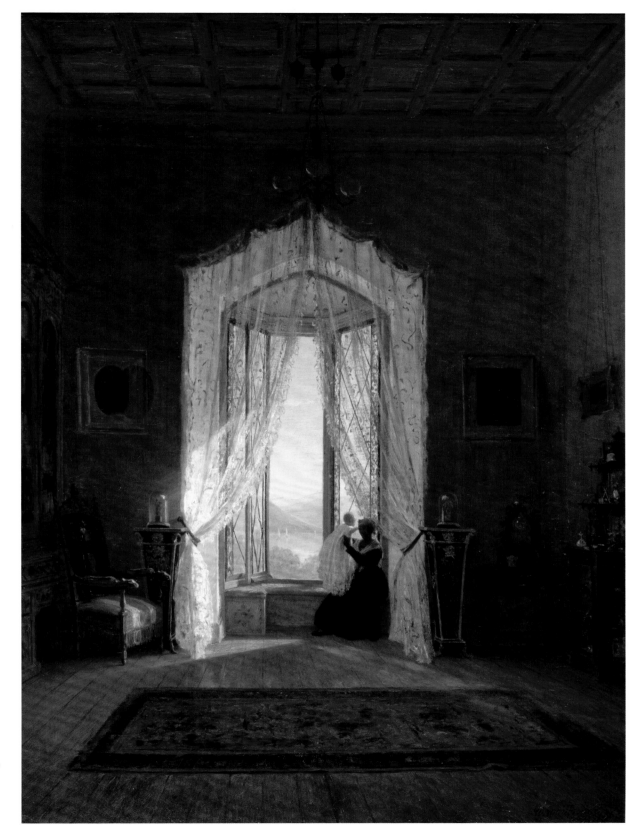

OPPOSITE: CAT. 24. Eastman Johnson
(1824–1906). *Negro Life at the South*, 1859

RIGHT: CAT. 53. Worthington Whittredge
(1820–1910). *The Window* (later known as
A Window, House on Hudson River), 1863

which he questioned her decency: "It is a horrible thought that a woman should write or a lady should read such productions as those by which her celebrity has been acquired. Are scenes of license and impurity, and ideas of loathsome depravity and habitual prostitution to be made the cherished topics of the female pen, and the familiar staple of domestic consideration of promiscuous conversation?"[91] In contrast, painters generally presented denatured images of blacks—freed or slave—so as not to agitate further the already potent anxieties of viewers whose thoughts would automatically yield to the verbal excesses of reform with which they were continually bombarded in the press. However much Whittredge may have sympathized with abolitionist views (he was a friend of Stowe and other members of the Beecher family), or Johnson may have wished to reveal forcefully the conditions of urban slavery in the nation's capital, the two men created images whose political meanings could be construed variously and which would be suitable for display in refined domestic interiors.

The same may be said for John Rogers, whose intimately scaled sculpture groups proved enormously popular despite their politicized content. Yet Rogers soft-pedaled potentially disturbing imagery in such pieces as *The Fugitive's Story* (cat. 37) and *Uncle Ned's School* (cat. 36), which, although they incorporate elements of high realism, were conceived after the close of the Civil War and do not portray specific events. In the former, an escaped slave clutches her child as she relates her experience to three of the preceding decade's most prominent abolitionists—the editor William Lloyd Garrison, the poet John Greenleaf Whittier, and the Congregational minister Henry Ward Beecher (the brother of Harriet Beecher Stowe). But Rogers's fictive anecdote focuses on a problem already resolved. Because the fight against slavery is finished, the imagery is relegated to the realm of history and is therefore invested with a self-congratulatory level of meaning and simultaneously emptied of the strident divisiveness of reform rhetoric.

In contrast, the elderly cobbler in *Uncle Ned's School* inserts a humorous tone that deflects the painful social realities of Reconstruction and the attendant problems of finding a place for thousands of newly freed men and women for whom a new battle for rights was in the offing. What is more, doubts about the competence of blacks to function independently remained at the core of arguments concerning the collective fate of the race in American society. Here, the black man is reduced to a type, relying especially on the

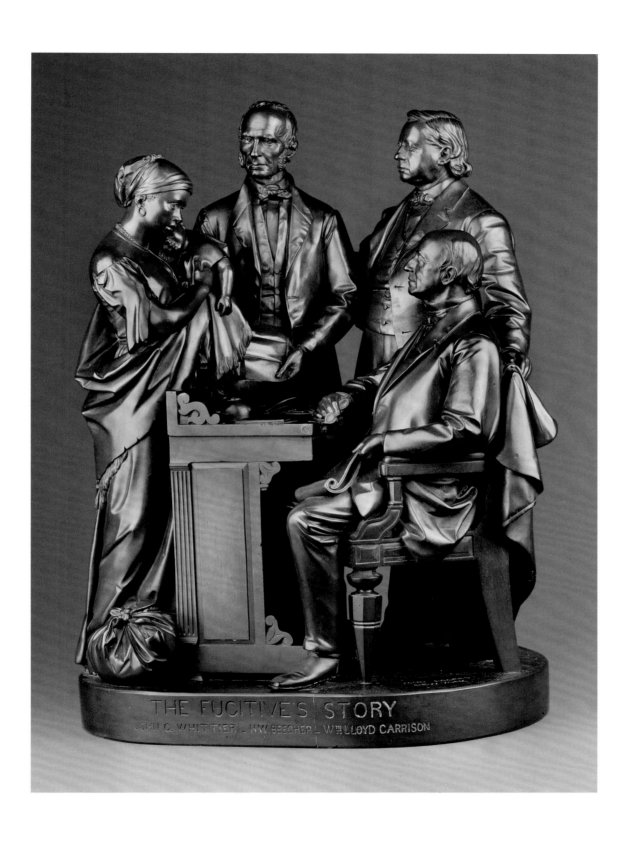

CAT. 37. John Rogers (1829–1904).
The Fugitive's Story, 1869

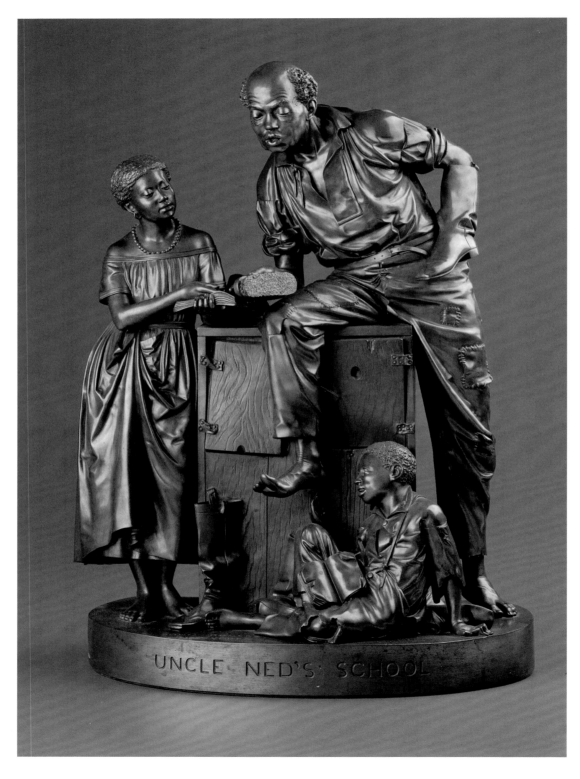

CAT. 36. John Rogers (1829–1904).
Uncle Ned's School, 1866

eponymous Uncle Ned of Stephen Foster's 1848 song. And, although the challenge and concomitant fears of an educated population of former slaves and their children were pressing national matters, Rogers sublimated the issue, submerging it in the ostensibly harmless charm of the youngsters and the presumed impotency of old age. Although Kimberly Orcutt's research confirms that Rogers intended Uncle Ned to be the teacher (see cat. 36), the sculpture evinced contradictory nineteenth-century interpretations that described the elderly man as struggling to read.[92] This ambiguity allowed for politically opposite understandings: one that supported the encouragement of blacks in their quest for education, and another, characterized by Albert Boime as one in which "viewers could be consoled by the implication that that education process would take such a long time that it would not immediately threaten the institutional control of blacks."[93] Indeed, the small scale of the sculpture and its comfortingly humorous elements helped to mitigate the importance of the ideas linking education with social power, making it an artfully entertaining ornament for a domestic interior.

Thomas Satterwhite Noble's *John Brown's Blessing* (cat. 33) elicited less favorable responses. Widely exhibited and reviewed, the large painting—which claimed the specificity of history—failed to find a purchaser, most likely because it magnified the disquieting ambiguities of contemporary American political culture. Even in the Reconstruction era, the depiction of Brown heading for the gallows aggravated emotional wounds that still festered in those on either side of the abolition issue. If the painting is examined through the lens of reform rhetoric, then the Christlike martyrdom often ascribed to Brown is contradicted by the view of him as a fanatical advocate of violence in the service of "a one-sided philanthropy."[94] By 1884, however, the American public had apparently achieved sufficient emotional distance so that the subject's impact was softened. Thomas Hovenden's (1840–1895) *Last Moments of John Brown* (although a commissioned work; The Metropolitan Museum of Art, New York), of a similar scale and composition, received laudatory reviews for its depiction of the "old hero."[95]

CAT. 33. Thomas Satterwhite Noble (1835–1907). *John Brown's Blessing,* 1867

Taste and History Painting

A survey of art commentary published throughout the 1850s reveals a growing consensus that the formation of taste was no longer the province of the intellectual elite, the mercantile class, or even the artists. Rather, it was said that the amorphous "public" controlled taste. As one reviewer flatly stated, "Art is essentially democratic. . . . The picture or the statue which is simply the pet of connoisseurs, but does not arrest the popular eye or touch the popular heart, is not immortal, because it is not of a universal interest."[96] This tendency was paralleled by the diminishing number of insightful tracts devoted to art theory. Although some effort was made to address serious aesthetic questions—mainly in the *Crayon* and in the writings of Tuckerman and James Jackson Jarves, the audience for these was relatively narrow. And, despite the continuing tradition of presidential addresses at the National Academy of Design, the "discourse custom," so strong in the earlier part of the century, was in decline. This trend signaled the continuing resistance to expertise or connoisseurship, an attitude that was set out in the *Albion*: "And let the spectator judge boldly for himself, eschewing the dogma now insisted upon in certain quarters—that Art should be no less systematized than Mathematics, and that in order to relish its delights one must be brought up at the feet of some lecturing Gamaliel."[97] At the same time, artists were excused for their part in contributing to low aesthetic standards, with sympathetic columnists asserting that painters were captive to public taste. This opinion was clearly expressed in the *Crayon*: "It is a mistake to suppose that artists are free to paint what pleases them best. . . . The truth is, that artists are compelled to meet the public by consulting its likes and dislikes. . . . And rarely is it the case that a noble thought or symbol, embodied with the greatest skill, finds that sympathy which common subjects are sure to excite, when set before us with the same, or even less power."[98]

Throughout the 1850s, landscape gained priority as the subject of choice, and by 1856 one critic noted that the National Academy of Design's spring exhibition included 104 landscapes, 91 portraits, 93 genre paintings and sketches, and only two historical subjects.[99] The increasingly steady visual diet of landscape triggered dissatisfaction among some reviewers and led one to complain, "We have been positively pelted with 'Studies of Nature,' till the weary eye and mind almost long for the impossible gods and goddesses of a Chardin and a Boucher."[100] The following year the *Evening Post*'s columnist ventured to explain the

overabundance of landscapes, saying that it indicated "that our artists receive more encouragement for their efforts in landscape painting than in the other and more difficult walk of the art [i.e., historical painting]."[101] There was, of course, great pride taken in American landscape production, for it marked the singular province in which native artists could excel in relation to their European contemporaries. What was left unsaid, however, was that few American painters were sufficiently competent to paint figures—a factor that contributed to the proliferation of landscape specialists in the first half of the century. Yet, the academic hierarchy governing subject matter was still in effect, albeit in a somewhat weakened form. The supposed paucity of history painting aside, its elevated role was repeatedly articulated in the press, as exemplified by the following comment that appeared in 1852: "Historical painting, to which common consent allots the first position in the various departments of art, is justly first because it represents men in action. It seizes moments of admirable heroism, or reveals the stately spectacle of the possible action of men, as beheld by the Imagination."[102]

Most of the midcentury painters who addressed historical and ideal figure subjects had received much of their art training or at least spent considerable time in Europe. The best part of a century had passed since Benjamin West had painted *The Death of General Wolfe* (fig. 16), which introduced the artist's innovative blueprint merging time-honored high-style aesthetics with modern events. West's revised approach to history painting was carried to the colonies by John Trumbull, where the formula was disseminated mainly through his murals installed in the United States Capitol Rotunda. Although highly admired for their patriotic content, Trumbull's panels (*The Declaration of Independence* [fig. 17], *The Surrender of Cornwallis at Yorktown, Virginia, October 19, 1781*, *The Surrender of Burgoyne at Saratoga, October 17, 1779*, and *General George Washington Resigning His Commission to Congress as Commander in Chief, 1783*) were static compositions populated by wooden figures. Trumbull's murals were eventually joined by four additional works, all of which were arguably of a higher artistic standard but no less patriotically didactic.[103] With Trumbull's, these later additions—John Gadsby Chapman's *The Baptism of Pocahontas* (fig. 18), Robert W. Weir's *The Embarkation of the Pilgrims at Delft Haven, Holland, July 22nd, 1620*, John Vanderlyn's *The Landing of Columbus*, and William Henry Powell's (1823–1879) *Discovery of the*

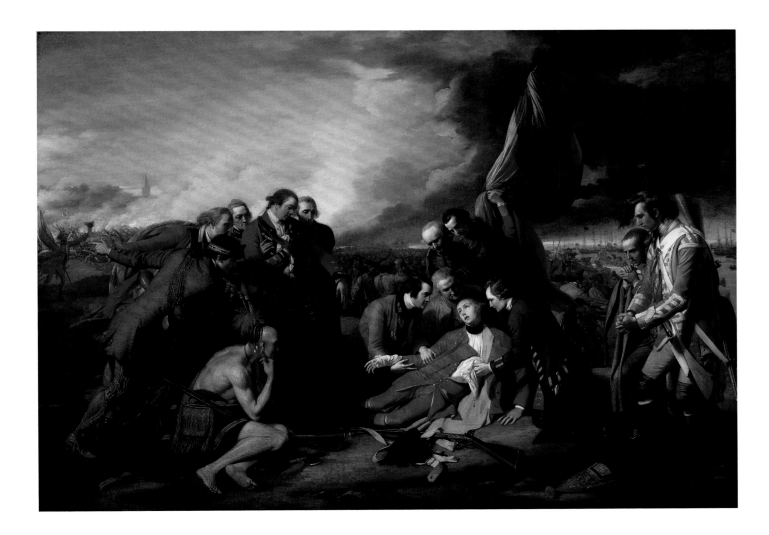

FIG. 16. Benjamin West (1738–1820). *The Death of General Wolfe*, 1770. Oil on canvas, 60 × 84 in. (152.6 × 214.5 cm). National Gallery of Canada, Ottawa. Transfer from the Canadian War Memorials, 1921 (Gift of the 2nd Duke of Westminster, England, 1918). Photo © National Gallery of Canada

Mississippi—standardized the use of the grand-manner mode for visualizing America's past and established the catalogue of key themes that would dominate the genre: namely, scenes of discovery and expansion, Pilgrim settlement, and the war for independence.

For the most part, artists were inspired by literary precedents. Chief among them were Washington Irving's *The Life and Voyages of Christopher Columbus* (1828), William H. Prescott's *History of the Conquest of Mexico* (1843), and George Bancroft's *History of the United States* (1834–74), passages from which often clarified painted imagery in exhibition pamphlets or catalogues.[104] Such histories exerted a sustained influence throughout the century with respect to content, but the formal inheritance of West and Trumbull lost aesthetic ground. Under their influence, the American Revolution was virtually calcified in paint, and, as one critic put it, "'Our glorious constitution' may be the life and soul of the body politic, but it is a perpetual wet blanket upon artistic genius, and we regret to see it so frequently thrown over the shoulders of young aspirants by those who should lead them to higher and better things." The same writer pointed to the "over-estimated Benjamin West" for inspiring the country's artists to "tickle the dull tastes of the ignorant million."[105]

ABOVE: FIG. 17. John Trumbull
(1756–1843). *The Declaration of
Independence*, 1818, installed 1826.
Oil on canvas, 12 × 18 ft. (3.6 × 5.4 m).
U.S. Capitol Rotunda. Architect of the
Capitol, Washington, D.C.

RIGHT: FIG. 18. John Gadsby
Chapman (1808–1889). *The
Baptism of Pocahontas*, 1839,
installed 1840. Oil on canvas,
12 × 18 ft. (3.6 × 5.4 m). U.S.
Capitol Rotunda. Architect of
the Capitol, Washington, D.C.

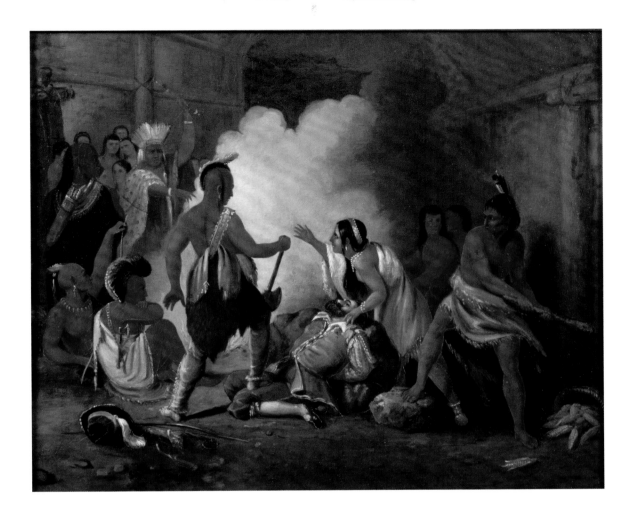

CAT. 6. John Gadsby Chapman
(1808–1889). *Pocahontas Saving
the Life of Captain John Smith*,
ca. 1836–40

Of the dominant themes relating to America's history, the colonial narrative arguably proved the most flexible. Its durability is witnessed by the somewhat standardized re-creation approach taken by Chapman in his determinedly spine-tingling *Pocahontas Saving the Life of Captain John Smith* (cat. 6) and the flirtatious humor of John Rogers's *"Why Don't You Speak for Yourself, John?"* (cat. 39). In many ways, the Pilgrim saga transcended the frozen iconography of Revolutionary politics and battles and lent itself to imaginative romance, consistently reinvigorated by such diverse sources as Henry Wadsworth Longfellow's poetry, Nathaniel Hawthorne's novels, and William Henry Bartlett's popular history, *The Pilgrim Fathers* (1853). It was Bartlett's volume that inspired George Boughton's *Pilgrims Going to Church* (cat. 1), the painting that led to his reputation as the "Painter of New England Puritanism." The elastic Pilgrim imagery crossed the boundaries separating history and genre, epic and domestic modes and easily filtered into popular culture while still retaining its essential moral gravity, as in such works as Augustus Saint-Gaudens's *The Puritan* (cat. 41).

By 1855, when the last of the Capitol Rotunda murals was installed, writers were questioning the viability of the grand-manner mode and simultaneously attempting to define an American national school. A new generation of painters specializing in history subjects had come into its own, among them Leutze, Ehninger,

CAT. 39. John Rogers (1829–1904).
"*Why Don't You Speak for Yourself,
John?*" 1884

CAT. 41. Augustus Saint-Gaudens
(1848–1907). *The Puritan*, 1899

FIG. 19. Friedrich Boser (1809–1881) and Karl Friedrich Lessing (1808–1880). *Bird Shoot of the Düsseldorf Artists at the Grafenberg*, 1844. Oil on canvas, 31 × 40 in. (78.7 × 101.6 cm). The New-York Historical Society. Robert L. Stuart Collection, S-92

Edwin White, and Peter Frederick Rothermel. Of the men listed here, it is significant that all but Rothermel were products of Düsseldorf training, a fact that reflects the city's importance for American artists who sought art education in Europe throughout the 1840s and 1850s.[106] The reputation of Düsseldorf's Königliche Kunstakademie was reinforced in New York by John Godfrey Boker's Düsseldorf Gallery, which housed his collection of paintings by artists associated with the German art academy from 1849 until the collection was sold in 1857 to the Cosmopolitan Art-Association, which dispersed the collection at auction in 1862.[107]

Boker's collection was most often discussed in terms of its being representative of a national school, yet visitors were likely hard-pressed to find any semblance of aesthetic unity among the hundred or so paintings that ran the gamut from large historical and religious subjects to genre, landscape, and still life. This diversity becomes apparent when two of the most admired works in the collection are considered—*Bird Shoot of the Düsseldorf Artists at the Grafenberg* (fig. 19) and Christian Köhler's political allegory *The Awakening of Germania in 1848* (fig. 20). As a whole, however, the collection was considered an exemplary demonstration of sound technique and, as one writer concluded, "Every sincere lover of painting, therefore, hailed the

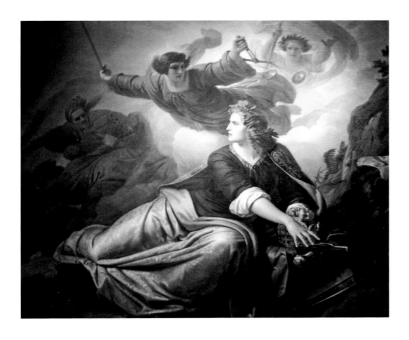

FIG. 20. Christian Köhler (1809–1861). *The Awakening of Germania in 1848*, 1849. Oil on canvas, 90 × 108 in. (228.6 × 274.3 cm). The New-York Historical Society. The Durr Collection, 1882.154

advent of these beautiful strangers with the hope that the example thus presented, might be of more value than the barren precepts which had previously been the principal guides of American Artists, and check that desire for *immediate realization*, which seems to be a national characteristic, and which, however useful in effecting internal improvements is extremely injurious in artistic education."[108] The author of the article, J. W. E., has been convincingly identified as John Whetten Ehninger, who had spent approximately two years (1847–49) in Düsseldorf. Ehninger's essay extolling the Düsseldorf School appeared in the official publication of the American Art-Union, the organization that provided the greatest patronage for his, Leutze's, and Woodville's paintings. Like most of his fellow Americans, Ehninger had been attracted to Düsseldorf training because it promised rigorous instruction emphasizing the human form. In this regard, the complex arrangement of numerous figures in Ehninger's *Peter Stuyvesant and the Cobbler* (cat. 15) reveals the yield of his German studies.

Bird Shoot of the Düsseldorf Artists at the Grafenberg (fig. 19), a joint production of Carl Friedrich Boser (who executed the figures) and Karl Friedrich Lessing (who executed the landscape) is particularly relevant in an American context. The group portrait includes Emanuel Leutze among the principal artists of the Düsseldorf milieu. (He is the long-haired young man with a mustache, facing right, at the table on the left.) The German-born Leutze's inclusion may have stirred the painting's American viewers to rationalize the conflict between nationalist desires and cosmopolitan art education. Initially part of Boker's collection, the painting continued to be a significant presence on the contemporary American art market because of its distinguished provenance: it was purchased by the New York collector John Wolfe in 1862 for $475 and acquired by Robert L. Stuart for $950 in 1864. By then Stuart owned an example of Leutze's work (cat. 28) and was beginning to collect European paintings. In this context, the Boser-Lessing canvas was an ideal purchase because it bridged the divide between American and European art production just as Leutze himself had done.[109]

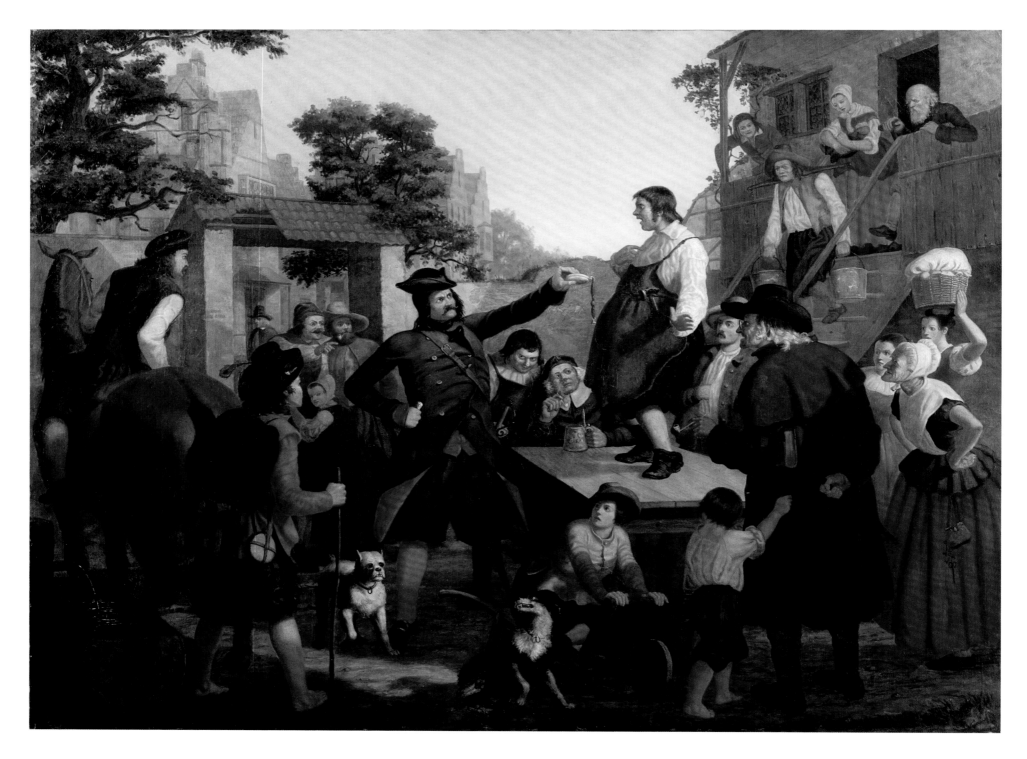

CAT. 15. John Whetten Ehninger (1827–1889). *Peter Stuyvesant and the Cobbler*, 1850

Like Leutze, Rothermel addressed a tightly circumscribed range of history subjects beginning with his own version of *Columbus before the Queen* (1841–42, Smithsonian American Art Museum), which had its origins in Irving's Columbus history. Always in Leutze's shadow, Rothermel nevertheless carved out a niche for himself by focusing on the exploration and conquest of Mexico by the Spaniard Hernán Cortés, mining his imagery from Prescott's history to produce the first of five canvases on the subject (cat. 40) almost immediately after the book was published. Although harshly criticized in some quarters for repeating the theme, Rothermel's Cortés paintings were either commissioned or purchased quickly by respected collectors, among them the Boston naturalist Amos Binney and the New Orleans banker James Robb.[110]

However, the painting that undoubtedly exerted the greatest impact on the American public was Leutze's mammoth *Washington Crossing the Delaware* (fig. 21), which he painted in Europe and sent in 1851 to the United States, where it was displayed to admiring crowds in New York and Washington, D.C. The painting fueled the already strong demand for Washington imagery (see cats. 5, 35) and was the source of a fresh flow of Washington subjects from such contemporaries as Ehninger, White, and Huntington, whose *The Republican Court (Lady Washington's Reception Day)* (fig. 22) drew devastatingly poor reviews yet appealed to a broad swathe of the American public, who purchased vast quantities of print reproductions of it. The connotations attached to American Revolutionary and particularly Washington imagery varied according to changing political circumstances throughout the antebellum period. If Chapman's young surveyor-Washington was emblematic of expansionist policies, then Leutze's grand *Washington Crossing the Delaware* and his other canvases featuring American Revolutionary events could be seen not only as heroicized visions of the not-so-distant past but also as a means to enlist the revolutionary spirit of the thousands of Germans who entered the United States as political exiles in the years surrounding the 1848 uprisings in their own fight for independence. Although the European struggles had been suppressed by the early 1850s, antimonarchical feelings still ran high and found consolation in the American Revolutionary imagery that substantiated the merit of their cause. In that regard, the German-born Johannes Adam Simon Oertel's *Pulling Down the Statue of George III, New York City* (cat. 34) registers as a triumphant sign of American independence and as an urgent reminder that the German people still had a reviled king to topple—the Prussian emperor Friedrich Wilhelm IV.[111]

FIG. 21. Emanuel Gottlieb Leutze (1816–1868). *Washington Crossing the Delaware*, 1851. Oil on canvas, 149 × 255 in. (378.5 × 647.7 cm). The Metropolitan Museum of Art, New York. Gift of John Stewart Kennedy, 1897 (97.34). Image copyright © The Metropolitan Museum of Art / Art Resource, NY

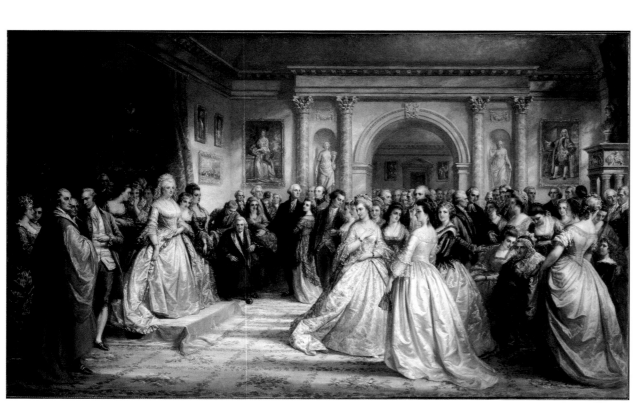

FIG. 22. Daniel Huntington (1816–1906). *The Republican Court (Lady Washington's Reception Day)*, 1861. Oil on canvas, 66 × 109¹⁄₁₆ in. (167.6 × 277 cm). Brooklyn Museum, New York, Gift of the Crescent-Hamilton Athletic Club, 39.536.1

CAT. 35. Rembrandt Peale
(1778–1860). *George
Washington*, 1853

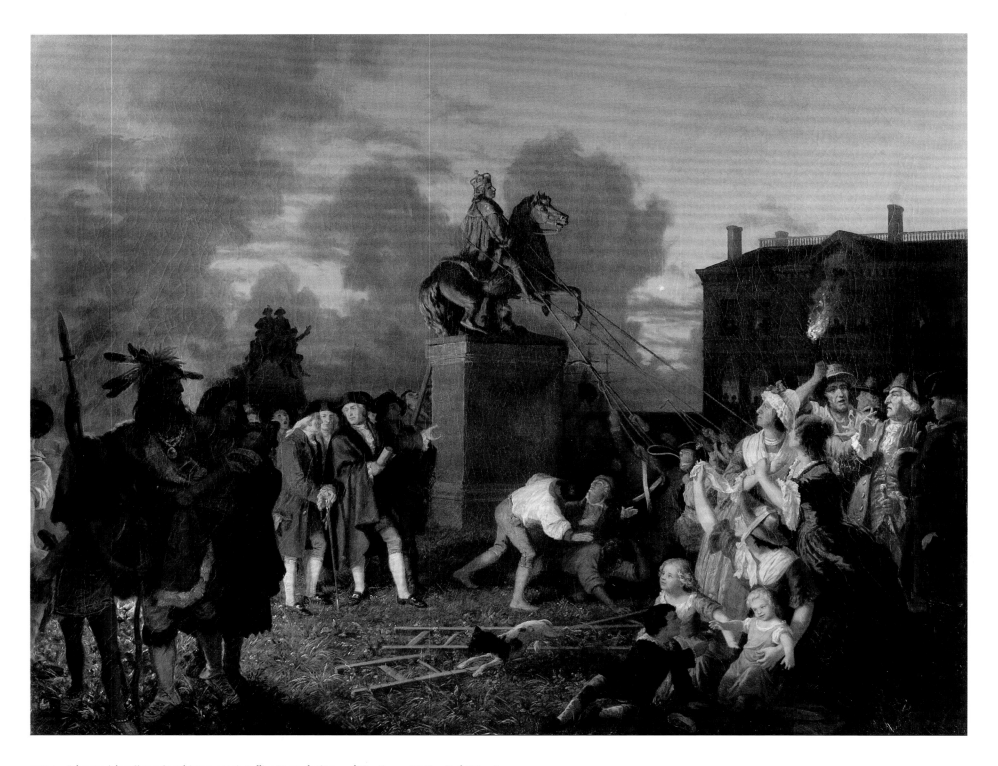

CAT. 34. Johannes Adam Simon Oertel (1823–1909). *Pulling Down the Statue of King George III, New York City*, 1852–53

FIG. 23. John C. McRae (ca. 1816–1892) after Johannes A. Oertel (1823–1909). *Pulling Down the Statue of King George III by the "Sons of Freedom," at the Bowling Green, City of New York, July 1776*, 1859. Engraving and etching on paper, image and text: 22½ × 30½ in. (57 × 77.5 cm); sheet 26 × 35½ in. (66 × 90 cm). Courtesy, American Antiquarian Society, Worcester, Mass.

Oertel's image took on added meaning, however, when it was reproduced in print form in 1859 (fig. 23) as a symbol of the nation's republican origins and (owing to the substitution of a black man for an Indian) as a provocative comment concerning the divisiveness that threatened to destroy the union.[112]

Contrary to the claims that peppered reviews, artists repeatedly tried to express the nation's history in elevated aesthetic terms, and many of these paintings met with success in terms of sales. Yet contradictory opinions concerning the state of the art of history painting flowed liberally in the press, indicating the wide gulf between the taste of professional critics and that of collectors. Some critics continued to insist that few examples of historical art were to be had, and, as one reviewer explained, those paintings that were publicly displayed were problematic on two counts. First, because the artists were unduly affected by foreign schools to the point that foreign influence had "so interpenetrated American Art and changed its essential character, that it should no longer be called American." Second, because of America's "want of picturesque past history." In connection with the latter, the writer concluded, "After taking out the Indians and the Puritans, what is there left besides the contentions of deliberative assemblies and the mathematical evolutions of the wars with Great Britain and Mexico?"[113] One writer fervently asserted that American artists must paint American subjects, saying, "Thus we find Vanderlyn painting Marius on the ruins of Carthage, when, with the same feeling and power, he might have painted a Washington in his reverses, and thus rendered vital a page in our history that would have borne the artist's name, and endeared him to the people, forever."[114]

Another columnist warned that artists "must beware of that nationality which consists of painting Niagara and the Indians, and singing Yankee Doodle. We are men before we are citizens and a Greek for the purposes of Art and Poetry, belongs to an American quite as much as Tecumseh or Sam Patch."[115]

Within this morass of critical dissension existed a layer of commentary that indiscriminately praised anything American, commending the painters of even the worst daubs for their good intentions rather than for their results. If there was a commonly held opinion, it was that the improved state of the arts in America was verified by the increasing number of people attending exhibitions and the amount of money spent on art. Even during the recession of 1857, a reviewer remarked on the success of the recent exhibition at the National Academy of Design, positing, "This all goes to prove that the taste of the public is decidedly artistic, and that, if good material be presented, there is wealth and taste enough among us to reward and appreciate it." The anonymous writer's linking of wealth and taste harks back to Morse's earlier statements, but here, the onus is placed on the artists who led him to conclude, "We have had a progress toward perfection in the details of art, but no progress in ideas. Art is, in reality, behind the times in this respect, or else Christianity and history have been so fully expressed by the old masters that nothing is left for the modern to embody."[116]

With the outbreak of the Civil War, expectations for the arts changed. American artists had a new and momentous subject to deal with, and the general belief was that the war would trigger a more vital form of American history painting. Although many artists did incorporate references to the war into their work, few attempted to portray the horrors of battle in the fresh visual language that was anticipated. Arthur Fitzwilliam Tait's *The Latest News* (cat. 42) tacitly contrasts the "peaceable kingdom" of farm life with the military accounts that undoubtedly dominate the newspaper clutched by one of the men. Alternatively, well-established colonial imagery took on revised, topical meanings. For example, White's *Signing of the Mayflower Compact*, described as a "picturesque group, somewhat like every Yankee's imagination has often painted them," prompted one columnist to remind his readers of the enduring value of noble Puritan precepts of justice and equality that were especially relevant under the conditions of war that rocked the "Ship of State."[117]

CAT. 42. Arthur Fitzwilliam Tait (1819–1905). *The Latest News,* 1862

In a report delivered to the Fine Arts Committee of the New-York Historical Society in January 1864, William J. Hoppin related the war to the progress of the arts: "So far, the arts of design have very inadequately expressed the heroism, patriotic devotion, the noble charities of the North, or . . . the unimaginable sufferings and the glorious martyrdoms of the loyalists of the South." Hoppin acknowledged the role of illustrated newspapers in reporting military actions but dismissed many of them because they sacrificed truth for sensation. He added that photography had been an important factor in recording the war but regretted that the medium did not allow for the "caution and deliberation" required to create a "successful" representation of battle, concluding, "[I]t is not surprising that what we have hitherto obtained in this way has been little besides a representation of that awful 'still life' which the plain shows after the conflict is over."[118]

Many artists did, however, attempt to create moving and relevant images of the war's ravages, as demonstrated in works by Louis Lang (cat. 27) and Victor Nehlig (cat. 32). Yet Lang's mammoth canvas, displayed twice in New York and once in Philadelphia during the war, registered with the critics as more of an artistic curiosity of local interest than as a lasting, emotionally gripping statement. Still, Lang was lauded for his skill in assembling a multitude of people in the "many touching episodes that diversify the scene when the soldier becomes again the citizen."[119] For New Yorkers especially, the popularity of Lang's visual report of the returning Irish regiment depended on the element of recognition, not only of a familiar place but also of the various portraits scattered throughout the composition. Lang's mission to provide a complete impression of an actual urban event on such a scale is unmatched in nineteenth-century American art, and it was perhaps the overwhelming accretion of detail that prevented it from satisfying the call for a noble heroic art. In a sense, his approach was too realistic and, in the long run, prematurely triumphal inasmuch as this image of victorious return remained relevant for only a short time before the regiment was back at the battlefront. Then, too, the painting's reception undoubtedly suffered from the anti-Irish backlash after the draft riots of 1863.

Nehlig's painting, in contrast to Lang's, was highly admired because it focused on the heroism of a single man, the young Lieutenant Henry B. Hidden of the New-York Volunteers—a valiant martyr to the Union

CAT. 27. Louis Lang (1814–1893). *Return of the 69th (Irish) Regiment, N.Y.S.M, from the Seat of War, N.Y.*, 1862. Photograph taken during 2010 treatment. Courtesy Williamstown Art Conservation Center

CAT. 32. Victor Nehlig (1830–1909). *An Episode of the War—the Cavalry*
Charge of Lt. Henry B. Hidden, 1862

OPPOSITE: CAT. 19. Gilbert Gaul
(1855–1919). *Charging the Battery,* 1882

cause—who is shown "fiercely contending in the whirlwind of battle." Notwithstanding the praise accorded Nehlig's canvas, the painting failed to satisfy the demand for a new mode of American history painting. It was deemed that "the German education of the artist is seen too plainly in every detail," and that the work "might pass without much question as an engagement between European soldiers."[120]

Several modern scholars have attempted to account for the failure of history painters to respond adequately to the challenge of visualizing the Civil War.[121] The most insightful conclusions revolve around the changing nature of warfare, which no longer consisted of isolated moments of either triumph or defeat but, instead, stretched into mass horrors of seemingly unending duration. Thus, as Steven Conn and Andrew Walker have concluded, the very type of warfare waged denied its translation into the vernacular of older visual narrative forms.[122] In this context, then, it is understandable why Gilbert Gaul's *Charging the Battery* (cat. 19) commanded the degree of critical acclaim that it did. Although it was painted nearly two decades after the war ended, Gaul's Civil War canvas approximated the blinding, nightmarish confusion of battle without yielding to distressingly graphic details.

On the whole, critics asserted that the historical art produced during the Civil War failed to capture the essence of heroic struggle. Under the influence of the Düsseldorf School, artists—namely Leutze, Lang, and White—had contributed to the revival of history painting in America by demonstrating improved technique and by fashioning easily understood narratives. But, as a writer for the *Christian Examiner* maintained in 1863, "For a time it [the Düsseldorf School] wholly swayed public taste, and does now the common mind. The quality of art that makes [Edwin] Forrest popular as an actor, makes Leutze equally so as a painter." The same author contended that genre painting was accumulating public favor, since "He that looks may understand," because of "clever imitation and a graphic bringing together of the common elements of life in their more materialistic sense." As for landscape, the American school was bending under the weight of a "dry literalness . . . divested of human associations" and collapsing from a "barrenness of thought and feeling."[123] Materialism had overtaken imagination and beauty in the aesthetic arena.

Beauty and Spiritualized Taste

Throughout the nineteenth century, American writers speculated that the national preoccupation with forging a prosperous economy had hindered the progress of the fine arts. To remedy this situation James Jackson Jarves proposed in 1875 that taste was integral to realizing the triumph of the spirit over the material.[124] An influential journalist, pioneer collector of the Italian primitives, and thoughtful art critic and historian, Jarves was one of the most prolific writers on the state of the arts in America in the last half of the nineteenth century.[125] For him, taste was the "guide to the beautiful" as well as the "psychological barometer whereby to measure the actual ethical condition of a human being, to prognosticate his destiny, and to mark the degree of his spiritual growth, or his progress in the opposite direction."[126] Irrespective of the centrality of spiritual attainment in his writings, Jarves eschewed religious orthodoxy in favor of the generic "divine." Indeed, that nineteenth-century commentators avoided discussing religious art presents a curious paradox since much of the nation's social and intellectual history was shaped by religion. In terms of visual tradition, however, the rejection of explicitly doctrinal Christian imagery resides in the Puritan heritage, a legacy dramatically expressed in Leutze's *The Iconoclasts* (fig. 24), which depicts the zealotry of seventeenth-century English Puritans as they run riot in a Catholic church, destroying statuary and paintings associated with papal authority.

The strong tradition of religious subject matter in the American arts notwithstanding (many painters essayed biblical subjects at one time or another), little attention has been given to what seems to have been a steady flow of American canvases depicting Magdalenes, Hagars, and other biblical personages throughout the nineteenth century. What is more, these now largely unknown works originally gained considerable popularity, as witnessed by Luther Terry's *Jacob's Dream* (cat. 44). Yet even Tuckerman did not cover the topic in his otherwise comprehensive 1867 survey *Book of the Artists*.[127] Tuckerman's almost singular reference to religious subject matter emerges in his discussion of Daniel Huntington, who "in other times and under different circumstances . . . would have become a religious painter, in which branch, by study and sentiment, he was specially fitted to excel."[128] Many of Huntington's paintings, including *Sowing the Word* (cat. 23) and *Mother and Child* (cat. 22) may be categorized as embodiments

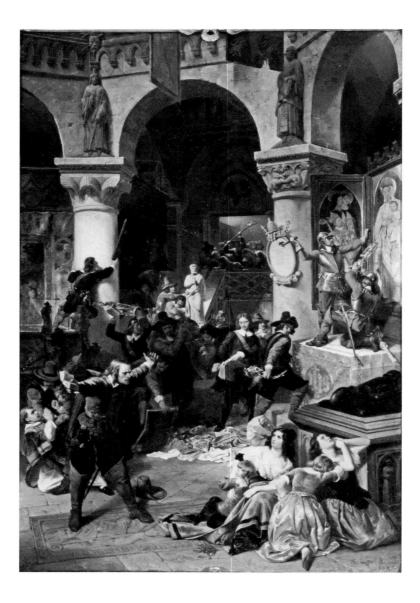

FIG. 24. Emanuel Gottlieb Leutze
(1816–1868). *The Iconoclasts*, 1846.
Oil on canvas, 60 × 41 in. (152.4 ×
104.1 cm). Collection of Victoria
Mansion (The Morse-Libby
Mansion), Portland, Maine, gift of
Mrs. Ralph G. Libby

of Christian sentiment but not necessarily as overtly religious works. The painter's abiding concern for spiritual refinement stemmed from his strict Congregationalist upbringing and matured with his embrace of the Episcopal faith in the late 1830s (likely inspired by his elder brother Jedediah, an Episcopal minister who ultimately converted to Catholicism).[129] Huntington's conversion to Episcopalianism—the American branch of the Anglican Church—coincided with the general growth of that denomination in America, largely in response to the "aesthetic attractions" it offered in contrast to the "cultural poverty of Puritan worship."[130]

Huntington's ideas on refinement and taste also likely owed much to his early study with Samuel F. B. Morse and to his even earlier association with the Congregational minister Horace Bushnell. Bushnell's efforts to reconcile the genteel trends in worship (i.e., Episcopalianism) with the more ascetic practice of Congregationalism are particularly relevant with respect to the formation of taste in the religious sphere.

CAT. 44. Luther Terry (1813–1900). *Jacob's Dream*, ca. 1852

His lengthy essay "Taste and Fashion," published in the *New Englander* in 1843, is a remarkable attempt to deter defection from his church to the Episcopalian ranks. Citing the need to emancipate beauty and taste from the "fetters of fashion," which would enable human society to approach its "finished state," Bushnell positioned fashion as a loosely disguised analogue for the aesthetic appeal of Episcopalian ritual. While asserting the fundamental importance of beauty and taste, Bushnell realigned the two concepts, removing them from the social exclusivity and sensualism associated with the flourishing High Church faith and bringing them closer to a plainer and, as he suggested, more democratic system. He granted that "[t]he last and finishing stage of human advancement . . . must be accomplished by the discipline of Taste—it must be that stage in which Beauty descends from heaven to be the clothing of spiritual intelligence and the grace of Christian piety." But, alluding to Episcopal practice, he stressed that some people labored under the pressures of fashion, which "can be expelled only by a higher love." The taste that Bushnell sought was one of "severe simplicity" dependent on "neatness, order, modesty and becomingness in dress, elegance of feeling, refinement of intercourse," a primly Protestant catalogue of characteristics within reach of everyone regardless of their social or economic status.[131]

Although Huntington's views eventually diverged from Bushnell's, the painter reiterated Bushnell's position that "the whole fabric of creation is an exertion of taste."[132] In his lecture on Christian art, delivered at the National Academy of Design in 1851, Huntington pronounced that all art is Christian art for it echoes the creative faculty of the divine Creator. Moreover, he rejected claims that "the fine arts are enervating indulgences . . . that . . . seduce the Pilgrim from the narrow and rugged way into easy and pleasurable by-paths, blinding the sense of Truth by the hazy and glimmering atmosphere of Beauty." He recommended that all should "look up and around them and see how fair the creator hath made all things!" Rather than denying the efficacy of art, Huntington underscored the value of imagery, emphasizing its serious and earnest intent: "Thousands will turn from the teaching of words, but every eye is arrested by the picture. In this light we see how high is the calling of every true artist."[133] Huntington's words find visual affirmation in his *Sowing the Word*, in which a bearded philosopher type

OPPOSITE: CAT. 23. Daniel Huntington (1816–1906). *Sowing the Word*, 1868

CAT. 22. Daniel Huntington (1816–1906).
Mother and Child, 1849

FIG. 25. Raphael (Raffaello Sanzio)
(1483–1520). *Madonna of the Chair*
(*Madonna della Seggiola*), ca. 1516.
Oil on wood, diameter 28 in. (71 cm).
Galleria Palatina, Palazzo Pitti,
Florence, Italy. Photograph © Scala /
Art Resource, NY

instructs two young women. Although the "word" is ultimately of supreme import, a page of the book
which the old man consults displays an image of Saint Luke at his easel, thus exalting the role of the artist
through association with the Gospel writer who was reputed to have painted the first portrait of the Virgin
and Child. This meaning is augmented by the painting-within-the-painting that is reminiscent of an early
Renaissance Flemish representation of the Virgin and Child and which acts as a foil for the two pupils.

Relatively few of Huntington's paintings focused on religious subjects in the traditional sense. Instead,
he constructed evocations of established religious iconography that functioned independently of a specific
creed yet resonated with Christian associations. This is especially true of *Mother and Child* (cat. 22), which
is related to an earlier version of the subject designated by the artist simply as "in the style of a sacred
subject."[134] The sacred subject Huntington referred to was undoubtedly the Christian Madonna and Child
and, as Wendy Greenhouse has suggested, the rounded form of the mother as she protectively embraces
her child recalls Raphael's extraordinarily popular *Madonna della Seggiola* (fig. 25).[135] Such visual

associations created indefinite but perceptible links with an artistic (and Catholic) past at a time of deep-seated anti-Catholic sentiment in the United States. Huntington's message, embedded in the image of the pair shown against the backdrop of a Roman ruin, implies the decay of the Old World and the old religion. Revenants of Catholic iconography, the mother and child are universalized, transformed into a generic sign of maternal love.

The often virulent reactions to Catholicism in antebellum America complicate speculation as to the intentions behind George Whiting Flagg's *The Nun* (cat. 18) and William Edward West's *The Confessional* (cat. 51). Both artists had spent considerable time in Europe, where they would have visited and no doubt appreciated the cathedrals and churches of the Catholic faith, experiences that fueled the already strong inclination among some American Protestants to investigate Catholicism's exotic spirituality.[136] This religious tourism has been characterized by the historian Jenny Franchot as a "gaze that acknowledged its spiritual desire, celebrated Catholicism as spectacle, and fantasied the consumption of this foreign substance rather than conversion to it."[137] Flagg had recently returned from European travels when his painting of a solitary nun was shown at the National Academy of Design in 1836, the year after violent anti-Catholic demonstrations had erupted in New York City. It is impossible to gauge what response the young Flagg expected for his sympathetic depiction of chaste Roman piety that differed substantially from Morse's emotionally distanced vision of worshipers at a rural Italian shrine painted some six years earlier (fig. 26). As for West, his extended sojourn in England, which ended in 1837, probably attuned him to the Romanizing Oxford Movement, which advocated a resumption of Roman Catholic ritual style within the Church of England. The Romantic return to older liturgical patterns also registered in the United States and generated a substantial body of paintings that revealed a marked interest in the mysteries of Catholicism. Although West's depiction of a young woman with an elderly monk does not simulate the Roman Catholic sacrament of confession, the crucifix bearing the sculpted body of Jesus, the figures' gestures, and the painting's title point toward an interpretation of the image as a narrative of the increasingly Romanized tendencies within some branches of Protestantism.

CAT. 18. George Whiting Flagg
(1816–1897). *The Nun*, ca. 1836

CAT. 51. William Edward West
(1788–1857). *The Confessional,*
ca. 1845–50

FIG. 26. Samuel F. B. Morse (1791–1872).
Chapel of the Virgin at Subiaco, 1830.
Oil on canvas, 29¹⁵/₁₆ × 37 in. (76 × 94 cm).
Worcester Art Museum, Worcester, Mass.,
Bequest of Stephen Salisbury

A simpler Protestant heritage manifested itself in two paintings by Durand and Johnson, both of which are titled *Sunday Morning* (cats. 11, 25). Durand's treatment of the theme reflects his well-known belief in the restorative capacity of the natural world in that the family he portrayed must first wend its way through a verdant sunlit landscape as if in spiritual preparation for the service that will take place in the distant church. All is well in Durand's rural *Sunday Morning*, where the young father points the way to church and metaphorically to the light of salvation. In contrast, Johnson pictured another American family at private worship in the dimly lit interior of their cramped and humble home. Daylight filters through a single window, illuminating the somber scene, which suggests the nation's spiritual exhaustion in the aftermath of the Civil War and the attendant need to resuscitate older values associated with New England moral virtue.[138]

If any one conclusion can be drawn based on the works mentioned here, it is that most American artists who sought to express the "spiritual" did not rely on orthodox tenets. This, however, did not exclude them from being considered "Christian artists," and, as one writer offered, "I am far from thinking that Christian

CAT. 11. Asher B. Durand (1796–1886). *Sunday Morning*, 1839

CAT. 25. Eastman Johnson (1824–1906). *Sunday Morning*, 1866

Art need be, or will be confined to subjects directly and professedly religious or devotional in character. The spirit of Christianity is neither narrow nor exclusive in its sympathies and tendencies, but fitted to embrace in its comprehensive grasp all that is pure, lovely, and noble, only rejecting and excluding, as utterly alien, whatever is essentially mean and base."[139] To return to Jarves, it is worth noting that "Beauty" was the key to achieving spiritual grace; the ethical duty of the artist and the viewer was to cultivate a level of taste that would support the apprehension of "Beauty"—an aesthetic condition that, in Jarves's mind, was a pathway to spiritual completion. A corresponding result was especially curative in that it counteracted the injurious effects of materialism. Distinctions were made between an instinctive desire for beauty and an intellectually determined appreciation for a beauty of noble purpose, the latter of which being defined as "High Art."[140] In this regard, midcentury readers were frequently subjected to monitory comments elaborating on the pitfalls of submitting to the material type of beauty: "Our artists are . . . running after what is objective and real, rather than venturing into the regions of the ideal and spiritual, drawing upon the perceptive faculties rather than upon the emotions, for recognition. This is all well enough, if it does not degenerate into mere formality, if a taste for the real does not render us commonplace and material."[141] In the end, taste and beauty were inextricably linked with the sacred, the spiritual, and the virtuous, without necessarily invoking official church doctrine.

The Fate of Taste: A Postbellum Postscript

The Civil War and its aftermath shattered the national psyche, divesting it of the optimism that had permeated American culture in the antebellum era. In the decades immediately after the war, the nation was in the grip of Reconstruction, contending with the task of healing and governing the restored Union. The country's altered mood was shaped by a process of anxious self-examination in which values of the colonial past were reviewed and revived in order to regenerate national unity, a trend whose crowning moment was the Philadelphia Centennial Exhibition in 1876. This retrospective cast of mind notwithstanding, a new chapter in the arts opened, marked by the mounting number of Americans who sought art training in Europe and returned to the United States to exhibit works whose subjects and progressive styles announced the

advent of often radical aesthetic transitions, which began to focus discussions of taste on matters of technique in which moral value was often equated with facture. For example, the smoothly finished surface of a canvas evoked notions of refinement, whereas rough, sketchy execution suggested vulgarity. Moreover, the emergence of new concepts—art for art's sake, in particular—stripped narrative imagery of its former authority and emphasized, instead, the primacy of a subjective response to art.[142] Confronted by an increasingly fragmented aesthetic vision that was compounded by the arrival of contemporary European stylistic innovation, American writers and audiences were defeated in their efforts to create a rational formula for artistic taste.

Although the earlier imperatives to quantify taste scientifically had collapsed, the word took on new shades of meaning and also retained old purposes. In the last quarter of the century, taste was more frequently associated with feminine sensibility. As an outgrowth of the country's rapid industrial expansion, the reins of domestic consumerism were handed over to women, whose duty was, according to one writer, to "civilize society." Continuing in that vein, the same writer remarked, "Never in the history of social development has this truth found fuller illustration than in the growth and ripening of a taste for the fine arts in America."[143] As the purview of the purportedly intuitive, nonrational feminine domain, taste in that context was assigned, if not an inferior position, at least one that related to a narrower segment of the population, which was ultimately branded effete or elitist. Yet the taste (read appetite) for art was by no means restricted to the privileged classes, as witnessed by the accelerated demand for cheap oil paintings, manufactured in assembly-line method in factories throughout the country. Whether they were copies of famous works or pedestrian "originals," these paintings found their way into thousands of homes, allowing owners to participate in an activity patterned on that of the higher-end art market.[144]

Whereas in some quarters these mass-produced oil paintings signified the robust and democratic condition of the American arts, for others the power of popularity forecast the demise of what was considered genuine or "true" taste. Some saw it as a sign of moral and social decay and railed against the debasement of art: "To be popular—and popularity just now is apt to be confounded with greatness—art must truckle to the vitiated taste of a mob of ignoramuses; . . . painting must give up historical memories

and religious inspirations for the sake of quick sales and gaudy coloring. . . . So with sculpture—we must have Rogers' groups, . . . anything that is domestic and prosaic, provided we have nothing heroic that will strain our powers of admiration, or excite high aspirations after the ideal."[145] Although they were part of an ever-diminishing minority, writers continued to echo Morse's earlier words as exemplified by the fervently put plea: "America needs a profound veneration for true art, and a munificent patronage of it. . . . We need a severity of public taste akin to that represented in the Theban law, which imposed a heavy fine upon the professed artist who should violate the truth and beauty of his subject."[146] Not by coincidence, this essentially reformist attitude was expressed by the abrupt rise in the number of museums founded largely through philanthropic enterprise from the 1870s until the beginning of World War I.[147] However, the familiar litany of art's capacity to elevate and educate the masses became tedious to modern ears. In 1902 the painter Thomas Wilmer Dewing (1851–1938) dismissed the notion of art's ability to improve public taste, saying, "Nonsense! Hang the educational value business altogether. We've heard enough of that kind of rot lately to last us for the rest of our natural lives. What is the value of art, anyhow? Nothing but the pleasure of making it."[148]

The sharp bifurcation of taste into "high" and "low" that arose at the end of the nineteenth century (and still exists) has been attributed to what Richard Hofstadter has identified as an inherent anti-intellectualism in American culture.[149] Such nineteenth-century tendencies as the distrust of connoisseurship, a preference for easily understood narrative imagery focusing on common experience, and the general resistance to European influence in the quest for a uniquely national art contributed to the widening taste divide that in itself has become a rich topic for artists and art historians.[150] The language of debate may have changed—indeed, the mere mention of taste today is often a source of embarrassment—but the central issue remains constant, inasmuch as cultural power in a democracy continues to be territory contested by the many and the few.

OPPPOSITE: Louis Lang (1814–1893).
Mary, Queen of Scots Dividing Her Jewels, 1861, detail (CAT. 26)

NOTES

Epigraphs: *An Education*, directed by Lone Sherfig, 2009; and Sir Joshua Reynolds, Edmond Malone, and Thomas Gray, *The Works of Sir Joshua Reynolds, Knight* (London: T. Cadell, Jun. and W. Davies, 1797), 1:xii.

1. "The Art-Union Pictures," *LW* 1 (April 3, 1847): 209.
2. "The Art-Union Pictures," *LW* 1 (October 23, 1847): 277.
3. "An Essay on Taste," *Boston Magazine* 1 (November 1783): 27.
4. "American Works of Painting and Sculpture," *United States Democratic Review* 20, no. 103 (January 1847): 56.
5. This essay differs from the approach adopted by Johns 1991, which excluded historical, literary, and religious narratives.
6. Hayden White, "The Value of Narrativity in the Representation of Reality," in *On Narrative*, ed. W. J. T. Mitchell (Chicago: University of Chicago Press, 1981), 14.
7. Nina Baym, *Novels, Readers, and Reviewers: Responses to Fiction in Antebellum America* (Ithaca, N.Y.: Cornell University Press, 1984), 108.
8. "Art: VII, Art and Artists of America," *Christian Examiner* 75, no. 1 (July 1863): 114.
9. For the "American" hierarchy, see [Samuel F. B. Morse], "Review: The Exhibition of the National Academy of Design, 1827; The Second, New York, D. Fanshaw, 1827," *United States Review and Literary Gazette* 2 (July 1827): 241–63.
10. See Richard L. Bushman, *The Refinement of America: Persons, Houses, Cities* (New York: Vintage Books, 1993). I am grateful to Dr. Jane H. Hunter for bringing this invaluable book to my attention.
11. These ideas are rehearsed in such important studies as Lillian B. Miller, *Patrons and Patriotism: The Encouragement of the Fine Arts in the United States, 1790–1860* (Chicago: University of Chicago Press, 1966); and Neil Harris, *The Artist in American Society: The Formative Years, 1790–1860* (Chicago: University of Chicago Press, 1982). Also see J. Meredith Neil, *Toward a National Taste: America's Quest for Aesthetic Independence* (Honolulu: University Press of Hawaii, 1975).
12. James B. Twitchell, *Carnival Culture: The Trashing of Taste in America* (New York: Columbia University Press, 1992), 15.
13. Morse Letters, Library of Congress, quoted in Miller, *Patrons and Patriotism*, 12.
14. Paul J. Staiti, *Samuel F. B. Morse* (Cambridge: Cambridge University Press, 1989), 21.
15. Dunlap 1834, 1:33.
16. Especially helpful on the writings on taste are Edward Niles Hooker, "The Discussion of Taste, from 1750 to 1770, and the New Trends in Literary Criticism," *PMLA* 49, no. 2 (June 1934): 577–92; Marjorie Grene, "Gerard's 'Essay on Taste,'" *Modern Philology* 41, no. 1 (August 1943): 45–58; Steven A. Jauss, "Associationism and Taste Theory in Archibald Alison's Essays," *Journal of Aesthetics and Art Criticism* 64, no. 4 (Autumn 2006): 415–28; and George Dickie, *The Century of Taste: The Philosophical Odyssey of Taste in the Eighteenth Century* (Oxford: Oxford University Press, 2003). See also Pierre Bourdieu, *Distinction: A Social Critique of the Judgement of Taste*, trans. Richard Nice (Cambridge, Mass.: Harvard University Press, 1984).
17. Archibald Alison, *Essays on the Nature and Principles of Taste* (1790; Edinburgh: Archibald Constable & Co, 1825), 89.
18. Quoted in Hooker, "The Discussion of Taste," 588.
19. An Egotist, "Taste," *South-Carolina Weekly Museum and Complete Magazine of Entertainment* 1 (January 1, 1797): 9.
20. Neil, *Toward a National Taste*, 6.
21. See Franziska Forster-Hahn, "The Sources of True Taste: Benjamin West's Instructions to a Young Painter for His Studies in Italy," *Journal of the Warburg and Courtauld Institutes* 30 (1967): 368.
22. See Dorinda Evans, *Benjamin West and His American Students* (Washington, D.C.: Smithsonian Institution Press, for the National Portrait Gallery, 1980).
23. See Carrie Rebora, "Sir Thomas Lawrence's 'Benjamin West' for the American Academy of the Fine Arts," *American Art Journal* 21, no. 3 (1989): 18–47.
24. Carrie J. Rebora, "The American Academy of the Fine Arts, New York, 1802–1842" (Ph.D. diss., City University of New York, 1990), 1:163–64.
25. "The American School of Art," *American Whig Review* 16, no. 2 (August 1852): 141.
26. Walter Thornbury, "West, the Monarch of Mediocrity," *Albion* 43, no. 30 (June 29, 1865): 352.
27. Samuel F. B. Morse to Jedidiah Morse, May 3, 1815, Morse Papers, Library of Congress, quoted in Staiti, *Morse*, 33.
28. Staiti, *Morse*, 7.
29. Timothy Dwight, "Essay on Taste," *American Museum, or, Universal Magazine* 10, no. 1 (July–December 1791): 51.
30. Morse, quoted in Staiti, *Morse*, 102.
31. See Albert H. Marckwardt, "The Chronology and Personnel of the Bread and Cheese Club," *American Literature* 6, no. 4 (January 1935): 389–97.
32. For the conflicts between the academies, see Rebora, "The American Academy."
33. *Samuel F. B. Morse, His Letters and Journals*, ed. and supplemented by his son, Edward Lind Morse (1914; London: BiblioBazaar, n.d.), 2:39
34. See Nancy Isenberg, *Fallen Founder: The Life of Aaron Burr* (New York: Penguin Books, 2008), 158: "Burr's home was designed almost as a French salon, with gracious surroundings meant for entertaining (usually small dinner parties); above all, his goal was to create an enlightened atmosphere of taste and learning."
35. Dunlap 1834, 2:36.
36. Ibid., 3:49–50.
37. See also William H. Gerdts, *The Great American Nude: A History in Art* (New York: Praeger Publishers, 1974), 52–61; David M. Lubin, *Picturing a Nation: Art and Social Change in Nineteenth-Century America* (New Haven: Yale University Press, 1994), 1–53; E. McSherry Fowble, "Without a Blush: The Movement toward Acceptance of the Nude as an Art Form in America, 1800–1825," *Winterthur Portfolio* 9 (1974): 120–21; and Harold E. Dickson, "Artists as Showmen," *American Art Journal* 5, no. 1 (May 1973): 4–17.
38. K., "Carus [*sic*] Marius, and Ariadne," *New-York Spectator*, October 2, 1826, 1.
39. Tuckerman 1867, 135.
40. See Maura Lyons, *William Dunlap and the Construction of an American Art History* (Amherst: University of Massachusetts Press, 2005).
41. Eleanor Bryce Scott, "Early Literary Clubs in New York City," *American Literature* 5 (1933–34): 7–8; and Allen Walker Read, "The Philological Society of New York, 1788," *American Speech* 9, no. 2 (April 1934): 131–36.
42. "Mr. Dunlap's Historical Pictures," *NYM*, March 24, 1832, 29.
43. Lyons, *Dunlap*, 27.
44. "The Connoisseur," *Juvenile Portfolio* (January 21, 1815): 10–11, quoted in Neil, *America's Quest*, 20.
45. "Art Patronage in America," *Cosmopolitan Art Journal* 1, no. 2 (November 1856): 34.

46. Citing the growth of parlor culture as "one of the great democratic movements of the nineteenth century," Bushman, *The Refinement of America*, 273, continues, "The construction of parlors in ordinary houses in the nineteenth century changed this relationship [between "genteel society" and the masses]. A parlor set off as a place for company with even rudimentary parlor furnishing meant that the people in the house were attempting to embrace gentility as their own, to possess it rather than to observe it."

47. "Paintings and Painters," *Portland Magazine* 2, no. 8 (May 1, 1836): 253.

48. Tuckerman 1867, 201.

49. For this trend in Britain, see Richard D. Altick, *Paintings from Books: Art and Literature in Britain, 1760–1900* (Columbus: Ohio State University Press, 1985).

50. See James T. Callow, *Kindred Spirits: Knickerbocker Writers and American Artists, 1807–1855* (Chapel Hill: University of North Carolina Press, 1967).

51. Andrew Burstein, *The Original Knickerbocker: The Life of Washington Irving* (New York: Basic Books, 2007), 67–88.

52. Cindy Dickinson, "Creating a World of Books, Friends, and Flowers: Gift Books and Inscriptions, 1825–1860," *Winterthur Portfolio* 31, no. 1 (Spring 1996): 53–66.

53. See Mary Alice Mackay, "Sketch Club Drawings for Byron's 'Darkness' and Scott's 'Lay of the Last Minstrel,'" *Master Drawings* 35, no. 2 (Summer 1997): 148.

54. "The Fine Arts: National Academy of Design; Fifth Notice," *NYM*, June 15, 1833, 398.

55. James Fenimore Cooper, *Notions of the Americans Picked up by a Travelling Bachelor* (Philadelphia: Carey, Lea, Carey, 1832), 113.

56. Alexis de Tocqueville, *Democracy in America*, ed. Isaac Kramnick (4th ed., 1841; New York: W. W. Norton, 2007), 415.

57. See Winifred H. Friedman, *Boydell's Shakespeare Gallery* (New York: Garland Publishing, 1976); John Boydell and Josiah Boydell, *Boydell's Shakespeare Prints* (Mineola, N.Y.: Dover Publications, 2004); and Robin Hamlyn, "The Shakespeare Galleries of John Boydell and James Woodmason," in Jane Martineau et al., *Shakespeare in Art* (London: Merrell, 2003), 96–101.

58. Helmut von Erffa and Allen Staley, *The Paintings of Benjamin West* (New Haven: Yale University Press, 1986), 271–73.

59. "The Shakspeare-Gallery," *Ladies' Monitor* 1, no. 11 (October 31, 1801): 87; and "Old Booksellers," *NYT*, March 3, 1900, BR4.

60. For Leslie's American career, see my "The American Career of Charles Robert Leslie," *Antiques* 172, no. 5 (November 2007): 122–29.

61. Allan Cunningham, *The Lives of the Most Eminent British Painters and Sculptors* (London: John Murray, 1832), 3:346.

62. "Fine Arts," *Critic: A Weekly Review of Literature, Fine Arts, and the Drama* 2, no. 3 (May 23, 1829): 47.

63. *NYM*, May 10, 1834, 355.

64. Bushman, *The Refinement of America*, 44, 80.

65. For the popularity of Shakespeare in America, see Lawrence W. Levine, *Highbrow Lowbrow: The Emergence of Cultural Hierarchy in America* (Cambridge, Mass.: Harvard University Press, 1988), 13–81.

66. Twain's *Adventures of Huckleberry Finn* was originally published in 1884. For the Hamlet soliloquy, see Mark Twain, *Adventures of Huckleberry Finn "Tom Sawyer's Comrade"* (New York: Signet Classic, 1997), 134.

67. See Wendy Greenhouse, "The American Portrayal of Tudor and Stuart History, 1835–1865" (Ph.D. diss., Yale University, 1989).

68. Samuel G. Goodrich, *The Pictorial History of England* (Philadelphia: Sorin and Ball, and Samuel Agnew, 1846), 11, quoted in ibid., 25–26.

69. A discussion of an unlocated work focusing on Mary, Queen of Scots by Peter Rothermel exemplifies this manner of reading content. A critic for the *New York Post* had deemed paintings like it as "worn-out and often pointless tales of buried mythology." The opinion was countered by the critic for the *Albion*, who defended the painting, saying, "Mary Queen of Scots, may indeed be a myth in the mind's eye of the writer quoted above, but even on his authority it will not be conceded that the antagonistic position of two Religions—the Protestant and the Roman Catholic—still standing in our day in the same attitude of rivalry and defiance—can be dismissed as a trivial incident, or be overshadowed in its human interest even by a New England Thanksgiving dinner." *Albion* 10, no. 20 (May 17, 1851): 237.

70. Henry T. Tuckerman, "Artists and Authors," *Cosmopolitan Art Journal* 3, no. 5 (December 1859): 195.

71. Tuckerman 1867, 411.

72. Robert Gilmor Jr., Jonathan Meredith, and Alan Wallach, "'This Is the Reward of Patronising the Arts': A Letter from Robert Gilmor, Jr., to Jonathan Meredith April 1, 1844," *American Art Journal* 21, no. 4 (Winter 1989): 76. For Leupp, see James T. Callow, "American Art in the Collection of Charles M. Leupp," *Antiques* 118, no. 5 (November 1980): 998–1007; for Sturges, see Christine I. Oaklander, "Jonathan Sturges, W. H. Osborn, and William Church Osborn: A Chapter in American Art Patronage," *Metropolitan Museum Journal* 43 (2008): 173–94.

73. Reported in John Durand, *The Life and Times of A. B. Durand* (1894; New York: Kennedy Graphics, 1970), 128. Durand continued, saying that Bennett, who was being asked at the time to give press support to the New-York Gallery of the Fine Arts, was reminded that it was "those people" who had the money.

74. William H. Gerdts, "The American 'Discourses': A Survey of Lectures and Writings on American Art, 1770–1858," *American Art Journal* 15, no. 3 (Summer 1983): 61–79.

75. Particularly valuable sources are Rachel N. Klein, "Art and Authority in Antebellum New York City: The Rise and Fall of the American Art-Union," *Journal of American History* 81, no. 4 (March 1995): 1534–61; and Patricia Hills, "The American Art-Union as Patron," in *Art in Bourgeois Society, 1790–1850*, ed. Andrew Hemingway and William Vaughan (Cambridge: Cambridge University Press, 1998), 314–39.

76. Mr. Bellows [Reverend Henry Whitney Bellows], "Proceedings at the Annual Meeting of the American Art-Union for 1844," *Transactions of the American Art-Union, for the Promotion of the Fine Arts in the United States* (New York: John Douglas, 1844), 10.

77. Hills, "The American Art-Union," 316.

78. The works purchased and/or engraved by the American Art-Union that are included in this exhibition are Huntington's *A Sibyl* (purchased 1840; engraved 1847); Chapman's *George Washington in His Youth* (purchased 1841); Matteson's *The Last of the Race* (purchased 1847); Woodville's *The Cavalier's Return* (purchased 1848); Huntington's *Mother and Child* (purchased 1850); and Mount's *Farmers Bargaining* (engraved 1851).

79. Klein, "Art and Authority," 1537–39, notes that Philip Hone (a Whig) helped organize the American Art-Union and served on its committee until 1851; William Cullen Bryant was the union's president from 1844 to 1846 and, although originally a Democrat, transferred his political loyalties to the Republican Party and to the Liberal Republicans after the Civil War.

80. Annual Report of the Management Committee, "Proceedings at the Annual Meeting of the American Art-Union for 1844. Annual Report of the Committee of Management of the American Art Union—for the Year 1844," *Transactions of the American Art-Union*, 1844, 5–6.
81. "The American Art-Union," *Harbinger* 6, no. 18 (December 1847): 53.
82. "Crushing: Amateur Merchants of the Art-Union," *Home Journal* 44, no. 194 (October 27, 1849): 2.
83. "American Works of Painting and Sculpture," *United States Democratic Review* 20, no. 103 (January 1847): 56: "The fame and fate of artists depend even still more upon the verdict of the people at large; and until true ideas of art are more generally diffused, and the demand becomes greater for works of a high order, it cannot be expected that men of genius will devote the utmost powers of their minds to produce fine compositions."
84. *Crayon* 4 (August 1857): 252.
85. David S. Reynolds, *Beneath the American Renaissance: The Subversive Imagination in the Age of Emerson and Melville* (Cambridge, Mass.: Harvard University Press, 1988), 99.
86. Works by Mount, Edmonds, and other painters of rural American culture did not lack serious sociopolitical content, as Johns 1991 eloquently demonstrated.
87. Cafferty's name appears on the list of signatories in "Special Notice," *NYT*, February 26, 1852, 3. This language echoes the antireformist rhetoric cited by Reynolds, *Beneath the American Renaissance*, that underscores the corrupting potential of the fanatical reformer.
88. For Talbot's reputation as a "Christian" artist, see Oculus, "Christian Artists," *New York Evangelist* 26, no. 48 (November 29, 1855): 1.
89. "A Note on Art," *Independent* 15, no. 738 (January 22, 1863): 4. The discussion was prompted by a work by Henry Peters Gray shown at an artists' reception. Described as a small picture representing the "Goddess of Liberty breaking the chains of a Negro Slave, and offering him a sword," the painting may be Gray's unlocated *America in '62*.
90. "The Thirty-fourth Exhibition of the Academy of Design," *NYEP*, April 25, 1859, 1.
91. George Frederick Holmes, "A Key to Uncle Tom's Cabin," *Southern Literary Messenger* 19 (June 6, 1853): 321–29, at 322. Granted, Holmes was a Southerner and vehemently disputed the abolitionist ideals espoused by Stowe. However, as Reynolds, *Beneath the American Renaissance*, 79, states, such opinions were not unique to Southerners, and Stowe's "vivid exposure of vice laid her open to nasty charges of hidden fascination with vice."
92. For example, Edwin Percy Whipple, *Eulogy on John Albion Andrew* (Boston: A. Mudge and Son, 1867), 34, described the sculpture as "representing a freedman receiving instruction from a young girl." See also "Art: John Rogers," *Aldine* 6, no. 1 (January 1873): 27: "in 'Uncle Ned's School' we see the desire, real or supposed, of the freedman for knowledge."
93. Albert Boime, *The Art of Exclusion: Representing Blacks in the Nineteenth Century* (Washington, D.C.: Smithsonian Institution Press, 1990), 105.
94. Anne Charlotte Lynch Botta to Henry Whitney Bellows, December 6, 1868, in *Memoirs of Anne C. L. Botta Written by Her Friends: With Selections of Her Correspondence and from Her Writings in Prose and Poetry*, ed. Vincenzo Botta (New York: J. Selwin Tait, 1893), 459. Botta's arguments against Brown's actions were cast in language comparable to that used against "immoral reformers": "I do not think his course sanctioned by our Saviour's example or precepts any more than the burning of heretics by the Inquisition, or of the Quakers by the Puritans, though both were done in His name."
95. "Mr. Hovenden's John Brown Picture," *Art Union* 1, no. 5 (May 1884): 109.
96. "The Fine Arts," *NYDT*, April 17, 1852, 6.
97. In the Judeo-Christian tradition, the Pharisee Gamaliel was a respected expert in Mosaic law. "Fine Arts: National Academy of Design," *Albion*, April 6, 1861, 165.
98. "National Academy of Design: Second Notice," *Crayon* 6 (June 1859): 190.
99. "Fine Arts: National Academy of Design," *Albion* (March 22, 1856): 141.
100. Ibid.
101. "Exhibition of the American Academy of Design," *NYEP*, May 30, 1857, 2.
102. "The Fine Arts: Exhibition of the National Academy, VII," *NYDT*, June 7, 1852, 5.
103. See Ann Uhry Abrams, "National Paintings and American Character: Historical Murals in the Capitol Rotunda," in *Picturing History: American Painting, 1770–1930*, ed. William Ayres (New York: Rizzoli, in association with Fraunces Tavern Museum, New York, 1993), 65–79.
104. For these influences, see William H. Truettner, "The Art of History: American Exploration and Discovery Scenes," *American Art Journal* 14, no. 1 (Winter 1982): 4–31.
105. *Albion* 10, no. 20 (May 17, 1851): 237.
106. Barbara Groseclose lists forty American painters who either enrolled in the Düsseldorf academy or spent time studying informally in the city between 1839 and 1859 in her appendix to *Emanuel Leutze, 1816–1868: Freedom Is the Only King* (Washington, D.C.: National Collection of Fine Arts, Smithsonian Institution, 1975), 132–51. For a fine study of the Düsseldorf presence in American art, see William H. Gerdts, "The Düsseldorf Connection," in Gerdts and Mark Thistlethwaite, *Grand Illusions: History Painting in America* (Fort Worth, Tex.: Amon Carter Museum, 1988), 125–68.
107. William H. Gerdts, "'Good Tidings to the Lovers of the Beautiful': New York's Düsseldorf Gallery, 1849–1862," *American Art Journal* 30, nos. 1–2 (1999): 50–81.
108. J[ohn] W[hetten] E[hninger], "The School of Art at Düsseldorf," *Bulletin of the American Art-Union*, no. 1 (April 1, 1850): 5.
109. Leutze capitalized on his dual national identities by presenting *Columbus before the High Council of Salamanca* (1842, unlocated) as his debut work in Düsseldorf. Recorded as having been inspired by Irving's 1828 life of Columbus, the painting was highly regarded in Germany and spurred Leutze to continue with Columbus themes. His *Columbus before the Queen* (1843, Brooklyn Museum) was purchased by American Art-Union president Abraham M. Cozzens for his personal collection and subsequently sold to Jonathan Sturges.
110. Mark Thistlethwaite, *Painting in the Grand Manner: The Art of Peter Frederick Rothermel (1812–1895)* (Chadds Ford, Pa.: Brandywine River Museum, 1995), 43.
111. See Arthur S. Marks, "The Statue of King George III in New York and the Iconology of Regicide," *American Art* 13 (Summer 1981): 61–82. Oertel may even have been familiar with the episode before he left Germany through Franz Xaver Habermann's engraving *La Destruction de la statue royale à Nouvelle Yorck*, published in Augsburg, Germany, about 1776 (Marks, 72).
112. See Kimberly Orcutt's discussion, cat. 34.
113. "Twenty-sixth Exhibition of the National Academy of Design," *Bulletin of the American Art-Union*, May 1, 1851, 21.
114. "Development of Nationality in American Art," *Bulletin of the American Art-Union*, no. 9 (December 1, 1851): 139.
115. "The Fine Arts," *NYDT*, May 29, 1851, 6.

116. "The Düsseldorf Gallery," *Emerson's United States Magazine* 5, no. 38 (August 1857): 212.
117. "Two Ships in a Storm," *Independent* 16 (January 14, 1864): 4. The painting referred to may be the one now in the collection of the Yale University Art Gallery that is dated 1867.
118. "Art and the War," *Chicago Tribune*, January 12, 1864, 3.
119. "Fine Arts: A New Historical Picture," *Albion* 40, no. 42 (October 8, 1862): 50.
120. "The National Academy of Design," *NYT*, June 24, 1863, 3.
121. Especially valuable is Lucretia Hoover Giese, "'Harvesting' the Civil War: Art in Wartime New York," in *Redefining American History Painting*, ed. Patricia M. Burnham and Giese (Cambridge: Cambridge University Press, 1995), 64–81, 344–48.
122. See Steven Conn and Andrew Walker, "The History in the Art: Painting the Civil War," *Art Institute of Chicago Museum Studies* 27, no. 1 (2001): 60–81, 102–3, at 66.
123. "Art: VII, Art and Artists of America," *Christian Examiner* 75, no. 1 (July 1863): 119, 120, 121.
124. James Jackson Jarves, "Ethics of Taste: The Duty of Being Beautiful," *Art Journal*, n.s., 1 (1875): 315.
125. Theodore Sizer, "James Jackson Jarves: Forgotten New Englander," *New England Quarterly* 6, no. 2 (June 1933): 328–52.
126. Jarves, "Ethics of Taste," 315.
127. Although Sally M. Promey points to increased scholarly interest in American religious art, an authoritative survey of religious art production in the eighteenth and nineteenth centuries remains to be written. See Promey, "The 'Return' of Religion in the Scholarship of American Art," *Art Bulletin* 85, no. 3 (September 2003): 581–603.
128. Tuckerman 1867, 321.
129. Wendy Greenhouse, "Daniel Huntington and the Ideal of Christian Art," *Winterthur Portfolio* 31 (Summer–Autumn 1996): 103–40.
130. See Bushman, *The Refinement of America*, 313–52.
131. Horace Bushnell, "Taste and Fashion," *New Englander* 1, no. 20 (April 1843): 153.
132. Ibid., 140.
133. Daniel Huntington, "Lecture on Christian Art," 1851, typescript, unpaginated, files of the National Academy of Design, New York.
134. *Catalogue of Paintings by Daniel Huntington, N.A. Exhibiting at the Art Union Buildings* (New York, 1850), 33.
135. Greenhouse, "Huntington and the Ideal of Christian Art," 124.
136. John Davis, "Catholic Envy: The Visual Culture of Protestant Desire," in *The Visual Culture of American Religions*, ed. David Morgan and Sally M. Promey (Berkeley: University of California Press, 2001), 105–28.
137. Jenny Franchot, *Roads to Rome: The Antebellum Protestant Encounter with Catholicism* (Berkeley: University of California Press, 1994), 234.
138. See Teresa A. Carbone, "The Genius of the Hour: Eastman Johnson in New York, 1860–1880," in Carbone and Patricia Hills, *Eastman Johnson Painting America* (New York: Brooklyn Museum of Art, in association with Rizzoli International Publications, 1999), 66–68.
139. G. J. W., "Christian Art," *Crayon* 7, no. 7 (July 1860): 187.
140. "National Academy of Design," *NYDT*, April 30, 1864, 3.
141. O. J. V., "The Spiritual in Expression," *Cosmopolitan Art Journal* 3, no. 5 (December 1859): 196.
142. See Kathleen Pyne, *Art and the Higher Life: Painting and Evolutionary Thought in Late-Nineteenth-Century America* (Austin: University of Texas Press, 1996).
143. Francis Marion Crawford, "False Taste in Art," *North American Review* 135, no. 308 (July 1882): 89–99.
144. See Saul E. Zalesch, "What the Four Million Bought: Cheap Oil Paintings in the 1880s," *American Quarterly* 48, no. 1 (March 1996): 77–109. Examples of contemporaneous articles are a satirical piece by Nym Trinkle, "High Art at Low Prices," *New York Leader*, September 16, 1866, 1, and "Low Art Paintings," *Michigan Farmer* 12, no. 26 (June 28, 1881): 7.
145. "Necessity Versus Art," *Catholic World: A Monthly Magazine of General Literature and Science* 17, no. 100 (July 1873): 560.
146. "Art: III, Fine Art; Its Nature, Necessity, and Offices," *Methodist Quarterly Review* 26 (April 1874): 44.
147. See Nathaniel Burt, *Palaces for the People: A Social History of the American Art Museum* (Boston: Little, Brown and Company, 1977).
148. [Sadakichi Hartmann], "A Photographic Enquête," *Camera Notes* 5, no. 4 (April 1902): 238.
149. See Richard Hofstadter, *Anti-Intellectualism in American Life* (New York: Alfred A. Knopf, 1970).
150. The works of Andy Warhol and Jeff Koons are significant examples. For art-historical examinations of the topic, see *Seeing High and Low: Representing Social Conflict in American Visual Culture*, ed. Patricia Johnston (Berkeley: University of California Press, 2006); and Kirk Varnedoe and Adam Gopnik, *High & Low: Modern Art and Popular Culture* (New York: Museum of Modern Art, 1991).

"Nature's Nation"
American Taste and Landscape Painting, 1825–1876

LINDA S. FERBER

In America, the romance vindicated nature's nation, land of Natty Bumppo,
against the artificiality of Europe.

— PERRY MILLER

T HE HISTORIAN Perry Miller's well-known characterization of America as "nature's nation" describes a fundamental belief still held by many today, that the destiny of the United States and the spiritual welfare of its citizens are somehow inextricably linked to its terrestrial environment. The seemingly limitless continental spaces and natural resources, although raw and uncultivated when compared with those of Europe, nevertheless guaranteed a glorious national future. The same wilderness conditions generated an American mythic past, as evoked by James Fenimore Cooper in the adventures of frontiersman Natty Bumppo in *The Leatherstocking Tales* (1823–41). In addition, abundant evidence found in exhibition reviews, criticism, and discussions of national taste shows that the prevalence of this belief fueled a popular American enthusiasm for landscape paintings that peaked during the middle decades of the nineteenth century.

For example, the *Literary World*, a weekly launched in 1847, promoted cultural nationalism among writers and championed the American Art-Union (1839–51) as an agent for the dissemination of a universal taste for art to American audiences. The magazine professed to speak for the American public

when calling the landscape artists of the day to national service in a review of the 1847 National Academy of Design annual:

> We wish it were in our power to impress it upon the minds of our landscape painters, particularly, that they have a high and sacred mission to perform. . . . The axe of civilization is busy with our old forests. . . . Yankee enterprise has little sympathy with the picturesque, and it behooves our artists to rescue from its grasp the little that is left, before it is for ever too late. This is their mission. What comparison is there between the garden landscapes of England or France and the noble scenery of the Hudson. . . . One is man's nature, the other—God's.[1]

Just a year earlier, the author, poet, and editor Nathaniel Parker Willis had also founded the *Home Journal*, a weekly devoted to culture and fashion. Although Willis opposed the populist program of the American Art-Union, preferring a more refined social agenda for the fine arts, he had long been a force in building landscape taste among middle-class audiences. Willis advocated the ideas of the landscape theorist and designer Andrew Jackson Downing and was an early promoter of rural cemeteries and urban parks.[2] His *American Scenery* (1840) was a popular best seller featuring engravings after William Henry Bartlett's watercolors of picturesque and historic sites in the United States, explicated by Willis's descriptive texts (fig. 1). This enterprise had expanded the geographic reach of their most famous early predecessor, William Guy Wall's series of hand-colored aquatints known as the *Hudson River Portfolio* (fig. 2). Wall's and Willis and Bartlett's combined success in disseminating a taste for the rituals of picturesque touring to receptive American audiences via graphic imagery and the written word was demonstrated in the multiple editions of both publications, the wide distribution of individual prints from each, and the mass replication of their scenes on transfer-ware pottery.[3] Print culture was a key factor early on in establishing destinations like Niagara Falls, the Catskill Mountains, and the Hudson River valley as so-called sacred places associated with both cultural and national identity.[4] Painters of landscape also served elite audiences as well as popular taste by portraying these subjects in oil paintings whose imagery conformed to topography but at the same

FIG. 1. G. K. Richardson after William Henry Bartlett (1809–1845). *Crow Nest from Bull Hill, West Point*, 1838, from Nathaniel Parker Willis, *American Scenery; or Land, Lake and River: Illustrations of Transatlantic Nature* (London: George Virtue, 1840). Steel engraving, 4½ × 7 in. (11.5 × 17.5 cm). The New-York Historical Society Library

FIG. 2. John Hill after William Guy Wall (1792–after 1864). *View near Fishkill*, no. 17 from *The Hudson River Portfolio* (New York: Henry J. Meagrey, 1820–25). Colored aquatint, image, 14½ × 21¾ in. (36.8 × 55.2 cm). The New-York Historical Society Library, Department of Prints, Photographs, and Architectural Collections

time dignified American locations by introducing visual conventions redolent of old master models and European aesthetic traditions, especially the sublime, the beautiful, and the picturesque. Early art patrons who were influenced in the later 1820s and 1830s by cultural nationalism, like Robert Gilmor Jr. in Baltimore, Daniel Wadsworth in Hartford, and Luman Reed in New York, assembled collections that included American landscapes, genre paintings, and portraits as well as European works.[5]

Landscape rhetoric and imagery had long been associated with American efforts to establish both cultural and national identity, functioning as an effective vehicle with which the new republic could begin to shake off the provincial marginality of a colonial possession and claim at least equal scenic status with the old European centers of empire, even surpassing them in certain conditions such as the wilderness sublime.[6] This rhetoric made its way into the discourses of the art academies and artists' societies established early in the republic, in which the abundant natural resources of the continent were consistently interpreted as important cultural as well as commercial assets. In his 1816 "Address before the American Academy of the Fine Arts" in New York City, DeWitt Clinton was confident that "[a] Republican government, instead of being unfriendly to the growth of the Fine Arts, is the appropriate soil for their cultivation." While acknowledging that the "painter of history has here an ample field for the display of his powers," Clinton also presented a case for the unique status of landscape in America, claiming, "Here Nature has conducted her operations on a magnificent scale. . . ." He continued the argument: "[C]an there be a country in the world better calculated than ours to exercise and to exalt the imagination—to call into activity the creative powers of the mind, and to afford just views of the beautiful, the wonderful and the sublime?"[7]

Landscape imagery was enlisted to reinforce patriotic as well as aesthetic agendas, serving the political ideal of national unity, over and above regional and sectional allegiances, by functioning as the American's natural birthright. Long before the *Literary World*'s call to American artists, Thomas Cole had opened his seminal 1835 "Essay on American Scenery" with just such an appeal to his fellow citizens:

> [American scenery] is a subject that to every American ought to be of surpassing interest; for, whether he beholds the Hudson mingling waters with the Atlantic . . . or stands on the margin of

FIG. 3. Thomas Cole (1801–1848). *View from Mount Holyoke, Northampton, Massachusetts, after a Thunderstorm (The Oxbow)*, 1836. Oil on canvas, 51½ × 76 in. (130.8 × 193 cm). The Metropolitan Museum of Art, New York. Gift of Mrs. Russell Sage, 1908 (08.228). Image copyright © The Metropolitan Museum of Art / Art Resource, NY

the distant Oregon, he is still in the midst of American scenery—it is his own land . . . and how undeserving of such a birthright, if he can turn towards it an unobserving eye, an unaffected heart![8]

Cole's declaration also demonstrated in its continental breadth what would be, perhaps, the most powerful function of mid-nineteenth-century landscape imagery: to serve agendas of national expansion as an emblem of Manifest Destiny. His own masterful *View from Mount Holyoke, Northampton, Massachusetts, after a Thunderstorm (The Oxbow)* (fig. 3) visualized the American landscape painter's mission; an artist resembling Cole is shown at his easel, painting *en plein air*, poised between the dual realms of wilderness sublime and domesticated pastoral.[9]

Cole was then at the peak of his career, at work on his magnum historical landscape opus, *The Course of Empire* (figs. 4–6 and fig. 6, p. 155), when he challenged the lowly rank of landscape in the traditional academic subject hierarchy. In a famous letter that was published in William Dunlap's *History of the Rise and Progress of the Arts of Design in the United States* (1834), Cole had written:

Will you allow me here to say a word or two on landscape? It is usual to rank it as a lower branch of the art, below the historical. Why so? Is there a better reason, than that the vanity of man makes

FIG. 4. Thomas Cole (1801–1848). *The Course of Empire: The Savage State*, ca. 1834. Oil on canvas, 39¼ × 63¼ in. (99.7 × 160.7 cm). The New-York Historical Society. Gift of the New-York Gallery of the Fine Arts, 1858.1

him delight most in his own image? In its difficulty (though perhaps it may come ill from me, although I have dabbled a little in history) it is equal at least to the historical. There are certainly fewer good landscape pictures in the world, in proportion to their number, than of historical. . . . I mean to say, that if the talent of Raphael had been applied to landscape, his productions would have been as great as those he really did produce.[10]

Dunlap, who was of an earlier generation steeped in academic tradition, disagreed. Nevertheless, his admiration and vigorous endorsements of Cole's work from 1825 on suggest that he recognized not only Cole's talent but also landscape's emergence as a powerful narrative force in the United States. Landscape was accessible to the larger population yet also capable, as Cole demonstrated in *The Course of Empire*, of conveying as much aesthetic and didactic content as traditional academic figural subjects.

Therefore, when the *Literary World* issued its call in 1847, landscape was already ascendant in New York, where Cole had been revered as the founding father of American landscape painting since his debut in 1825. Cole's major landscape rival, Asher B. Durand, had recently been elected president of the National Academy of Design. The landscape careers of Cole, Durand, and a rising generation of younger painters, including John Frederick Kensett (1816–1872), Jasper Cropsey (1823–1900), and Frederic Edwin Church

ABOVE: FIG. 5. Thomas Cole (1801–1848). *The Course of Empire: The Consummation of Empire*, ca. 1835–36. Oil on canvas, 51¼ × 76 in. (130.2 × 193 cm). The New-York Historical Society. Gift of the New-York Gallery of the Fine Arts, 1858.3

RIGHT: FIG. 6. Thomas Cole (1801–1848). *The Course of Empire: Desolation*, 1836. Oil on canvas, 39¼ × 63¼ in. (99.7 × 160.7 cm). The New-York Historical Society. Gift of the New-York Gallery of the Fine Arts, 1858.5

(1926–1900), were also buoyed by the American Art-Union's energetic efforts to promote contemporary American art to wider audiences and markets.[11] The English critic John Ruskin galvanized American readers of his phenomenally popular series *Modern Painters* (1843–60) to think anew about the making, meaning, and importance of contemporary landscape painting. An 1847 review of the first American edition of Ruskin's work concluded: "In short, the work is one which will not only delight and instruct the artist, but the poet, the philosopher, and every lover of the works of GOD."[12] Early in 1848 the shock of Cole's sudden death only raised the volume of the landscape conversation, as the artist and his works were elevated to iconic status. His memorial ceremonies and exhibitions stimulated artists' ambitions and were catalysts as well for public interest in landscape that lasted well into the 1850s.[13]

The historical moment of 1847 was also politically ripe for an American landscape mission. Just as Cole's rapid rise had coincided with the opening of the Erie Canal, so the geographic reach of the nation had just been extended with the annexation of all western territories confirmed by the United States' victory in the Mexican War. The expansionist impulses of Manifest Destiny gained momentum but caused rising sectional tensions over the spread of slavery to new territories and fueled ongoing national debate about the forcible removal of Native Americans from tribal homelands. American landscape paintings would gain their special authority as a cultural force in the following two decades largely because these resonant images already engaged audiences, now especially attuned to national agendas that glorified and naturalized expansionist policies.[14] At the same time, stirring images of tracts of American wilderness and pastoral visions of cultivated countrysides conferred the sense of an "imagined community," of a cultural, political wholeness on a United States whose growing populations were actually only tenuously united.[15] Narratives of a visible past like Johannes Oertel's *Pulling Down the Statue of King George III* (cat. 34) and George Boughton's *Pilgrims Going to Church* (cat. 1) and images of American character types like Durand's *The Pedlar* (cat. 10), William Sidney Mount's *Farmers Bargaining* (cat. 31), and George Caleb Bingham's *The Jolly Flatboatmen* (see fig. 1, p. 12) contributed to the cultural work of establishing identity, especially when discussed widely in the press and circulated as engravings. Landscape would also emerge at midcentury as an equally powerful visual instrument for reaching wide audiences with *scenic* narratives that created and

CAT. 10. Asher B. Durand (1796–1886). *The Pedlar*, 1836

FIG. 7. Frederic Edwin Church (1826–1900). *The Heart of the Andes*, 1859. Oil on canvas, 66⅛ × 119¼ in. (168 × 302.9 cm). The Metropolitan Museum of Art, New York. Bequest of Margaret E. Dows, 1909 (09.95). Image copyright © The Metropolitan Museum of Art / Art Resource, NY

reinforced a sense of the nation as an "imagined community" through what the art historian Angela Miller has so aptly described as the "Empire of the Eye."[16]

By the 1850s landscape paintings and the subject of landscape loomed large in critical responses to the National Academy and American Art-Union's annual exhibitions. Partisans asserted repeatedly that landscape was "the first field and the best field for our painters."[17] The critical rhetoric of the 1850s and 1860s during the heyday of landscape painting and the monumental panoramas of Church (fig. 7) and Albert Bierstadt (1830–1902) (fig. 8) were informed by several beliefs outlined below, each made clear by excerpts from journals and newspapers.

National geography and political institutions had ordained landscape to be a primal source of inspiration for creative Americans as well as a potent source of spiritual guidance for all Americans.

"If, in fact," wrote a reviewer for the *New York Daily Tribune*, "America is destined to have a school of painting all her own, it will necessarily be that of Landscapes. . . . In the New World, especially, nature preserves an aspect of majestic grandeur. . . . Here, in America, is natural, veritable, abundant source of inspiration for Art; here are its vocation and its road. . . . Accordingly our original poets and painters are landscapists."[18] Durand captured the prevailing sentiment of poets, painters, and the public in his "Letters on Landscape Painting" (1855), in which he extolled the spiritual influence of Nature on the "mind and heart": "The external appearance of this our dwelling-place is fraught with lessons of high and holy

FIG. 8. Albert Bierstadt (1830–1902). *The Rocky Mountains, Lander's Peak,* 1863. Oil on canvas, 73½ × 120½ in. (186.7 × 306 cm). The Metropolitan Museum of Art, New York. Rogers Fund, 1907 (07.123). Image copyright © The Metropolitan Museum of Art / Art Resource, NY

meaning, only surpassed by the light of Revelation." In worldly terms, Durand issued an artistic declaration of independence in the "Letters," investing landscape with a political subtext that equated the act of painting with freedom: "I desire not to limit the universality of the Art, or require that the artist shall sacrifice aught to patriotism," he wrote, "but, untrammeled as he is, and free from academic or other restraints by virtue of his position, why should not the American landscape painter, in accordance with the principle of self-government, boldly originate a high and independent style, based on his native resources?"[19] Cole, who, unlike Durand, had serious doubts about the American political experiment, also inferred a political mission for the American landscape painter, articulating the ameliorating power of nature and its visual interpretation in landscape paintings as forces for the public good: "The painter of American scenery has indeed privileges superior to any other; all nature here is new to Art."[20] In fact, Cole would qualify his own reverence for European landscape traditions by reminding readers that the political associations of the venerable architecture in these otherwise admirable works often conjured past tyrannies—"ruined tower to tell of outrage"—while in rustic republican America were to be found "freedom's offspring—peace, security, and happiness."[21]

The study of nature in the field, not in the formal academy, was the right and proper school for American landscape painters; a distinct advantage, of course, for artists far from European centers of artistic education.

"It is perhaps fortunate for us that we have no such thing as a school, in the old world sense, but that our artists, having access to no great public galleries of art, and therefore unfettered by rules and precedents, are obliged to obtain their ideas of form and color in the fields, the woodlands, or on the mountain side. They thus instinctively become landscape painters at the outset. . . . Our artists in going directly to nature have started on the right path, and . . . will soon relieve us from the reproach of possessing no desire or capacity to cultivate art."[22] Letter I in Durand's "Letters on Landscape Painting" urged the student to bypass formal instruction: "You need not a period of pupilage in an artist's studio to learn to paint. . . . [L]et me earnestly recommend to you one STUDIO which you may freely enter, and receive in liberal measure the most sure and safe instruction ever meted to any pupil . . . the STUDIO of Nature."[23]

Americans, who were still in the early stages of aesthetic development as a nation, had an instinctive taste for landscape over all other subjects, except portraits.

"Our landscapists are the most active and best understood of our painters. . . . And our public is too little advanced in knowledge or love of art to encourage any form of it save that which, being nearest to its level, requires the least thought to appreciate it. Landscapes . . . excite our curiosity and appeal to us by our memories of nature."[24] Moreover, the *Literary World* opined, landscape paintings also appealed to the American frontier spirit: "[T]he strongest feeling of the American is to that which is new and fresh—to the freedom of the grand old forests. . . . He may look with interest to the ruins of Italy, but with enthusiasm to the cabin of the pioneer."[25] For example, in 1836 Samuel F. B. Morse, a founder of the National Academy of Design, commemorated the establishment of New York University with a classical Claudian landscape to provide an appropriately Parnassian setting for the somewhat architecturally dissonant Gothic-Revival University Building (cat. 30). Twenty years later, Durand's 1855 landscape allegory, *The First Harvest in the Wilderness* (fig. 9), cast the founding benefactor of the Brooklyn Institute, a local businessman named Augustus Graham, as a backwoods pioneer-farmer complete with log cabin.[26]

The insightful critic James Jackson Jarves was no fan of mainstream American landscape in general and especially what he called "the literalness" and "overstrained atmospherical effects" of Church's and Bierstadt's monumental wilderness panoramas. Nevertheless, he recognized in all of these works the enthusiasms of his fellow Americans and acknowledged their pictures and landscape in general as a "thoroughly American branch of painting, based upon the facts and tastes of the country and people. . . . It surpasses all others in popular favor, and may be said to have reached the dignity of a distinct school. Almost everybody whose ambition leads him to the brush essays landscape."[27]

Of course, opposing voices (including that of Jarves) were also raised against the idea that popular preferences should dictate the only viable premise for a native school and a national taste. "It is not by painting portraits," argued the *New York Times*, "it is not by producing Indian Summers and green

CAT. 30. Samuel Finley Breese Morse (1791–1872). *Landscape Composition: Helicon and Aganippe (Allegorical Landscape of New York University)*, 1836

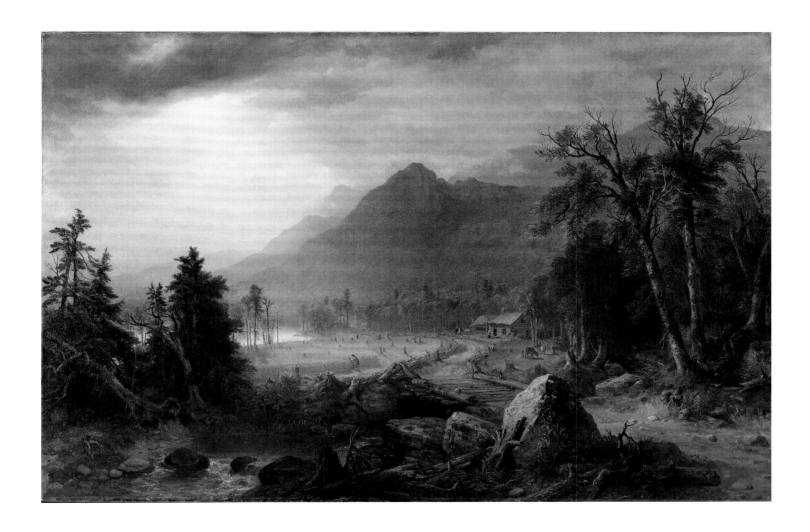

FIG. 9. Asher B. Durand (1796–1886).
The First Harvest in the Wilderness,
1855. Oil on canvas, 31⅝ × 48¹⁄₁₆ in.
(80.3 × 122 cm). Brooklyn Museum,
New York, Transferred from the
Brooklyn Institute of Arts and Sciences
to the Brooklyn Museum, 97.12

landscapes . . . that American artists can hope to rival their European brethren, or create a school of their own, with vitality in it. History, poetry, fable, and the inexhaustible treasures of the imagination, are the subjects, of which the preceding should be but adjuncts. . . . America has a history—sufficiently romantic to engage the attention of Leutze. Why need it be discarded by Americans?"[28] The *Times* was surely referring to Emanuel Gottlieb Leutze's epochal history painting *Washington Crossing the Delaware* (see fig. 21, p. 90), and, indeed, the landscape elements of icy river and lowering sky are powerful accessories to the human enactment of an American foundation myth on a colossal scale, while Durand's bucolic rural setting sets the tone of pastoral piety in *Sunday Morning* (cat. 11). The precipice and dramatic sunset heighten the tragedy of Tompkins Harrison Matteson's *The Last of the Race* (cat. 29) and Central Park's man-made landscape was deemed the appropriate setting for John Quincy Adams Ward's large-scale version of *The Indian Hunter* (cat. 46).

Nevertheless, in the heyday of the Great Pictures, the landscape subject itself took the leading role as protagonist, and peripatetic artists like Church and Bierstadt were themselves actors in adventure narratives of transnational exploration and nation building. "Adventure," wrote Henry T. Tuckerman in 1867, "is an element in American artist-life which gives it singular zest and interest. . . . its record abounds with pioneer enterprise and hardy exploration."[29] National ambitions were naturalized in these works by transferring human agency away from the victors and victims who take center stage in figural narratives of expansion and conquest like Peter Frederick Rothermel's *Cortés's First View of the City of Mexico* (cat. 40) or Matteson's *The Last of the Race*. Instead, Manifest Destiny is interpreted as the landscape itself envisioned as an earthly promised land. Canvases of heroic scale like Church's *The Heart of the Andes* (fig. 7) and Bierstadt's *The Rocky Mountains, Lander's Peak* (fig. 8) offered monumental exemplars of the possibilities held by national expansion south and west, presented as thrilling experiences that were embedded in the viewers' communal visual possession of the panoramic landscapes. Conceived for broad appeal, these giant paintings were literally and figuratively framed as high art, but they were often exhibited in theatrical installations that invoked the popular entertainments of moving panoramas.[30]

Other landscape specialists, like Durand and Kensett, embraced more modestly conceived works that evoked a collective domestic reverence for the "familiar and home-endeared beauty" of sites in the original colonies of the eastern seaboard from the South to New England. "Go not abroad then," Durand admonished his fellow artists, "in search of material for the exercise of your pencil, while the virgin charms of our native land have claims on your deepest affections."[31] Scenes of the long-familiar Hudson River valley, Catskills, Adirondacks, and White Mountains grew in importance as markers of cultural continuity, national identity, and unifying imagery as sectional tensions were rising at midcentury. As a result, for a few decades in the middle of the nineteenth century, landscapes functioned to naturalize and reinforce collective American narratives by presenting audiences with identifiable sites endowed with important historic and cultural associations. American landscapes also helped to establish a national presence abroad, where, whether admired or not, they were regarded as unique. "No one is likely to mistake an American landscape for the landscape of any other country," Tuckerman stated when reporting on the 1867 Universal

OPPOSITE: CAT. 29. Tompkins Harrison Matteson (1813–1884). *The Last of the Race*, 1847

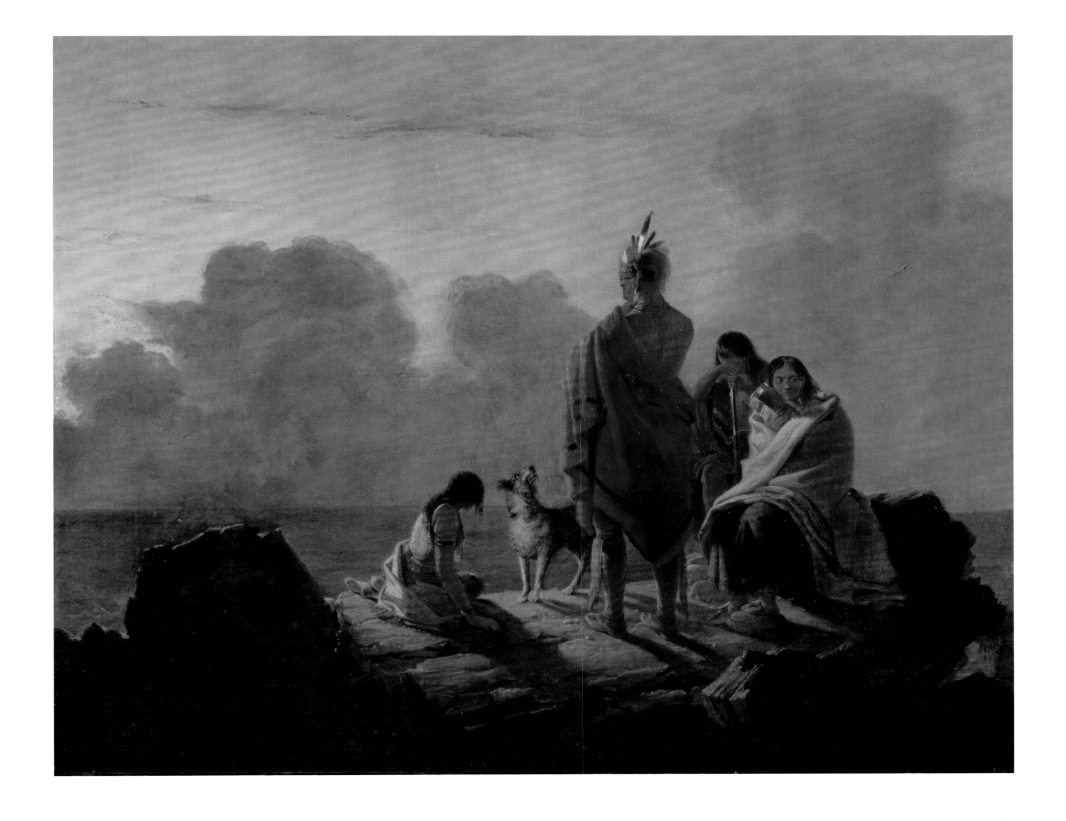

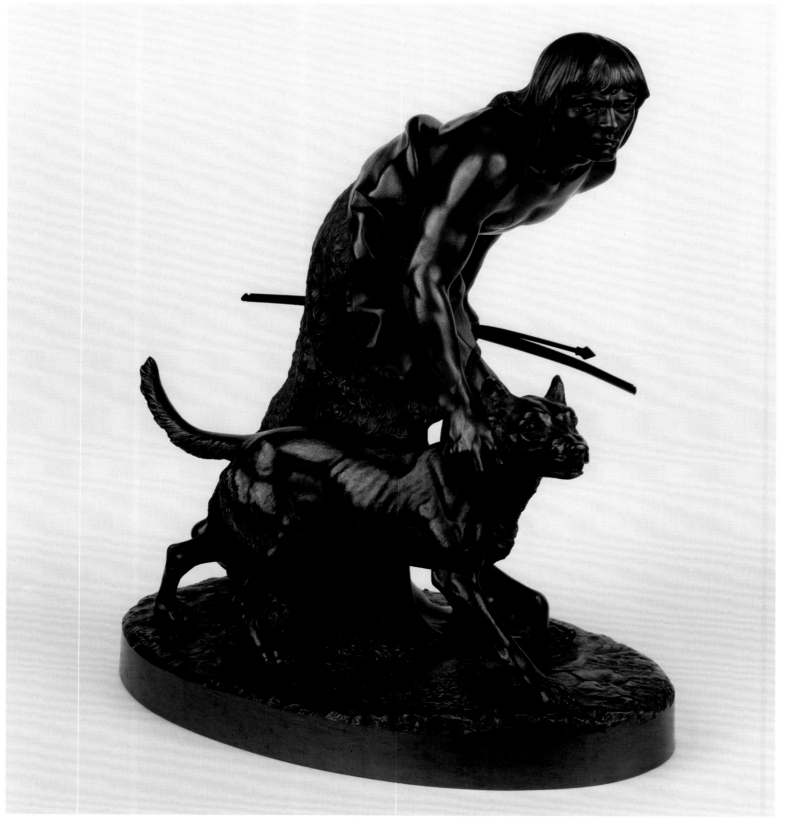

CAT. 46. John Quincy Adams Ward
(1830–1910). *The Indian Hunter*,
1860

Exposition. "It bears its nationality upon its face smilingly."[32] Church in particular commanded special attention abroad. Not only were monumental New World subjects like *Niagara* (1857, Corcoran Gallery of Art, Washington, D.C.) and *The Heart of the Andes* (fig. 7) hailed as works conceived in the spirit of both Ruskin and the German naturalist and geographer Alexander von Humboldt, but he himself was also seen as the quintessential homegrown American landscape genius: enterprising and accomplished although "unacquainted with European studies and academic traditions." "When will America," one English reviewer mused about *The Heart of the Andes*, "send us an original historical, or imaginative picture of any thing like equal power?"[33]

Two important American art surveys of the later 1860s presented landscape painting as a uniquely American accomplishment at the very moment when the pendulum of taste was beginning to swing in another direction. In *The Art Idea* (1864), Jarves acknowledged without apology that Americans were materialistic and pragmatic. "They yet find their chief success in getting, rather than enjoying; in having, rather than being; hence, material wealth is the great prize of life." Nevertheless, he predicted that "new forms rooted in novel conditions of national being" would emerge over time to temper the "common mind" of the new democracy with "the counteracting element which is found in the art-sentiment."[34] While Jarves himself preferred the more painterly and poetic vision then emerging in the landscapes of John La Farge (1835–1910) and George Inness (1825–1894), he recognized the "common mind" in the ambitious detailed panoramas of Church and Bierstadt. Tuckerman's *Book of the Artists* (1867), a more old-fashioned chronicle driven by biography rather than intellectual speculation, also recognized landscape as a unique American specialty born of both geographic and political circumstances: "And where should this kind of painting advance, if not in this country? Our scenery is the great object which attracts foreign tourists to our shores. No blind adherence to authority here checks the hand or chills the heart of the artist."[35] Like Jarves, Tuckerman located the creative energy of the current landscape stars in "pioneer enterprise and hardy exploration."[36]

Both acknowledged the cultural importance of the 1867 Universal Exposition in Paris. While Tuckerman loyally celebrated the American contributions in the fine arts, Jarves noted more objectively

that exposure abroad had "taught us a salutary lesson by placing the average American sculpture and painting in direct comparison with the European, thereby proving our actual mediocrity."[37] In retrospect, the 1867 exposition would prove to be the watershed event that not only redirected the taste and buying habits of post–Civil War American collectors away from the native school toward Europe, but also steered a younger generation of American artists toward study abroad. Robert L. Stuart, whose collecting history is surveyed in Ella Foshay's essay in this volume and who was a major lender to the exposition, would purchase few American paintings after 1867 and concentrate instead on acquiring works by contemporary European artists.[38] Nor did the heroic American landscape school fare well critically on home ground a decade later at the 1876 Philadelphia Centennial Exhibition, where earlier works by Church and Bierstadt were recalled with admiration but those on display were sharply criticized as inferior performances.[39] The art market also reflected the critical dismissal of landscape narratives of cultural nationalism. The 1876 sale of European figural paintings in the J. Striker Jenkins collection brought high prices, while his important American landscapes sold for so little that one journalist mused, "The recent auction sales of pictures in New York ought to furnish sufficient evidence to American artists that landscape painting has seen its best days, and that there is no hope for art now but in the delineation of human beings."[40]

Ironically, the Hudson River School would be history when the phrase itself was coined about 1879. While the epithet acknowledged the former appeal of American landscape, the term was applied at the time as critical shorthand for old-fashioned painters working on provincial subjects in an outmoded style.[41] "Whatever may be said about landscape painting as a fine art," wrote one critic, "it is certain that the public taste requires something better than the productions which our once favorite artists found it profitable to paint in their studios."[42]

The American landscape school would largely remain in eclipse until the resurgence of cultural nationalism in the 1930s and 1940s reanimated the interests of art historians, museum curators, dealers, and collectors. The bicentennial celebrations of 1976 reconfirmed the popularity of the Hudson River School as an enduring American taste that is still fueled today by some of the same ideas and beliefs that drove "nature's nation" in the nineteenth century.

OPPOSITE: CAT. 40. Peter Frederick Rothermel (1812–1895). *Cortés's First View of the City of Mexico*, 1844

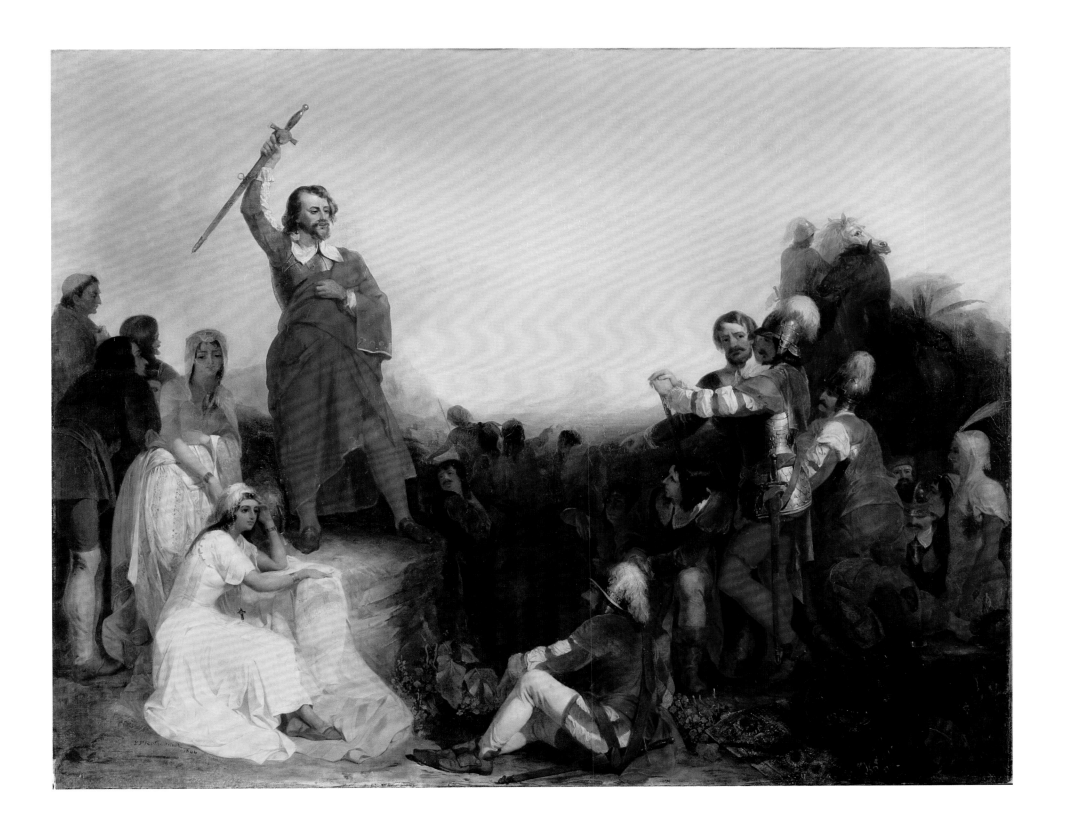

NOTES

Thanks are due to Sarah B. Snook, N-YHS Research Associate, for her valuable assistance during this project.

Epigraph: Perry Miller, "Melville and Transcendentalism," in *Nature's Nation* (Cambridge, Mass.: Belknap Press of Harvard University, 1967), 185.

1. "The Fine Arts: Exhibition at the National Academy," *LW* 1 (May 15, 1847): 348. Rachel N. Klein, "Art and Authority in Antebellum New York City: The Rise and Fall of the American Art-Union," *Journal of American History* 81, no. 4 (March 1995): 1534–61, notes that Evert A. Duyckinck, editor of the *Literary World*, served on the American Art-Union's committee of management.

2. N. H., "Communications: A. J. Downing's Architecture of Country Houses," *Home Journal* 35, no. 237 (August 24, 1850): 2; "Public Cemeteries and Gardens," *Home Journal* 31, no. 181 (July 28, 1849): 1; and "Original Communications: Parks and Parking," *Home Journal* 43, no. 298 (October 25, 1851): 4. For Willis, see Thomas N. Baker, *Sentiment and Celebrity: Nathaniel Parker Willis and the Trials of Literary Fame* (New York: Oxford University Press, 2001). For the *Home Journal*'s campaign against the American Art-Union, see Klein, "Art and Authority," 1548–54; for further discussion of landscape taste as social currency, see Angela Miller, "Landscape Taste as an Indicator of Class Identity in Antebellum America," in *Art in Bourgeois Society, 1790–1850*, ed. Andrew Hemingway and William Vaughn (Cambridge: Cambridge University Press, 1998), 340–61.

3. For the *Hudson River Portfolio* and *American Scenery*, see Roberta J. M. Olson, *Drawn by New York: Six Centuries of Watercolors and Drawings at the New-York Historical Society* (New York: New-York Historical Society, in association with D Giles Limited, 2008), 20–22, 166–68, 208, 230–32. For the picturesque tour, see Edward J. Nygren and Bruce Robertson, eds., *Views and Visions: American Landscape before 1830* (Washington, D.C.: Corcoran Gallery of Art, 1986); Kenneth J. Myers, "On the Cultural Construction of Landscape Experience: Contact to 1830," in *American Iconology: New Approaches to Nineteenth-Century Art and Literature*, ed. David C. Miller (New Haven: Yale University Press, 1993), 58–79; and John F. Sears, *Sacred Places: American Tourist Attractions in the Nineteenth Century* (New York: Oxford University Press, 1989).

4. For landscape imagery, picturesque touring, and the rise of tourism, see Sears, *Sacred Places*; Kenneth J. Myers, *The Catskills: Painters, Writers, and Tourists in the Mountains, 1820–1895* (Yonkers, N.Y.: Hudson River Museum, 1987); and Kevin J. Avery, "Selling the Sublime and the Beautiful: New York Landscape Painting and Tourism," in *Art and the Empire City: New York, 1825–1861*, ed. Catherine Voorsanger and John K. Howat (New York: Metropolitan Museum of Art, 2000), 109–34.

5. For Gilmor, see Lance Lee Humphries, "Robert Gilmor, Jr. (1774–1848): Baltimore Collector and American Art Patron" (Ph.D. diss., University of Virginia, 1998); for Wadsworth, see Elizabeth Mankin Kornhauser, *American Paintings before 1945 in the Wadsworth Atheneum* (Hartford, Conn.: Wadsworth Atheneum; New Haven: Yale University Press, 1996), 1:3–20; for Reed, see Foshay 1990 and her essay in this volume.

6. For landscape and imperial ambition, see Albert Boime, *The Magisterial Gaze: Manifest Destiny and Landscape Painting, c. 1830–1865* (Washington, D.C.: Smithsonian Institution Press, 1991); Angela Miller, *The Empire of the Eye: Landscape Representation and American Cultural Politics, 1825–1875* (Ithaca, N.Y.: Cornell University Press, 1993); W. J. T. Mitchell, "Imperial Landscape," in *Landscape and Power* (Chicago: University of Chicago Press, 1994), 5–34; and Patricia Hills, "The American Art-Union as Patron for Expansionist Ideology in the 1840s," in Hemingway and Vaughn, *Art in Bourgeois Society*, 314–39.

7. Clinton's address of October 23, 1816, is published in Thomas S. Cummings, *Historic Annals of the National Academy of Design* (1861; New York: Kennedy Galleries and Da Capo Press, 1969), 8–17. For other antebellum discourses and addresses on the fine arts and landscape, see William H. Gerdts, "'The American 'Discourses': A Survey of Lectures and Writings on American Art, 1770–1858," *American Art Journal* 15 (Summer 1983): 61–79; and Gerdts, "American Landscape Painting: Critical Judgments, 1730–1845," *American Art Journal* 17 (Winter 1985): 28–59.

8. Thomas Cole, "Proceedings of the American Lyceum: Essay on American Scenery," *American Monthly Magazine*, January 1836, in *American Art, 1700–1960: Sources and Documents in the History of Art*, ed. John W. McCoubrey (Englewood Cliffs, N.J.: Prentice-Hall, 1965), 98–109, at 98.

9. While modern scholarship rightly places *The Oxbow* among Cole's most important paintings, the work was not a critical success when exhibited in 1836. Despite its monumental proportions and innovative perspective, the title *View from Mount Holyoke* appears to have consigned the work critically to the lesser realm of topography rather than the higher-ranking composition. The painting was purchased by Charles L. Talbot, who owned property in Northampton, on the advice of fellow merchant Luman Reed. For *The Oxbow*, see Oswaldo Rodriguez Roque, "*The Oxbow* by Thomas Cole: Iconography of an American Landscape Painting," *Metropolitan Museum Journal* 17 (1984): 63–73; Elwood C. Parry III, *The Art of Thomas Cole: Ambition and Imagination* (Newark: University of Delaware Press, 1988), 172–77; Alan Wallach, "Making a Picture of the View from Mount Holyoke," in Miller, *American Iconology*, 80–91; and David Bjelajac, "Thomas Cole's Oxbow and the American Zion Divided," *American Art* 20 (Spring 2006): 61–83.

10. Dunlap 1834, 365.

11. For the American Art-Union, see Klein, "Art and Authority"; and Hills, "The American Art-Union."

12. "Modern Painters: By a Graduate of Oxford," *Knickerbocker* 30, no. 4 (October 1847): 346. For Ruskin in America, see Roger B. Stein, *John Ruskin and Aesthetic Thought in America, 1840–1900* (Cambridge, Mass.: Harvard University Press, 1967); and Linda S. Ferber and William H. Gerdts, eds., *The New Path: Ruskin and the American Pre-Raphaelites* (Brooklyn, N.Y.: Brooklyn Museum, 1985).

13. For Cole's death and aftermath, see J. Gray Sweeney, "The Advantages of Genius and Virtue: Thomas Cole's Influence, 1848–58," in *Thomas Cole: Landscape into History*, ed. William H. Truettner and Alan Wallach (Washington, D.C.: National Museum of American Art, in association with Yale University Press, 1994), 113–36.

14. For landscape and Manifest Destiny, see Boime, *The Magisterial Gaze*; Miller, *The Empire of the Eye*; and Hills, "The American Art-Union."

15. The concept of "the nation as imagined community" is presented in Benedict Anderson, *Imagined Communities: Reflections on the Origin and Spread of Nationalism* (London: Verso, 1983) and discussed in the context of landscape painting in Angela Miller, "Everywhere and Nowhere: The Making of the National Landscape," *American Literary History* 4, no. 2 (Summer 1992): 207–29.

16. Miller, *The Empire of the Eye*.

17. "The Fine Arts: Exhibition of the National Academy, Second View; The Landscapes Again," *LW* 6 (May 4, 1850): 447.

18. R. T., "Exhibition of the National Academy of Design," *NYDT*, May 7, 1855, 6.

19. Asher B. Durand, "Letters on Landscape Painting," *Crayon*, 1855, reprinted in Linda S. Ferber, ed., *Kindred Spirits: Asher B. Durand and the American Landscape* (New York: Brooklyn Museum, in association with D Giles Limited, 2007), 233–52, Letter II, 235.

20. Cole, "Journal," cited in Elizabeth Mankin Kornhauser, *Hudson River School: Masterworks from the Wadsworth Atheneum Museum of Art* (New Haven: Yale University Press, in association with the Wadsworth Atheneum Museum of Art, 2003), 7.

21. Cole, "Essay on American Scenery," 109.

22. "The National Academy of Design," *NYEP*, April 22, 1858.

23. Durand, Letter I, in Ferber, *Kindred Spirits*, 233.

24. E. B., "Art: About Landscapes at the Academy," *Round Table* 3 (May 19, 1866): 7.

25. "The Fine Arts: Exhibition of the National Academy of Design, No. III," *LW* 10 (May 8, 1852): 331.

26. For the Morse, see Barbara Dayer Gallati's entry in this volume; for the Durand, see Ferber, *Kindred Spirits*, 168–71.

27. James Jackson Jarves, *The Art Idea* (1864; Cambridge, Mass.: Belknap Press of Harvard University Press, 1960), 189.

28. "National Academy of Design," *NYT*, April 12, 1855, 4.

29. Tuckerman 1867, 389.

30. For the panorama's influence on landscape painting, see Kevin J. Avery, "The Panorama and Its Manifestation in American Landscape Painting, 1795–1870" (Ph.D. diss., Columbia University, 1995).

31. Durand, Letter II, in Ferber, *Kindred Spirits*, 234–35; for the construction of "homeland" as well as "colonial" landscape sites, see Mitchell, "Imperial Landscape."

32. Tuckerman 1867, 18.

33. "From the *Literary Gazette* (August 21, 1858): American Landscape Painting," *Littell's Living Age*, September 24, 1859, 817.

34. Jarves, *The Art Idea*, 148, 151.

35. Tuckerman 1867, 187–88.

36. Ibid., 389.

37. Jarves, *Art Thoughts* (1869), 297–99, cited in Carol Troyen, "Innocents Abroad: American Painters at the 1867 Exposition Universelle, Paris," *American Art Journal* 16 (Autumn 1984): 2–29.

38. For the impact on American artists and collectors of the 1867 Paris exposition, see Troyen, "Innocents Abroad"; for Robert L. Stuart, see Paul Sternberger, "'Wealth Judiciously Expended': Robert Leighton Stuart as Collector and Patron," *Journal of the History of Collections* 15, no. 2 (November 2003): 229–40; and see Foshay in this volume, 159, 164.

39. For American art at the Philadelphia Centennial Exhibition of 1876, see Troyen, "Innocents Abroad," 22; and Kimberly Orcutt, "Revising History: Creating a Canon of American Art at the Centennial Exhibition" (Ph.D. diss., Graduate Center, City University of New York, 2005).

40. "Fine Arts," *Independent*, May 11, 1876, 6.

41. For the historiography and the decline of the Hudson River School, see Kevin J. Avery, "A Historiography of the Hudson River School," in John K. Howat et al., *American Paradise: The World of the Hudson River School* (New York: Metropolitan Museum of Art, 1987), 3–20; and Doreen Bolger Burke and Catherine Hoover Voorsanger, "The Hudson River School in Eclipse," in ibid., 71–90.

42. "Fine Arts," *Independent*, May 11, 1876, 6.

Luman Reed and Robert L. Stuart: A Double Portrait

ELLA M. FOSHAY

A COLLECTION OF ART is a portrait of an individual; it can be thought of as a cumulative expression of the collector's personal choice, circumstance and wealth, of prevailing public taste, and of availability. The images of Luman Reed (1785–1836) and Robert Stuart (1806–1882) are framed by nineteenth-century New York, and the landscape surrounding them takes on the colors and shapes of political, social, economic, and cultural influences affecting the collector. Yet, neither the figure nor the landscape in these projected portraits remains in fixed focus: we witness changes as the scene evolves and the collector shifts his aesthetic preferences (figs. 1, 2).

Born a little more than twenty years apart and beginning to collect art at a similar remove in time, Reed, a grocery merchant, and Stuart, a refiner of sugar, provide an obvious contrast as New York collectors of successive generations. Indeed, they were in many ways exemplars of their respective periods, the first and second halves of the century. Both were substantially self-made businessmen, but the comparative size of their economic successes parallels the exponential expansion of New York as a commercial and manufacturing center over the course of the century. Consistent with the post–Civil War period, Stuart's sugar-refining business was conducted on a scale many times that of Reed's grocery trade. He died childless, leaving an estimated five million dollars to his wife, Mary McCrea (fig. 3).[1] Luman Reed's estate, by contrast, which he left to his wife (fig. 4) and children, could be measured in the hundreds of thousands.[2] Similarly, the number

of paintings acquired by each, approximately 240 by Stuart and 60 by Reed, speak of the ascension of New York, between the 1830s and the 1880s, to the rank of leader in America's thirst for culture and the acquisition of art.[3] Reed's early-nineteenth-century cultural landscape appeared to Henry James as a wasteland. He saw nothing in it but "blankness . . . a curious paleness of colour and paucity of detail . . . ; no literature, no novels, no museums, no pictures, no political society, no sporting class—no Epsom nor Ascot!"[4] Stuart's milieu on the other hand was animated by commercial galleries, exhibition spaces, auctions, dealers, and burgeoning public institutions of learning and culture in the United States and in Europe, where he traveled often. Most of these did not exist in the 1830s, and Reed never traveled abroad.

RIGHT: FIG. 3. Daniel Huntington (1816–1906). *Portrait of Mary McCrea Stuart*, ca. 1892. Oil on canvas, 48⅛ × 36¼ in. (122.3 × 92.1 cm). The New-York Historical Society. Robert L. Stuart Collection, S-60

ABOVE: FIG. 4. Charles Cromwell Ingham (1797–1863). *Mrs. Luman Reed*, ca. 1835. Oil on canvas, laid on composition board, 30⅛ × 25 in. (76.5 × 63.5 cm). The Metropolitan Museum of Art, New York. Bequest of Frederick Sturges Jr., 1977 (1977.342.2). Image copyright © The Metropolitan Museum of Art / Art Resource, NY

The most divergent aspect of the picture collections of these two New Yorkers lies in the trajectories of their purchases. Reed began collecting work by European old masters, his acquisitions mostly dictated by what his dealer made available, and only later turned his attention to contemporary American artists; Stuart's later acquisitions, following the fashion of the time and the advice of dealers, were mostly contemporary European academic paintings, whereas his earlier purchases had been of American art.[5] The opposing directions of their aesthetic preferences paralleled those of a good many art collectors of nineteenth-century New York and define their generational difference. Nonetheless, Reed's and Stuart's collections were notable in the nineteenth century for their American paintings, and that is the measure of their merit today.

While an art collection can be viewed and interpreted in many ways, fundamentally, it is a personal enterprise.[6] A comparison of the portraits, by offering an unaccustomed angle, reveals telling nuances in the complex, and perhaps ultimately unknowable, phenomenon of personal taste. What attracts collectors to the works they buy, and what do the works they gather reveal about them?[7]

Both Luman Reed and Robert Stuart were born to hardworking parents, who employed them at early ages in the family business and who instilled in them an ethos of hard work, disciplined habits, and a strong sense of loyalty. Reed, who inherited his family's grocery business in upstate New York, was admired for his "sagacity, promptness, self-reliance, remarkable organizing power."[8] Stuart inherited from his Scottish-born father, Kinloch Stuart, a fifteen-hour workday, six days a week, along with the receipt for his father's repayment of a debt incurred by a brother in Scotland.[9] Looking ahead to his funeral at the Presbyterian Church on Fifth Avenue, Stuart chose a plain oak coffin covered by a black cloth and declined ornamental flowers and ceremonial pallbearers. During the service celebrating his life, Stuart forbade any personal references—the ultimate suppression of ego.[10] Stuart's asceticism derived from his Old School Presbyterian upbringing and religious beliefs, which are fundamental aspects of his personality, commercial success, and collecting practice.[11] Reed's Episcopal Protestantism was more of a social formality. He enjoyed entertaining, storytelling, the theater, and, especially, the companionship of his family.

Reed and Stuart lived in New York for most of their adult lives and bought properties and conducted business there. While we think of them as separated by a generation, it is important to remember that when their lives in the city overlapped, the New York they inhabited was still a small town. Its diminutive scale shocked the young French traveler Alexis de Tocqueville when he first glimpsed the city from a ship in 1831. "Here we are in New York," wrote the homesick twenty-five-year-old to his mother,

> Picture a sea dotted with sails, a lovely sweep of notched shoreline, blossoming trees on greensward sloping down to the water, a multitude of small, artfully embellished candy-box houses in the background and you have the entrance to New York by way of the Sound. . . . There isn't a dome,

a steeple or a large edifice in sight, which leaves one with the impression that one has landed in a suburb, not the city itself.[12]

If minuscule in aspect to the European eye, New York had grown exponentially in the preceding fifteen years. One historian cites 1815 as the year "New York became the great commercial emporium of America."[13] That year, after the end of the War of 1812 and the lifting of the embargo, British trading ships chose New York as the place to dump excess manufactures that had been prevented from entering the United States during the war. Auction sales of these welcome surplus goods brought customers from great distances to New York.[14] Reed was one of them; in 1815 he moved his produce and freighting business from Coxsackie, in upstate New York, to the city.[15] Located at 125 and 127 Front Street, just a block from the busy C. H. Slip, Reed's storehouses and office were perfectly positioned to receive goods from vessels and make use of the innovations in water transportation. Later in the century, the transcontinental railroad provided a rapid overland route to western markets for Stuart's sugar-refining business. Both men profited from good judgment and simply being in the right place at the right time.

To consider Luman Reed and Robert Stuart collectors of separate generations, whose lives and collecting practices reflect the social, political, and cultural character of the pre– and post–Civil War eras respectively, would require a wide-angle historical perspective.[16] A close-up, instead, brings into focus the particulars of individual experience that shape specific lives, and they shared many during the 1820s and 1830s: a great number of connections and/or coincidences suggest that they might even have known one another. Both men built new houses in the city in 1831, the year of Tocqueville's visit. Reed's residence at 13 Greenwich Street was approximately twelve blocks south of the Stuart brothers' houses at 167 and 169 Chambers Street. While both men expressed their increased wealth through larger houses and collections, both eschewed self-promotion and elaborate display. The Reed house was admired not for its grandeur but for its good materials and solid construction. Similarly, contemporaries applauded the lack of ostentation in Stuart's use of genuine rather than faux materials in his first Fifth Avenue house at no. 154:

The marbles come from quarries, and not paint-shops; the woods grew in forests, and not from the dexterous fingers of imitative grainers; the panels are genuine relief, and not painted surfaces. Sham, so prevalent in New-York houses, is wholly ignored, and the spectator . . . feels himself the nobler for this example of righteous rendering, in a community poisoned with plastered and painted lies.[17]

The moral association with the truth-to-nature materials matched Stuart's own modesty-is-morality ethics.

In addition to a preference for the practical in building materials and style, the two men sought the convenience in utilities that modern invention allowed. Reed installed a furnace for heat, rudimentary plumbing, and even gas lighting.[18] The *New York Times* recorded that the adjacent Stuart brothers' houses "were among the first-class dwellings of the city, and were the first houses into which gas was introduced."[19] It does not matter whether Reed or Stuart first used gas to illuminate his home in the 1830s; they shared intentions and values.[20]

Membership in New York social clubs encouraged both men in their emerging interest in art, offering them connections with artists and other men of taste. About 1834 Reed joined the Sketch Club, where "the cross-fertilization of art, literature, and other professions united artist and patron and forced each member to broaden his outlook."[21] Henry T. Tuckerman, a chronicler of nineteenth-century artistic life, recalled the lively meetings of the group, some of which were held in the art gallery at Reed's Greenwich Street house. "What delightful reunions took place there," he said, and "what a mingling there was of artists and literary men."[22] Asher B. Durand was a Sketch Club member along with Reed, and their personal relationship deepened through this shared association. As a founding member of the Century Association, an offshoot of the Sketch Club, Durand had been a member for twelve years when Stuart joined in 1859. Already the owner of Durand's *Franconia, White Mountains*, Stuart continued to buy contemporary works by American artist members of the club—John Frederick Kensett (1816–1872), Sanford Gifford (1823–1880), Frederic E. Church (1826–1900), and Eastman Johnson—sometimes at Durand's suggestion.[23] While Reed had been a source of encouragement to Durand when the latter was a young artist, Stuart used the well-established Durand as an art adviser in selecting artists and paintings for his collection.[24] Although additional sources

FIG. 5. Nicolino Calyo (1799–1844).
*The Great Fire of 1835: View of New
York City Taken from Brooklyn Heights
on the Same Evening of the Fire,*
ca. 1835. Gouache on paper, 20⅛ ×
27³/₁₆ in. (51.1 × 69.1 cm). The New-
York Historical Society, Purchase,
1935.167

for the sale and exhibition of art had developed by midcentury, clubs remained as important a milieu for Stuart's developing taste as they had been for Reed's.

On the evening of December 16, 1835, when Reed was fifty and Stuart twenty-nine, a devastating fire broke out in the city. It was so dramatic and destructive that it left no New Yorker unaffected (fig. 5). Philip Hone, whose eight-volume diary recorded New York life from 1828 to 1851, described his acute emotional reaction to the Great Fire on the following day:

> *Unparalleled calamity by Fire.* How shall I record the events of last night, or how attempt to describe the most awful Calamity which has ever visited these United States. The greatest loss by Fire that has ever been known . . . I am fatigued in body, disturbed in mind, and my fancy filled with Images of horror which my pen is inadequate to describe. Nearly one half of the first ward is in ashes. 500 to 700 Stores, which with their contents are valued at 20 to 40 millions of dollars, are now lying in an indistinguishable mass of Ruins.[25]

The property damage of the Great Fire remained the worst destruction in the city's history until the tragedy of September 11, 2001.[26]

In addition to its horror, which was recorded daily and in lurid detail in the newspapers, the fire threatened to devastate the businesses of both Reed and Stuart. Reed's storehouses on Front Street were "only a few doors above Wall Street," the outer reach of the fire, and were "at times in danger," as his nephew later recalled.[27] There was a strong wind from the west that night, and the frigid temperature caused fire engines and hoses to freeze and become inoperable, increasing the spread and resultant damage of the fire. The *New York Herald* predicted the nighttime blaze would "sweep away the whole of that section of the city, in its range through Pearl, Water and Front streets [where Luman Reed's business was located] to the East river."[28] Quickly, Reed recognized that, in fighting this immense conflagration, most of the firefighting equipment had been damaged and that property destruction claims would bankrupt insurance companies, crippling both fire protection and insurance.[29] He arranged to have his "teas, coffee, spices and foreign liquors," among other valuable goods in his storehouses, loaded on a schooner anchored in New York Harbor. Once his goods were safely off land, he bought marine insurance in the amount of thirty thousand dollars.[30]

The R. L. & A. Stuart Company, owned jointly in 1835 by Robert and his younger brother Alexander and located at the corner of Chambers and Greenwich streets, a few blocks northwest of the fire, was never directly threatened. However, the brothers could not have missed the dramatic blaze, with flames so massive and high that, as the *New York Herald* reported the next morning, "Wall street" on that night "for hours was as light as day."[31] How alarming it must have been for them to read that sugar, then a rare and expensive product, fueled some of the flames.

Fortuitously, earlier in 1835, the Stuarts had erected a new structure for their business, replacing three small wood buildings on the same site with a commanding five-story factory made of brick. The refining of sugar had become more important than their confectionary trade, and the Stuarts had imported from Europe new machinery that allowed their firm to be the first to use steam processing in the United States, which increased the speed and the volume of sugar production, creating extraordinary profits but with a great deal more heat. Brick provided fire protection to the factory, now exposed to the high temperatures produced by

FIG. 6. Thomas Cole (1801–1848). *The Course of Empire*, 1834–36, installed according to Cole's plan in the Luman Reed Gallery at the New-York Historical Society, 2005. The New-York Historical Society Pictorial Archives

the steam. With the adoption of innovative refining machinery and the use of brick in the construction of the new factory building, Stuart's combination of prudence and strategic business sense expanded his fortune exponentially. Both Stuart and Reed were careful and savvy men who enjoyed the exhilaration of rapid success, paired with the fear of instant ruin by fire. However, Reed was mature and accomplished at the time of the Great Fire, whereas Stuart was still young and a recent proprietor of his own business. Such an alarming experience could be expected to have a profound cautionary effect on a youthful, not yet personally successful, and already conservative man.

Given their many shared character traits and common experiences, it is not surprising that Luman Reed and Robert Stuart selected similar works of American art for their collections and that they displayed them in a separate gallery space. But the expansion of wealth and the possibilities for exposure to art and culture over the course of thirty years of the nineteenth century modified their relative significance. In 1835 Reed was a pioneer, if not alone, in collecting American art; he was an even greater pathbreaker in building a separate gallery space in his house (fig. 6) for his collection, and was perhaps the first to make such a space available to the public.[32] His art collection, the gallery, and his patronage of American artists were recognized for the key roles they played in the development of a national culture. The appreciation was immediate and lasted for decades, and he was applauded for exceptional patriotism.[33] Stuart's collection, by contrast, was just one

of many, and while he included a separate gallery space in each of the successively larger houses that he built on Fifth Avenue in the 1850s and 1880s, that practice had become commonplace, too.[34] "Private galleries are becoming almost as common as private stables," the nineteenth-century collector and critic James Jackson Jarves wrote derisively.[35] Stuart never saw his art collection installed in the gallery at Fifth Avenue and Sixty-eighth Street because he died on December 12, 1882, two weeks before the house was completed. Only ten years later the *Art Amateur* judged that "the majority of the paintings in the Stuart collection are of no merit or interest," and in no time afterward the collector and the collection were almost forgotten (figs. 7, 8).[36]

By the 1880s many wealthy collectors, including John Taylor Johnston, August Belmont, and William H. Vanderbilt, had opened their private art galleries to the public,[37] but practical problems had emerged. James Lenox, Stuart's fellow Scottish Presbyterian and mentor in institutional leadership and philanthropy, opened the art gallery in his Fifth Avenue house to the public, "but his marble statues were daubed, his crayons smutted and fingered, [and] his engravings ruined by the rudeness and curiosity of visitors," so he closed it.[38] Although there is no evidence that Stuart was influenced by Lenox's taste in art, it is likely that Lenox's private gallery experience convinced Stuart not to make the art collection in his house publicly available, and he never did.[39] Stuart's educational intentions were expressed instead through his extensive philanthropy to public institutions during his life,[40] but education for him always took second place to religious conviction and practice. Stuart's wife, Mary, revoked his bequest of minerals, books, and art to the Metropolitan Museum of Art and the American Museum of Natural History because the boards of those institutions were contemplating keeping them open on Sundays. For the Stuarts, the importance of observing the Sabbath trumped the educational purpose in giving the working public access to culture on their one day off per week. All of Stuart's library, art, minerals, and other collections were deposited instead at the Lenox Library (subsequently the New York Public Library), where they were required to be housed in a special room and never exhibited on Sunday.[41]

Pride in and promotion of the national interest were powerful drivers of the collecting patterns of Luman Reed and Robert Stuart. "Let us make something of ourselves out of our own materials & we shall then be independent of others," wrote Reed, speaking of American artists, "it is all nonsense to say that we

ABOVE: FIG. 7. *Home of Mrs. Robert L. Stuart, No. 871 5th Avenue.* From Louis Oram, *Our Firemen: A History of the New York Fire Department* (1887). Milstein Division of U.S. History, Local History and Genealogy, New York Public Library, Astor, Lenox and Tilden Foundations

RIGHT: FIG. 8. Art gallery in the Robert L. Stuart residence at 871 Fifth Avenue. Photograph. Rare Books Division, New York Public Library, Astor, Lenox, and Tilden Foundations

have not got the materials."[42] Realism of subject, whether landscape or genre, with specificity of locale and accurate detail, was an aesthetic ideal for Reed and other American collectors. "I hope you will not turn off a picture until the work is masterly executed," wrote Reed to a young artist, "one picture finished in that way will be of more service to you than fifty that lack detail."[43] Such literalism came to be associated with morality—a truthfulness that bespoke a national, democratic art.[44]

Stuart's early purchases were largely landscape paintings by American artists, often of identifiable American scenery, by such artists as Thomas Cole, Asher B. Durand, and Régis Gignoux (1814–1882).[45] The taste for local, specific American landscapes by contemporary American artists was an established pattern by the 1850s. What distinguished Stuart's nationalist bent was not the purchase but the retention of the American paintings. Most other collectors were selling their American work, often by choice and sometimes because of economic necessity, as they began to buy pictures by contemporary European artists. An 1859 newspaper review praised the Stuart collection as being distinct from others because "the works, with four or five exceptions, are by American artists, whom he takes great pleasure in fostering and encouraging."[46]

The purchase of art directly from artists themselves, instead of through a third party, was a practice both Reed and Stuart preferred, no doubt for some of the same reasons. Patronizing artists firsthand assured the buyers of authenticity and offered some control over the finished product.[47] They shared a delight in their relations with creative men and rewarded them not only with encouragement but also generosity. Reed's extensive correspondence with American artists documents his close personal ties with them, his appreciation for their work, and his flexibility with respect to the subjects they chose and the time they took to make the paintings. And he paid them handsomely, often more than they requested.[48] Reed supported and personally encouraged Thomas Cole while he was creating his most important series of paintings, *The Course of Empire* (1834–36), a commission that had been declined support by the patron Robert Gilmor.[49] He and such other American patrons as Philip Hone and Daniel Wadsworth preferred local American scenery to didactic historical landscape subjects. Reed shared their preference but deferred to the artist's choice of subject. Stuart was similarly appreciative and generous. Stuart, in confirming receipt of Durand's landscape *Franconia Notch* in a letter of June 3, 1857, noted that his enclosed check for thirteen hundred dollars

FIG. 9. William Adolphe Bouguereau (1825–1905). *The Secret*, 1876. Oil on canvas, 51½ × 38¼ in. (130.8 × 97.2 cm). The New-York Historical Society. Robert L. Stuart Collection, S-176

exceeded what he had promised the artist, because he was so "very much pleased with the painting."[50] Stuart did on occasion commission works from contemporary European artists, but far less frequently than from American artists, making his European collection a lesser measure of his personal taste. From the French artist William Bouguereau (1825–1905), Stuart commissioned *The Secret* and told the artist not to rush but to take his time in finishing it (fig. 9). "It is all the same to me," wrote Stuart, "whether in one year or two years." Bouguereau took advantage of the American's lenience by spending four years on the picture, and it is likely that Stuart increased his payment in spite of the delay.[51] Reed and Stuart were inspired to deal with artists directly for the enjoyment of the interactions, because collecting, for them, was pleasure, not work.

Beginning in the 1870s, Stuart bought the great majority of his contemporary European paintings from dealers, and it seems he rarely voiced his opinion. Partly as a result of delegating responsibility, Stuart has been criticized as a follower of convention, "a collector whose tastes reflect, by the book, the tastes of the period."[52] Moreover, he purchased European art quickly and in bulk. The catalogue of his collection lists more than one hundred paintings purchased in a single year, just before his death. Dealer pressure and speed of purchase account, in part, for the varying quality in Stuart's European collection. Certain works Stuart bought characterize him as an uninformed collector lacking personal taste and discrimination, a man who could be duped by advisers into buying low-quality pictures. Émile Jean-Baptiste Antoine Béranger (1814–1883), a French artist whose work was in the collection, was described as "scarcely known at home, though he drives a flourishing trade in picture-manufacture for exportation. He is a fair specimen of that picture-dealer's standby, the 'painter for the American market.'"[53] Reed's early purchases of old master European paintings, also acquired through dealers, were likewise of mediocre quality and dubious authenticity. It was Reed himself who recognized this and turned his attention to American art, whereas Stuart proceeded with dealers' advice to paper the extensive walls of his new house with contemporary European paintings.

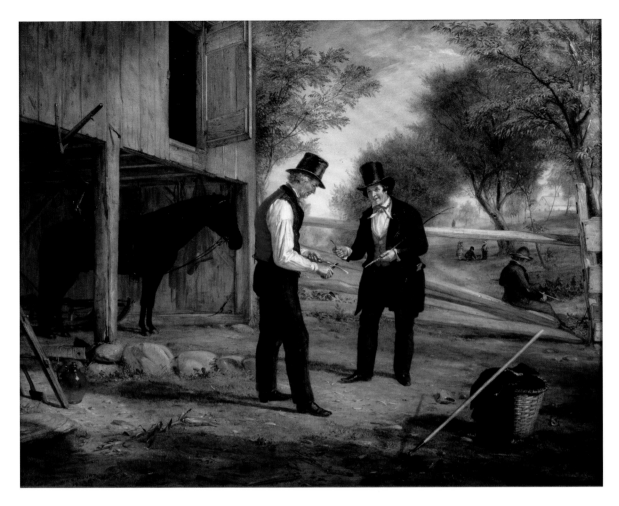

LEFT: FIG. 10. William Sidney Mount (1807–1868). *Coming to the Point*, 1854. Oil on canvas, 25 × 30 in. (63.5 × 76.2 cm). The New-York Historical Society. Robert L. Stuart Collection, S-141

Narrative subjects constituted a large percentage of the painting collections of both Luman Reed and Robert Stuart, and these included scenes from American life, religious subjects, and historical and literary themes. Domestic genre was a new and relatively rare subject in American art when Reed purchased his paintings, whereas national narrative subjects were well-established collectibles when Stuart formed his collection. Nothing could be more indicative of the shared personal taste of the two men than the purchase of two paintings. In 1863 Stuart bought a genre painting by William Sidney Mount, *Coming to the Point* (fig. 10), which was described by the artist as a "variation" on a subject he had composed in 1835 for Reed, a painting called *Farmers Bargaining* (later called *Bargaining for a Horse*) (cat. 31). In effect, Reed and Stuart chose the same painting for their collections, but their purchases reflect subtle personal and cultural differences. In 1835 Reed and critics were attracted by the familiarity of the American type depicted and the story the image recounted. Reed could identify personally with the farmer subject and the practice of bargaining, having grown up on a farm and negotiated grocery prices as a merchant. The subject also bore a direct relationship to the current American president, Andrew Jackson, who started life in Tennessee as a farmer. Reed met the president in 1831 and commissioned Durand to paint Jackson's portrait from life for his series of seven presidential portraits. The farmer, therefore, was an iconic image of both personal and

OPPOSITE: CAT. 31. William Sidney Mount (1807–1868). *Farmers Bargaining* (later known as *Bargaining for a Horse*), 1835

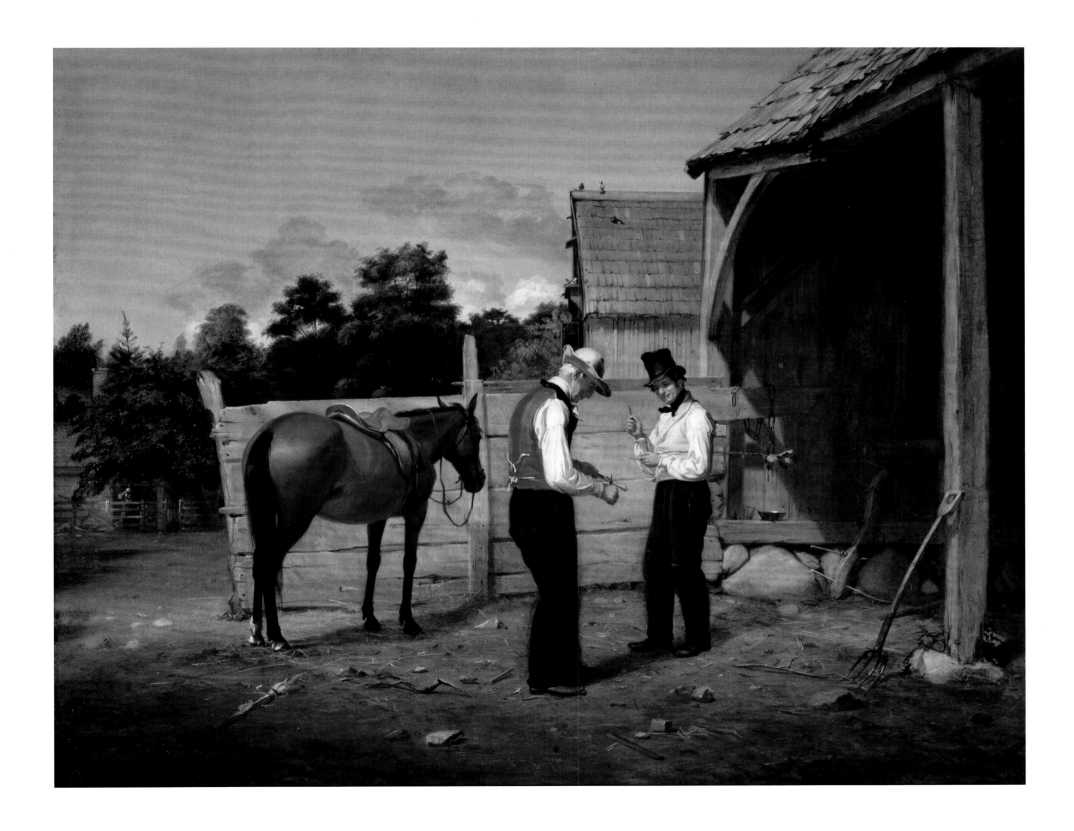

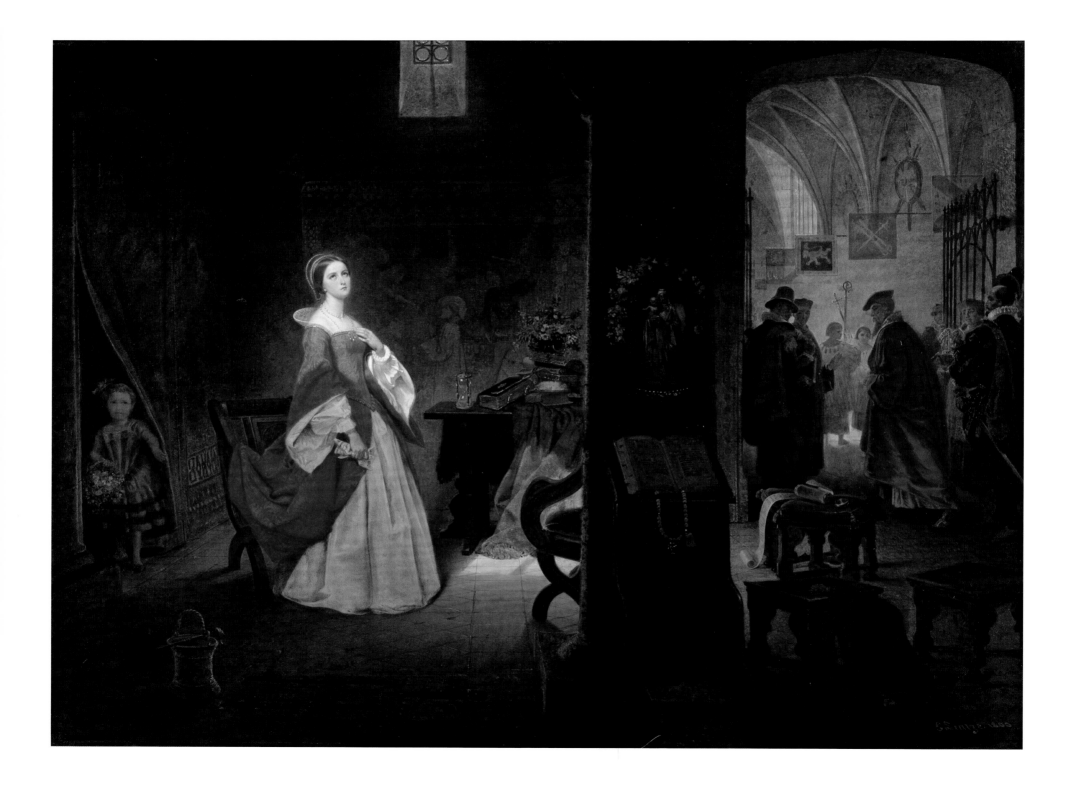

public importance to Reed. The dramatic suspense inherent in a depiction of two men negotiating the price of a horse also appealed to Reed's fondness for the theater and his delight in storytelling. "Every day Scenes where the picture tells the story are the kinds most pleasing to me," Reed wrote in a letter to Mount, "and must be to every true lover of the art."[54]

Stuart, however, was not born on a farm but in New York City, and by the time he purchased Mount's 1854 version of *Farmers Bargaining*, it was described as "an old-world character piece" and criticized as a "great falling off," both in execution of detail and expression.[55] The farmer had become a historical subject, the detailed storytelling seemed to have missed its mark, and Andrew Jackson was no longer in office. But the painting appealed to Stuart nonetheless, and his choice is revealing. Whereas Reed had promoted a new genre and delighted in the contemporary relevance of its subjects and implications, Stuart was drawn to the accepted category and perhaps attracted by the outmoded image of a simpler and less contentious time—before the slavery debate divided the nation.[56] His selection of Mount's later version of *Farmers Bargaining* speaks to his conservative bias in art, as in religion, and the changing political landscape of midcentury America.

Reed did not commission George Whiting Flagg's *Murder of the Princes in the Tower* (cat. 16), an English history subject, but he liked it so much when he bought it that he offered to subsidize Flagg for seven years in exchange for all his work. Reed greatly admired the American artist Washington Allston (1779–1843), Flagg's uncle and teacher, and believed the young man, if properly nurtured, would contribute to the development of homegrown culture in America, Reed's most important motivation in patronizing the arts. In 1860 Stuart commissioned the Elizabethan imprisonment subject *Princess Elizabeth in the Tower* (cat. 28) from the German-born and -trained American painter Emanuel Leutze. A critic for the *Crayon* had drawn attention to the painting's theme of religious persecution—a theme very compelling to Stuart. "Elizabeth is here represented as, in effect, a prisoner, having just passed an inquisitorial examination regarding her faith," wrote the critic, "evidently resigned to her fate, whatever it may be."[57] The Protestant struggle with the Catholic Church during the English Reformation for freedom from persecution and the preeminence of their faith resonated with the collector's lifelong commitment to American Protestants' right

OPPOSITE: CAT. 28. Emanuel Gottlieb Leutze (1816–1868). *Princess Elizabeth in the Tower*, 1860

to religious freedom.[58] As leader of the American and Foreign Christian Union, Stuart challenged the United States government to protect American Protestants from all forms of "maltreatment and insult" imposed on them in Catholic countries.[59] The historical counterpart in England provided Stuart and other American Protestants with a model of the struggle against a repressive Catholic Church. As a potent symbol of contemporary issues, both religious and political, Reformation subjects became popular with artists and collectors at midcentury, but they resonated profoundly with Stuart's desire not only to protect but also to disseminate his Presbyterian faith.[60] Stuart's taste for the subject of Protestant heroism in art accounts for his delight in Leutze's painting. A contemporary critic lamented the poor quality of the draftsmanship, coloring, and composition in the artist's rendering of *Princess Elizabeth in the Tower* and disparaged its subject as "outré."[61] Stuart bought Leutze's painting anyway, because it told the story he wanted to tell.

The same conflation of individual freedom and Protestantism might have drawn Stuart to George H. Boughton's painting *Pilgrims Going to Church* of 1867 (cat. 1), which shows a procession of believers, with guns for protection, braving not only the hardship of a cold New England winter but risking immediate attack by Indians or wild animals in order to practice their faith. Stuart saw the Pilgrims' mission of spreading their religion in the New World as the forerunner of his commitment to the promotion and extension of his faith across the American continent. Fortunately for Stuart, the artist Earl Shinn helped promote his cause by featuring Boughton's painting as the star of his collection in his (i.e., Shinn's) luxuriously illustrated 1879 publication touting the quality of art accumulated in American collections. "Relieved against the snow, like niello figures set in silver, the Pilgrims in their peaked hats proceed to a church of the wilderness, grim and God-fearing, trusting in heaven and keeping their powder dry . . . ," wrote Shinn. "The cavalcade proceeding to the church, the marriage procession (if marriage procession could be thought of in those frightful days) was often interrupted by the death-shot of some invisible enemy."[62] The explicitly French quality of Boughton's style was noted by critics, but it would have appealed to Stuart, too.[63] By the time he purchased this painting in 1868, Stuart had served on the Works of Art Advisory Committee for the Paris Universal Exposition of 1867 and had begun to favor paintings by contemporary European artists over those by Americans. He was supported in this shift by the help and advice of the connoisseur and art dealer Samuel P. Avery.[64]

CAT. 1. George Henry Boughton (1833–1905). *Pilgrims Going to Church*, 1867

The intensification of the divisive debates over slavery in the decades after Reed died in 1836 can be seen in the number of African Americans in paintings that Stuart began to buy in the 1860s. William Sidney Mount was the rare artist who had produced impressive images of black men in genre paintings during the 1830s, but no depictions of this subject entered Reed's collection.[65] Images of blacks in paintings increased markedly during the 1850s and 1860s, and Stuart acquired examples from Eastman Johnson, James Cafferty, and Edwin White.[66] It is not clear what prompted Stuart to purchase these pictures, apart from their popularity and general critical approval, or what they reflect about his attitude toward slavery, evident or coded. One impetus for Stuart's commission from Cafferty of *Baltimore News Vendor* (cat. 4) was the collector's affection for picturesque urban types, a tradition exemplified by engravings of the "Cries of New York" from 1808.[67] Reed's purchase of Flagg's *The Match Girl—London* (fig. 11), a poor but admirably enterprising urban vendor, indicates that he had earlier fancied the same type of popular subject.

In April 1862, one year to the month after the Civil War broke out, Stuart purchased, from the National Academy of Design exhibition, two paintings by the artist Edwin White. They represent elderly figures seated in a rustic interior by a simple hearth: one, a white woman spinning flax on a spinning wheel, *Olden Times* (also known as *Spinning Flax, Olden Times*; cat. 52); the other, a black man reading a newspaper, *Thoughts of the Future* (also known as *Thoughts of Liberia [Emancipation]*; fig. 12). A careful examination of these two pictures points to the critical shift in the political landscape between the decades when Reed formed his collection and Stuart assembled his. By the 1860s the burgeoning, optimistic commercial backdrop of New York the two men had shared in the 1830s had darkened into a landscape of national conflict. Stuart's commitment to the Union was profound, and he, like all of his generation, was deeply affected by the advent of civil war. Seen together, these two paintings reflect the searing conflict between the North and the South and propose connections with topical issues of the day in the search to resolve it.[68]

Efforts to find alternatives to cotton, thereby eliminating the need for slave labor, had been under way for decades. In the 1850s a new steam process was invented that was heralded as "a revolution in flax as great in magnitude, if not greater, than has been effected by the cotton gin in cotton."[69] The world, it was imagined, could now be clothed in clean, white linen. Grown on prairies in the Midwest and produced by

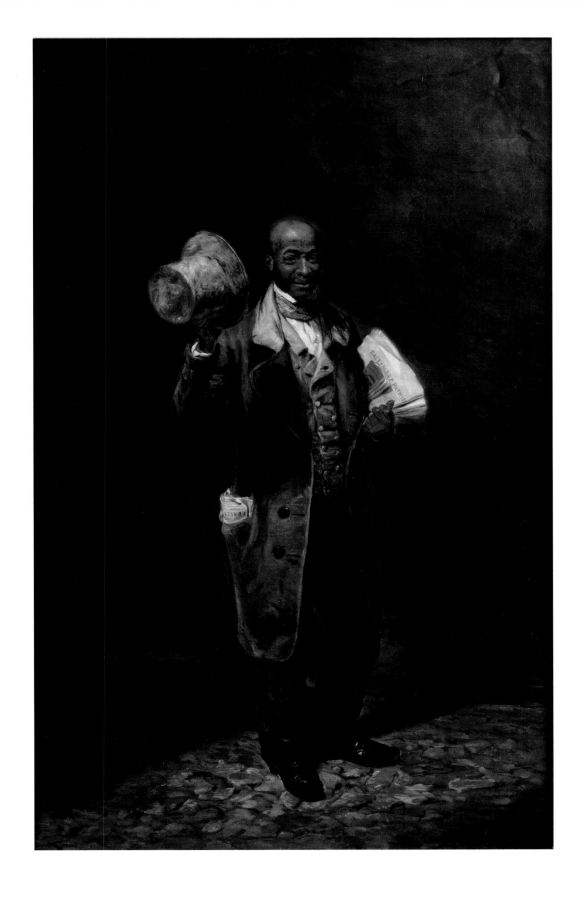

ABOVE: FIG. 11. George Whiting Flagg
(1816–1897). *The Match Girl—London*,
1834. Oil on canvas, 29½ × 24½ in.
(74.9 × 62.2 cm). The New-York
Historical Society. Gift of the New-York
Gallery of the Fine Arts, 1858.30

RIGHT: CAT. 4. James Henry
Cafferty (1819–1869) after Thomas
Waterman Wood (1823–1903).
Baltimore News Vendor, 1860

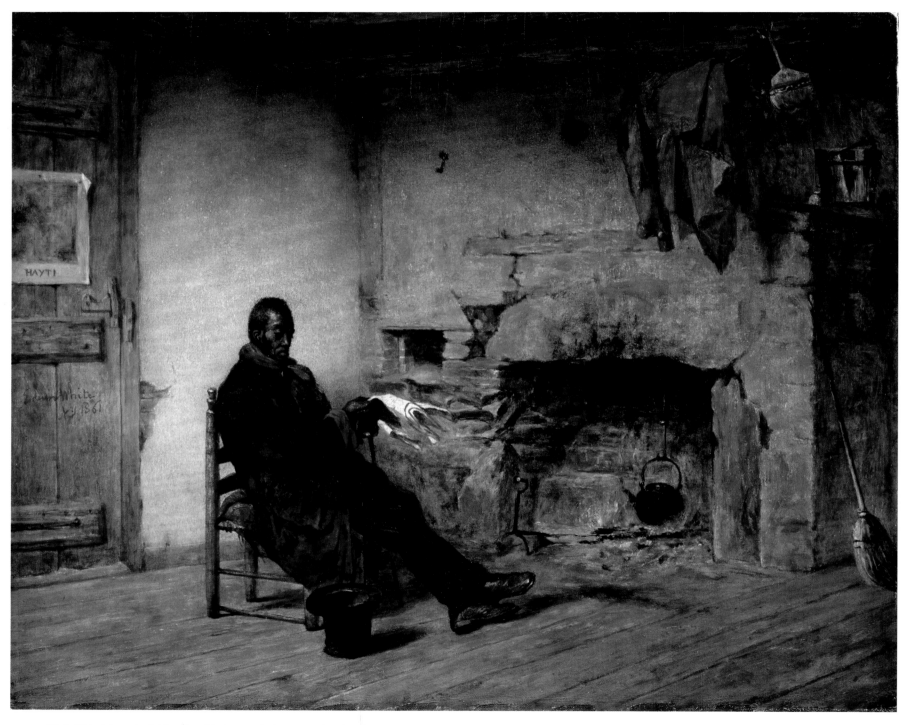

FIG. 12. Edwin White (1817–1877). *Thoughts of the Future* (also known as *Thoughts of Liberia, Emancipation*), 1861.
Oil on canvas, 18 × 21 in. (45.7 × 53.3 cm). The New-York Historical Society. Robert L. Stuart Collection, S-200

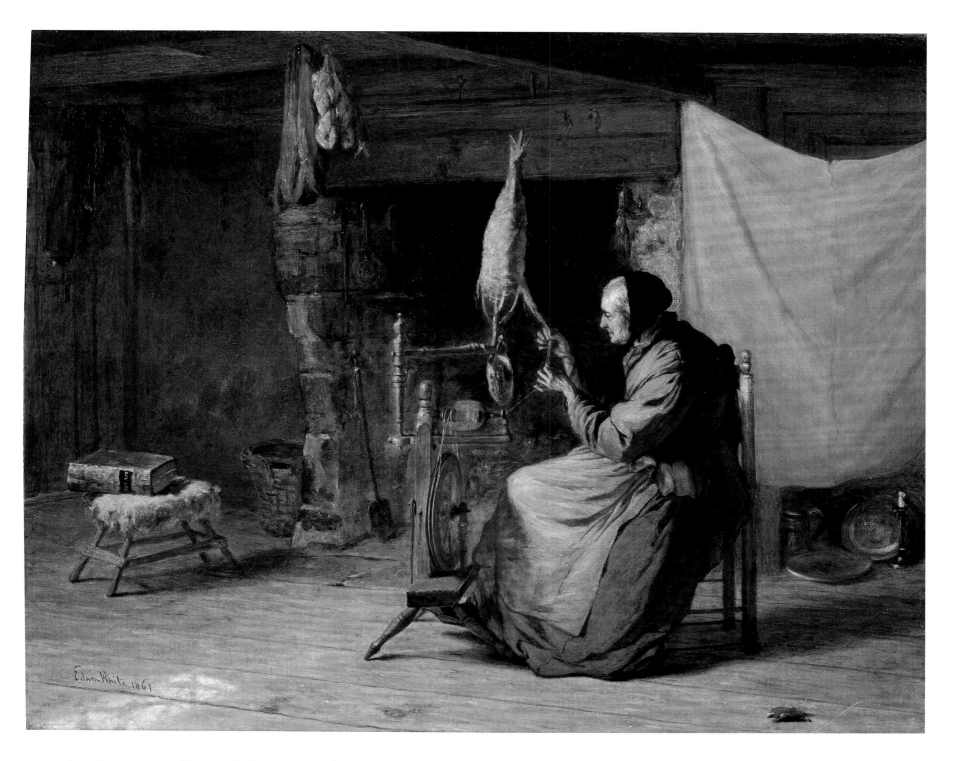

CAT. 52. Edwin White (1817–1877). *Olden Times* (also known as *Spinning Flax, Olden Times*), 1861

machinery and not slave labor, it offered a potential resolution to the heated North-South debate. After the conflict began, hopes for avoiding civil war transformed into hopes for ending it. In White's painting *Olden Times*, the old woman, posed in a rustic interior, is spinning flax from an old-fashioned spinning wheel, a nostalgic reverie on an earlier, simpler time. The products of her labor, in the form of three skeins of flax, hang to dry over the hearth. In red, white, and blue, they are suspended like a salutary American flag, healing wounds from the conflict and promising reunification. A notable detail in *Thoughts of the Future* (also known as *Thoughts of Liberia, Emancipation*) behind the African American man is a broadside imprinted "Hayti" tacked to the door. Haiti, like Liberia, was considered a place to which black Americans could be relocated to reduce the threat of revolt and diminish the practice of slavery on American soil. James Redpath, a Scottish émigré abolitionist journalist, initiated a program that recruited and sent blacks to Haiti from 1860 to 1862. He published and distributed a pamphlet advocating emigration entitled *Guide to Haiti*, and it is possible that the broadside in White's painting is one of those distributed by Redpath's recruiting agents.[70]

The American Colonization Society was the original 1820s sponsor of a "compensated emancipation of the slaves, contingent upon their removal to Africa." That organization was founded in Princeton, New Jersey, at the college there and the Princeton Theological Seminary. Both Presbyterian institutions received generous support from Stuart starting in the 1850s.[71] It is likely that Stuart supported his church's initiative to relocate blacks outside the country to prevent rebellion and possibly avoid war.[72] In their thematic suggestions of a resolution to the national conflict, White's paintings of a black man and a white woman are aligned with Stuart's support of President Abraham Lincoln and his allegiance to the Union.[73] Stuart's attitude toward slavery was probably conservative, largely influenced by the position of the Presbyterian Church. Until the 1850s Princeton Theological Seminary and Princeton College supported the institution of slavery. By 1854 that view had been modified to a more ambiguous stance, which suggested that "although slavery could be justified on scriptural grounds, it was hardly a desirable condition."[74] Robert Stuart likely agreed.

In the 1830s Alexis de Tocqueville had recognized, as Reed and most Americans did not, that "slavery, in the midst of the democratic freedom and enlightenment of our age, is not an institution that can endure."[75] Tocqueville acknowledged that this insight depended on his broader perspective as "a foreigner [who] often

learns important truths at the hearth of his host, who might conceal them from friends."[76] The American Civil War erupted two years after Tocqueville's death in France and a year before Robert Stuart purchased Edwin White's paintings of figures seated at the hearth: they depict a black man and a white woman, and as they have been proved in this catalogue to have been conceived as a pair, were intended to be hung together. Both paintings were placed in the Main Hall on the first floor of Stuart's house, identified as nos. 100 and 104 in the 1885 catalogue of his collection produced by Mary Stuart after the collector's death. It seems that the paintings, depicting a black man and a white woman, intended as companions, were probably not installed as a pair. One wonders if the artist consciously conceived their narrative message of social justice and whether it was rejected by or eluded Robert Stuart.

In spite of the expansion of wealth and access to art that occurred in America from the 1830s through the 1860s, the period during which Reed and Stuart began to acquire paintings, their collections show a remarkable overlap in narrative subjects. This is due, in part, to the similarity of backgrounds, experience, and outlook of the individual men, and a close-up view brings into focus the details of the individual aspirations of each collector. Luman Reed's collection projects a pioneering spirit, with a patriotic commitment to promoting the arts in America as well as the careers of individual American artists. The profile of Stuart's works of art traces a conservative outlook fashioned by family background and Presbyterian beliefs. He tended to favor American subjects that were almost out of fashion when he bought them but that had been new and topical in Reed's day. From the wide-angle perspective, we see the increasing conflict over the slavery issue and the agony of civil war that followed providing an altered background of Reed's and Stuart's collecting choices. In 1833 the *Weekly Emancipator*, New York's first abolitionist paper, was published. It heralded only the early simmering of the slavery debate, just when Reed began collecting art.[77] By the 1850s the tensions of dispute had reached an irrepressible boil, culminating in the explosion at Fort Sumter; a landscape of war then came into focus around the figure of Stuart and the subjects in some of the paintings he gathered. The urgency of the contemporary civil conflict localized some of Robert Stuart's collecting choices, in the inclusion of African American subjects and symbolic references to war, while the works of art Luman Reed gathered reflect the broad national optimism of his American moment.

NOTES

Hilary Thompson's extraordinary organizational skills, patience, and clarity of thought are imprinted on every page of this essay. I am deeply indebted to Lori Zabar for sharing with me her brilliant research acumen and thoughtful insights, particularly as they relate to Robert Stuart.

1.　"An Old Merchant Gone: The Death Yesterday of Robert L. Stuart," *NYT*, December 13, 1882.

2.　In 1828 a list of the sixty wealthiest New Yorkers whose net worth was between $100,000 and $250,000 was compiled using New York City tax assessment records; Reed's name was on the list. By the time of his death in 1836, his net worth was probably more. Edward Pessen, "The Wealthiest New Yorkers of the Jacksonian Era: A New List," *New-York Historical Society Quarterly* 54 (April 1970): 155, quoted in Foshay 1990, 26.

3.　Unless otherwise noted, all information about Robert Leighton Stuart can be found in Paul Sternberg, "'Wealth Judiciously Expended': Robert Leighton Stuart as Patron and Collector," *Journal of the History of Collections* 15, no. 2 (November 2003): 229–49; for Luman Reed, see Foshay 1990.

4.　Henry James, *Hawthorne* (New York: AMS Press, 1887), 43: "One might enumerate the items of high civilization, as it exists in other countries, which are absent from the texture of American life, until it should become a wonder to know what was left. No State, in the European sense of the word, and indeed barely a specific national name. No sovereign, no court, no personal loyalty, no aristocracy, no church, no clergy, no army, no diplomatic service, no country gentlemen, no palaces, no castles, nor manors, nor old country houses, nor parsonages, nor thatched cottages nor ivied ruins; no cathedrals, nor abbeys, nor little Norman churches. . . ."

5.　Stephen Edidin estimates that three-fifths of the 244 paintings in Stuart's collection at his death were European. Two dozen of those were purchased in 1881–82 from M. Knoedler. Edidin, untitled lecture, City University of New York, February 25, 2008.

6.　Anne McNair Bolin, "Art and Domestic Culture: The Residential Art Gallery in New York City, 1850–1870" (Ph.D. diss., Emory University, 2000), 195; and Henry Duffy, "New York City Collections: 1865–1895" (Ph.D. diss., Rutgers University, 2001), ii.

7.　The portrait of Reed draws from an extensive collection of family papers at the New-York Historical Society, given by the Reed family in 1990, while that of Stuart relies on a relatively small, scattered family archive at the New York Public Library and the papers of some of the artists he collected and dealers he consulted.

8.　John Durand, quoted in Foshay 1990, 24–25.

9.　Matthew Hale Smith, *Bulls and Bears of New York, with the Crisis of 1873, and the Cause* (Hartford: J. B. Burr & Company, 1875), 286–87; and "Alexander Stuart," *NYT*, December 24, 1879, 5.

10.　"Funeral of Robert L. Stuart," *NYT*, December 16, 1882, 3.

11.　"Biographical Sketch of Robert L. and Alexander Stuart," in *Encyclopaedia of Contemporary Biography of New York* (New York: Atlantic Publishing and Engraving Company, 1882), 2:9.

12.　Alexis de Tocqueville, "Letters from America, Alexis de Tocqueville," *Hudson Review* 62 (2009): 357–404, at 367.

13.　Robert Greenhalgh Albion, *The Rise of New York Port [1815–1860]* (New York: South Street Seaport Museum, 1984), 2.

14.　Ibid., 12.

15.　Foshay 1990, 24.

16.　Duffy, "New York City Collections: 1865–1895," ii.

17.　Sternberger, "'Wealth Judiciously Expended,'" 230.

18.　"Memento" biography, dated 1884, signed B. [George Barker, Mrs. Luman Reed's nephew], 51, Luman Reed Papers, N-YHS Library, quoted in Foshay 1990, 35.

19.　*NYT*, December 24, 1879, 5. Innovations included in Stuart's residences are noted in Sternberger, "'Wealth Judiciously Expended,'" 230.

20.　Gas lighting of streets in New York started in the 1760s. It was first installed in the private dwelling of Samuel Leggett, the founder of the New York Gas Light Company, in 1824. While New Yorkers applauded gas lamps to illuminate the streets, they objected to them for home use for fear of explosion and were therefore slow to accept them. William P. Gerhard, *The American Practice of Gas Piping and Gas Lighting in Buildings* (New York: McGraw Publishing, 1908), 267.

21.　John Durand, *Prehistoric Notes of the Century Club* (New York: Century Club, 1882), 19, quoted in James T. Callow, *Kindred Spirits: Knickerbocker Writers and American Artists, 1807–1855* (Chapel Hill: University of North Carolina Press, 1967), 15.

22.　Tuckerman 1867, 228.

23.　Mark White Sullivan, "John F. Kensett: American Landscape Painter" (Ph.D. diss., Bryn Mawr College, 1981), 67.

24.　When Stuart purchased George Boughton's painting *Winter Twilight* from the 1858 National Academy of Design exhibition, it was reported that he relied on the advice of the president, Asher B. Durand. Stuart was one of "several ardent collectors, who had plenty of money to spend on works of art, but no time to select them for themselves." Alfred Lys Baldry, *George Henry Boughton (Royal Academician): His Life and Work* (London: Virtue & Co., 1904), 5.

25.　Philip Hone, "Diaries, 1826–1851," 11:122, N-YHS.

26.　See *Empire City: New York through the Centuries*, ed. Kenneth Jackson and David Dunbar (New York: Columbia University Press, 2002), 458.

27.　Foshay 1990, 26.

28.　"Terrible Conflagration," *NYH*, December 17, 1835.

29.　Recent scholarship indicates that the volume of claims against damage from the fire caused bankruptcy for twenty-three of New York's twenty-six insurance companies. Jackson and Dunbar, *Empire City*, 458.

30.　Foshay 1990, 26.

31.　*NYH*, December 19, 1835. I am grateful to Harry W. Havemeyer for sharing his expertise in the history of New York City and sugar manufacture.

32.　Bolin, "Art and Domestic Culture," 31, suggests that the 1828 Boston exhibition of Thomas Jefferson's art collection might have inspired Reed to install a separate gallery in his house. James Silk Buckingham reported that Reed opened his gallery once a week to "persons properly introduced," in *America: Historical, Statistical and Descriptive* (London: Fisher, Son, & Co., 1841), 1:213–14n56, quoted in Foshay 1990, 201.

33.　Bolin, "Art and Domestic Culture," 37.

34.　Stuart's house at 154 Fifth Avenue at Twentieth Street was completed by 1853. By 1859 it had a two-story skylighted addition, presumably for a gallery. His house at 961 Fifth Avenue at Sixty-eighth Street was finished in 1882.

35.　James Jackson Jarves, "Art in America," *Fine Arts Quarterly Review*, 1863,

399–400, quoted in Melissa Geisler Trafton, "Critics, Collectors, and the Nineteenth-Century Taste for the Paintings of John Frederick Kensett" (Ph.D. diss., University of California, Berkeley, 2003), 74.

36. "The Lenox Library Pictures," *Art Amateur* 28 (April 1893): 129.

37. Bolin, "Art and Domestic Culture," 196. "Since Mr. Vanderbilt has generously set apart every Thursday, from eleven o'clock until four, as a time when the public may be admitted into the gallery by cards of invitation, the influence of this brilliant array of pictures is an important element in the cultivation of the artistic taste of the metropolis." *Artistic Houses* (New York: D. Appleton, 1883), vol. 1, part 2, p. 171, quoted in William S. Ayres, "The Domestic Museum in Manhattan: Major Private Art Installations in New York City, 1870–1920" (Ph.D. diss., University of Delaware, 1993), 56.

38. Smith, *Bulls and Bears*, 283.

39. Lenox's art collection featured American portraits and religious history paintings as well as the work of English painters. *Lenox Library: A Guide to the Paintings and Sculptures Exhibited to the Public* (New York: printed by order of the Trustees, 1889).

40. "Biographical Sketch," 2:10–12.

41. Harry Miller Lydenberg, "A History of the New York Public Library, Part 3: The Lenox Library," *Bulletin of the New York Public Library* 20 (1916): 703.

42. Luman Reed to William Sidney Mount, November 23, 1835, William Sidney Mount Papers, Museums at Stony Brook, New York, quoted in Foshay 1990, 57.

43. Foshay 1990, 64.

44. Lillian Miller, *Patrons and Patriotism: The Encouragement of the Fine Arts in the United States, 1790–1860* (Chicago: University of Chicago Press, 1969), 156.

45. Stuart's very earliest purchases in 1852 were European works: G. Engelhardt's *Old Mill in the Alps* and *Swiss Landscape* and Henry Jaeckel's *Swiss Lake* and *Swiss Village.* He began purchasing American landscape works in the late 1850s, and many depict specific sites. Some examples are Asher B. Durand's *White Mountain Scenery,* purchased in 1857, and *Catskill Creek* by Thomas Cole, purchased in 1858. Paul Spencer Sternberger, "Portrait of a Collector and Patron: Robert Leighton Stuart," undated typescript, pp. 11–14, N-YHS, Museum Department Files.

46. "Fine Arts," *Home Journal for the Cultivation of the Memorable, the Progressive, and the Beautiful,* April 2, 1859, 2.

47. Herbert L. Kleinfield et al., *The Diaries 1871–1882 of Samuel P. Avery, Art Dealer* (New York: Arno Press, 1979), xxx.

48. Foshay 1990, 122, 131, 138.

49. Cole to Gilmor, January 29, 1832, Cole Papers, quoted in Foshay 1990, 130.

50. Sternberger, "'Wealth Judiciously Expended,'" 233. Reed paid Thomas Cole more than he had promised for *The Course of Empire.* See Foshay 1990, 131, 138.

51. Vincens-Bouguereau Archives, published in *William Bouguereau* (Montreal: Montreal Museum of Fine Arts, 1983), 109, quoted in Sternberger, "Portrait of a Collector," 20.

52. Trafton, "Critics, Collectors and the Nineteenth-Century Taste for the Paintings of John Frederick Kensett," 135.

53. Edward Strahan [Earl Shinn], ed., *The Art Treasures of America: Being the Choicest Works of Art in the Public and Private Collections of North America* (Philadelphia: George Barrie, 1880), 2:123, quoted in Sternberger, "Portrait of a Collector," 10.

54. Reed to Mount, July 25, 1835, Mount Papers, quoted by Burgard in Foshay 1990, 181.

55. Quoted in Koke 1982, 2:402–4. Important sociopolitical interpretations of these paintings can be found in Johns 1991; and Lesley Carol Wright, "Men Making Meaning in Nineteenth-Century American Genre Painting, 1860–1900" (Ph.D. diss., Stanford University, 1993).

56. The collector Robert M. Olyphant criticized Stuart for merely following fashion and for a lack of connoisseurship. R. M. Olyphant to J. F. Kensett, April 12, 1859, John Frederick Kensett Papers, 1806–1896, microfilm reel 1534, frames 1–2, AAA: "I hope that [Mr. Stuart] may be so instructed as some day to enjoy his possessions for the good there is in them—that so he may get good, & dispense good—sometimes his enjoyment seemed to me too much that of one who did not enjoy in reality—but tried to seem to do so because others thought he ought to!"

57. "National Academy of Design: Second Notice," *Crayon* 7, no. 6 (June 1860): 171.

58. "Protection to American Citizens," *Independent* 6 (January 19, 1854): 24; "An Important Meeting," *New York Evangelist* 25 (January 19, 1854): 10; and "Religious Liberty," *NYT,* January 27, 1854, 1.

59. "Religious History," *NYT,* January 27, 1854.

60. A thorough exploration of the vogue for English historical subjects by American history painters and their sociopolitical implications can be found in Wendy Greenhouse, "Daniel Huntington and the Ideal of Christian Art," *Winterthur Portfolio* 31 (1996): 104–40, at 135. Stuart helped fund the building of the Presbyterian church at Fifth Avenue and Nineteenth Street, and in 1852 he built his house one block away. "Stuart, Robert Leighton," in *The National Cyclopaedia of American Biography* (New York: James T. White, 1909), 24. He gave several significant donations to supporting Presbyterian education at Princeton College and Princeton Theological Seminary.

61. "National Academy of Design: Second Notice," *Crayon* 7, no. 6 (June 1860): 171.

62. Strahan, *The Art Treasures of America,* 2:122.

63. "George Boughton," *Appleton's Journal of Literature, Science and Art* 3, no. 40 (January 1, 1870): 11: "He belongs to no country as a painter; for he is not English by style, but French; he is not French by his sentiment, but English." Kleinfield et al., *The Diaries of Samuel P. Avery.*

64. Kleinfield et al., *The Diaries of Samuel P. Avery,* xxi.

65. Reed continually requested additional paintings from Mount, whose work he admired greatly, leaving the selection of subject to the artist, so the lack of black subjects cannot be attributed to a particular personal bias.

66. Recent complex interpretations of African American images and their ambiguity can be found in John Davis, "Eastman Johnson's 'Negro Life at the South' and Urban Slavery in Washington, D.C.," *Art Bulletin* 80 (March 1998): 67–92; and Johns 1991.

67. Wright, "Men Making Meaning," 140.

68. Barbara Dayer Gallati suggests convincingly in this volume that Edwin White intended these paintings as a pair. See cat. 52.

69. "Sea and Upland Cotton vs. Flax and Hemp," *Merchants' Magazine and Commercial Review* 45, no. 4 (October 1, 1861): 337.

70. I am grateful to Lori Zabar for her research on this subject and for suggesting the connection to the painting.

71. Sean Wilentz, "Princeton and the Controversies over Slavery," *Journal of Presbyterian History* 85 (Fall–Winter 2007): 106.

72. In the course of the nineteenth century, the American Colonization Society transported about 16,000 blacks to Liberia, with immigration peaking between 1848 and 1854. "The Colonization of Liberia," *In Motion: The African-American Migration Experience*, Schomburg Center for Research in Black Culture, New York Public Library, at http://www.inmotionaame.org/migrations /topic.cfm?migration=4&topic=4.

73. On February 21, 1861, Stuart was included in a breakfast for president-elect Abraham Lincoln hosted by Moses H. Grinnell, as reported in "Mr. Lincoln's Journey," *New York Observer and Chronicle*, February 28, 1861, 70.

74. Wilentz, "Princeton and the Controversies over Slavery," 106. As a refiner of sugar, produced on plantations with slave labor, the institution also served his economic livelihood.

75. Alexis de Tocqueville, *Democracy in America*, ed. Harvey C. Mansfield and Debra Winthrop (Chicago: University of Chicago Press, 2000), 348.

76. Leo Damrosch, *Tocqueville's Discovery of America* (New York: Farrar, Straus & Giroux, 2010), xvi.

77. Leo H. Hirsch, "New York and the National Slavery Problem," *Journal of Negro History* 16, no. 4 (October 1931): 454–55.

OPPOSITE: Detail of CAT. 28.
Emanuel Gottlieb Leutze (1816–1868).
Princess Elizabeth in the Tower, 1860

Artists' Biographies and Catalogue Entries

George Henry Boughton

(1833–1905)

Best categorized as Anglo American, the painter and illustrator George Henry Boughton forged a career on both sides of the Atlantic. He was born in Norwich, England, and raised in Albany, New York, where his parents settled when he was a child.[1] Little is known of his early training, but he is said to have begun as a painter of theatrical scenery in Albany. The proceeds from the 1852 sale to the American Art-Union of one of his first oil paintings, *The Wayfarer* (unlocated), enabled Boughton to go to England to study. Nothing is known about his reported six-year stay in England. He surfaces again in New York, where his *Winter Twilight* (The New-York Historical Society, The Robert L. Stuart Collection) drew positive critical response at the National Academy of Design in 1858. Although his early reputation as a painter rested on winter scenes, Boughton's aspirations included figure painting, as witnessed by his enrollment in a life class at the National Academy of Design in 1859–60. Further evidence of this shift was his study with Édouard Frère (1819–1886) in France in 1860–61.[2] By December 1861 Boughton was in London, where he lived for the rest of his life.[3]

Boughton's star rose quickly in England. He began exhibiting at the British Institution in 1862 and in 1863 at the Royal Academy, where he showed annually thereafter (he was elected an Associate Royal Academician in 1879 and a full academician in 1896). Completely assimilated into British cultural and social life, Boughton was also a member of the Royal Institute of Painters in Water Colours and the Pastel Society and was invited to participate in the exclusive Grosvenor Gallery exhibitions from 1877 to 1890. He became known for North American colonial themes as well as for picturesque English and Dutch subjects. In 1865 he married Katherine Louise Cullen, and the couple adopted a daughter, Florence. The family eventually lived in a fine house and studio, West House, in Campden Hill, designed by the renowned architect Richard Norman Shaw (1831–1912).[4]

At the same time that he was gaining popularity in England, Boughton maintained a high profile in the United States by exhibiting at the National Academy of Design (to which he was elected a full academician in 1871) and the Artists' Fund Society as well as through his association with such dealers as Goupil & Vibert and Samuel Putnam Avery. His paintings were acquired by notable American collectors, including William H. Vanderbilt, George Seney, and Henry G. Marquand, the latter of whom Boughton occasionally advised about his art purchases. A talented writer, Boughton also gained attention through a number of articles and books, including *Sketching Rambles in Holland*, which recounts his experiences there in the company of fellow artist Edwin Austin Abbey (1852–1911).[5]

Toward the end of his career, Boughton turned to a quasi-Symbolist style that remains to be investigated. He died of heart failure in his West House studio in 1905.[6]

1. Among the best sources for information on Boughton are Alfred Lys Baldry, *George H. Boughton (Royal Academician): His Life and Work* (London: Virtue & Co., 1904); Olivia Fitzpatrick, in *Oxford Dictionary of National Biography* (Oxford University Press, 2004, at http://www.oxforddnb.com/view/article/31984); and David B. Dearinger's entry for Boughton in Dearinger 2004, 59–61.
2. Most sources give 1859 as the year of Boughton's departure for France, but several notices in the *NYH* suggest that he did not arrive in Paris until July 1860. See "Fine Arts," *NYH*, February 25, 1860, 8, for the notice that he will travel to France in the spring. A later bulletin states that he had registered in Paris with Lansing & Co. Bankers in July 1860.
3. "Art Gossip," *NYH*, December 10, 1861, 10.
4. The studio was featured in Cosmo Monkhouse, "Some English Artists and Their Studios," *Century* 24, no. 4 (August 1882): 553–68.
5. George H. Boughton, *Sketching Rambles in Holland* (New York: Harper & Brothers, 1885).
6. "Obituary: Mr. G. H. Boughton, R.A.," *Times* (London), January 21, 1905, 6.

1

George Henry Boughton (1833–1905)

Pilgrims Going to Church

1867

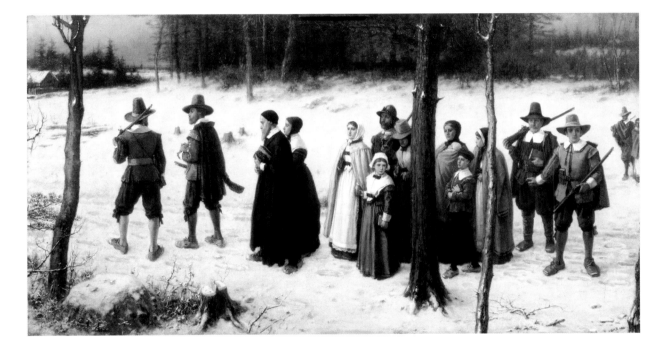

Oil on canvas, 29 × 52 in. (73.7 × 132.1 cm)
Signed and dated lower right: *G. H. B. 67*
The Robert L. Stuart Collection, S-117

For color, see page 165

George Boughton is best known for his images of the early New England settlers. By 1896 he was acclaimed "The Painter of New England Puritanism."[1] *Pilgrims Going to Church*, the first and most important of these colonial subjects, is considered his most popular painting.[2] Boughton took his cue from William Henry Bartlett's 1853 history, *The Pilgrim Fathers*. On the wood panel that originally backed the painting was glued a paper label inscribed with the following passage from Bartlett:

> [T]he few villages were almost isolated, being connected only by long miles of blind pathway through the woods; and helpless indeed was the position of that solitary settler who erected his rude hut in the midst of the acre or two of ground that he had cleared. The cavalcade proceeding to church, the marriage procession—if marriage could indeed be thought of in those frightful days—was often interrupted by the death shot from some invisible enemy.[3]

Boughton departed slightly from Bartlett's description and also took some historical liberties. He depicted, not a wedding, but a group of worshipers. And, as can be seen at the left, their settlements were compact and enclosed, so there was no need for a dangerous trek through the forest to attend services.[4] The settlers process in a solemn, friezelike fashion through a snowy wood toward the settlement at the left. Some of the men carry guns, and Boughton made reference to the hidden dangers the Puritans faced: one man at the far right has stopped and gestures toward his companion, as if he had heard something in the woods. Their picturesque costumes, if not historically accurate, are rendered in careful, smoothly

painted detail, in contrast to the high impasto in the snow and the loose, atmospheric handling of the background forest.[5] The scene is eminently legible to anyone, but Boughton also employed modern devices that would appeal to his more sophisticated viewers. He abruptly cropped the trees on either side and even some figures on the right. He also inserted tall tree trunks that rise out of the picture and perhaps infinitely upward, suggesting the overwhelming magnitude of the forest, thereby creating interesting visual breaks in the composition.[6]

The painting was singled out for warm praise when it was first displayed among the hundreds at the London Royal Academy's 1867 exhibition under the title *Sunday in the Old Colon[ies:] Early Puritans of New England Going to worship Armed, to protect themselves from Indians and Wild Beasts.*[7] The *Athenæum* lauded the "capitally painted figures and faces," and the *Times* called it "the best as well as the most important work yet produced by this very agreeable and thoughtful artist."[8] The American dealer Samuel Putnam Avery purchased the painting that year and sold it to the New York collector Robert L. Stuart in 1868. By the time Stuart lent the painting to the 1876 Centennial Exhibition in Philadelphia, it was well known through engravings and received a number of notices, though reviews were mixed. The writer for the *New York Times* praised the strength of the drawing but felt the image a bit ponderous, commenting, "the Pilgrim fathers and mothers move as if a half a ton of clay were adhering to each foot."[9]

In this painting and others, Boughton straddled the border between art and illustration.[10] His themes were historical in nature, and the works were of the significant size commensurate with history painting. However, his carefully rendered figures and straightforward compositions in tandem with their frequent reproduction in books and engravings may have affected his critical reception. In 1873 the London *Art Journal* gave Boughton's work faint praise, advising viewers to note its "negative excellences," such as simplicity, tenderness, and a charmingly subdued palette.[11] Many years later *New England Magazine* offered the lukewarm comment that Boughton's paintings lent themselves well to engraving.[12]

Here the artist depicted, not a heroic episode in keeping with traditional history painting, but an intimate moment showing quiet bravery and piety. Boughton may have been aware of a similar trend in the United States, as artists conflated genre and history painting in subjects that showed great men in domestic settings or everyday citizens performing heroic acts.[13]

—KPO

1. William Elliot Griffis, "George H. Boughton: The Painter of New England Puritanism," *New England Magazine* 15 (December 1896): 481–501.
2. Alfred Lys Baldry, *George H. Boughton (Royal Academician): His Life and Work* (London: Virtue & Co., 1904), 8; Koke 1982, 1:77–78; Griffis, "Boughton," 495; and Amanda J. Glesmann, "Sentimental Journey: Envisioning the American Past in George Henry Boughton's *Pilgrims Going to Church*" (M.A. thesis, University of Delaware, 2002), 3, 70.
3. William Henry Bartlett, *The Pilgrim Fathers* (London: Arthur Hall, Virtue & Co., 1853), 228. The inscription was written on the reverse of a letter embossed with the artist's monogram, "G.H.B." See Koke 1982, 1:78–79.
4. Glesmann, "Sentimental Journey," 7.
5. Ibid., 6, notes that the cut and fabric of the clothing resemble nineteenth-century styles more closely than seventeenth-century ones and that the rifles are nineteenth-century models, rather than muskets of the earlier period.
6. Boughton returned to the subject a few years later, painting a smaller version in 1872 (Toledo Museum of Art).
7. The same inscription includes text relating to the painting's submission to the Royal Academy, but the glue used to affix it to the backing board makes some of the text difficult to read, so the title given is an approximation. See Koke 1982, 1:78–79. See Glesmann, "Sentimental Journey," 31–34, for the various titles given the painting before it was exhibited as *Pilgrims' Sunday Morning* at the 1876 Centennial Exhibition.
8. "Fine Arts: Royal Academy," *Athenæum*, May 25, 1867, 697; and "The Exhibition of the Royal Academy: Third Notice," *Times* (London), May 14, 1867, 6.
9. Gar., "The Art of America," *NYT*, June 13, 1876, 1.
10. Boughton's work prefigures his later involvement in illustration for *Harper's Weekly* and London's *Pall Mall Magazine* in the 1880s as well as his 1885 book *Sketching Rambles in Holland* (New York: Harper & Brothers, 1885).
11. James Dafforne, "The Works of George Henry Boughton," *Art Journal* (London) 12 (January 1873): 44.
12. Griffis, "Boughton," 491.
13. See Jochen Wierich, "The Domestication of History in American Art, 1848–1876" (Ph.D. diss., The College of William and Mary, 1998).

William Henry Burr

(1819–1908)

By the time he died at eighty-nine, William Henry Burr's career as an artist had been all but forgotten. Instead, he was remembered for his years as an official reporter of the House of Representatives and, in the words of his friend, the political orator Robert Green Ingersoll, as "the great literary detective."[1]

Burr, a son of a glove maker, was born in Gloversville, New York. He received his undergraduate education at Union College, Schenectady, New York, where he was also awarded a master of arts degree in 1846. By then he had already begun painting professionally, having debuted in 1841 at the National Academy of Design in New York, where he exhibited portraits and genre subjects until 1859. Apart from exhibiting works at the Pennsylvania Academy of the Fine Arts (1847) and at the American Art-Union (1848), no additional exhibition history for Burr's art has surfaced.

After studying stenography, Burr virtually abandoned the arts to embark on a new career as a court reporter. He recorded the proceedings of the New York Superior Court from 1861 to 1863, and his job as reporter for the *Congressional Globe* (1865–69) took him to Washington, D.C., where he apparently resided for the rest of his life. Judging from the nature of the books, essays, and pamphlets Burr wrote over several decades, he was a man of distinctive and sometimes eccentric ideas. Among some of the theories he advanced was that Abraham Lincoln's assassination was the product of a Jesuit conspiracy, that Francis Bacon was not only the bastard son of Elizabeth I but also the true author of plays attributed to Shakespeare, and that DeWitt Clinton had committed suicide.[2] One of his most widely distributed works was *Self-Contradictions of the Bible: 144 Propositions, Theological, Moral, Historical and Speculative; Each Proved Affirmatively and Negatively, by Quotations from Scripture . . . Embodying Most of the Palpable and Striking Self-Contradictions of the So-Called Inspired Word of God.*[3] Determinedly agnostic, Burr lived out his days in Washington, D.C., dying in 1908.

1. "William Henry Burr," *NYT*, February 29, 1908, 7.
2. "Star Beams," *Oakland Tribune*, March 16, 1903, 12.
3. The book was in its fourth edition when it was published in 1860 in New York by A. J. Davis & Co.

2

William Henry Burr (1819–1908)

The Intelligence Office

1849

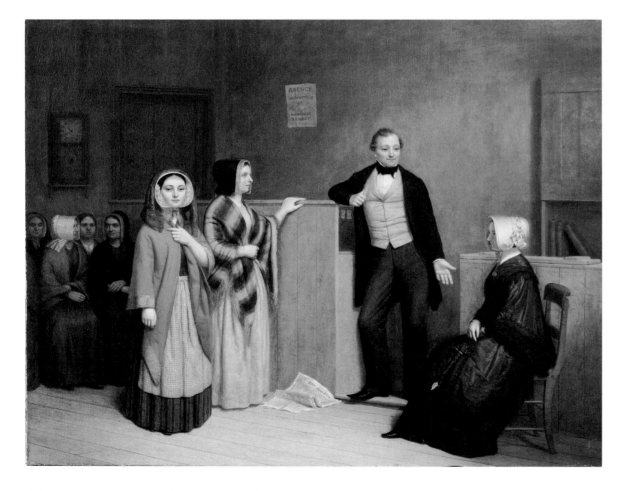

Oil on canvas, 22 × 27 in. (55.9 × 68.6 cm)
Signed lower left: *W. H. Burr*; inscribed on reverse:
 The Intelijuns Ofis / Wm Henri Bur / June 1849
Purchase, Abbott-Lenox Fund, 1959.46

For color, see page 64

William Henry Burr's depiction of a richly dressed woman inspecting prospective servants at an intelligence office—or employment agency—garnered no critical attention when it was shown at the National Academy of Design in 1850. Although the painting is roughly consonant in style with favorably reviewed paintings by other genre specialists of the time (for instance, paintings by Francis W. Edmonds), it has been suggested that *The Intelligence Office* was overlooked because American viewers found its portrayal of this aspect of social interaction unacceptable in a work of art.[1] It was not as if the subject of household help was unfamiliar in art, but the vast majority of the paintings devoted to this theme maintained an aura of gentility by restricting the imagery to the household sphere and by sometimes using humorous situations as a narrative anchor.[2] Thus, Burr's treatment of what was essentially a business transaction for hired female help was likely too realistic compared with what was more often than not dealt with humorously in cartoons that focused on the "servant problem," a phrase that was easily interpreted to mean the difficulties in managing Irish domestics.[3] The truth of the matter rested in the fact that most of the candidates for domestic jobs were drawn from the thousands of Irish immigrants who entered the United States through New York. Demand for such service was great, and by 1855 there were thirty-one thousand domestics in New York City, a workforce that ensured that one of every four households employed at least one servant.[4]

Burr's scene unfolds under a centrally positioned sign on the wall that reads, "Agent for Domestics. Warranted Honest." While the general assumption might be that it is the honesty of the applicants that is vouched for, one

might also infer that Burr was inserting a sly reference to the questionable practices of the employment broker. Intelligence offices had been licensed in New York since 1830. However, newspaper articles indicate that by the 1850s employment agency practices were hard to regulate and increasingly disreputable.[5] As one article reported, the "intelligence office blood-suckers" defrauded not only job seekers but also potential employers.[6]

Modern discussions of *The Intelligence Office* agree on Burr's allegiance to social realism, yet they sometimes hinge on relatively benign interpretations of the workings of employment agencies. The most recent analysis assumed that the central issue was the "need to trust strangers" in the hiring process (as a reflection of urban existence) and simply pointed out the "risk of admitting pretty servants into a household."[7] Granted, this issue has a bearing on the narrative Burr presents, but in light of contemporaneous associations with intelligence offices, a far darker content emerges; as one commentator put it, the job seekers were "oftentimes sent not only to service, but to sin." Among the worst of the anecdotal examples cited was the reportedly common "trick of the trade" in which the proprietors of brothels disguised themselves as future employers, thus preying on naïve and innocent girls newly arrived in the country.[8] Elizabeth O'Leary interprets the painting along these lines and speculates on the symbolic meaning that attaches to the red cloak worn by the younger, "prettier" applicant, suggesting that the color may refer to the girl's already "fallen" status.[9] In view of the expanded narrative potential of *The Intelligence Office* presented here, it is even less surprising that the painting was ignored by nineteenth-century critics and collectors.[10] —BDG

1. Johns 1991, 160: "[T]hat there were class differences at all in the constituency [the American populace] was disguised, even denied, in public rhetoric."
2. See Elizabeth L. O'Leary's excellent *At Beck and Call: The Representation of Domestic Servants in Nineteenth-Century American Painting* (Washington, D.C.: Smithsonian Institution Press, 1996).
3. See, for instance, cartoons featuring the Irish maids Bridget and Peggy in "The Miseries of Mistresses," *Harper's New Monthly Magazine* 14, no. 80 (January 1857): 286. According to Virginia Penny, *The Employments of Women: A Cyclopaedia of Women's Work* (Boston: Walker, Wise & Company, 1863), 403: "Most are raw Irish girls, who think, when they come to this country, everybody is equal. Consequently, they do not know their places as they do in the old country, where there are distinct grades in society."
4. Edwin G. Burrows and Mike Wallace, *Gotham: A History of New York City to 1898* (New York: Oxford University Press, 1999), 731.
5. "New-York City: Intelligence Offices," *NYT*, June 27, 1853, 6.
6. "Intelligence Offices—Blood-Suckers," *NYT*, July 26, 1855, 3. The article began, "It is remarkable how Intelligence Offices have multiplied in New-York within the last two years . . . now the number is but little, if any, short of a hundred."
7. See Bruce Robertson, "Stories for the Public, 1830–1860," in *American Stories: Paintings of Everyday Life, 1765–1915*, ed. H. Barbara Weinberg and Carrie Rebora Barratt (New York: Metropolitan Museum of Art, 2010), 65. Robertson mentions the possible untrustworthiness of the agent but does not pursue the topic.
8. George Ellington, *The Women of New York: or, The Under-World of the Great City* (New York: New York Book Co., 1869), 501. Although this volume was published almost twenty years after Burr executed *The Intelligence Office*, there is no reason to doubt that this manner of trickery had been in practice for decades.
9. O'Leary, *At Beck and Call*, 128, links the color with, among other things, the biblical Whore of Babylon from the book of Revelation, Nathaniel Hawthorne's *The Scarlet Letter* (1850), and the Protestant attitude that saw the Whore of Babylon as symbolic of a corrupt papacy.
10. *The Intelligence Office* was offered at auction at the American Art-Union, Artists' Sale of "very valuable and choice paintings recently selected from the studios of the Most Distinguished American and Resident Artists" to be sold without reserve by David Austen Jr. on December 30, 1852. The results of that sale are unknown at this writing (Smithsonian Pre-1877 Art Exhibition Catalogue Index).

James Henry Cafferty

(1819–1869)

Although his art is relatively unfamiliar to contemporary audiences, James Henry Cafferty enjoyed a reputation as a talented painter of portraits, landscapes, still lifes, and genre subjects.[1] One of seven children born to an Albany, New York, tailor, his early years are largely undocumented. It is believed that he may have been introduced to the arts by the portrait specialist Charles Loring Elliott (1812–1868), before moving to New York City in 1839 (by 1844 the two men were sharing studios in the Granite Building on Chambers Street).[2] After spending his first two years in New York working as a sign painter, Cafferty attended antique classes at the National Academy of Design in 1841–42 and 1842–43. His debut at the academy's annual exhibition in 1843 consisted of a portrait of the collector and amateur artist John Mackie Falconer (1820–1903), whom he probably met through his membership in the New-York Sketch Club, which he served as first vice president and later as president.[3]

From 1843 until his untimely death at fifty-one, Cafferty's paintings were regularly exhibited at the National Academy of Design and were occasionally displayed through the American Art-Union, the Brooklyn Art Association, the Artists' Fund Society, the Boston Athenæum, the Pennsylvania Academy of the Fine Arts, and the Washington Art Association. He was elected an associate member of the National Academy in 1849 and a full academician in 1853.[4] His primary reputation as a portraitist throughout the early decades

of his career is substantiated by his exhibition pattern. In 1855 an admiring writer declared, "Mr. Cafferty approaches Elliott, without being an imitator. What he paints is his own."[5] Throughout the 1840s he traveled to the Catskills and other favorite haunts of his more famous Hudson River School contemporaries, but his efforts as a landscape painter, though popular with the American Art-Union administrators, received scant encouragement from the critics. During this period he also buttressed his income by contributing illustrations to a few publications and by selling art materials.[6] His thematic interests seem to have had no bounds, and in 1858 his collaboration with Charles G. Rosenberg (1818–1879) resulted in the large street scene *Panic of 1857, Wall Street; Half Past 2 O'clock, October 13, 1857* (Museum of the City of New York). In 1858 Cafferty turned to still-life and dead game subjects, a redirection possibly spurred by the onset of poor health.

Cafferty's personality, like his style of painting, was described as "brusque."[7] Although he was apparently well liked by his colleagues, the reputation of his offhand or curt demeanor persisted. When his death was announced in one newspaper, the writer cited the cause as "dropsy superinduced by the want of care on his own part. He had always been too strong and vigorous to comprehend the danger from which he was suffering."[8] He was survived by his wife, the former Sarah Elizabeth Haight, and four children.

1. David Steward Hull, *James Henry Cafferty, N.A. (1819–1869)* (New York: New-York Historical Society, 1986), the only scholarly publication devoted to the artist, provides a brief introduction to Cafferty's career and includes an invaluable catalogue raisonné.
2. According to one obituary, "He was the intimate friend of the late Charles L. Elliott, and was one of his earliest associates in Albany"; "James H. Cafferty: Artist," *NYT*, September 9, 1869, 4.
3. See James Pipes of Pipesville, "Pipe-Stems," *Spirit of the Times*, November 20, 1852, 480, in which the writer notes that the next meeting of the Sketch Club would convene at Cafferty's studio. See also "The New-York Sketch Club," *New York Daily Times*, October 23, 1854, 2.
4. Hull, *Cafferty*, 12, gives 1850 as the year of Cafferty's election to associate status. However, Jonathan Harding gives 1849 as the election year in his entry on Cafferty in Dearinger 2004.
5. "Editor's Table," *Knickerbocker* 45, no. 5 (May 1855): 529.
6. See E. B. Burkhart, *Fairy Tales and Legends of Many Lands* (New York, 1849) and *Appleton's Illustrated Handbook of American Travel* (New York, 1857).
7. "National Academy of Design," *Home Journal*, May 10, 1851, 3: "The Style of this artist, like that of his person wears an air of brusqueness."
8. "James Henry Cafferty, N.A.," *NYH*, September 8, 1869, 2.

3

James Henry Cafferty (1819–1869)

The Sidewalks of New York

1859

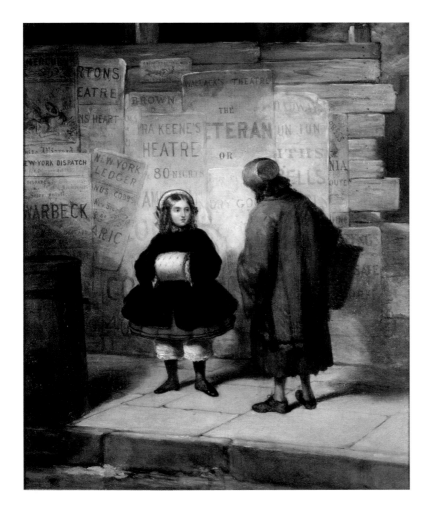

Oil on canvas, 20 × 16 in. (50.8 × 40.6 cm)
Signed and dated lower left: *JH* [in
 monogram] *Cafferty. 1859*
Purchase, 1983.39

For color, see page 65

James Henry Cafferty's *The Sidewalks of New York* (also known as *The Encounter* and *Rich Girl, Poor Girl*) underscores the yawning divide between rich and poor in antebellum New York.[1] By staging a meeting between a finely turned-out little girl and an impoverished woman on a New York street, Cafferty also graphically references the increasingly carnivalesque nature of urban life in the city, whose population had doubled over the previous decades owing mainly to the annual arrival of thousands of Irish and German immigrants.[2]

Although the scenario is an unlikely one—such a little girl would not have ordinarily walked the streets unaccompanied—the situation underscores the fact that the barriers separating social classes were breaking down and that privileged citizens were literally faced with moral dilemmas about how to deal with the poor. Yet the seed of Cafferty's inspiration for the narrative may have originated in a hoax perpetrated on the needy. When it was announced that free bread would be distributed at Union Square on November 18, 1858, hundreds of the poor, identified as predominantly Irish women, waited in the cold as operagoers arrived at a nearby theater in their finery.[3] The girl's expression suggests her trepidation (and perhaps disgust) at being confronted by the woman whose tired and humble posture implies no harm. Although it has been suggested that the woman is a beggar, her empty shopping basket indicates that she is merely one of the hungry poor who called for "work or bread."[4] It is not clear if they exchange words, but it nonetheless appears that this chance public interaction has confused the girl; she does not know how to react to what is no doubt a new experience for her.

The problem of the urban poor had intensified in the late 1850s, not only because of the flow of immigrants but also because of the Panic of 1857, an economic depression that had spurred numerous demonstrations throughout the industrial Northeast. In 1857 New York's mayor, Fernando Wood, had responded to a "Mass Petition for the Unemployed" by attempting to create jobs and housing for the poor.[5] His efforts were countered by the Association for the Improvement of the Condition of the Poor, whose policies supported strictly meted-out private aid. In the end, Wood's next electoral bid was defeated, largely by wealthy businessmen, who saw to it that the polls were closed before laborers were free to get there.[6] Cafferty's acute awareness of the social and economic consequences of the panic is undeniable given the alacrity with which he had addressed the subject in *Panic of 1857, Wall Street; Half Past 2 O'clock October 13, 1857* (Museum of the City of New York), shown at the National Academy of Design in 1858. Over the next few years, Cafferty would paint a number of street scenes featuring newsboys and beggars, most of which were reportedly commissioned or immediately purchased without having been publicly exhibited.[7]

Cafferty's use of the common device of portraying figures against a backdrop of posters may have found particular inspiration in his early experience as a sign painter. The chaotic array of advertisements not only acts as a metaphor for the unruly, destabilized social life of the city but also injects a note of irony into the content of the painting. The most legible posters publicize current or recently closed theatrical fare,

including the successful *Our American Cousin*, which ran from late 1858 to early 1859 at Laura Keene's theater; *The Veteran; or France and Algeria*, performed at Wallack's in 1859; and the English import, *Woman's Heart*, which had been performed by the play's author, Miss Vandenhoff, at Burton's Theatre on December 6, 1858. Also prominent are bills promoting popular literature, among them the *New York Ledger* announcement of the serialization of Sylvanus Cobb's *Alaric, or the Tyrant's Vault* and the *New York Dispatch*'s offering of the new story, "Warbeck."

The assortment of posters—topped by a small panel promoting racing at Centerville, Long Island, and another that promises "fun, fun" on Broadway—cumulatively deliver a message that these common, trivial enjoyments are far from the grasp of the bedraggled woman. With her back to the viewer, she remains only one of the anonymous, faceless masses whose lives were seen merely as threats to the "civility" of upper-class urban existence. —BDG

1. No contemporary reference to this painting has been located. The title used here is that provided in David Steward Hull, *James Henry Cafferty, N.A. (1819–1869)* (New York: New-York Historical Society, 1986), 35.
2. For a lively summary of the impact of immigration in New York in the 1840s and 1850s, see Edwin G. Burrows and Mike Wallace, *Gotham: A History of New York City to 1898* (New York: Oxford University Press, 1999), 735–60.
3. "A Mean Hoax," *NYH*, November 19, 1858, 1.
4. "Another Mass Meeting of Workingmen," *NYH*, November 7, 1857, 1.
5. "Important Municipal Proceedings," *NYH*, October 23, 1857, 1.
6. Burrows and Wallace, *Gotham*, 851.
7. For example, *Beggar Girl* (1861, originally owned by Robert L. Stuart, on permanent loan to the New-York Historical Society).

4

James Henry Cafferty (1819–1869) after Thomas Waterman Wood (1832–1903)

Baltimore News Vendor
1860

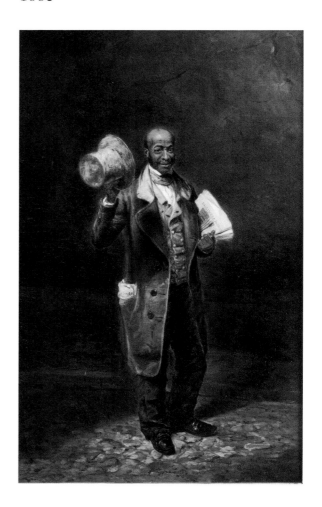

Oil on canvas, 24⅛ × 15⅛ in. (61.3 × 38.4 cm)
The Robert L. Stuart Collection, S-30

For color, see page 167

The New York collector Robert L. Stuart commissioned James Henry Cafferty to paint this copy of Thomas Waterman Wood's *Baltimore News Vendor* (1858, Fine Arts Museums of San Francisco) after Stuart lost a lawsuit against the Baltimore sugar refiner John Christian Brune for Wood's painting, which had been mistakenly sold to both men.[1] Stuart had probably spotted Wood's original in 1858, when it was displayed at the National Academy of Design, from which he purchased works by Francis W. Edmonds (see cats. 13, 14).

Wood had reportedly encountered Moses Small, the genial subject of this painting, when he moved to Baltimore in 1856. Known as "Old Moses," Small was a fixture on Baltimore streets; he sold the *Baltimore Gazette* from 1813 to 1838 and, when the *Gazette* merged with the *Baltimore Patriot*, he continued selling the *Patriot* until his retirement in 1857, after having reportedly never missed a day of work for almost five decades.[2] Thus, Wood's painting is not simply a portrayal of a familiar urban type; it is a portrait of a member of Baltimore's community of free blacks, one who was "universally respected and esteemed."[3]

Small's flamboyant, "gentlemanly" costume and ready smile must have endeared him to his Baltimore customers to whom he tipped his hat, yet his identity as an individual seems not to have registered with the New York critics, who could not resist commenting on the painting in terms of race. The reviewer for the *Independent* found it a "pleasant, smiling picture, representing the apparent anomaly of an article of merchandise selling other articles of merchandise."[4] Another described the painting's surface as "having the shining hardness characteristic of a mulatto," while yet another categorized it as a "novelty . . . a highly finished cabinet full-length of a gentleman of colour, clever and well-toned."[5] In the case of the last remark, it is impossible to tell if the writer was referring to the painting or the subject as "clever and well-toned."

While Wood's painting of Moses Small may have appealed to Brune simply because Small was a popular local figure, the reasons are less clear for Stuart's eagerness to acquire Wood's debut academy work in the early phase of his collecting activity. But there must have been something particular about the original that spurred Stuart to commission a copy once the Wood was out of his grasp. Given Stuart's satisfaction with Cafferty's copy (for which he paid the artist fifty dollars), it must be assumed that authorship was not a factor; rather, it was the image that Stuart desired. It must be noted that Cafferty's version is not an exact copy: here Small holds the *Baltimore American* (which he never sold) instead of the pro-Southern *Baltimore Patriot* that was featured in Wood's original. This change may have been motivated by specific political views, but it is not known whether Cafferty or Stuart decided to make this revision.

Stuart's attitude toward slavery was ambiguous at best. Although he supported the Union during the Civil War, his sugar-refining business depended on the labor of slaves and free blacks on Caribbean sugar cane plantations.[6] Although the bonds of union were still tenuously in place in the spring of 1858, when Wood's painting was displayed, the national debate about slavery dominated the national press throughout the country, especially after the Supreme Court's 1857 Dred Scott decision, which determined, among other things, that blacks, whether slave or free, were not eligible to be citizens of the United States. Thus, in the highly charged political atmosphere of 1858 (and 1860, when Cafferty made his copy), *Baltimore News Vendor* would have inevitably summoned associations of the ongoing national struggles as reported in the very newspapers that the elderly black man sold on the streets. For Northerners like Stuart, many of whom feared a sudden influx of blacks from the South, the painting of the courteous and deferential Moses Small had the capacity to divest the black male of the threat he ordinarily carried. Whether or not Stuart read the painting as a portrait, the painting may have reflected a comforting moral stance that validated the existence of free blacks but still kept them within the control of the industrial system on which the North depended.[7] —BDG

1. Stuart's record books show that he purchased Wood's *Baltimore News Vendor* on July 14, 1858, for one hundred dollars. See Paul Spencer Sternberger, "Portrait of a Collector and Patron: Robert Leighton Stuart," undated typescript, p. 11, N-YHS, Museum Department Files. See also Sternberger, "'Wealth Judiciously Expended': Robert Leighton Stuart as Collector and Patron," *Journal of the History of Collecting* 15, no. 2 (2003): 234–35.
2. J. Thomas Scharf, *The Chronicles of Baltimore* (Baltimore: Turnbull Brothers, 1874), 586–87. Scharf notes that Moses Small died on April 15, 1861.
3. Ibid., 587.
4. "A Last Visit to the Academy," *Independent*, June 17, 1858, 1.
5. "The National Academy of Design," *NYDT*, May 4, 1858, 6; and "Fine Arts," *Albion* 36, no. 19 (May 8, 1858): 225.
6. Sternberger, "'Wealth Judiciously Expended,'" 236.
7. For more on this issue, see Lesley Carol Wright, "Men Making Meaning in Nineteenth-Century American Genre Painting, 1860–1900" (Ph.D. diss., Stanford University, 1993), 167–69.

John Gadsby Chapman

(1808–1889)

Although John Gadsby Chapman applied himself to a range of subjects, he gained his greatest recognition for *The Baptism of Pocahantas* (1840), commissioned by Congress for the U.S. Capitol Rotunda (see fig. 18, p. 82). Also admired for his drawing skills, Chapman wrote *The American Drawing-Book*, a manual that enjoyed several printings after its initial publication in 1847.

Chapman was born and raised in Alexandria, Virginia, where he attended a local academy. Contact with the Washington, D.C.–based Charles Bird King (1785–1862) nurtured his strong interest in the arts, and before he was twenty Chapman was working as a portraitist in Winchester, Virginia.[1] In 1827 he moved to Philadelphia, where, on the suggestion of Thomas Sully (1783–1872), he studied with Pietro Ancora (act. early nineteenth century). This training proved slight, however, and with financial help from friends and commissions to copy old master paintings, in 1828 Chapman went to Rome for further study. During his three years in Italy, he associated with Samuel F. B. Morse and other Americans in residence.[2]

Chapman returned to the United States in 1831 and, after marrying Mary Elizabeth Luckett in 1832, traveled throughout Virginia painting portraits. Chapman also made landscapes featuring sites relevant to the life of George Washington. Because his ambitions were not satisfied by eking out an existence as a rural portraitist, Chapman moved to New York City about 1833, the same year he debuted at the National Academy of Design annual exhibition with a literary genre subject based on

Miguel de Cervantes's *Don Quixote* (1605, 1615). He was made a full member of the academy in 1836. He devoted much energy, however, to the lucrative field of illustrating. With his sights still set on painting great historical subjects, Chapman was successful in his campaign, through his friend Henry Wise, a Virginia congressman, to contribute a painting for the U.S. Capitol Rotunda.

Chapman maintained a hectic and productive schedule into the 1840s. In addition to writing *The American Drawing-Book*, he continued to paint and illustrate at a remarkable rate (for example, he produced 1,400 drawings for Harper's *Illuminated Bible*). His health suffered under the pressures of work, and in 1848 Chapman, his wife, and three children left for Europe. After living for a time in London, Paris, and Florence, they settled in Rome in 1850, becoming integral members of the American expatriate community. There Chapman and eventually his sons, the artists John Linton (1839–1905) and Conrad Wise (1842–1910), specialized in picturesque depictions of the Italian countryside and peasantry that particularly appealed to the American and British tourist trade. Except for two brief visits to the United States, Chapman remained in Rome for more than thirty years.

Financial problems and poor health prompted the aging Chapman (by then a widower) to return to the United States in 1884. He visited his son Conrad in Mexico in 1888 but otherwise lived out his life with his other son in Brooklyn, where he died in 1889.[3]

1. See William P. Campbell, *John Gadsby Chapman: Painter and Illustrator* (Washington, D.C.: National Gallery of Art, 1962).
2. For Chapman in Italy, see Theodore E. Stebbins Jr. et al., *The Lure of Italy: American Artists and the Italian Experience, 1760–1914* (Boston: Museum of Fine Arts, Boston, in association with Harry N. Abrams, 1992).
3. The place of his death is variously given. This entry relies on Chapman's obituary notice: "John G. Chapman," *NYT*, November 30, 1889, 5.

5

John Gadsby Chapman (1808–1889)
George Washington in His Youth
1841

Oil on canvas, 28 × 22 in. (71.1 × 55.9 cm)
Signed and dated lower right: *J. G. G. / 1841*
Bequest of Mrs. Bryan Kirby Stevens, 1930.2

For color, see page 59

Chapman, born and raised in Alexandria, Virginia, was intimately familiar with the community's close and proud ties to the first president, who considered it his hometown. Alexandrians' loyalty to Washington was only an intensified version of the esteem for the founding father and curiosity about his life felt across the nation. Biographical accounts were compiled well before his death in 1799, and Mason Locke Weems published his

very popular mythologizing *Life of George Washington* in 1800. Readers could also look to John Marshall's more authoritative biography, published serially from 1804 to 1807. Other accounts appeared regularly from the 1820s through the 1840s. Celebrations commemorating Washington's birthday began during his life and continued with fervor into the nineteenth century.

Chapman was a frequent guest at Mount Vernon and painted several portraits of Washington family members.[1] Chapman's Washington-related oeuvre constitutes a fascinating record of the man and important sites marking his life and includes *Bed Chamber of Washington in Which He Died with All the Furniture as It Was at the Time*, *View of the Birthplace of Washington*, and *Tomb of Washington* (all three, Old Print Shop, New York). He also copied a portrait of the first president by Charles Willson Peale (1834, West Point Museum, N.Y.).

Washington is best known as the leader of the Continental Army against the British forces in the American Revolution and the first president of the United States, but he also pursued a lifelong interest in geography and cartography. Beginning during his early career as a Virginia County surveyor and throughout his life as a soldier, planter, businessman, land speculator, farmer, military officer, and president, Washington relied on and benefited from his knowledge of maps. Between 1747 and 1799 Washington surveyed more than two hundred tracts of land and held title to more than sixty-five thousand acres in thirty-seven different locations.[2]

In the New-York Historical Society's painting, person and place are combined to present a foundational "prehistoric" moment. The future father of his country

is presented as a noble lad who bears the signs of future greatness. Chapman made innovative use of portrait conventions by posing his subject as if for a grand-manner portrait but placing him in an uncultivated wilderness. Washington stands with one foot elegantly extended forward, gazing into the distance. His pose emulates European models of the period for a portrait of an eminent personage. However, whereas a European would normally be seen in an elegant interior with his hand resting on a table, perhaps with a view of his estate visible through a window, here Washington's hand rests on a bare rock, and he stands in uncharted wilderness, vividly illustrated by the menacing tree roots and storm-blasted trunk to his left. Washington's sextant leans against the rock he stands on, indicating his literal role in "charting" the wilds of Virginia County. The deep space behind him, embracing a lake and mountains, suggests the vast nation he will help bring into being.

When Chapman exhibited this painting in 1841 at the Apollo Association gallery in New York, the listing in the catalogue was accompanied by an extended quotation on the founding father's early days from George Bancroft's *History of the United States*, no doubt to accommodate keen public interest in the subject.[3] Critics expressed misgivings about the young man's courtly costume and the light Rococo style of the composition; they expected more gravity from depictions of Washington, even those of his early days.[4] —KPO

1. Georgia S. Chamberlain, "John Gadsby Chapman, Painter of Virginia," *Art Quarterly* 24 (Winter 1961): 379.
2. Forrest McDonald, "George Washington," in *American National Biography* (New York: Oxford University Press, 2000), 2:758.
3. Apollo Association, *Catalogue of the Eighth Exhibition* (New York: Charles Vinten, 1841), 8.
4. "The Apollo Association," *Arcturus*, November 1841, 373; and "The Fine Arts: The Apollo Association," *NYM*, December 18, 1841, 407.

6

John Gadsby Chapman (1808–1889)

Pocahontas Saving the Life of Captain John Smith

ca. 1836–40

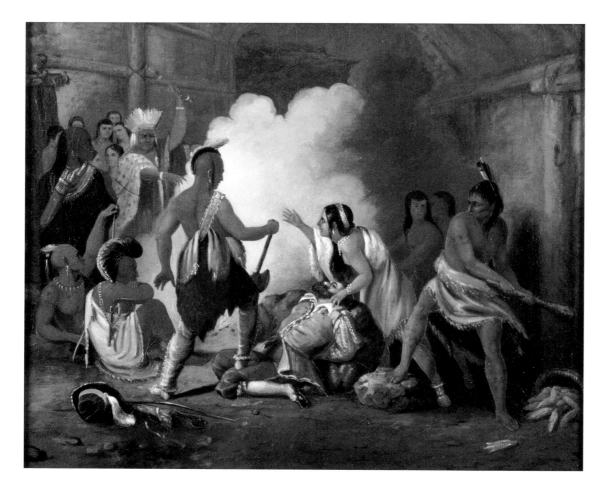

Oil on canvas, 21 × 26 in. (53.3 × 66 cm)
Gift of George A. Zabriskie, 1943.174

For color, see page 83

In 1834 a commission was announced for four murals to be placed in the Capitol Rotunda that would illustrate episodes from the nation's early history. Like many of his colleagues, John Gadsby Chapman was keenly interested in securing one of the coveted commissions.[1] In keeping with his Virginian roots, Chapman proposed a scene from the early life of the Jamestown colony, focusing on Pocahontas, daughter of the powerful Indian chief Powhatan. Her gifts of food saved the colonists from starvation, and, according to Captain John Smith's account, she rescued him from execution. Her story was familiar to nineteenth-century Americans through poems, articles in general-interest magazines, historical accounts, and paintings by such antebellum artists as Robert W. Weir and Joel Tanner Hart (1810–1877).[2]

Chapman was awarded the commission, which represents his only major historical subject. To prepare for it, the artist studied contemporary accounts of the relations between the Jamestown settlers and the Powhatan Indians and consulted his former teacher Charles Bird King (1785–1862). King had painted numerous Indian portraits, and Chapman owned at least two of them.[3] He also examined a number of purported portraits of Pocahontas.[4]

As part of his campaigning efforts, Chapman had exhibited two paintings at the National Academy of Design in 1836 that depict episodes from Pocahontas's life, *Coronation of Powhatan* and *The Warning of Pocahontas*. The New-York Historical Society's picture, *Pocahontas Saving the Life of Captain John Smith*, represents the most heroic moment of the girl's legend. Her father, Chief Powhatan, at the left, pronounces Smith's death sentence with one arm raised and the other

gesturing toward the Englishman. Smith awaits his fate; an Indian wielding an ax holds him against a rock. Pocahontas appeals to her father, leaning over the Englishman protectively. The trio of victim, executioner, and rescuer is dramatically spotlit by the fire behind them and framed by a cloud of white smoke that obscures the deeper space of the hut and the outdoors.

The figures show widely varied degrees of finish. Pocahontas, Smith, and the executioner wear colorful, carefully detailed costumes. Powhatan wears the beginnings of an elaborate cape and headdress. Other figures are more cursorily rendered, particularly the three Indians in profile at the left. This painting is smaller than Chapman's other Pocahontas subjects, and he did not exhibit it, as he did the others. It may have been an early idea for the mural, before the artist turned to the subject of Pocahontas's baptism into the Christian faith. Indeed, when the mural was unveiled, critics wondered why Chapman had not chosen this earlier incident, but Chapman may have known that the event was already present in the Capitol Rotunda in the form of a relief sculpture by Antonio Capellano (1780–1840).[5]

The Baptism of Pocahontas (see fig. 18, p. 82) was completed in 1840 and pictures the culmination of the Indian maid's virtuous acts. Chapman may have chosen the subject to provide a reassuring example to a public anxious about present-day problems surrounding the assimilation of Indian populations. During the 1830s the American public had witnessed the forced removal of tens of thousands of Native Americans from their native lands in the migration known as the Trail of Tears. Subjects such as Chapman's suggested that the Indian was instinctively capable of goodness and could be redeemed by conversion to Christianity.[6] Pocahontas's later life bore out the possibility of assimilation into white society. She converted to Christianity and took a Christian name, Rebecca. She married a white man, John Rolfe, traveled to England, and was presented at court. She died in England, leaving her son Thomas, who returned to North America and became a successful businessman. The brochure accompanying the finished mural said of Pocahontas, "She stands foremost in the train of those wandering children of the forest who have . . . been snatched from the fangs of a barbarous idolatry, to become lambs in the fold of the Divine Shepherd."[7] —KPO

1. The other commissions resulted in John Vanderlyn's *Landing of Columbus* and Robert Weir's *Embarkation of the Pilgrims*. Henry Inman received a commission as well but did not live to fulfill it. He was replaced by William Henry Powell, who painted *The Discovery of the Mississippi*.
2. See the Smithsonian American Art Museum Art Inventories Catalog (http://www.siris.si.edu) for examples of paintings. A small sampling of poems includes L[ydia] H[oward] Sigourney, *Pocahontas*, in *Pocahontas and Other Poems* (New York: Harper & Bros., 1841); *Virginia: or, The Fatal Patent. A Metrical Romance in Three Cantos* (Washington, D.C.: Davis & Force, 1825); and Oliver Prescott Hiller's *Pocahontas, or, The Founding of Virginia; A Poem in Three Cantos* (London: Hatchard and Co.; New York: Mason Brothers, 1865).
3. *The Picture of The Baptism of Pocahontas* (Washington, D.C.: Peter Force, 1840); and Georgia Stamm Chamberlain, *Studies on John Gadsby Chapman* (Annandale, Va.: Turnpike Press, 1963), 18. Chapman was listed as the owner of King's portraits *Eagle's Delight* and *Young Omahaw, War Eagle, Little Missouri, and Pawnees* when they were exhibited at the National Academy of Design in 1837 and 1838, respectively.
4. Faith Andrews Bedford, "The Baptism of Pocahontas," *Antiques* 168 (January 2009): 142.
5. Ibid., 141.
6. Chamberlain, *Studies on Chapman*, 18–19. A prominent later example is Erastus Dow Palmer's *The Indian Girl, or the Dawn of Christianity* (1856, The Metropolitan Museum of Art).
7. *The Picture of The Baptism of Pocahontas*, 3, 5.

Thomas Cole

(1801–1848)

Celebrated as a founder of the Hudson River School of landscape painting, Thomas Cole aspired to what he called "a higher style of landscape" that would elevate the minds and taste of viewers by conveying essentially conservative religious and political ideals in an allegorical mode.[1] His passion for nature was linked with his fears for the future of America, about which he wrote eloquently in essays and poetry.[2]

Cole was born in Bolton-le-Moor, Lancashire, England, son of a muslin manufacturer. After attending boarding school, the fourteen-year-old Cole went to work as an engraver for a calico manufacturer, but when his father's business failed in 1818, the family went to the United States. By then, Cole had his mind set on a career as an artist. To that end, he worked as an engraver in Philadelphia and an itinerant portrait painter in the area around Steubenville, Ohio, where his family had settled, and schooled himself by reading art instruction manuals and drawing from antique casts at the Pennsylvania Academy of the Fine Arts, where he exhibited a landscape in 1824.

He moved to New York City in 1825 and that summer made his first sketching trip along the Hudson River. His early Hudson River landscapes were purchased by John Trumbull (1756–1843), William Dunlap, and Asher B. Durand, whose joint "discovery" of Cole set him on the path that led to his eventual reputation as America's foremost landscape painter. He began exhibiting at the American Academy of the Fine Arts (of which Trumbull was president) and soon attracted the patronage of such important collectors as Robert Gilmor Jr. and Daniel Wadsworth. He was able

to count among his friends and colleagues the writer-editor William Cullen Bryant and the lawyer-politician Gulian Crommelin Verplanck. He was a founding member of the National Academy of Design (in 1826) and the Sketch Club (in 1829).

Already strongly influenced by European aesthetics—namely the pastoral qualities characterizing the art of Claude Lorrain (1600–1682) and the sublime elements found in the work of Salvatore Rosa (1615–1673)—Cole furthered his course of self-education with a trip to Europe, where, from 1829 to 1832, he spent time in England, France, and Italy. Shortly after returning to the United States, he received his first commission from Luman Reed, whom Cole soon persuaded to commission the five-painting series *The Course of Empire* (1834–36, The New-York Historical Society). The public exhibition of the series in 1836 brought Cole critical and public adulation. That same year Cole married Maria Bartow, settled permanently in the town of Catskill, and published his now famous "Essay on American Scenery."

He made a second trip to Europe in 1841, again visiting England and France, and spending most of his time in Rome. Returning to Catskill in 1842, he received poor financial returns from exhibitions in New York and Boston featuring his recent Italian landscapes. Increasingly disillusioned by America's dearth of moral fortitude and deficiencies in taste, Cole nonetheless persisted in painting historicized landscapes that conveyed moralizing and religious content. The demand for this type of art, however, was in decline, and his last efforts along these lines met with disappointment. He died in Catskill in 1848.

1. See Ellwood Parry III, *The Art of Thomas Cole: Ambition and Imagination* (Newark: University of Delaware Press, 1988).
2. See Marshall B. Tymm, *Thomas Cole's Poetry* (York, Pa.: Shumway, 1972).

7

Thomas Cole (1801–1848)

Landscape (*later known as* Moonlight)

ca. 1833–34

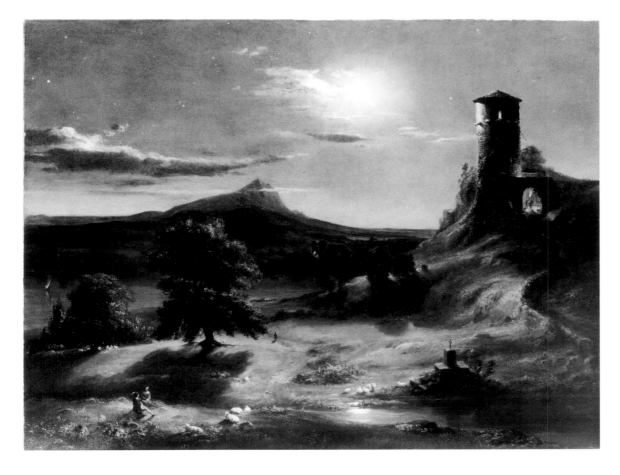

Oil on canvas, 24⅝ × 31¾ in. (62.5 × 80.6 cm)

Gift of The New-York Gallery of the Fine Arts,
 1858.31

For color, see page 42

This nocturnal scene was one of seven paintings by Thomas Cole on display at the 1834 annual exhibition of the National Academy of Design.[1] The Romantic landscape, replete with medieval tower and trysting couple, was patently imaginary and stood in marked contrast to the painter's Catskill and Italian views. The poetic origins of Cole's mystery-laden image were confirmed by the accompanying text in the exhibition catalogue—the opening stanza from "Parisina," a poem by Lord Byron from 1816:

> It is the hour when from the boughs
> The nightingale's high note is heard;
> It is the hour when lover's vows
> Seem sweet in every whispered word;
> And gentle winds and waters near,
> Make music to the lonely ear.
> Each flower the dews have lightly wet,
> And in the sky the stars have met,
> And on the wave is deeper blue,
> And on the leaves a browner hue,
> And in the heaven that clear obscure
> So softly dark, and darkly pure,
> Which follows the decline of day,
> As twilight melts beneath the moon away.[2]

According to the *American Monthly Magazine*, the painting was "the chef d'oeuvre, the gem of the exhibition," and Byron's lines were "a picture, [and] the picture which is designed from them is poetry."[3]

The title of Byron's poem from which the lines were taken—"Parisina"—was not provided in either the exhibition catalogue or the review cited here. This omission, it seems, was founded on matters of taste and the contemporaneous tendency to commingle the

bizarre facts of Byron's life with the often seductive and violent themes he addressed. Byron's personal affairs were considered debauched and immoral by many American and English readers who found it difficult to reconcile their moral affront with their admiration for him as a man of letters. "Parisina" was particularly problematic in this vein; even Byron did not attach his name to it when the poem was first published in 1816.

"Parisina" was based on the historical events surrounding the lives of Niccolò III d'Este of Ferrara and his second wife, the fifteen-year-old beauty Parisina Malatesta. The young wife found herself in charge of Niccolò's eight children and fell in love with the eldest, the handsome and valiant fourteen-year-old Hugo. The couple's illicit love was discovered, and the two were beheaded by the wronged husband-father. Although Byron made several modifications to this tragedy (for instance, changing the duke's name from Niccolò to Azo and making the nature of Parisina's ghastly death ambiguous), the poem's themes of incest (as it was then understood) and violent retribution provoked mixed reactions. On the one hand, shortly after "Parisina" appeared in print, a commentator for the English publication the *Eclectic Review* wrote, "Our objections, however, originate rather in taste than respect for morality. The subject of the tale is purely unpleasing, and the manner in which it is treated does not reconcile us to it."[4] In the United States, on the other hand, the reception of Byron's writings was governed by morality, with one writer declaring, "[A]lmost the whole mass of Lord Byron's writings is, in one way or another, tainted with immorality."[5]

In light of the strong feelings generated by Byron's life and work, Cole's use of the Parisina theme was tantamount to a subversive challenge to standard assumptions concerning taste. Although his visual language corresponded with works by highly esteemed modern masters ranging from Washington Allston's 1819 *Moonlight* (Museum of Fine Arts, Boston) to John Constable's *Hadleigh Castle: The Mouth of the Thames—Morning after a Stormy Night* (1829, Yale Center for British Art, New Haven), his veiled references to horrific content negated the ideal of refinement that contemporary theorists required for the creation of a great work of art. Despite the absence of overt narrative elements in the painting (and the failure to name "Parisina" specifically), the fiery glow emanating from the castle interior invests the otherwise innocuous image with an insistent feeling of apprehension. The narrative potential of the hellish light at the base of the tower was ignored, however, and it was only remarked as being "at variance with the character of the piece."[6]

It is impossible to know whether the reviewer(s) ignored or were ignorant of the dreadful events that would unfold for the lovers pictured, but in view of the frequency with which Byron entered the American cultural consciousness, it is most likely that acknowledgment of the ultimate fate of the couple would be unseemly. As Byron himself admitted, "I am aware that in modern times the delicacy or fastidiousness of the reader may deem such subjects unfit for the purposes of poetry."[7] Whatever the case, the critic for the *American Monthly Magazine* was certain that "[w]hoever shall hereafter become its owner, will possess a picture of rare, and on this side of the Atlantic, unsurpassed excellence."[8] By 1836 the painting was in the collection of Luman Reed, listed in his inventory as *Moonlight*. —BDG

1. The others were *View of the Protestant Burying-Ground at Rome; Head of a Deer; Sunset—View on the Catskill; The Titan's Goblet; Italian Scene;* and *Dead Abel.*
2. The stanza was also included in the review of the painting, "Miscellaneous Notices of the Fine Arts, Literature, Science, the Drama, &c. National Academy of Design: 9th Exhibition, 1834," *American Monthly Magazine* 3 (May 1, 1834): 212.
3. Ibid.
4. *Eclectic Review* (London), n.s., 5 (January–June 1816): 273.
5. A. H. Everett, *North American Review* 20, nos. 12–13 (January 1825), quoted in H. L. Kleinfield, "Infidel on Parnassus: Lord Byron and the North American Review," *New England Quarterly* 33, no. 2 (June 1960): 172.
6. "Miscellaneous Notices."
7. *The Works of Lord Byron Complete in One Volume* (Frankfurt am Main: H. L. Brönner, 1826), 126.
8. "Miscellaneous Notices."

William Dunlap

(1766–1839)

A central figure in Knickerbocker New York, William Dunlap was active as an artist, playwright, and historian. He is remembered especially as the author of *A History of the American Theater* (1832) and *A History of the Rise and Progress of the Arts of Design in the United States* (1834), valuable resources for the study of American culture.[1]

Born in Perth Amboy, New Jersey, William was the only child of the merchant Samuel and Margaret (née Sargent) Dunlap. Dunlap's education was episodic, shaped by the exigencies of the Revolution and an accident at the age of twelve that caused the loss of his right eye. In 1777 his loyalist father moved the family to British-held New York City, where the youth briefly attended school. Despite his impaired vision, Dunlap aspired to a career as an artist, and his father supplied him with the requisite materials and supported his occasional study with Abraham Delanoy (1742–1795) and William Williams (1727–1791). Committed to portraiture by 1782, Dunlap made a pastel portrait from life of George Washington (1783, United States Capitol).

Samuel Dunlap sent William to England in 1784 for formal training with Benjamin West. In 1787, after three years of what the young Dunlap called a "life of unprofitable idleness," he returned to New York. Because portrait commissions were infrequent, he turned to writing plays. His *The Father; or American Shandyism* was first performed at the John Street Theatre in 1787. When he married Elizabeth Woolsey in 1789, Dunlap joined his father's business. Between 1789 and 1805 Dunlap was active in the theater world, acquiring an interest in the Old American Company, of which he subsequently became sole proprietor during the company's residence at the Park Theatre. Under Dunlap's aegis, the company staged numerous foreign productions in translation as well as his own plays. The company went into bankruptcy in 1805, and Dunlap moved his family to Perth Amboy (his only remaining property) and resumed painting.

Dunlap's renewed activity as a painter signaled a period of itinerancy during which he sought portrait commissions, but he was back in New York in 1806, lured by the offer to manage the resuscitated Park Theatre, which he did until 1811. His consistently precarious finances prompted his return to portrait painting in 1812. In the 1820s Dunlap produced several large religious paintings (now lost), which he sent on tour. Throughout the second and third decades of the century, Dunlap became increasingly involved in the fine arts. He exhibited at the American Academy of the Fine Arts (where he was keeper and librarian from 1818 to 1819) but severed his connections with the institution when the National Academy of Design was founded in 1826. Dunlap served the latter organization as council member, professor of historical composition, and vice president.

In addition to his histories of American art and theater and thirty plays, Dunlap wrote novels and biographies of the actor George Frederick Cooke (1756–1812) and Charles Brockden Brown (1771–1810), a friend and man of letters. He also contributed substantially to the growing body of art commentary that appeared in newspapers and periodicals during the 1820s and 1830s. Plagued with increasingly poor health, he resigned from administrative duties in the National Academy of Design in 1838. He died from a stroke in 1839.

1. Dunlap 1834 and *The Diary of William Dunlap (1766–1839): The Memoirs of a Dramatist, Theatrical Manager, Painter, Critic, Novelist and Historian*, transcribed and ed. Dorothy C. Barck (New York: New-York Historical Society, 1930) are the foundation for Dunlap studies. See also Oral S. Coad, *William Dunlap: A Study of His Life and Works and of His Place in Contemporary Society* (New York: Dunlap Society, 1917); and Maura Lyons, *William Dunlap and the Construction of an American Art History* (Amherst: University of Massachusetts Press, 2005).

8

William Dunlap (1766–1839)

The Artist Showing a Picture from "Hamlet" to His Parents

1788

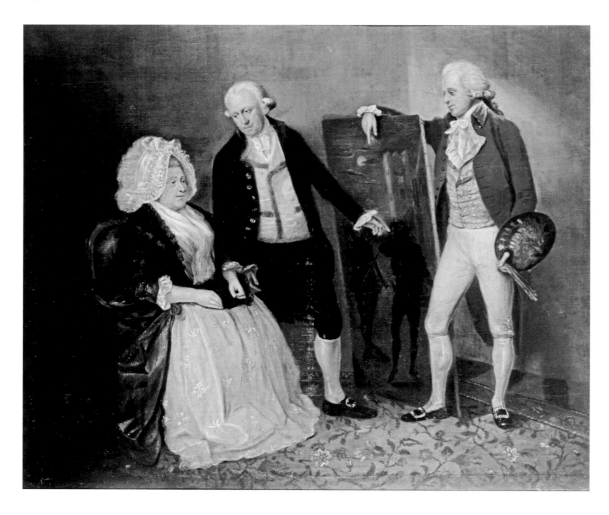

Oil on canvas, 42¼ × 49 in. (107.3 × 124.5 cm)
Gift of John Crumby, 1858.87

For color, see page 34

William Dunlap was barely twenty-two years old when he executed this painting, yet there is no documented exhibition of the work until 1833, when it was included in the annual display of the National Academy of Design. By then, the painting had become a souvenir of his distant youth and was recognized as such by the critic for the *New York Mirror*, who, comparing it with two of the artist's recent portraits hanging above it, stated, "This exhibits his attainment in the art almost half a century ago. Here we see the costume of the year in which our invaluable constitution was adopted. Such pictures are historical documents." Nevertheless, the writer admitted that the painting "has merit as a composition as well as a record."[1]

Here Dunlap adopted the conversation piece convention that blended portraiture and narrative, presenting the sitters in an extended context. He had returned from his studies in England the previous year and had spent much of his time since then seeking commissions unsuccessfully from a studio in his father's New York home, where he created this relatively ambitious and highly personal work. The painting, as its title indicates, depicts the artist's parents, Samuel and Margaret Dunlap, to whom the young palette-wielding Dunlap demonstrates his artistic progress as represented in a canvas illustrating the ghost scene from Shakespeare's *Hamlet*. Lacking the richness of detail found in the conversation pieces of William Hogarth (1697–1764) and Johann Zoffany (1733–1810), the composition seems to echo the almost "democratic" simplicity displayed in such works as Matthew Pratt's *The American School* (1765, The Metropolitan Museum of Art) and Benjamin West's *The Artist's Family* (ca. 1772, Yale Center for British Art,

New Haven).[2] In a sense, the triple portrait
functions as an ironic apology to his parents
inasmuch as Dunlap admittedly neglected his
studies under Benjamin West in England and
squandered the opportunity financed by his father
with long evenings attending the theater (alluded to
in the Hamlet subject) and socializing.[3] On one
level, the father-son theme is central and
established compositionally by the gestures linking
Samuel and William, whose left and right hands
(respectively) are enclosed within the artistic sphere
of the painting-within-the-painting, the content of
which hinges on Prince Hamlet's conflicts arising
from his father's death. Samuel Dunlap's role is one
of mediation, for he points out features of the
painting to his relatively inexpressive wife, as if to
validate their son's vocation. In broader terms,
however, the present work embraces the belief in
the necessity of absorbing European tradition and
applying it to American art—with respect not only
to the visual arts but also to literature and the
theater.[4] —BDG

1. "The Fine Arts. National Academy of Design. Fourth Notice,"
 NYM, June 8, 1833, 387.
2. See Kate Retford, *The Art of Domestic Life: Family Portraiture in
 Eighteenth-Century England* (New Haven: Yale University Press,
 for the Paul Mellon Centre for Studies in British Art, 2006).
3. See Dorinda Evans, *Benjamin West and His American Students*
 (Washington, D.C.: Smithsonian Institution Press, for the
 National Portrait Gallery, 1980), 111–12.
4. See Maura Lyons, *William Dunlap and the Construction of an
 American Art History* (Amherst: University of Massachusetts
 Press, 2005), esp. 55–87.

Asher B. Durand

(1796–1886)

Asher B. Durand first attained success as one of the nation's foremost engravers and then as the most enduring painter-practitioner of the Hudson River School landscape aesthetic. As he made the shift from engraver to landscape painter, he produced a considerable number of fine portraits and genre subjects, thus proving himself one of the most versatile artists of his generation.

Durand was born in Jefferson Village (now Maplewood), New Jersey, the eighth child of John and Rachel Meyer Durand.[1] He left his father's farm in 1812 to begin a five-year apprenticeship with the Newark-based engraver Peter Maverick (1780–1831). In 1817, at the end of his training, Durand joined Maverick's firm, opening a branch of the business in New York City. The partnership dissolved in 1820, precipitated by a dispute between the two over Durand's acceptance of an important commission from John Trumbull (1756–1843) to engrave Trumbull's *Declaration of Independence*, the 1823 publication of which established Durand as a master engraver.

Durand's engraving activity (which also included his partnership in A. B. & C. Durand, Wright & Co., a printing and banknote engraving company) placed him in contact with the leaders of the New York art community. In 1825 he was among the artists who formed the New York Drawing Association, which in 1826 became the National Academy of Design, an institution at which he would regularly display his art and which he would serve as president from 1845 to 1861. In 1829 he was a founding member of the Sketch Club, the parent organization of the Century Association. Although he had experimented in oil

painting early in his career and began displaying his canvases in the 1820s, it was not until 1836 that he was listed as a portrait painter in the New York City directory. By then he had benefited from the patronage of the merchant and collector Luman Reed.

Durand began to focus on landscape subjects in the 1830s, spurred by the work of his friend Thomas Cole with whom he was particularly close throughout the decade. With the exhibition of nine landscapes at the National Academy of Design annual in 1838, Durand firmly declared his commitment to that specialty and thereafter would rarely deviate from the subject. In 1840, at the age of forty-three, Durand embarked on his only trip to Europe. After arriving in England, he visited France, Holland, Belgium, Germany, Switzerland, and Italy, often in the company of Francis W. Edmonds and his former student John William Casilear (1811–1893). After a year in Europe, Durand returned to the United States to settle into a relatively fixed routine of spending summers sketching in the Catskills, Adirondacks, or the White Mountains, and winters painting in his New York studio. His opinions regarding the relationship of art and nature were summarized in a nine-part series, "Letters on Landscape Painting," published in the *Crayon* in 1855. From the time of Cole's death until his 1869 retirement to the New Jersey farm of his birth, Durand retained his position as one of the country's leading landscapists. With the exception of family tragedies over the years (including the 1830 death of his first wife, Lucy Baldwin, whom he had married in 1821, and the 1857 death of his second wife, Mary Frank, whom he had married in 1840), Durand's life was

relatively tranquil. He died at home in Maplewood, New Jersey, at the age of ninety.

1. Key sources on Durand are John Durand, *The Life and Times of A. B. Durand* (1894; New York: Kennedy Graphics, 1970); David B. Lawall, "Asher Brown Durand: His Art and Art Theory in Relation to His Times" (Ph.D. diss., Princeton University, 1966); and Linda S. Ferber, ed., *Kindred Spirits: Asher B. Durand and the American Landscape* (New York: Brooklyn Museum, in association with D Giles Limited, London, 2007).

OPPOSITE: CAT. 9, detail

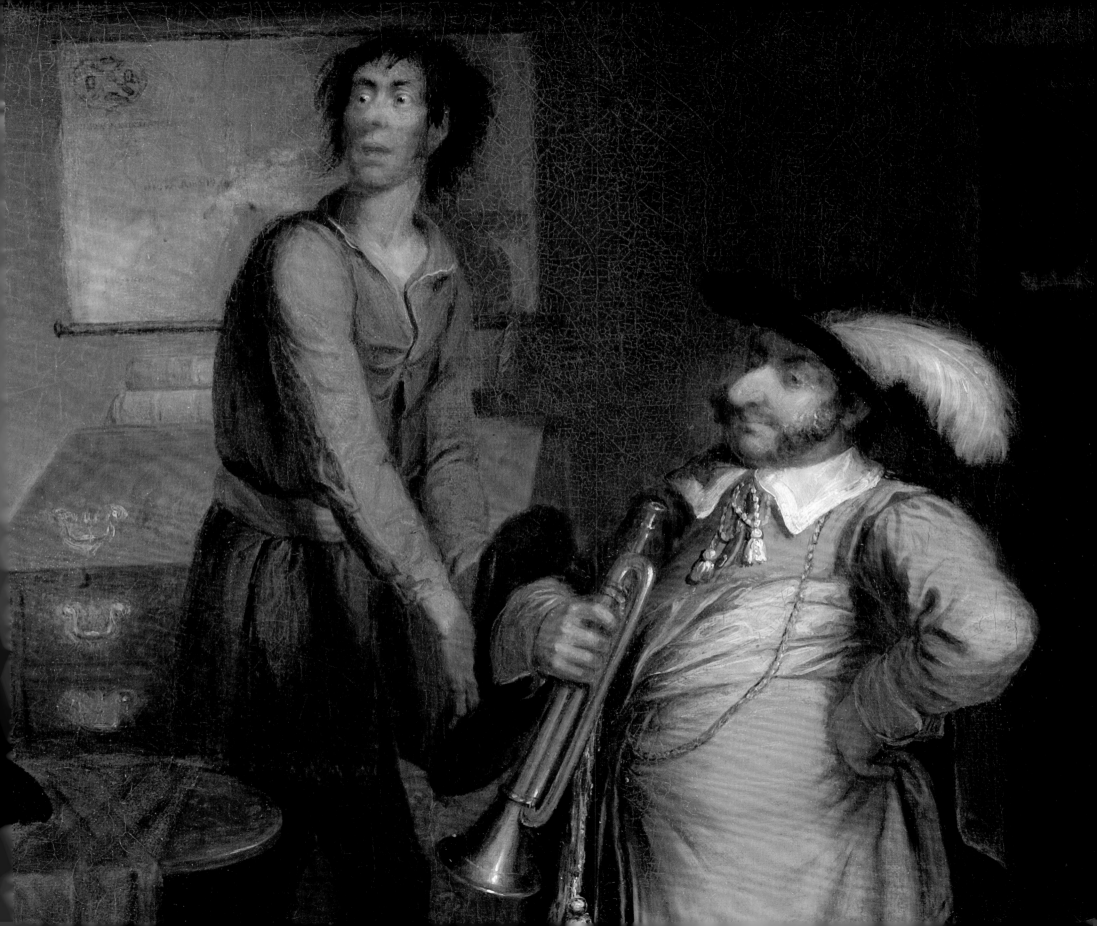

9

Asher B. Durand (1796–1886)

Peter Stuyvesant and the Trumpeter

1835

Oil on canvas, 24¼ × 30¼ in. (61.5 × 76.8 cm)
Gift of The New-York Gallery of the Fine Arts,
 1858.28

For color, see page 37

Peter Stuyvesant and the Trumpeter, Durand's first
major effort in literary genre painting, was created for
the merchant and art collector Luman Reed. The artist's
career was in flux at the time; he was shifting his focus
from engraving to oil painting and experimenting with
various genres as he sought a subject specialty.

 The painting depicts an episode from Washington
Irving's famed 1809 satire, *A History of New York, from
the Beginning of the World to the End of the Dutch
Dynasty*, written under the pseudonym Diedrich
Knickerbocker. Filled with high drama bordering on the
burlesque, Durand's interpretation matches Irving's text
in mood and detail in its portrayal of the Dutch colonial
governor's rage on receiving the information that the
Dutch Fort Casimir (near what is now Wilmington,
Delaware) had been captured by a Swedish contingent.
The furious Peter Stuyvesant dominates the left side of
the composition, while on the right, Dirk Schuyler (who
delivered the news) shrinks in fear, and the corpulent
trumpeter Anthony Van Corlear awaits Stuyvesant's
order to summon the council. In addressing this subject,
Durand not only allied himself with the nascent school
of American genre painting but also publicly affiliated
himself with an influential circle of Knickerbocker New
York writers, artists, and publishers, whose collective
cultural identity derived its name from Irving's
pseudonymous Diedrich Knickerbocker.[1]

 The topic was clearly of Durand's choosing; Luman
Reed wrote to William Sidney Mount in September
1835, "Durand has a picture in hand for me but I have
not seen it nor do I know the subject."[2] Evidence of
Reed's satisfaction with the work is found in subsequent
letters to Mount, in which he declared the painting "very

excellent" and "a great stride for the first attempt [at genre]."[3] Even without consulting Reed on the subject, Durand could calculate with some assurance that an episode from Irving's landmark *History* would guarantee success. Irving's popularity had soared with his 1832 return to the United States after a seventeen-year absence in Europe. Hailed as a national hero for validating American literature in the eyes of Europeans, his very presence on American soil precipitated a wave of articles in the press and inspired artists and playwrights to mine his writing for subject matter.[4] Durand is likely to have been aware of Reed's personal relationship with Irving, who is known to have visited the collector's gallery in 1835.[5] What is more, another recipient of Reed's patronage—the actor James Henry Hackett—had portrayed Stuyvesant, or "Peter the Headstrong," on the New York stage in 1834.[6]

Peter Stuyvesant and the Trumpeter was shown at the 1836 exhibition of the National Academy of Design, along with five other paintings by Durand, including a portrait of Reed and *The Pedlar* (cat. 10), a work that was also in Reed's collection. It was the Knickerbocker subject that received the bulk of the commentary devoted to Durand. As usual, the *New York Mirror*, headed by Knickerbocker writer George Pope Morris, bestowed the most approving of the reviews and described the painting as "richly-coloured and strongly designed . . . full of the spirit of fun which pervades the work it tends to illustrate." Yet even that critic (possibly Morris himself) qualified his praise: "It is questionable with us, whether a character of historical merit, and well known as such, should be made the subject of the grotesque either in writing or painting."[7] The writer's

discomfort with respect to the grotesque elements he perceived in both Irving's and Durand's imagery is symptomatic of the unresolved state of the youthful nation's notions of what its art should be. Even Irving had second thoughts about the tone and content of Knickerbocker's *History* and admitted to Washington Allston (1779–1843) that he would "conceive the scenes in a much purer style" and adjust the measure of "grossierté [coarseness]" that defined his humor.[8] It is not known if Durand entertained similar sentiments, but *Dance on the Battery in the Presence of Peter Stuyvesant* (1838, Museum of the City of New York)—his second painting based on the *History*—reveals an approach to the human figure that is less caricatured and closer in manner to the work of the revered Scottish painter Sir David Wilkie (1785–1841). —BDG

1. For the Knickerbocker circle, see James T. Callow, *Kindred Spirits: Knickerbocker Writers and American Artists, 1807–1855* (Chapel Hill: University of North Carolina Press, 1967).
2. Reed to Mount, September 24, 1835, quoted in Koke 1982, 301.
3. Reed to Mount, October 29, 1835, and Reed to Mount, November 23, 1835, both quoted in ibid.
4. Other artists whose imagery was derived from Irving's narratives were Henry Inman (1801–1846), John Quidor (1801–1881), and John Whetten Ehninger (see cat. 15).
5. Reed to Mount, December 11, 1835, quoted in Alfred Frankenstein, *William Sidney Mount* (New York: Harry N. Abrams, 1975), 72.
6. "Knickerbocker upon the Stage at Last!" *NYM*, February 1, 1834, 247. See also cat. 17.
7. "The Fine Arts: National Academy of Design; Fourth Notice," *NYM*, June 4, 1836, 390.
8. Irving to Allston, May 21, 1817, quoted in Sarah Burns, *Painting the Dark Side: Art and the Gothic Imagination in Nineteenth-Century America* (Berkeley: University of California Press, 2004), 105.

10

Asher B. Durand (1796–1886)

The Pedlar

1836

Oil on canvas, 24 × 34½ in. (61 × 87.6 cm)
Gift of The New-York Gallery of the Fine Arts,
1858.26

For color, see page 131

The second of Asher B. Durand's genre subjects painted for Luman Reed, *The Pedlar* reveals the painter's assimilation of Dutch and British traditions, which he then infused with a distinctly American perspective.[1] As a relative newcomer to genre painting, Durand was surely conscious of the need to create a work that would satisfy the taste of his patron and demonstrate his competitiveness in the growing market for genre subjects, recently spurred by the emergence of William Sidney Mount as a specialist in that field.

Like Mount, Durand took inspiration from seventeenth-century Dutch paintings of domestic interiors as well as from the rustic genre subjects of the Scottish painter Sir David Wilkie (1785–1841), engraved examples of which were readily available in America in the 1820s and 1830s.[2] The artist's son John stated that *The Pedlar* was "a picture of local life suggested by Wilkie's treatment of similar subjects," and, as Timothy Anglin Burgard has further suggested, it was James Stewart's (1791–1863) print after Wilkie's *The Pedlar* (1814) that may have directly influenced Durand's portrayal of an itinerant pedlar displaying his goods to, in this case, a rural family.[3] Regardless of its immediate source, Durand's *The Pedlar* also reiterates the general formula adopted by contemporaneous American artists for presenting groups of people enclosed in domestic interiors and even includes the almost ubiquitous black servant who hovers at the doorway. Here, however, the friezelike arrangement of men, women, and children in a sparsely furnished farmhouse betrays Durand's inexperience in handling multifigure compositions.

Durand probably banked on the possibility that the pedlar theme would suit Reed, hoping that it would bring to his patron's mind fond thoughts of his early life in rural upstate New York, where Reed's father had briefly gone door to door selling his wares. Then, too, Reed's interest in theater, where the pedlar had entered the common currency of Yankee types that populated American productions, may have influenced Durand's choice of theme.[4] In any case, in an era marked by strong nationalist trends, the revision of European pedlar imagery into a distinctly American idiom was popular and pervasive. The actor George Handel Hill's performances as Zechariah Dickerwell in William Boyle Bernard's several variants of *The Yankee Pedlar—or Old Times in Virginia* drew frequent note. In fact, Hill eventually was known as "Yankee Hill" and came to epitomize the Yankee pedlar in the public mind. Comic, shrewd, and boisterous, the Yankee pedlar was soon stereotyped as a spinner of yarns told to distract his customers. A description of Hill's rendition of the pedlar vividly defined the character "as the essence of humbug,—the knave, *par excellence*, the visible spirit of chicane,—simplicity dipped in the profound of roguery— a pedlar as much exceeding the European professors of the art, as the benefit of a soil congenial to trickery, aided by perpetual practice, can enhance a talent originally made for the perfection of swindling."[5] A similar account of the pedlar type had appeared in a volume of cartoons and humor in 1831: "There is no person that can describe an incredible fact with greater plausibility than a Yankee pedlar. His difficult profession teaches him to preserve an iron gravity in expatiating on his wares, which in few cases can be said to recommend themselves."[6]

Durand seems to have tapped into this stereotype. With a sly smile and sidelong glance, the pedlar gestures to his wares while regaling his audience with the value of his offerings. The children appeal to their parents, clearly excited by the prospect of getting a toy or bauble. The elder daughter catches her mother's eye, looking for approval to purchase the fabric that she imagines will make a lovely dress. Despite the hubbub around them, the master and mistress of the house seem immune to the pedlar's patter, an attitude of indifference that is heightened by the grandmother's complete disregard of the goings-on. Thus, as entertaining as the pedlar may be, the painting actually praises the common American's ability to see through the "essence of humbug."

The Pedlar was shown at the 1836 annual exhibition of the National Academy of Design, where, with *Peter Stuyvesant and the Trumpeter* (cat. 9), this "scene of American country life" confirmed the wisdom of Durand's decision to abandon the graver for the paintbrush.[7] —BDG

1. Unless otherwise indicated, the information provided here relies on Timothy Anglin Burgard's excellent entry for the painting in Foshay 1990, 148–49.
2. See Catherine Hoover, "The Influence of David Wilkie's Prints on the Genre Paintings of William Sidney Mount," *American Art Journal* 13 (Summer 1981): 4–33.
3. John Durand, *The Life and Times of A. B. Durand* (1894; New York: Kennedy Graphics, 1970), 120.
4. See Francis Hodge, *Yankee Theatre: The Image of America on the Stage, 1825–1850* (Austin: University of Texas Press, 1964).
5. Reuben Percy, "The World We Live In," *Mirror of Literature, Amusement and Instruction* 28 (1836): 394.
6. Henry James Finn, *American Comic Annual* (Boston: Richardson, Lord and Holbrook, 1831), 146.
7. "The Fine Arts: National Academy of Design," *NYM*, April 2, 1836, 318.

11

Asher B. Durand (1796–1886)

Sunday Morning

1839

Oil on canvas, 25¼ × 36¼ in. (64.1 × 92.1 cm)
Signed and dated lower left: *A B Durand / 1839*;
 inscribed on back of canvas in artist's hand:
 Presented to my Wife / Mary F Durand / 1840
Gift of the children of the artist, through John
 Durand, 1903.3

For color, see page 112

Asher B. Durand's meditation on rural American life came in the early years of his painting career and combined his experiments in genre subjects with his growing interest in landscape. Here, he depicts a family whose members range in age from an elderly grandfather to a boy stopping to tie his shoe. The brightly lit figure of a young man gestures to a dim and winding path leading to a church that shimmers in the distance like a heavenly apparition. Farther down the road, other churchgoers approach the threshold.

This was the first of several instances in which Durand overtly addressed the role of nature in Sabbath observance, a theme that Linda Ferber has identified as "pastoral piety."[1] In this work and such others as *Early Morning at Cold Spring* (1850, Montclair Art Museum, N.J.) and *Sunday Morning* (1860, New Britain Museum of American Art, Conn.) Durand focused on the distance between the human figure and the building signifying communal worship. The year after he executed this painting, the artist wrote, "Today again is Sunday. I have declined attendance on church service, the better to indulge reflection unrestrained under the high canopy of heaven . . . [a] fit place to worship God. . . . This mode of passing the Sabbath became habitual with me in early life."[2] In this painting, the family follows the roadway to the church together, but Durand's later variations offer no clear path to corporate worship. Instead, they place the viewer, along with the artist, in a wooded setting looking across a body of water contemplating the divine in nature.

Durand's paintings seem to evolve toward a personal conception of worship, in contrast to this communal vision. However, the artist's full intentions for this work

cannot be entirely known. The year that he painted it, he also displayed a work at the National Academy of Design titled *Saturday Afternoon*, which may have been a pendant to this one, along the lines of his 1840 pair *The Morning of Life* and *The Evening of Life* (National Academy Museum, New York). The location of *Saturday Afternoon* is currently unknown, but reviews describe figures dancing in a landscape, suggesting a contrast of communal leisure and frivolity with the restrained, sober pursuits of the Sabbath in *Sunday Morning*.[3]

Durand exhibited *Sunday Morning* in 1840 to decidedly mixed reviews. The *New York Herald* called it "very good" but criticized the foreground composition and the color, among other things.[4] The *New York Mirror* considered it "very beautiful, but not strong" and "obviously handled by an engraver."[5] This last must have stung, because Durand had made great efforts to leave his engraving career behind and establish himself as a painter. According to an inscription on the back of the painting, Durand presented it to his wife in 1840, and it remained in the Durand family until it was presented to the New-York Historical Society in 1903.

Durand may have considered *Sunday Morning* personal in nature, since he kept it in his family. However, it enjoyed lively public attention and more favorable responses in later years; perhaps the artist's growing success colored retrospective responses to his earlier works. Durand exhibited it at the Brooklyn Institute Annual Exhibition in 1843 and the Boston Athenæum in 1845. A young artist named W. S. Elwell saw it in Boston and was moved to write to Durand, calling it a "beautiful . . . truth-telling scene" and asking whether he would sell it (which Durand did not).[6] The painting was also engraved twice, once by John McRae and then by Robert Hinshelwood. The Hinshelwood version was published by the New York dealer Michael Knoedler in 1864 and appeared five years later as the frontispiece in *Appleton's Journal*.[7] —KPO

1. Linda S. Ferber, *Kindred Spirits: Asher B. Durand and the American Landscape* (New York: Brooklyn Museum, in association with D Giles Limited, London, 2007), 138.
2. Asher B. Durand, "European Journal," Sunday, June 14, 1840, Asher B. Durand Papers (originals at New York Public Library), reel 20, frame 5, AAA. When he wrote this reflection, the artist was traveling by ship to Europe. While praising the sublime expanses of sky and water before him, he also affirmed those same feelings for "the world of woods and plains and mountains," perhaps already missing his native land.
3. "National Academy," *NYH*, May 17, 1839.
4. "National Academy," *NYH*, July 4, 1840, 2.
5. "Our Landscape Painters," *NYM*, July 18, 1840, 30.
6. W. S. Elwell to Asher B. Durand, August 1, 1845, Asher B. Durand Papers, New York Public Library.
7. Koke 1982, 1:309; and *Appleton's Journal* 2 (1869).

Francis W. Edmonds

(1806–1863)

An accomplished painter whose genre subjects frequently drew favorable comparison with those of William Sidney Mount, Francis W. Edmonds simultaneously conducted a successful career in banking. His expertise in both spheres often intersected in the administrative duties he performed for a variety of professional art organizations, including the American Art-Union and the National Academy of Design.[1]

Edmonds was born in Hudson, New York, the son of the Revolutionary War hero Samuel Edmonds. According to his own account, he achieved proficiency in drawing by the age of thirteen and taught himself the rudiments of grinding colors and painting in oils.[2] He met disappointment when an apprenticeship with the Philadelphia engraver Gideon Fairman was financially untenable, and he eventually went to New York in 1823 to clerk at the Tradesmen's Bank. The job occupied him exclusively until 1826, when he enrolled in the Antique School of the newly formed National Academy of Design. His budding artistic career was signaled by his professional debut at the academy's 1829 annual, but his progress was interrupted in 1830, when he was appointed cashier of the Hudson River Bank in his hometown of Hudson. While living there, he married Martha Norman, who bore him two children. Business took him back to New York in 1832, when he accepted the important post of cashier of the Leather Manufacturers' Bank. Still eager to pursue the arts, he received informal advice from William Page (1811–1885) and managed to produce and display works at the National Academy of Design in 1836, 1837, and 1838, all of which were exhibited under the pseudonym E. F. Williams, a name he adopted presumably to save him

embarrassment in case they were poorly received.

By the late 1830s, Edmonds was fully immersed in the cultural workings of New York City and maintaining a challenging business career. He was elected an associate of the National Academy of Design in 1837 and attained full academic status in 1840. A member of the Sketch Club by 1839, he was also a charter member of the Century Association and the first treasurer of the Apollo Association (which he helped to reorganize as the American Art-Union in 1842). Gripped by depression after his wife's death in 1840, he found relief in travel to Europe, where he toured for about eight months in 1841, often keeping company with John Frederick Kensett (1816–1872) and Asher B. Durand.

Edmonds returned to New York revived, and in 1842 he married Dorothea Lord, with whom he would have six children. During the 1840s, he bought property along the rail line of the Harlem Railroad (of which he was a director) and in 1850 built a thirty-room mansion in Bronxville. From 1842 to 1859 he showed twenty-nine paintings at the National Academy of Design and also exhibited at the Pennsylvania Academy of the Fine Arts, the Maryland Historical Society, and the Boston Athenæum. He assumed even more administrative work in 1853, when he helped found the New York Clearing House and became a partner in the Bank Note Engraving Company (later the American Bank Note Company). This frenetic pace was halted in 1855, when he resigned from the Mechanics' Bank (with which he had been affiliated since 1839) and the Clearing House, accused of unscrupulous dealings. His reputation among his fellow artists seems not to have suffered, however, and he continued to exhibit and to participate in professional

organizations until 1863 with his sudden death at the age of fifty-six.

1. Maybelle Mann, *Francis W. Edmonds: Mammon and Art* (New York: Garland Publishing, 1977); and H. Nichols B. Clark, *Francis W. Edmonds: American Master in the Dutch Tradition* (Washington, D.C.: Smithsonian Institution Press, for the Amon Carter Museum, 1988).
2. In 1844, at the request of his friend Asher B. Durand, Edmonds wrote a summary of his life. See Francis W. Edmonds, "'The Leading Incidents & Dates of My Life': An Autobiographical Essay by Francis W. Edmonds," *American Art Journal* 13, no. 4 (Autumn 1981): 5–10.

12

Francis W. Edmonds (1806–1863)

Grinding the Scythe

1856

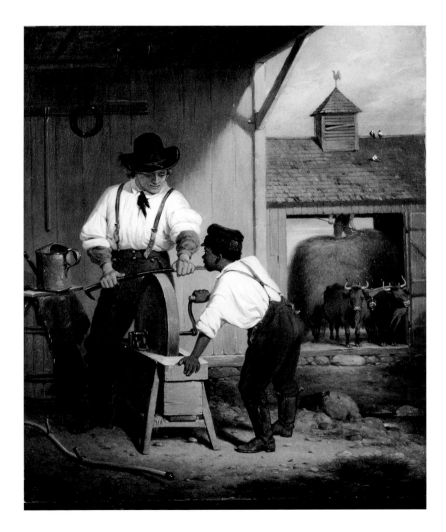

Oil on canvas, 24⅛ × 20 in. (61.3 × 50.8 cm)
Signed and dated lower left: *F. W. Edmonds / 1856*
Gift of Charles E. Dunlap, 1947.493

For color, see page 71

Grinding the Scythe has been traditionally known as *The Scythe Grinder*. However, the earliest located mention of the painting refers to it as *Grinding the Scythe*, a title that seems more appropriate given that both principal figures participate in sharpening the blade of the tool.[1] This image of cooperation is essentially benign, but, as has been found with so many genre paintings of the antebellum period, a more pointed political message may be embedded in the motif.

No contemporaneous interpretations of *Grinding the Scythe* are known, but it has been suggested that the painting is a companion piece to Edmonds's *All Talk and No Work*, which was displayed at the National Academy of Design in 1856, and that the two works are emblematic of industry and idleness, respectively.[2] This hypothesis is eminently viable since the paintings share almost identical measurements, are vertically oriented, and were executed at approximately the same time. Most important, each depicts a pair of black and white male protagonists in farmyard settings, which in the context of the social and political environments of the time and Edmonds's own convictions as a Jacksonian Democrat, might be expected to provoke thoughts of race relations. This expectation remained unfulfilled, judging by the derogatory comments devoted to other examples of Edmonds's art displayed in 1856.

From the beginning of his career in the arts, Edmonds had been categorized as an imitator of his contemporary William Sidney Mount, and, as one critic complained about *All Talk and No Work*, "This is the nearest approach to Mount's style, which Mr. Edmonds seems to aim at copying, that we have seen. But it is Mount's manner without his meaning. The scene represented is

the interior of a barn, and the figures are a white man and a negro. Nothing more."[3] Writing about the artist's *The Thirsty Drover* (1850, The Nelson-Atkins Museum of Art, Kansas City, Mo.), another rural farmyard subject also on view in the academy's galleries that year, the same critic bemoaned Edmonds's lack of imagination and added, "[H]is subjects are not only low, but common."[4]

Had *Grinding the Scythe* been displayed in 1856, it surely would have suffered similarly disparaging comments, since it too exhibits the same narrative opacity for which *All Talk and No Work* was criticized. A kernel of meaning lodged in racial superiority might have been gleaned from the physical dominance of the white farmer, towering over the bent form of the young black farmhand. Yet a closer look reveals that it is the youth's physical force that powers the whetstone. Indeed, as Charles Dudley Warner wrote in his semiautobiographical book *Being a Boy*, "Turning grindstones is one of those heroic but unobtrusive occupations for which one gets no credit."[5] Both workers, therefore, contribute to preparing the tool that will aid in bringing in the harvest, an activity highlighted by the vignette on the right of storing the hay in the barn. Yet the painting cannot be categorized as an antislavery statement. Rather, it can be read as a call for supporting the status quo derived from the recognition that the bulk of the nation's agrarian economy depended on slave labor. Such an interpretation corresponds to the Democratic Party platform of the 1850s, which advocated laissez-faire business policies and maintained a position of noninterference regarding slavery.[6] Thus, the painting's

multivalent message could satisfy abolitionists by displaying racial harmony in the labor sphere, while still implicitly endorsing the idea of white superiority. —BDG

1. "Francis W. Edmonds," *Merchants' Magazine and Commercial Review* 48, no. 4 (April 1863): 289.
2. This was first suggested by H. Nichols B. Clark, *Francis W. Edmonds: American Master in the Dutch Tradition* (Washington, D.C.: Smithsonian Institution Press, for the Amon Carter Museum, 1988), 117, and expanded on by Teresa A. Carbone in her entry for *All Talk and No Work*, in Carbone et al., *American Paintings in the Brooklyn Museum: Artists Born by 1876* (London: D Giles Limited, 2006), 1:505–6.
3. "The National Academy of Design," *NYDT*, April 19, 1856, 8. Although Edmonds may have known Mount's *Who'll Turn the Grindstone?* (1851, The Long Island Museum, Stony Brook, N.Y.), his rendition of the theme does not convey the same quaintly humorous effect.
4. "The National Academy of Design," *NYDT*, April 12, 1856, 4.
5. Charles Dudley Warner, *Being a Boy* (Teddington, Eng.: Echo Library, 2009), 21.
6. For a fine summary of the conflicting political views in New York regarding slavery and free blacks in the labor force, see James Oliver Horton, "Black New York and the Lincoln Presidency," in *Lincoln and New York*, ed. Harold Holzer (New York: New-York Historical Society; London: Philip Wilson Publishers, 2009), 98–125. The interpretation offered here differs from that provided in Clark, *Edmonds*, 22, 118–19, in which the author ascribes a content of optimism and egalitarianism to *Grinding the Scythe* and attributes it to Edmonds's connections with the Democratic Party.

13

Francis W. Edmonds (1806–1863)

Bargaining (*later known as* The Christmas Turkey)
ca. 1858

Oil on canvas, 16½ × 23⅜ in. (41.9 × 59.4 cm)
Signed lower left: *F. W. Edmonds*
The Robert L. Stuart Collection, S-50

For color, see page 55

Of the three works by Francis W. Edmonds displayed at the 1858 National Academy of Design exhibition, *Bargaining* received the most attention.[1] As one reviewer observed, "Mr. Edmonds's *Bargaining* . . . a traveling poulterer selling a plucked goose to an old woman in spectacles, arrests your attention; and worthily, for the touch is crisper than this artist sometimes manifests, while his other good points remain."[2] The theme of bargaining was not a new one in American art, as demonstrated by William Sidney Mount's *Farmers Bargaining* of 1835 (cat. 31) and Mount's reprise of the topic in *Coming to the Point* (see fig. 10, p. 160). Depictions of canny citizens negotiating in the quest to get the better of each other were commonly associated with the stereotype of Yankee opportunism. Yet, in 1858, the shades of meaning surrounding the art of the deal had shifted, shaped by the economic downturn known as the Panic of 1857.

The panic, which lasted until the outbreak of the Civil War, began with the bankruptcies spurred by excessive borrowing to finance western railroad and land speculation, a situation that led to widespread financial chaos and the suspension of convertibility.[3] As a banker, Edmonds was surely well aware of the situation. In fact, he benefited from the financial flux inasmuch as a

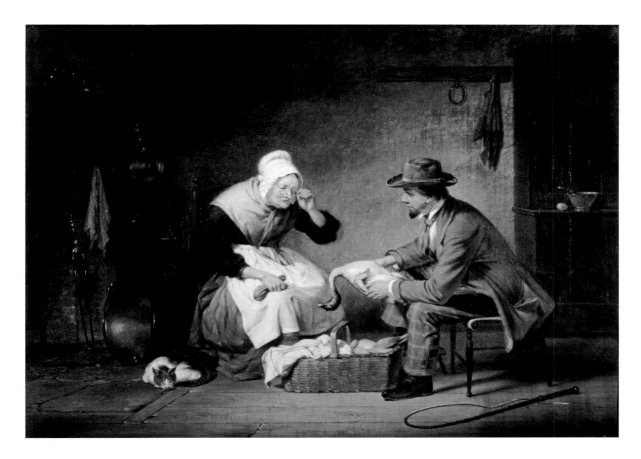

whose only companion is likely the cat who sleeps at her side. The salesman leans forward to display his merchandise. His posture conveys his eagerness to seal the bargain but does not convey the cunningness usually associated with cutthroat dealing. Indeed, as H. Nichols B. Clark has noted, both protagonists are on equal footing;[4] to this may be added the observation that neither exhibits the urge to take advantage of the other. Rather, the bargaining imperative rests on the financial need of both in a climate of economic hardship, a reality hinted at by a writer for the *Crayon* in the description of the pair as "an old woman and a countryman."[5] Thus, Edmonds replaces humor with pathos, a tendency that pervades much of his later work in which he concentrated on the travails of old age.[6] An additional measure of sentimentality enters with the belief that the elderly woman was modeled after the artist's mother, Lydia Worth Edmonds.[7]

Bargaining was purchased by Robert L. Stuart (through John Durand) in 1858, and, though noted in Stuart's account books as *Sale of Turkey*, it was soon after given the more mawkish title *The Christmas Turkey*. —BDG

number of banknote companies were consolidated, their corporate activities folded into the American Bank Note Company, an enterprise formed in 1857 in which Edmonds had a substantial interest.

Bargaining, therefore, must be interpreted against the backdrop of the economic crisis. Whereas the earlier "bargaining" subjects of Mount embraced an optimistic, albeit ironically humorous attitude toward the workings of a rural economy, Edmonds's image of an old woman's careful deliberations over the purchase of a goose (or turkey) is redolent of the financial anxiety that flowed through Northern households in the late 1850s. With one hand, she adjusts her glasses so as to get a better look at the bird, and, with the other, she tightly grasps a small pouch containing what we can imagine is the full extent of her limited funds. The single egg on the cupboard on the right suggests just how extravagant the prospective purchase would be for this elderly soul,

1. The other works by Edmonds on view were *The Wind Mill* (cat. 14) and *The Pan of Milk* (The New-York Historical Society).
2. "Fine Arts," *Albion* 36, no. 19 (May 8, 1858): 225.
3. See Charles W. Calomiris and Larry Schwiekart, "The Panic of 1857: Origins, Transmission, and Containment," *Journal of Economic History* 51, no. 4 (December 1991): 807–34.
4. H. Nichols B. Clark, *Francis W. Edmonds: American Master in the Dutch Tradition* (Washington, D.C.: Smithsonian Institution Press, for the Amon Carter Museum, 1988), 128.
5. "Sketchings," *Crayon* 5, no. 6 (June 1858): 177.
6. Consider, for instance, Edmonds's *Reading the Scriptures* (ca. 1856, private collection) and *Devotion* (1857, sold at Christie's, New York, January 28, 1995, lot 805).
7. Maybelle Mann, "Humor and Philosophy in the Paintings of Francis William Edmonds," *Antiques*, November 1974, 869.

14

Francis W. Edmonds (1806–1863)

The Wind Mill

ca. 1858

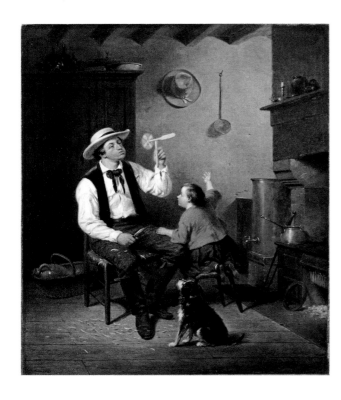

Oil on canvas, 24 × 20⅛ in. (61 × 51.1 cm)
Signed lower left: *F. W. Edmonds*
The Robert L. Stuart Collection, S-217

For color, see page 56

Francis W. Edmonds showed *The Wind Mill* at the National Academy of Design in 1858 along with two other domestic subjects, *Bargaining* (cat. 13) and *The Pan of Milk* (The New-York Historical Society). Although genre painting was well represented in the exhibition, only a few works in this category received significant attention, among them Charles F. Blauvelt's (1824–1900) *Warming Up*, a large canvas filled with incident that dispensed with humor in favor of the naturalistic treatment of a tavern interior where stagecoach passengers warm themselves at a stove.[1] Whereas Blauvelt's painting was singled out by one reviewer as "one of the most successful pictures in the collection," the same columnist almost grudgingly acknowledged Edmonds's exhibits, saying, "Mr. Edmonds's pictures are not improvements on his former works, but as is usual with him, they are humorous and tell their own stories."[2]

Nonetheless, a number of brief press notices admired *The Wind Mill*; one announced that "Mr. F. W. Edmonds is at home with *The Windmill* [*sic*], one of his pleasant interiors, wherein childhood is wonderingly entertained with a toy-windmill, just whittled by the principal figure."[3] To be sure, this appealing image of a father amusing his young son with a homemade toy requires no further explanation. Set in a carefully ordered, albeit modest household, this inconsequential episode finds its dramatic peak in the contrast between the child's intense excitement and the disciplined attentiveness of the family dog. If there is deeper content here, it is discovered in the compositional metaphor linking child and animal nature, wherein the dog's stable, triangular form echoes that of the gesturing child

and underscores the commonly held belief that children, like family pets, needed training to prepare them for civilized society. What is unusual, however, is that Edmonds portrayed an intimate and playful moment shared by a father and son within the domestic sphere normally presided over by the woman of the house. This was perhaps a reflection of Edmonds's own experience of fatherhood (he had eight children), but it remains impossible to say whether viewers noticed that this image of lighthearted paternal interest extended the boundaries of the stereotypical masculine purview.[4]

The broad appeal of Edmonds's three contributions to the academy's exhibition was forecast by a reviewer for the *New York Evangelist*, who listed them with other examples of genre paintings deemed "characteristic subjects"; they were "all good, and we doubt not, will be fully appreciated, as they appeal to the popular feeling."[5] All three of the Edmonds paintings from the 1858 display were acquired by the New York collector Robert L. Stuart by April of that year through a deal negotiated by John Durand (the son of the artist Asher B. Durand, who was also Edmonds's close friend).[6] —BDG

1. Blauvelt's painting was offered at Sotheby's, New York, March 5, 2003, lot 53.
2. "The National Academy of Design," *NYDT*, May 4, 1858, 6.
3. "Fine Arts: National Academy of Design; Second Notice," *Albion* 36, no. 18 (May 1, 1858): 213. A similarly worded description is found in the *Crayon*, June 1858, 177: "a father blowing upon a toy windmill, just made for a wondering child."
4. Coincidentally, Lilly Martin Spencer's (1822–1902) *Fi! Fo! Fum!* (1858, Smithsonian American Art Museum, Washington, D.C.) was also on view in the 1858 academy exhibition. Here, however, the father's interaction with his two daughters is mediated by the mother's presence.
5. "Miscellaneous: National Academy of Design," *New York Evangelist* 29, no. 21 (May 27, 1858): 2.
6. Edmonds to John Durand, April 14, 1858, Asher B. Durand Correspondence, New York Public Library.

John Whetten Ehninger

(1827–1889)

John Whetten Ehninger first gained recognition as a genre painter, but as his career matured, he was described as "one of the [nation's] most accurate and accomplished draftsmen," based on his many illustrations of the works of such authors as Washington Irving and Henry Wadsworth Longfellow.[1] A man of many interests, Ehninger was also involved in bringing the *cliché verre* process to the United States, was an amateur actor, a classical scholar, and a linguist.

Ehninger was born to a socially prominent and economically privileged New York family. He was a grandson of the German émigrés John Christopher Ehninger and his wife, the former Caroline Astor. His mother's family (the Whettens) had made a fortune in the China trade and had intermarried with other leading New York families, including the Brevoorts and the Sedgwicks. Ehninger graduated from Columbia College in 1847 and by 1848 was studying at the Königliche Kunstakademie in Düsseldorf under Carl Ferdinand Sohn (1805–1868) and taking instruction from Karl Friedrich Lessing (1808–1880) as well as from his good friend Emanuel Leutze. The young artist recorded his impressions of student life at Düsseldorf in an 1850 article published in the *Bulletin of the American Art-Union*.[2]

Ehninger returned to New York in 1850 and began to show his work at the National Academy of Design and the American Art-Union. By 1853, however, he was back in Europe, this time visiting major cities and training briefly in Paris under Thomas Couture (1815–1879), with whom he would study again in 1859. For the most part, however, the decade was spent in New York, where he forged a reputation as a painter and illustrator.[3] He seems to have made several extensive trips to Europe in 1859 and the 1860s; in 1867 various sources mentioned his recent return from Europe and cite paintings whose titles reflect his sojourns in France, Spain, and England, where, as Henry Tuckerman pointed out, Ehninger's art was "more appreciated than in his own country."[4] In the spring months of 1867 the painter also spent time in St. Augustine, Florida. Reference is also occasionally made to his teaching activity at New York's Cooper Institute.

It was doubtless because of Ehninger's freedom from financial worries that he was able to travel so frequently and, as Tuckerman suggested, his personal wealth also accounted for the somewhat "desultory" manner with which he pursued his career.[5] Nevertheless, Ehninger was elected a full academician at the National Academy of Design in 1860 and enjoyed membership in the Century Association. He married Katherine Young Beach of Saratoga Springs in 1872. The couple made Saratoga their permanent residence, and their names also appeared in columns reporting Newport society. He died of apoplexy at his Saratoga home.[6]

1. "Literature and Art," *Galaxy* 7, no. 4 (April 1869): 600–601.
2. J[ohn] W[hetten] E[hninger], "The School of Art at Düsseldorf," *Bulletin of the American Art-Union*, no. 1 (April 1, 1850): 5–7.
3. There is no thorough study of Ehninger's career, and published references to his movements often conflict or are vague at best.
4. See, for instance, "Art Gossip," *Frank Leslie's Illustrated Newspaper*, no. 395 (February 23, 1867): 355; and Tuckerman 1867, 464.
5. Ibid.
6. "Obituaries," *New York Genealogical and Biographical Record* 20, no. 2 (April 1889): 93.

15

John Whetten Ehninger (1827–1889)

Peter Stuyvesant and the Cobbler

1850

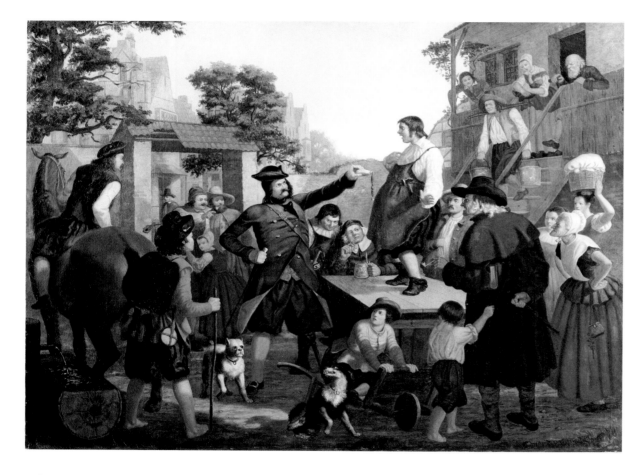

Oil on canvas, 36 × 48⅛ in. (91.4 × 122.2 cm)
Inscribed and dated lower left: *N. Y. / 1850*
Gift of Mr. Hugh W. Long, 1950.335

For color, see page 88

Reported to be John Whetten Ehninger's first oil painting, *Peter Stuyvesant and the Cobbler* reveals the artist's affinity for literary subjects, especially those inspired by the works of Washington Irving.[1] Here Ehninger depicts the episode of Governor Peter Stuyvesant's confrontation with the rabble-rousing cobbler taken from Irving's *A History of New York, from the Beginning of the World to the End of the Dutch Dynasty*. The large canvas, densely populated with a wide array of types, reveals the artist's assimilation of Düsseldorf training that emphasized complicated orchestrations of figures in service of historical or literary subjects. Indeed, the artist was fresh from Europe when he executed the work, a print of which was distributed through the American Art-Union in 1850. The Art-Union *Bulletin* quoted the relevant passage from Irving's *History* in an explanatory note, part of which reads: "The shrewd Peter took no notice of the skulking throng around him, but advancing to the brawling bully-ruffian, and drawing out a huge silver watch . . . requested the Orator to mend it, and set it going. The Orator humbly confessed it was utterly out of his power, as he was unacquainted with the nature of its construction."[2]

Ehninger was probably eager to display the technical skills he had acquired under the guidance of Karl Friedrich Lessing (1808–1880), Wilhelm Camphausen (1818–1885), and Emanuel Leutze in Düsseldorf, but he was probably just as determined to please his American audience by choosing a theme of national rather than foreign origin. By positioning himself as a new artistic interpreter of an author who had entered the pantheon of national "greats," Ehninger was

assured of escaping criticism that may have stemmed from his being too European in his outlook. Yet he had communicated his beliefs concerning the state of the arts in the United States and the advisability of foreign training in a letter written in Europe and published in the *Bulletin of the American Art-Union*:

> Very many of our painters show in their production a fine feeling for color, and generally a nice appreciation of character, and great natural vigor of action. Moreover, one of our prominent national attributes is enthusiasm. These are the germs which, with proper culture, may form eventually a great American school. But in many works hitherto produced, in which one or perhaps all of the above mentioned merits are observable, the eye is shocked by some palpable fault in drawing, some unmistakable evidence of haste or carelessness, some lamentable deficiency in anatomical knowledge. . . . It is in the severity of its elementary studies that the Düsseldorf School chiefly differs from our own, and to this cause its excellence may be chiefly attributed.[3]

Although Irving's humorous chronicles surrounding New York's early Dutch history under the leadership of Peter Stuyvesant had long been part of popular culture, the cobbler anecdote was rarely addressed in the visual arts. Ehninger's decision to focus on this particular story line, therefore, is unusual. Also out of the ordinary is Ehninger's visual interpretation, which invests the scene with a level of gravity that suggests it records an actual historic event rather than a comic incident drawn from satirical fiction. Of course, Ehninger's artistic training would have had an impact on his stylistic approach, but consideration must also be given to the fact that his

years in Düsseldorf coincided with the revolutionary turmoil in Germany created by nationalist, republican movements throughout that country. Although nothing is known of Ehninger's personal politics, it is worth speculating whether the theme of Stuyvesant's notoriously despotic treatment of the masses held particular relevance for him in view of his German heritage and his recent experiences of the political situation in Europe. As noted in an article published in 1854, because Stuyvesant was "thoroughly aristocratic in all his notions, he was not well fitted to govern a simple people, with republican tendencies, like those of New Netherland."[4] —BDG

1. This was Ehninger's first oil painting, according to "Artists of America," *Crayon* 7, no. 2 (February 1860): 49. It is, however, doubtful that the painting was his first oil, not only because of its relatively polished technique but also because he had already benefited from several years of training in Düsseldorf (ca. 1847–49/50). Rather, it can be said that it was his first oil painting exhibited in the United States.
2. *American Art-Union Bulletin*, December 1850, 173.
3. J[ohn] W[hetten] E[hninger], "The School of Art at Düsseldorf," *Bulletin of the American Art-Union*, no. 1 (April 1, 1850): 5–7.
4. "The Dutch in Manhattan," *Harper's New Monthly Magazine* 9, no. 52 (September 1854): 447.

George Whiting Flagg

(1816–1897)

George Whiting Flagg showed early promise as a painter of history and genre subjects, yet despite his advantages of training and patronage, much of his livelihood depended on portrait commissions. As Henry T. Tuckerman wrote sympathetically in 1867, "Flagg has suffered from ill health, and his efforts have been unequal, and often wholly subservient to temporary necessities."[1]

Flagg was born in New Haven, Connecticut, son of a lawyer and brother of the painters Henry Collins Flagg (1812–1862) and Jared Bradley Flagg (1820–1899). The family moved to Charleston, South Carolina, when the boy was about three. Both William Dunlap and Tuckerman state that Flagg's precocious artistic talents were soon recognized and that, after some instruction from the itinerant portrait painter James Bowman (1793–1842), he was permitted to travel to Boston in 1831 with Bowman to take further instruction from his uncle, the famed Washington Allston (1779–1843). During his eighteen months under Allston's tutelage, Flagg developed a taste for grand-manner themes, especially those redolent of the scenes of gothic romance espoused by his uncle. Flagg soon began to exhibit his work at the Boston Athenæum and set up his own studio at Graphic Court. In 1833 he moved to his native New Haven, and, although most of his income derived from portraiture, he also pursued the history subjects favored by Allston.

With the generous patronage of the New York collector Luman Reed—cemented with a seven-year contract signed in 1834—Flagg gained the freedom to follow his inclinations in developing his art as well as the opportunity to go to Europe.[2] After traveling in England, France, and Italy from 1834 to 1835, Flagg returned to the United States only to enter a period of restless movement that took him to Boston, Charleston, and New Haven, a way of life likely exacerbated by Reed's death in 1836 and the resulting need to generate commissions. After having exhibited occasionally at the National Academy of Design, Flagg was made an honorary member in 1843 and a full academician in 1851. Throughout the decade of the 1850s, he reportedly spent most of his time in Charleston painting portraits.[3] Doubtless because of the increasingly contentious political atmosphere in the months leading up to the Civil War, Flagg left the United States in October 1859, sailing on the clipper ship *Dreadnought* for Liverpool.[4] Except for infrequent and brief press notices to the effect that he was achieving success in London, very little is known about Flagg's life during the seven or so years he stayed in England.[5]

Flagg was back in the United States by the spring of 1866. That year he sent one painting—*The Suspicious Note*—to the National Academy's annual, where it received devastatingly poor reviews.[6] Apart from a few sporadic attempts to show his work thereafter, Flagg seems to have given up hope of success. He lived in New Haven (where city directories indicate that he ran an art school) until retiring in 1879 to Nantucket, Massachusetts, where he died in 1897.[7]

1. Tuckerman 1867, 407.
2. For Flagg and Reed, see relevant catalogue entries by Timothy Anglin Burgard, in Foshay 1990, 150–65.
3. See Anna Wells Rutledge, "Artists in the Life of Charleston: Through Colony and State from Restoration to Reconstruction," *Transactions of the American Philosophical Society*, n.s., 39, no. 2 (1949): 168; and Barbara K. Nord, "George Whiting Flagg and His South Carolina Portraits," *South Carolina Historical Magazine* 83, no. 3 (July 1982): 214–34.
4. "Departures," *NYH*, October 6, 1859, 8.
5. One report stated, "G. W. Flagg is in London, and quite successful in painting cabinet pictures of the British nobility." "Fine Arts," *NYH*, March 2, 1861, 7.
6. "Exhibition at the National Academy," *Frank Leslie's Illustrated Newspaper*, May 19, 1866, 139.
7. For Flagg's last years, see Jonathan Harding's entry in Dearinger 2004, 193.

16

George Whiting Flagg (1816–1897)

Murder of the Princes in the Tower

ca. 1833–34

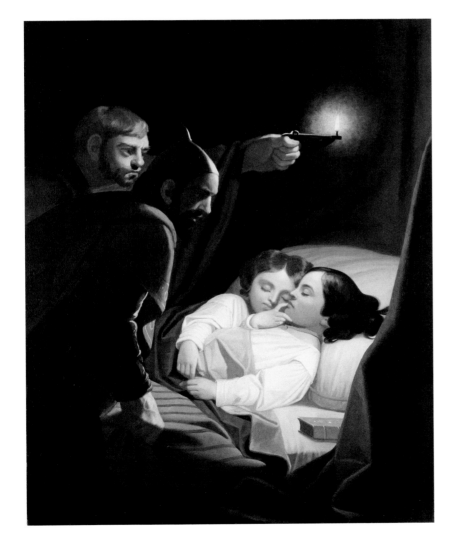

Oil on canvas, 56 × 44 in. (142.2 × 111.8 cm)
Gift of The New-York Gallery of the Fine Arts, 1858.48

For color, see page 45

George Whiting Flagg was barely eighteen when *Murder of the Princes in the Tower*, *Falstaff Playing King* (cat. 17), and *Sleeping Female* (The New-York Historical Society) first represented him at the National Academy of Design in 1834. His ambition to paint historical and literary subjects was doubtless shaped by his training with his uncle Washington Allston (1779–1843). William Dunlap reported that Flagg painted the present work around the same time that Allston had written to Dunlap proudly informing him that Flagg had "met with a most munificent patron—munificent for any country."[1] According to Dunlap, that patron was Luman Reed, the man who would become Flagg's most significant patron.[2]

Flagg's depiction of a pivotal moment from Shakespeare's *Richard III* (act 4, scene 3) demonstrates his reliance on standardized high-art imagery and the international popularity of Shakespeare's plays.[3] The scene itself—the seconds before the two sleeping boys, Edward, Prince of Wales, and Richard, Duke of York, are smothered at the presumed behest of their uncle, Richard of Gloucester—not only evinced horror but also gave aesthetic license to painters to use a range of dramatic, formal elements to heighten the tension surrounding the incident. Such British artists as John Opie (1761–1807), Thomas Stothard (1755–1834), James Northcote (1746–1831), Charles Robert Leslie (1794–1859), and the Frenchman Paul Delaroche (1797–1856) had previously addressed this or related episodes from the tragedy.[4] Their works were frequently engraved and illustrated in, for instance, *The Boydell Shakespeare Prints*, for which Francis Legat's (1755–1809) engraving of Northcote's version of the scene was produced (see fig. 11, p. 44).[5] The similarities between

Northcote's and Flagg's compositions are convincing evidence that Flagg relied on the English artist's work, and it may be that Flagg was directed to it by Allston, who would have known Northcote's 1786 version of the subject owned by his English patron, the Earl of Egremont. Both Northcote and Flagg were faithful to Shakespeare's lines in which Sir James Tyrrel conveys the murderers' report of the deed to Richard.[6]

Shakespeare's *Richard III* was a favorite among New Yorkers. It was the first of his plays to be produced in America, when Thomas Kean performed the role of Richard in New York City on March 5, 1750.[7] Subsequent New York productions included an 1821 staging at the Park Theatre, in which Junius Brutus Booth made his American debut, and another marking Booth's return to the role at the Bowery Theater in December 1832.[8] Thus, in addition to aligning himself with a well-established European tradition in the visual arts, Flagg could expect his treatment of one of the most popular and heartrending episodes from Shakespeare's oeuvre to have immediate appeal for New York viewers.

Flagg's *Murder of the Princes* received lengthy comment in the *American Monthly Magazine*, whose critic allowed that, "For so young a man and so young an artist as Mr. Flagg, this is in truth a wonderful piece of painting." However, the writer found the painting too gaudy and apologetically concluded, "We speak our mind with all good feeling, we are convinced that it is no friendship to an incipient artist to feign an approbation which is not felt; and, did we not hope that our admonitions might be serviceable, we should not condescend to admonish."[9] The tone and content of this commentary suggest that the author was the magazine's editor Henry William Herbert, an Englishman who had arrived in New York in 1831. The aristocratic Cambridge graduate was a cultural elitist, especially with respect to the need to emulate the old masters, whose palettes were characterized by "a judicious contrast between one or two rich and gorgeous colors." In light of such supportive and constructive criticism, it is unsurprising that *Murder of the Princes* was the first of eleven of Flagg's paintings to enter the collection of Luman Reed before the artist turned twenty. —BDG

1. Dunlap 1834, 2:449–50.
2. For Reed's patronage of Flagg, see the relevant catalogue entries by Timothy Anglin Burgard, in Foshay 1990, 150–65.
3. See Richard D. Altick, *Paintings from Books: Art and Literature in Britain, 1760–1900* (Columbus: Ohio State University Press, 1985).
4. Roy Strong, *Painting the Past: The Victorian Painter and British History* (London: Pimlico, 2004), 123.
5. For a summary of Boydell's Shakespeare Gallery and the publication of prints based on the paintings displayed there, see Altick, *Paintings from Books*, 43–49.
6. See Burgard, in Foshay 1990, 150–51.
7. Robert Falk, "Shakespeare in America: A Survey to 1900," in *Shakespeare Survey Volume 18: Shakespeare Then Till Now*, ed. Allardyce Nicoll (Cambridge: Cambridge University Press, 1965), Cambridge Collections Online.
8. Lawrence W. Levine, *Highbrow Lowbrow: The Emergence of Cultural Hierarchy in America* (Cambridge, Mass.: Harvard University Press, 1988), 29.
9. "Miscellaneous Notices of the Fine Arts, Literature, Science, the Drama, &c." *American Monthly Magazine* 3, no. 4 (June 1, 1834): 282.

17

George Whiting Flagg (1816–1897)

Falstaff Playing King

ca. 1834

Oil on canvas, 35½ × 28½ in. (90.2 × 72.4 cm)
Gift of The New-York Gallery of the Fine Arts, 1858.16

For color, see page 47

One of two Shakespearean subjects displayed by George Whiting Flagg at the National Academy of Design in 1834, *Falstaff Playing King* presented a comedic contrast to the pathos of *Murder of the Princes in the Tower* (cat. 16). It depicts the popular episode from *Henry IV*, part 1, act 2, scene 4, in which the rotund Sir John Falstaff assumes the role of the king at the pleasure of Prince Hal (standing at left) in preparation for Hal's upcoming interview with the king, his father, to justify the company he keeps (namely Falstaff's). The mock father-son audience begins:

> Prince Henry: Do thou stand for my father, and
> examine me upon the particulars of my life?
>
> Falstaff: Shall I? Content. This chair shall be my state,
> this dagger my sceptre, and this cushion my crown.

When the two later switch roles, the notorious braggart Falstaff defends himself as the prince's companion. This virtual play-within-a-play, a common Shakespearean device, lends itself to an array of pointed ironies whose contradictions helped define the carnivalesque character of Falstaff, making him one of the most popular of the playwright's creations.

Falstaff was a familiar figure in American visual and literary culture, and several sources may be cited as direct inspirations for Flagg's treatment of the subject.[1] Washington Allston (1779–1843) had painted two works featuring Falstaff and presumably transmitted his passion for Shakespeare to his nephew Flagg.[2] Here, however, Flagg seems to have borrowed from Robert Smirke's (1752–1845) version of Falstaff enacting the king,

engraved by Robert Thew (1758–1802) for *The Boydell Shakespeare Prints*.[3] Falstaff surfaced in American literary life, most notably in Washington Irving's parodic essay "The Boar's Head Tavern, East Cheap: A Shakespearean Research."[4] Flagg may have been especially conscious of Irving's essay, not only because the author was one of the few American-born writers to achieve a transnational reputation but also because of Allston's close friendship with Irving.[5]

Flagg was also likely aware of his patron Luman Reed's backing of the actor James Henry Hackett. Hackett had initially been in the grocery business in Utica, New York (through which he may have come in contact with Reed), but when his enterprise failed in the mid-1820s, Reed lent him one thousand dollars to finance his theatrical career. Hackett's star rose quickly in the United States and England when he undertook the role of Falstaff (in Philadelphia in 1832). After triumphal appearances in England, in 1833 he returned to New York, where he reprised the role at the Park Theatre. Thus, Flagg's display of a favorite scene from the play was both timely and astute, since informed viewers would be able to associate him with the popular actor with whom he shared the benevolent support of one of the city's leading citizens.

Flagg's *Falstaff* received mixed reviews, one of which began, "We are somewhat at a loss whether to applaud or condemn the boldness of this choice of subject."[6] Like *Murder of the Princes in the Tower*, this painting was considered too brightly colored— "wanting in finish and mellowness of tone."[7] On the positive side, most reviewers agreed that the composition was well managed. All, however, objected to the depiction of Falstaff. As one writer complained, "The artist has mistaken the character of that fat, joyous knight. Falstaff was a gentleman by birth and education, a man of brilliant wit, and, arrant tipper as he was, not destitute of a certain species of refinement. In this picture he is a coarse buffoon, a mere stupid, vulgar lump of fat."[8] Arguments about whether Falstaff was a gentleman or simply a lout had consistently occupied Shakespeare commentators. Flagg may have taken his cue from Hackett, who later denied that Falstaff should be interpreted as a gentleman.[9]

Flagg's depiction of Falstaff as vulgar corresponds to interpretations of Falstaff as a representation of the common people, or the "new order," that would eventually challenge the power of the nobility.[10] Falstaff's line "Stand aside, nobility" (act 3, scene 4) likely pleased American audiences especially, and, given the frequency with which Falstaff was referenced in early-nineteenth-century press reports and speeches, the character's potential to enliven and give meaning to political commentary was probably easily recognized by contemporary readers.[11] —BDG

1. See entry by Timothy Anglin Burgard, in Foshay 1990, 152–53.
2. Allston's *Falstaff Playing the Part of the King* (1806–8) is unlocated. His *Falstaff Enlisting His Ragged Regiment at Justice Shallow's* is in the collection of the Wadsworth Atheneum Museum of Art, Hartford, Connecticut. See Amy Ellis's entry in *American Paintings before 1945 in the Wadsworth Atheneum*, ed. Elizabeth Mankin Kornhauser (Hartford, Conn.: Wadsworth Atheneum; New Haven: Yale University Press, 1996), 62–64.
3. See *The Boydell Shakespeare Prints*, intro. A. E. Santaniello (New York: Blom, 1968), n.p.
4. The essay was part of Irving's *The Sketch Book of Geoffrey Crayon, Gent.*, serialized in 1819–20 and published collectively in the United States in 1824.
5. See, for instance, Andrew Burstein, *The Original Knickerbocker: The Life of Washington Irving* (New York: Basic Books, 2007), 117–18.
6. *NYM*, May 10, 1834, 355.
7. "National Academy of Design," *NYEP*, May 23, 1834, 2.
8. *NYM*, May 10, 1834, 355.
9. James Henry Hackett, *Notes, Criticisms, and Correspondence upon Shakespeare's Plays and Actors* (New York: Carleton, 1863), 320.
10. See William B. Stone, "Literature and Class Ideology: Henry IV, Part One," *College English* 33, no. 8 (May 1972): 891–900.
11. See, for example, "From the Newport Spectator," *New-Hampshire Patriot & State Gazette*, April 11, 1825, 2, which commented on the presidential election: "The excited hopes, and subsequent disappointment of the federalists, bears so strong an affinity to that of Falstaff, in Shakspeare's Henry IV, that we cannot forbear quoting it. . . ."

18

George Whiting Flagg (1816–1897)
The Nun
ca. 1836

Oil on canvas, 30 × 24 in. (76.2 × 61 cm)
Gift of The New-York Gallery of the Fine Arts, 1858.34

For color, see page 109

George Whiting Flagg's conception for *The Nun* originated in his European travels in 1834–35. It is not clear whether he painted *The Nun* while abroad or immediately after his return to the United States, but his depiction reflects the wide gulf between American and European perceptions of religious subjects.

A young nun has paused in her reading, looking away from her book with a thoughtful expression. Despite the ecclesiastical nature of the subject, the scene does not appear to take place in a church. The generalized interior includes no lavish decoration and no religious paintings or implements of the mass, and the way that the nun casually leans on the table at her side precludes it as an altar. By showing her in the act of study and contemplation, the artist draws attention to the life of both the spirit and the intellect.

While pictures of moralizing subjects and biblical tales were common during the nineteenth century, few took specifically Catholic themes. When they did, they often addressed American ambivalence about the Church and its practices. Artists sometimes shaded their images with a sense of exoticism and otherness: in Samuel F. B. Morse's *The Chapel of the Virgin at Subiaco* (see fig. 26, p. 111), a peasant woman stops at a roadside shrine, and Robert W. Weir's later *Taking the Veil* (1863, Yale University Art Gallery) shows the ceremony and spectacle of a novice taking vows. Sensational and lurid tales of convent life, including Rebecca Reed's *Six Months in a Convent* of 1835 and Maria Monk's *Awful Disclosures of the Hotel Dieu Nunnery in Montreal* of 1836, were extremely popular. Two years earlier, in 1834, a mob ransacked and burned down Mount Benedict, an Ursuline convent in

Charlestown, near Boston.[1] In 1840 in New York there were fewer than a dozen Catholic churches, but they were subject to a virulent nativist political movement that militated against immigrants and Catholics, especially in the 1830s and 1840s. Despite this, Father Félix Varela y Morales and the Sisters of Charity won high praise for their heroic efforts tending to victims of the cholera epidemic that struck the city in 1832.[2]

Flagg's interpretation is remarkably sympathetic in light of the suspicion that surrounded Catholics, and cloistered nuns in particular, in the United States. Rather than portraying the nun as an object of mystery and possibly scandal, the artist emphasized the individual in direct contact with the divine through her contemplation of sacred texts. Though her order cannot be determined with certainty, her habit most closely resembles that of the Poor Clares, a Franciscan order dedicated to prayer and poverty. The community was founded in 1212 near Assisi, and in the nineteenth century there were several convents in Italy. Flagg might also have encountered nuns from such convents in France or England during his European travels.

As a young man, Flagg was hailed as a prodigy: a few years before he painted *The Nun* William Dunlap wrote of the artist's acclaim in Boston, and Henry T. Tuckerman even expressed concern that early accolades would work to Flagg's disadvantage, putting him in danger of striving for praise alone.[3] Flagg's patron Luman Reed wrote in 1835 of his high expectations for the young man, assuring him that "your fame stands higher here than any artist's ever did at your age."[4] However, this particular painting attracted little comment. Flagg displayed *The Nun* at the National Academy of Design's spring exhibition in 1836,

but it suffered from being hung too high. The *New York Evening Post* conceded, "[F]rom what we could see of it we think it a good conception and well executed."[5] —KPO

1. James Hennesey, *American Catholics: A History of the Catholic Community in the United States* (Oxford: Oxford University Press, 1981), 121–22.
2. Terry Golway, ed., *Catholics in New York: Society, Culture, and Politics, 1808–1946* (New York: Fordham University Press, 2008), 56, 134; and Edwin G. Burrows and Mike Wallace, *Gotham: A History of the City of New York to 1890* (New York: Oxford University Press, 1999), 542–56, 593.
3. Tuckerman 1867, 406.
4. Luman Reed to George W. Flagg, March 9, 1835, Luman Reed Papers, N-YHS Library.
5. "National Academy of Design," *NYEP*, May 25, 1836, 2. See Flagg's biography and cat. 17 in this volume for more information on the relationship between Flagg and Reed.

(William) Gilbert Gaul
(1855–1919)

Called the "Detaille of America," Gilbert Gaul was most admired for his highly dramatic paintings and illustrations of Civil War scenes.[1] He also traveled extensively to the American West and Central America, often chronicling his impressions in articles he wrote and illustrated for such publications as the *Century Illustrated Magazine*.[2]

Gaul was born and raised in Jersey City, New Jersey. After attending public school in Newark, New Jersey, he went to Claverack Military Academy in New York State.[3] His plans for a naval career thwarted by poor health, he went to New York City, determined to become an artist. From 1872 to 1875 he studied at the National Academy of Design, training mainly with Lemuel E. Wilmarth (1835–1918) and John George Brown (1831–1913). He also took classes at the Art Students League. He made his exhibition debut at the academy in 1877 and two years later was made an associate on the basis of genre subjects done in the mode of Wilmarth and Brown. (He was elected a full academician in 1882.)

Gaul's interest in painting rather quaint domestic genre themes was short-lived. A journey to the American West in 1876 began his fascination with the lives of Native Americans, and he documented their way of life for the rest of his career. This led to his contributing to the 1894 *Report on Indians Taxed and Indians Not Taxed* for the United States Indian Agency. It was for his military paintings, however, that he received the bulk of critical favor, beginning in 1881, the year he and his wife (Susie A. Murray, whom he married in 1880) moved to a rural property he had inherited in Tennessee.

After four years in the South, Gaul returned to New York City, but he soon embarked on a series of travels throughout the 1890s that were documented in an 1898 article by Theodore Dreiser.[4] Gaul's upper Manhattan studio and home were filled with military paraphernalia and sketches and photographs of Civil War battle sites that he used to create his accurately detailed paintings. Gaul received international recognition for his work when it was shown at such venues as the International Exhibition in Munich in 1883, the Paris Universal Exposition of 1889, the World's Columbian Exposition of 1893 in Chicago, and the 1901 Pan-American Exposition in Buffalo.

Despite his professional successes, his personal life was made difficult by, among other things, the death of his wife (he remarried in 1898), his battle with tuberculosis, and financial problems that he unsuccessfully attempted to allay by teaching. After living for a time in Ridgefield, New Jersey, he moved to Edgecombe Avenue in the St. Nicholas section of northern Manhattan, where he died in 1919.[5]

1. Jeannette L. Gilder, "A Painter of Soldiers," *Outlook* 59, no. 9 (July 2, 1898): 570–73. The French academic artist Édouard Detaille (1848–1912) specialized in battle scenes.
2. See, for instance, Gilbert Gaul, "Personal Impressions of Nicaragua, with Pictures by the Author," *Century Illustrated Magazine* 46, no. 1 (May 1893): 64–72.
3. The principal published source on Gaul is James F. Reeves, *Gilbert Gaul* (Huntsville, Ala.: Huntsville Museum of Art, 1975).
4. Theodore Dreiser, "A Painter of Travel," *Ainslee's Magazine* 1 (June 1898): 391–98.
5. "G. W. Gaul, Painter, Dies," *NYT*, December 22, 1919, 15.

19

(William) Gilbert Gaul (1855–1919)
Charging the Battery
1882

Oil on canvas, 36 × 44 in. (91.4 × 111.8 cm)
Gift of Mr. Donald Anderson, 1954.111

For color, see page 99

Battle scenes and vignettes of the Civil War continued to be popular artistic subjects for decades after its end. However, the manner of their portrayal evolved with changing styles and with the ways that Americans wished to remember the traumatic conflict. Gilbert Gaul was one of the foremost painters of Civil War themes in the late nineteenth century. *Charging the Battery*, considered one of Gaul's most important works, does not depict a particular incident. Rather, it shows Union soldiers engaging in an unspecified night attack. At right, a twisting column of men scrambles toward the hellish glow of cannon or artillery fire in the distance. At left, the bodies of the dead and wounded are strewn about. In the foreground, one man sits clutching his chest, and another, perhaps having been thrown to the ground, looks over his shoulder at the action behind him. Though smoke obscures much of the sky, the scene is illuminated by haunting moonlight and the unearthly glow of battle, so that the men, and even their flag at upper right, are reduced to silhouettes delineated by the light glinting off their bayonets, their belts, and the U.S. insignia on their cartridge boxes.

Gaul's choice of a night scene resulted in a tour de force of lights and darks that spares the viewer the pain and fear of individual soldiers, instead concentrating attention on the valiant movement of the whole. His loose brushwork and generalized treatment of the subject, along with the unusual composition, demonstrate his keen understanding of changing aesthetic tastes. In the decades after the war, artists employed looser, freer brushwork and often experimented with unusual vantage points, in keeping with European trends.

Gaul exhibited the painting at the National Academy of Design in 1882. The picture earned great acclaim that focused at least as much on its technical merits as on its subject.[1] The picture was reproduced in several publications in tribute to the innovative composition. The *New York World* cited Gaul's successful balance of accuracy and aesthetics.[2] The *Art Interchange* called it "almost impossible to criticize."[3] The *Art Journal* considered it "so attractive that one forgets to ask if it is true."[4] The academy agreed, voting to grant Gaul full academician status at the age of twenty-seven, making him one of the youngest ever to achieve that honor.

Gaul seems to have understood the need for Civil War pictures that softened its harsher realities. Americans had been all too familiar with injury, loss, and death, and as painful memories grew distant with time, they wanted images that reflected a more abstract and less particular view of the war that justified those sacrifices. In fact, one writer touched on this desire to avoid direct confrontation when he complained that, in spite of Gaul's generalized treatment, the artist still reminded viewers too pointedly of danger, commenting uncomfortably, "[T]here was no need of setting us right in the cannon's eye."[5] —KPO

1. The painting was also exhibited at the 1889 Universal Exposition in Paris, where it earned a bronze medal.
2. "National Academy of Design," *New York World*, April 10, 1882, 4.
3. "Fifty-sixth Academy," *Art Interchange* 8 (April 27, 1882): 103.
4. "Art Notes," *Art Journal* 8 (June 1882): 190.
5. "The National Academy Exhibition," *Art Amateur* 6 (May 1882): 117.

Henry Peters Gray

(1819–1877)

Throughout his career, Henry Peters Gray adhered to the example of the Venetian Renaissance masters whose themes and techniques informed his art. Gray's conservative aesthetics—typified by mellow tones and allegorical subjects—set his art apart from that of most of his contemporaries, a view affirmed by Henry T. Tuckerman's observation that Gray's works "look as if painted to last, to become heirlooms and domestic treasures . . . to be hung against carved oak panelings, or in cabinets sacred to meditation and illumined by tempered light."[1]

Gray was born in New York City, the privileged son of the merchant George W. Gray and a grandson of Harry Peters, whose farm had occupied significant Manhattan acreage that later became Vauxhall Gardens.[2] He attended Hamilton College in Clinton, New York, where he may have met Daniel Huntington, whose official pupil he became in 1838. Peters made his first trip to Europe with Huntington in late 1839 and spent much of his approximately two-year stay in Italy, where he studied especially the art of the Venetian School and ancient Greek art. Returning to New York in 1841, he immediately established himself as a portrait painter. He attained associate status in the National Academy of Design in 1841 and was elected a full academician in 1842. In 1843 he married Susan Clark, an artist in her own right who cofounded the Ladies' Art Association in 1867.

After a second trip to Europe in 1845 (from which he returned in 1846), Gray began to focus on painting allegorical subjects redolent of Greek mythology. Among these was *The Greek Lovers* (1846, The Metropolitan Museum of Art), a canvas acquired by the important collector Abraham M. Cozzens that was instrumental in shaping Gray's reputation as a painter of subjects having the "stamp of antiquity."[3] For a brief period, he contributed articles to the *St. Louis Leader*, founded and coedited by Jedediah Vincent Huntington, the brother of Daniel.[4] At the same time Gray began to devote a considerable amount of his energies to administrative duties at the academy, serving regularly on the council throughout the next fifteen years, assuming a nine-year tenure as vice president, and serving as president from 1869 to 1871.

Gray traveled to Europe again in 1872 and lived in Florence until 1875, when he returned to New York. His remaining two years were marked by poor health, and he died from Bright's disease in 1877.[5] Although Gray was remembered especially for his efforts in allegorical genre, such canvases were deemed "not in perfect accord with the realistic spirit of the age" and ultimately overshadowed by the estimated four to five hundred portraits that issued from his hand.[6]

1. Tuckerman 1867, 444.
2. Principal sources for the information presented here are ibid.; Daniel O'C. Townley, "Living American Artists: No. II; Henry Peters Gray, President of the National Academy of Design," *Scribner's Monthly* 2, no. 4 (August 1871): 401–2; and Charles P. Daly, *In Memory of Henry Peters Gray* (New York, 1878).
3. The phrase was used to describe Gray's *Cupid Begging for His Arrows* (1844, Pennsylvania Academy of the Fine Arts) when it was shown at the 1845 annual exhibition of the National Academy of Design. See "National Academy of Design," *NYH*, May 3, 1845, 1.
4. Gray's essay "Authority in Art" was published in the *Leader* in 1855. See Daly, *In Memory*, 16.
5. "Obituary," *NYT*, November 13, 1877, 4.
6. "Fine Arts: Notes from the American Studios in Italy," *Appleton's Journal* 12, no. 281 (August 8, 1874): 189. Accounts vary as to the number of portraits Gray actually painted. The estimate provided here is from "Obituary."

20

Henry Peters Gray (1819–1877)
Portia and Bassanio—from "The Merchant of Venice"
1865

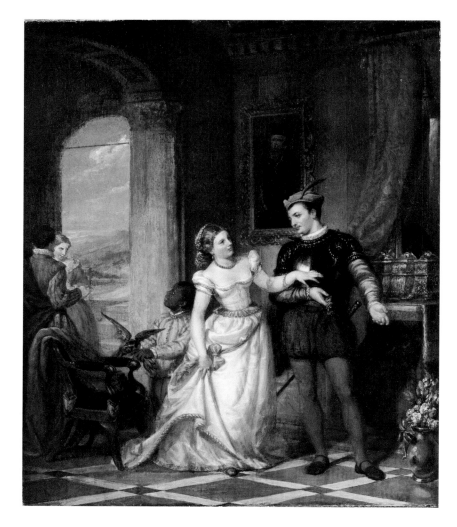

Oil on canvas, 24 × 20 in. (61 × 50.8 cm)
Signed and dated lower left: *H P Gray 1865*
Gift of Mrs. F. Robert Schell, 1932.3

For color, see page 48

Henry Peters Gray's modest cabinet picture featuring a scene from *The Merchant of Venice* represents a rare example of his excursion into Shakespearean subject matter. Despite being considered one of the artist's most important works of the 1860s, *Portia and Bassanio* failed to receive much critical notice when it was displayed at the National Academy of Design in 1865.[1] No reviews for it have been located apart from one that stated the painting was "good in color, but inexpressive."[2]

Several factors may account for the painting's lack of attention, one of which was the growing taste for contemporary subjects and styles, which, according to Henry T. Tuckerman, betrayed German and French influence rather than the "Roman" manner that Gray espoused.[3] Tuckerman differentiated between the opinions of critics and the preferences of a "class of amateurs" who admired Gray's paintings, "partly from association, and partly from their intrinsic and historical significance; to these Gray's style and method were full of interest, as being legitimate, though retrospective."[4] Among the "amateurs" to whom Tuckerman referred were some of New York's most respected collectors, including Jonathan Sturges, Abraham M. Cozzens, and Robert M. Olyphant, whose active collecting days had passed.

Another contributing factor to the critical silence was an anti-academy attitude provoked by the predominance of academicians' work in the institution's exhibition of 1865. As one reviewer put it, Gray and his fellow academicians displayed merely frames.[5] Such feelings may also have been generated by antipathy for the academy's new building, a Venetian-Gothic confection

designed by Peter Bonnett Wight (1838–1925), which opened its doors that year. In that context, Gray's choice to exhibit a Shakespearean theme set in Venice would have been supremely apt, not only because he was known as the "American Titian" but also because he had been a key figure in the campaign to raise funds to pay for the new building.

Painted in the mellow, glowing colors for which Gray was celebrated, the canvas evokes the style and milieu of Titian's Renaissance Venice. The action takes place in Portia's rooms at her family estate. The couple at the left are likely Lorenzo and Jessica (Shylock's daughter), and the servant boy is probably meant to be Balthazar. Here, Bassanio confesses to Portia his desire to help Antonio (the Merchant of Venice) pay his debt to Shylock and insists that this must be done before he and Portia can marry. Before he takes his leave, Portia gives him her ring, which he promises never to surrender.

Although the composition appears to conflate various scenes from the play, the gestures of the golden-haired beauty Portia and her beloved Bassanio suggest that Gray may have relied particularly on the lines that close act 3, scene 3:

Portia: O love, dispatch all business, and be gone.

Bassanio: Since I have your good leave to go away,
I will make haste: but, till I come again,
No bed shall e'er be guilty of my stay,
 Nor rest be interposer 'twixt us twain.

As attractive as the painting might have been to some contemporary viewers, Gray's decision to portray Portia and Bassanio was possibly problematic for his audience.

The play was popular with American theatergoers, but it was the character of Shylock and not the romantic pair of Portia and Bassanio that fascinated the crowds.[6] Despite the impending ordeal of her separation from Bassanio, the virtuous, rational, and ultimately cross-dressing Portia countered nineteenth-century expectations for womanly behavior and in 1863 was categorized with several other Shakespearean heroines who "asserted their prerogative, as intellectual creatures, to be the companions (in the best sense), the advisors, the friends, the equals of men."[7] Such ideas of female independence contradicted the messages contained in paintings that underscored the pain of separation enforced by the Civil War, exemplified by Winslow Homer's (1836–1910) *The Initials* (private collection) and John George Brown's (1831–1913) *Thus Perish the Memory of Our Loves* (unlocated), which were also on view in the academy's 1865 exhibition. —BDG

1. Daniel O'C. Townley, "Living American Artists: No. II; Henry Peters Gray, President of the National Academy of Design," *Scribner's Monthly* 2, no. 4 (August 1871): 402.
2. "National Academy of Design East Room," *NYT*, June 7, 1865, 4.
3. Tuckerman 1867, 443.
4. Ibid.
5. "National Academy of Design," *NYT*, June 27, 1865, 5.
6. See Floyd Stovall, "Whitman's Knowledge of Shakespeare," *Studies in Philology* 49, no. 4 (October 1952): 646, in which he states that *The Merchant of Venice* was one of several Shakespeare plays that was produced in New York "every year, often many times during a year, from 1832 to 1862."
7. Charles Cowden Clarke, *Shakespeare-Characters: Chiefly Those Subordinate* (London, 1863), 305–6. See especially Julie Hankey, "Victorian Portias: Shakespeare's Borderline Heroine," *Shakespeare Quarterly* 45, no. 4 (Winter 1994): 426–48.

Daniel Huntington

(1816–1906)

Of the more than twelve hundred paintings that Daniel Huntington produced, approximately one thousand were portraits. Nevertheless, he is now remembered primarily for what he called "Christian allegories" and works based on Stuart and Tudor history.[1] Less recognized are his landscapes, a small segment of his output that demonstrates his considerable talent in that genre. A tireless worker, Huntington also found time to write (for example, he wrote pseudonymously as Flake White for the *Crayon*), and he was an active force in the administration of the National Academy of Design (serving as its president from 1862 to 1869 and again from 1876 to 1891), a founder of the Century Association, and a trustee of the Metropolitan Museum of Art.[2]

Huntington was born in New York City. His stockbroker father, Benjamin, and his mother, Faith Huntington née Trumbull, were distant cousins whose shared lineage in a prominent Connecticut family included generations of distinguished military and civic officials. Huntington reportedly became interested in the arts early in life but was discouraged by the history painter John Trumbull (1756–1843) to whom his mother was related. After briefly attending Yale University, Huntington transferred to Hamilton College, in Clinton, New York, where he encountered the portrait painter Charles Loring Elliot (1812–1868). Under Elliot's influence, Huntington left his academic studies and returned to New York, with plans to become an artist. In 1836 Huntington was training with Samuel F. B. Morse at New York University. Around this time he also studied with the portrait painter Henry Inman (1801–1846) and worked as an assistant in the studio of the portrait and genre specialist Frederick

Spencer (1806–1875). An admirer of Thomas Cole, Huntington also began painting landscapes during this period. In 1836 he began his long history of exhibiting at the National Academy of Design, and by 1838 he was instructing his first student, Henry Peters Gray.

Huntington's career was punctuated by several extended trips to Europe, the first of which was in the company of Gray in 1839 and spent mainly in Italy. Inspired by the art of the old masters, Huntington returned to New York in 1840 and took the spotlight with the display of *Mercy's Dream* (Pennsylvania Academy of the Fine Arts). Having been elected an associate of the National Academy of Design in 1839, he was made a full academician in 1841. In 1842 he married the Brooklynite Harriet Sophia Richards, and the two went to Europe, where they lived mainly in Rome until 1845. The artist's mounting success was proved by the exhibition of 130 of his works at the Art Union Buildings on Broadway in 1850, a project arranged by popular demand of Huntington's many friends and colleagues. The Huntingtons returned to Europe in 1851, this time settling in England until 1858. A final trip took him to Spain in 1882.

Huntington remained true to the academic precepts he learned from Morse at the beginning of his career. As S. G. W. Benjamin commented in 1881, "If he [Huntington] has wrested no discoveries from the truths of nature, if he has not explored deeply into the mysteries of character, or introduced new styles of artistic expression, he has, on the other hand, been no tame imitator, he has not cloyed the taste with inane mannerisms, and the motive of his art life has been pure and elevating."[3] He died in his ninetieth year in 1906 at his home at 49 East Twentieth Street.[4]

1. The best modern scholarly sources are William H. Gerdts, "Daniel Huntington's *Mercy's Dream*: A Pilgrimage through Bunyanesque Imagery," *Winterthur Portfolio* 14 (Summer 1979): 171–94; and Wendy Greenhouse, "Daniel Huntington and the Ideal of Christian Art," *Winterthur Portfolio* 31 (Summer–Autumn 1996): 103–40.
2. See Wendy Greenhouse, "The *Crayon*'s 'Flake White' Identified," *American Art Journal* 18, no. 1 (Winter 1986): 77–78.
3. S. G. W. Benjamin, "Daniel Huntington, President of the National Academy of Design: Second and Concluding Article," *American Art Review* 2, no. 7 (May 1881): 6.
4. "Daniel Huntington Dies," *NYT*, April 20, 1906, 11.

OPPOSITE: CAT. 22, detail

21

Daniel Huntington (1816–1906)

A Sibyl

1839

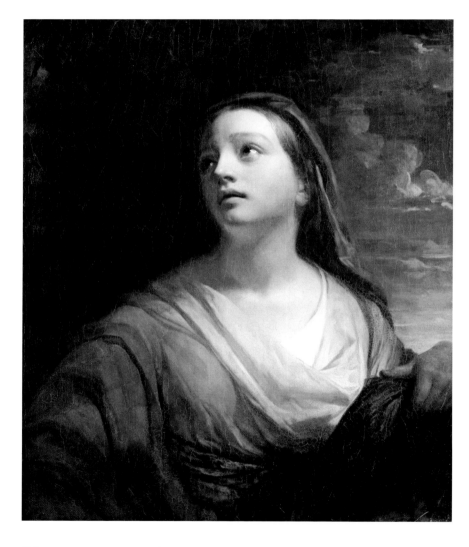

Oil on canvas, 30½ × 25 in. (77.5 × 63.5 cm)
Gift of the American Art-Union, 1863.9

For color, see page 13

In an 1851 lecture, Daniel Huntington admonished his audience: "Art is not to be treated as a trifle. . . . It has a powerful influence for good or for ill in the minds of men."[1] He considered all works of art to carry moral import, regardless of whether they depicted overtly religious subjects. One of his first religious pictures, *A Sibyl* combines allegory with spirituality in an image that is subtly allusive, in contrast to the explicit moralizing of his later religious works such as *Sowing the Word* (cat. 23). While in Florence in 1839, the artist painted from a local model. She also appears in the prosaically titled *Florentine Girl* (Pennsylvania Academy of the Fine Arts), but in *A Sibyl* she takes on the mystical role of prophetess.

The sibyl, a female oracle of the gods, originated in ancient Greek myth. The tradition was later Christianized, transforming the sibyl into a herald of the New Dispensation. In Huntington's words, "She is supposed to be receiving intimations of the advent of Christ." His audience may not have been familiar with the subject, particularly in a religious context, and Huntington was careful to assure viewers that such figures appeared in the company of prophets and apostles in old master paintings.[2] Huntington was also influenced by the Baroque painters whose work he would have seen during his Italian sojourn, such as Guercino (1591–1666), Guido Reni (1575–1642), and Domenichino (1581–1641). He later expressed admiration for the latter two in particular, and their bust portraits of saints reverently gazing upward are very similar in format and mood to *A Sibyl*.[3]

The young artist's talent is evident in the fluid and harmoniously colored drapery, rendered in shades of rose

and gold that complement the soft, atmospheric treatment of the young woman's skin. Her face and form are bathed in divine light, and she lifts her dewy eyes as the sun rises behind her, seemingly ushering in the Christian era. She holds a book in her left hand, perhaps some pagan text, but it is almost lost in shadow and rendered irrelevant. The artist visited Rome during his 1839 European trip and very likely would have seen the famous Delphic and Libyan Sibyls in the Sistine Chapel, who also hold books and scrolls but look away from them, toward the divine source of direct revelation.

In 1840 Huntington exhibited *A Sibyl* at the Apollo Association, the precursor to the American Art-Union. It appears to have aroused little comment apart from that offered by the writer for the *Ladies' Companion*, who praised its design and execution.[4] The Art-Union later demonstrated its high regard for the work: it was engraved by John William Casilear (1811–1893) in 1847 and distributed to the many thousands of Art-Union members across the country. It was included in an 1850 exhibition of Huntington's work in the Art-Union gallery, where it earned mixed praise: "gracefully conceived and executed, yet the inspiration might have been conveyed much more forcibly and definitely."[5] It was also the first painting the organization purchased as part of a short-lived plan to form a permanent collection.[6]

The painting accrued further fame when it appeared at the 1864 Metropolitan Fair in New York, organized by the U.S. Sanitary Commission to raise funds in aid of Union soldiers. Years later, in 1881, the critic S. G. W. Benjamin called it effective in its simple arrangement and imbued with grace and dignity.[7]

Huntington went on to produce a number of large-scale works illustrating episodes from John Bunyan's popular seventeenth-century allegory *The Pilgrim's Progress* and episodes from the English Reformation as well as sermons in paint such as *Sowing the Word*, but this early effort, with its singularly nuanced spiritual vision, continued to enjoy critical esteem. —KPO

1. Daniel Huntington, "Lecture on Christian Art," 1851, p. 7 3/4 [sic], Feinberg Autograph Collection, reel D-316, AAA.
2. *Catalogue of Paintings by Daniel Huntington, N.A.* (New York, 1850), 21–22.
3. Huntington, "Lecture on Christian Art," 34–35.
4. "The Apollo Association," *Ladies' Companion*, November 1840, 50.
5. G. W. P., "The Huntington Exhibition," *Bulletin of the American Art-Union* 3 (April 1850): 5.
6. The Art-Union gave the painting to the New-York Historical Society in 1863.
7. S. G. W. Benjamin, "Daniel Huntington, President of the National Academy of Design: First Article," *American Art Review* 2 (April 1881): 226. Benjamin's article was reprinted in Walter Montgomery, *American Art and American Collections* (Boston: E. W. Walker & Co., 1889), 1:19–36.

22

Daniel Huntington (1816–1906)

Mother and Child

1849

Oil on canvas, 30¾ × 25½ in. (78.1 × 64.8 cm)
Signed and dated lower left: *D. Huntington / 1849*
Gift of Mrs. Louis A. Gillet, 1945.449

For color, see page 106

The present-day scholar Wendy Greenhouse, one of the few to write on Daniel Huntington, has observed that, "Insisting on the vitality of academic tradition, Huntington drew on it to realize a consciously Christian art that would serve mutually the causes of religion and art."[1] In this painting, Huntington combined sacred iconography with artistic accomplishment. *Mother and Child* bears the influence of Huntington's stay in Rome from 1842 until 1845. Though not overtly religious, the subject and style echo the many images of the Madonna and Child that he would have seen there. The artist exhibited a painting of the same title at the National Academy of Design in 1846, three years before he executed this signed and dated work. He commented that the 1846 painting was "treated with simple drapery, in the style of a sacred subject."[2] Its location is not currently known, but the artist's brief description suggests that it may have been similar to this later version. Huntington's caveat that the painting was "in the style of a sacred subject" rather than actually being a sacred subject indicates that he intended to depict a secular theme infused with the moral seriousness that he felt should permeate all works of art.[3]

Huntington portrayed a mother curled protectively around her child in an isolated setting marked by ruins. The mysterious ruin with its rounded arches and the glimpse of a pastoral landscape in the distance would have evoked a scene in the Roman Campagna to the artist's well-traveled viewers. The juxtaposition of the mother and child surrounded by crumbling architecture might also have alluded to the iconographic trope of the Old Covenant giving way to the New. The artist placed the female figure in a challenging pose that showcases

his ability to render the human form. Her exposed back, neck, and arm create a curving expanse of glowing flesh. Her bent leg and sharply foreshortened foot demonstrate Huntington's technical skills. Placing the figures in an architectural setting with a view through the arches combines the genres of landscape and figure painting, hinting at the breadth of the artist's talents.

This version of *Mother and Child* was exhibited at the American Art-Union in 1849 but it did not attract critical attention among the hundreds of paintings on view. According to the Art-Union's procedures, it was distributed by lottery to one of its members, Mrs. A. J. Gillet of New York, and one of her descendants gave it to the New-York Historical Society nearly a century later.—KPO

1. Wendy Greenhouse, "Daniel Huntington and the Ideal of Christian Art," *Winterthur Portfolio* 31 (Summer–Autumn 1996): 104.
2. *Catalogue of Paintings by Daniel Huntington, N.A.* (New York, 1850), 33.
3. Daniel Huntington, "Lecture on Christian Art," 1851, p. 7 3/4 [*sic*], Feinberg Autograph Collection, reel D-316, AAA.

23

Daniel Huntington (1816–1906)

Sowing the Word

1868

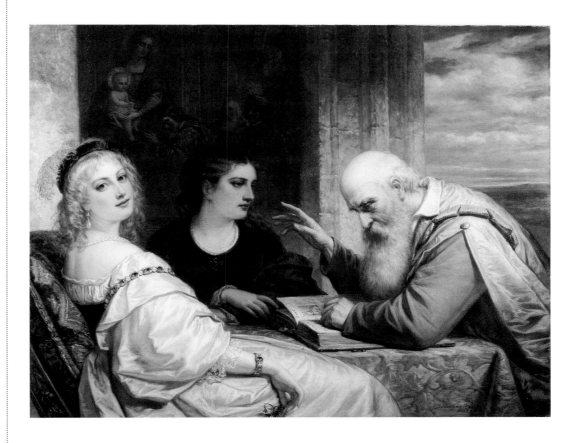

Oil on linen, 44½ × 56¼ in. (113 × 142.9 cm)

Signed and dated lower right: *D. Huntington / 1868*

Gift of the Estate of Isaac Newton Phelps Stokes, 1948.158

For color, see page 104

Daniel Huntington came from a deeply religious family, and his sacred themes evolved over the course of decades. His popular success, *Mercy's Dream* of 1841 (Pennsylvania Academy of the Fine Arts), drew on John Bunyan's classic allegory *Pilgrim's Progress*. In the 1850s and 1860s his religious subjects were taken from the New Testament,[1] and late in his career he turned to the subject of religious instruction itself.

The two young women here are being instructed by an elderly man in an eminently legible allegory of

impressionable youth and venerable wisdom. The reclining woman on the left wears a bejeweled silk dress, necklace, and earrings and looks suggestively over her shoulder at the viewer. Her right hand curves to conceal a flower, as if she is secretly offering it to the observer. Her languor and sensuality contrast with her companion, who leans forward, attending to her instructor. Her plain, dark-colored dress is unembellished by ornament or jewelry. Their master leans forward, his eyes trained on the illuminated text. The word "Luce" at the top of the page and the illustration of a man at an easel suggest he is reading the Gospel of Luke, the evangelist credited with painting the first pictures of the Virgin Mary.

The scene recalls Jesus's parable of the sower that appears in Luke 8:1–15 (as well as the Gospels of Matthew and Mark):

A sower went out to sow his seed: and as he sowed, some fell by the way side; and it was trodden down, and the fowls of the air devoured it. And some fell upon a rock; and as soon as it was sprung up, it withered away, because it lacked moisture. And some fell among thorns; and the thorns sprang up with it, and choked it. And other fell on good ground, and sprang up, and bare [sic] fruit an hundredfold. And when he had said these things, he cried, He that hath ears to hear, let him hear.[2]

In Huntington's painting, the knowledge the master offers falls on the fertile ground of the attentive, somber woman on the right, where it will presumably flourish, but it also falls on the rocky ground symbolized by the worldly woman at left, where it will not grow.

Huntington exhibited the painting at the National Academy of Design in 1869. Because he was president of the academy, his contributions were subject to close scrutiny, and the conservative style and subject of *Sowing the Word* did not go unnoticed. One writer began his review with a long and respectful acknowledgment of the artist's leadership before criticizing the painting for its lack of originality, poor drawing, and crude color.[3] The famously caustic Clarence Cook wasted no time with formalities, writing that the women were "dressed like servant girls on a bender" and that the man appeared to be wearing his wife's opera cloak. He claimed not to understand the title, which is difficult to credit. Perhaps he enjoyed mocking Huntington for taking a didactic approach that was so *retardataire* that it was incomprehensible to "modern" viewers.[4] Most other reviews were less satirical but no more flattering.[5] However, the critic for *Appleton's Journal* praised the female figures for their "supreme charm," calling them "delicious ideals of womanly beauty."[6]

Huntington no doubt realized the change in artistic taste, but the painting bears out his declaration of nearly two decades before: "I am aware that it has been said . . . that the end of art is never to *teach*, and especially never to teach *morality*." He warned his listeners not to be deluded: "[I]t has dominion over matter—mind and morals."[7] His views may have been shared by the New York merchant and banker Anson Phelps Stokes, who owned the painting at the time of its exhibition at the National Academy. He was part of the influential Phelps-Stokes families who were deeply involved in the religious and philanthropic life of New York City.

When it was exhibited at the 1876 Centennial Exhibition in Philadelphia, it was called "old-fashioned" and "a connecting link between deceased and living artists," though it "helped make [Huntington's] fame."[8] However, that very quality of timelessness seems to have established its posterity. An engraving after the painting was widely circulated. It was often listed among Huntington's principal paintings and remains among his best-known works. —KPO

1. See Wendy Greenhouse, "Daniel Huntington and the Ideal of Christian Art," *Winterthur Portfolio* 31 (Summer–Autumn 1996): 103–40.
2. Luke 8:5–8 (King James Version).
3. "National Academy of Design," *Watson's Art Journal*, June 5, 1869, 74.
4. [Clarence Cook], "The Fine Arts: The National Academy of Design," *NYDT*, May 22, 1869, 1.
5. "Fine Arts: The National Academy of Design," *NYT*, April 30, 1869, 4; and "Fine Arts: The Forty-fourth Annual Exhibition of the National Academy of Design," *New York Evening Mail*, April 16, 1869, 1.
6. "Table Talk," *Appleton's Journal* 1 (May 8, 1869): 186.
7. Daniel Huntington, "Lecture on Christian Art," 1851, pp. 10–11, Feinberg Autograph Collection, reel D-316, AAA.
8. Ruhamah, "Art at the Centennial," *National Republican*, June 15, 1876, 1; Phillip T. Sandhurst, *The Great Centennial Exhibition* (Philadelphia: P. W. Ziegler & Co., 1876), 53; and "The Changes Made in the Art Department of the Exhibition during the Past Week," *NYH*, June 19, 1876, 9.

Eastman Johnson

(1824–1906)

Considered the successor to William Sidney Mount as America's leading genre painter, Eastman Johnson, in contrast to Mount, injected his art with a poignant sobriety and technical facility indicative of his extensive European training. These differences aside, Johnson continued his predecessor's practice of depicting distinctly American subjects that often embraced issues of political significance.

Johnson was born in Lovell, Maine, but his family moved throughout the state during his childhood owing to his father's career as a government official.[1] Little is known of his early years, but his natural inclination for art was probably encouraged by a brief apprenticeship with a Boston lithographer about 1840. By 1842, however, he was back with his family (then in Augusta, Maine), where he began to produce finely drawn crayon portraits. When his father's new government appointment took the family to Washington, D.C., Johnson followed in 1846 and established a reputation as a specialist in crayon and chalk portraits in the nation's capital, which he parlayed into a successful stint in Boston with commissions from Henry Wadsworth Longfellow.

Johnson left Boston in 1849 and, with George Henry Hall (1825–1913), went to Germany to study at the Königliche Kunstakademie in Düsseldorf. In 1851 he became closely associated with Emanuel Gottlieb Leutze, who exerted considerable influence on him. When Leutze returned to the United States later that year, Johnson went to England and then to Holland for a four-year stay, during which time he devoted close study

to the art of seventeenth-century Dutch painters. His European sojourn closed in Paris, where he trained briefly with Thomas Couture (1815–1879) before returning to the United States in 1855.

Johnson settled in New York City in 1859 after spending a few years working in Washington and making periodic visits to the region around Lake Superior, where he executed studies of Native Americans in preparation for a major painting he was contemplating. Although he had previously exhibited at the National Academy of Design, his 1859 display of *Negro Life at the South* (cat. 24) brought him great acclaim and resulted in his election as an associate in the organization (he achieved full membership in 1860). Throughout the 1860s and 1870s Johnson's career flourished. His output ranged from intimate scenes inspired by Édouard Frère (1819–1886) to densely populated landscapes such as *The Cranberry Harvest, Island of Nantucket* (1880, Timken Museum of Art, San Diego). His marriage to Elizabeth Buckley in 1869 and the birth of their only child, Ethel, in 1870 introduced an atmosphere of domesticity to his imagery.

Despite the fact that Johnson was an early member of the relatively progressive Society of American Artists, his subject matter had begun to register as old-fashioned and nostalgic by the 1880s. He returned successfully to his original focus on portraiture, specializing in male sitters, many of whom were fellow members of the Union League Club, the Century Association, and fellow cofounders of the Metropolitan Museum of Art. Johnson died in New York in 1906, remembered at the time primarily as a portraitist.[2]

1. See John I. H. Baur, *Eastman Johnson, 1824–1906: An American Genre Painter* (Brooklyn: Brooklyn Museum, 1940); Patricia Hills, *The Genre Painting of Eastman Johnson: The Sources and Development of His Style and Themes* (New York: Garland Publishing, 1977); and esp. Teresa A. Carbone and Patricia Hills, *Eastman Johnson: Painting America* (New York: Brooklyn Museum of Art, in association with Rizzoli International Publications, 1999).
2. "Eastman Johnson Dead: The Artist Had Painted Portraits of Many Famous People," *NYT*, April 6, 1906, 11.

24

Eastman Johnson (1824–1906)

Negro Life at the South

1859

Oil on linen, 37 × 46 in. (94 × 116.8 cm)
Signed and dated lower right: *E. Johnson / 1859*
The Robert L. Stuart Collection, S-225

For color, see page 72

Eastman Johnson secured his reputation as one of the nation's foremost genre specialists with the display of *Negro Life at the South* at the 1859 exhibition of the National Academy of Design.[1] Hailed as the "gem" of the exhibition, the painting drew extensive critical commentary praising the artist's technical prowess and his exploration of the "spirit of negro life."[2] Almost without exception, contemporary critics imagined it to portray a scene of plantation life, an assumption that soon led to the painting's popular title, *The Old Kentucky Home*.[3] In actuality, the painting depicts the yard behind slave quarters in Washington, D.C., next door to Johnson's father's house not far from the White House. As a consequence of this displacement, an important layer of the painting's meaning having to do with the highly contested issue of slavery in the District of Columbia was lost to its viewers.

Although many commentators claimed the image was a "truthful . . . and artistic glance at the *dolce far niente* of our coloured brethren,"[4] Johnson's uncommon look into the private life of a group of slaves as they make music, court, play, or simply relax evoked a variety of responses, depending on the individual writer's point of view. It has been suggested that Johnson intended the painting to be ambiguous to broaden the appeal of the already highly politicized image. Thus, for some viewers, the ostensibly temperate vision of slaves at leisure may have justified the continuation of slavery or at least lessened the sting of guilty consciences. For others, the decrepit structure and its unkempt yard (in contrast to the neatly maintained property next door) signaled the inevitable decay of the cruel system of enslavement. Even the most sympathetic of the reviews tended to catalogue

the protagonists according to racial stereotypes, as witnessed by the *Tribune*'s critic, who saw the painting as "a sort of 'Uncle Tom's Cabin' of pictures," referring to the best-selling novel by Harriet Beecher Stowe published in 1851.[5] Such links with literary works underscore the narrative potential of the painting, which was perceived as a "story within a story," part of which was as "telling as a chapter from 'Slavery As It Is,' or a stirring speech from the Anti-Slavery platform." Countering this was the feeling that the painting revealed the "careless happiness of simple people, intent only upon the enjoyment of the present moment, forgetful, perhaps ignorant, of degradation, and thoughtless of how soon may come the rupture of all those natural ties in which lie the only happiness that life can give them."[6]

The nuanced meanings embodied in the picture are far too complex to examine fully in the present context. However, several comments relating to taste may be cited to illuminate problems attached to the reception of the painting. Johnson's portrayal of slaves in a communal, social situation was regarded in some quarters as inappropriate for high art. One critic explained, "We hold it to be very difficult to present negroes pleasantly on canvass," but the writer found the problem mediated by the arrival of the young white woman at the right, whose "presence sheds a refinement over the scene, and as she is not startled, we need not be, at witnessing the innocent enjoyment of negro Southern life."[7] A writer for the *Crayon* put it more forcefully, stating that Johnson's painting "is of a kind of Art that will be always popular, so long as lowly life exists to excite and to reveal the play of human sympathy. But 'Negro Life at the South' is not 'high Art,' for the reason

that the most beautiful thoughts and emotions capable of Art representation, are not embodied in the most beautiful forms, and in the noblest combinations."[8]

Such criticism did not impede the painting's sale; it was purchased for twelve hundred dollars by John Frederick Kensett (1816–1872) and within a year was owned by the New York cotton broker William P. Wright.[9] In 1868 it was acquired by the sugar refiner Robert L. Stuart for six thousand dollars. John Davis has remarked that both men's fortunes depended on slave labor and speculates that they may have interpreted the painting in self-serving terms, "representing slavery as benign so long as adequate restraints were in place to prevent individual cases of abuse."[10] —BDG

1. See esp. Patricia Hills, "Cultural Racism: Resistance and Accommodation in the Civil War Art of Eastman Johnson and Thomas Nast," in *Seeing High and Low: Representing Social Conflict in American Visual Culture*, ed. Patricia Johnston (Berkeley: University of California Press, 2006), 103–23; Patricia Hills, "Painting Race: Eastman Johnson's Pictures of Slaves, Ex-Slaves, and Freedmen," in Teresa A. Carbone and Hills, *Eastman Johnson: Painting America* (New York: Brooklyn Museum of Art, in association with Rizzoli International Publications, 1999), 121–65; and John Davis, "Eastman Johnson's 'Negro Life at the South' and Urban Slavery in Washington, D.C.," *Art Bulletin* 80, no. 1 (March 1998): 67–92.
2. "National Academy of Design," *NYH*, May 8, 1859, 5.
3. Davis, "Johnson's 'Negro Life at the South,'" 70, points out that the alternative title became attached to the work as early as August 1859, when the painting was on view at the Boston Athenæum.
4. "Fine Arts," *Albion* 37, no. 19 (May 7, 1859): 225.
5. "The National Academy Exhibition," *NYDT*, May 21, 1859, 6.
6. Ibid.
7. "National Academy of Design: No. 1," *Spirit of the Times: A Chronicle of the Turf, Agriculture, Field Sports, Literature, etc.* 29, no. 12 (April 30, 1859): 133.
8. [John Durand?], "The National Academy of Design: Second Notice," *Crayon* 6 (June 1859): 191.
9. Hills, "Painting Race," 126.
10. Davis, "Johnson's 'Negro Life at the South,'" 87.

25

Eastman Johnson (1824–1906)

Sunday Morning

1866

Oil on canvas, 24¼ × 36 in. (61.5 × 91.4 cm)
Signed and dated lower right: *E. Johnson / 1866*
The Robert L. Stuart Collection, S-219

For color, see page 113

In the years following the Civil War, artists who aspired to paint subjects from everyday life were challenged to find new approaches and subjects to address a United States struggling to reunite after a bloody period of division and disillusionment. Some turned to the nation's origins. Religious themes that centered on the country's New England roots reassured Americans of the nation's unique spiritual dispensation. Moralizing images of Bible reading at the family hearth were popular at the midcentury,[1] and in *Sunday Morning* Eastman Johnson combined these themes in an effort to connect the country's troubled present to an idealized past.

Johnson's principal subjects often evolved over time. In the case of *Sunday Morning*, the artist had literally set the stage for his composition years before. About 1863 he painted *New England Kitchen* (Mr. and Mrs. R. Philip Hanes Jr.), which depicts the room where *Sunday Morning* takes place but devoid of human activity. During that period he also painted *The Chimney Corner* (Munson-Williams-Proctor Arts Institute, Utica, N.Y.), in which an elderly black man sits reading in the same pose that the patriarch assumes in the present painting. These works, created during the Civil War, were repurposed in Johnson's postwar meditation on old-fashioned New England piety. In *Sunday Morning* the players have taken the stagelike space of the spare, dim kitchen. Light streams in from the small window at the left, illuminating the Bible that the family patriarch reads, surrounded by his wife and younger family members.

Contemporary responses to the painting suggest that it was understood as a reminder of the country's cultural roots in rural New England. When it was exhibited at the National Academy of Design in 1866, critics relished

describing the family members and read the painting as a benign morality play. The *Albion* called the "congregation . . . a very attentive one."[2] *Harper's Weekly* observed "the very Sunday in the air" and commended the artist for "show[ing] them [the New England family] as they are."[3] The art critic Henry T. Tuckerman considered the picture "deeply associated with Peace." He was particularly taken with the nursing mother who "loses not one word; she even seems eager to treasure their comfort and their peace."[4] That year the painting was purchased by the New York sugar broker and ardent Presbyterian Robert L. Stuart.

Sunday Morning appeared at the Paris Universal Exposition in 1867 and the Yale School of Fine Arts in 1870. It was also exhibited at the 1876 Centennial Exhibition in Philadelphia's Fairmount Park. It had apparently become a familiar fixture in the art world by that time, but although it was mentioned in a number of accounts, it inspired few specific comments. It was also on view at the Brooklyn Art Association in 1887.[5]

Initial responses to *Sunday Morning* show that it was interpreted as an uncomplicated and benevolent family scene, but a closer reading of the figures suggests a somnolent lesson being taught to a mostly unwilling younger generation.[6] At the far left a young man, perhaps a grandson, leans back in his chair and plays with the ring on his finger. The young woman next to him looks down disaffectedly. The girl to her right gazes at her grandfather with rapt attention in a vivid exception to the others' seeming indifference. At right, an adult male, perhaps the patriarch's son, sits with his back to the viewer. As the likely successor to family leadership, his attitude sets the tone for the humble

worship service. His expression is hidden and so is his response to the lesson being taught—though his folded arms and crossed legs indicate a hint of impatience. Next to him a woman, perhaps his wife, wearily nurses a baby as the matriarch behind her listens to the reading. The group is completed by two children crouched at the far right engaged in a conversation of their own.

Johnson's intentions for the painting are not known. However, it may be that the artist meant to convey a more nuanced message than critics initially discerned. His depiction of differing responses to traditional moral instruction parallels the contrasting reactions of the two young women in Daniel Huntington's roughly contemporary work *Sowing the Word* (cat. 23).[7] The contrast between receptivity and indifference is further emphasized in Johnson's picture, since almost all of the coming generation demonstrate a lack of interest. Johnson's rendering suggests a veiled skepticism about the country's future and concerns about the difficult years of recovery that lay ahead.—KPO

1. Patricia Hills, *Eastman Johnson* (New York: Clarkson N. Potter, 1972), 38; and Teresa A. Carbone and Patricia Hills, *Eastman Johnson: Painting America* (New York: Brooklyn Museum of Art, in association with Rizzoli International Publications, 1999), 66.
2. "Fine Arts," *Albion* 5 (May 1866): 213.
3. "Editor's Easy Chair," *Harper's Weekly* 33 (June 1866): 117.
4. Tuckerman 1867, 469.
5. "The Fine Arts at the Centennial: VIII," *American Architect and Building News* 1 (August 19, 1876): 270; J. S. Ingram, *The Centennial Exposition* (Philadelphia: Hubbard Bros., 1876), 374; and Hills, *Eastman Johnson*, 260–62.
6. Carbone, in Carbone and Hills, *Johnson*, 68, notes that most of the family members appear distracted from the Sunday lesson, particularly the father whose back is to the viewer.
7. Thanks to Barbara Gallati for pointing out this similarity.

Louis Lang

(1814–1893)

Louis Lang's reputation was initially defined by his work as a portraitist, but by the end of his career he was recognized as a specialist in sentimentalizing genre scenes.[1] His large history paintings, therefore, represent a lesser-known aspect of his output. These ambitious endeavors undoubtedly reflect the influence of his father, who was a history painter based in Waldsee, near Württemberg (now Germany), where Lang was born. When his father became disabled by illness, Lang began to assist him, concentrating on carriage painting and church decoration. By the time he was twenty, however, Lang had reportedly produced several hundred portraits in pastel.

Lang went to Paris to study in 1834, then lived in Stuttgart briefly before going to the United States. Settling in Philadelphia in 1838, he supported himself for three years as a portraitist, occasionally exhibiting his work at the Philadelphia Art Association. In 1841 he went to Italy, traveling extensively, often in the company of American artists.[2] In Rome for the winter and spring of 1844–45, he was affiliated with the Sketch Club of American Artists at Rome, whose membership included Emanuel Gottlieb Leutze and Daniel Huntington.[3] This unsettled existence abated from 1845 to 1847. During this two-year period he was in New York City, working as an ornamental painter and modeler of plaster figures. His earliest submissions to the National Academy of Design and the Boston Athenæum in 1847 reveal that his subject matter centered on Italian genre subjects and Shakespearean themes. Except for another extended stay in Italy from 1847 to 1849, Lang remained in New York until 1872, when he departed for his last Italian sojourn.

Among other friendships that Lang forged in Italy were those with Thomas P. Rossiter (1818–1871) and John Frederick Kensett (1816–1872). These bonds strengthened back in New York, and by the spring of 1851, Lang, Rossiter, and Kensett (and fellow artist John William Casilear [1811–1893]) were installed in the elegant Waverly House studios at 697 Broadway. Lang's exhibition activity intensified around this time with regular showings at the National Academy of Design (where he was elected an associate in 1852 and a full academician in 1853). He and Kensett were particularly close; they shared a studio (moving to 1193 Broadway in 1867) until Kensett's death in 1872, except for a two-year period (1854–56), when Lang was in Washington, D.C., painting portraits of notable government officials.

From the 1860s onward, Lang's output was confined largely to cabinet pictures featuring young women in domestic or landscape settings. For a short time he operated a "school of art for ladies." The enterprise, as it was announced in late 1866, included instruction in drawing and painting as well as in the "art of harmony and musical composition—a branch in which he is quite competent to educate."[4]

In 1872, after auctioning the contents of his studio, Lang sailed for Europe, where he remained for a number of years, mainly in Rome. His last years in New York are largely undocumented, although a strong hint of his idiosyncratic personality is found in an article that appeared shortly after his death, which stated, "Louis Lang was known for years in the artists' colony of this city as an eccentric."[5]

1. See my entry for the artist in *American Paintings in the Brooklyn Museum: Artists Born by 1876*, ed. Teresa A. Carbone (New York: Brooklyn Museum, in association with D Giles Limited, London, 2006), 2:747–49.
2. See Thomas B. Brumbaugh, "A Venice Letter from Thomas P. Rossiter to John F. Kensett—1843," *American Art Journal* 5, no. 1 (May 1973): 75–76.
3. Avis Berman, "Sketch Club of American Artists at Rome," *Archives of American Art Journal* 40, nos. 1–2 (2000): 2–3.
4. "Art Notes," *Albion* 44, no. 45 (November 10, 1866): 538. It is not known if Lang's school was a success.
5. "Left an Eccentric Will: An Ambiguous Clause in Artist Lang's Last Testament May Make Trouble," *NYT*, May 24, 1893, 9.

26

Louis Lang (1814–1893)

Mary, Queen of Scots Dividing Her Jewels

1861

Oil on canvas, 36¼ × 48 in. (92.1 × 121.9 cm)
Signed and dated lower right: *Louis Lang / 1861*
The Robert L. Stuart Collection, S-82

For color, see page 52

Mary, Queen of Scots (1542–1587) achieved cult status in nineteenth-century Britain, a trend that was transmitted across the Atlantic chiefly in the novels of Sir Walter Scott and numerous biographies of the queen.[1] The turbulent life of the doomed monarch was romanticized and allowed her to represent for nineteenth-century audiences the ideal of the beautiful, suppressed Victorian heroine and the tragedy of societal division.[2]

The daughter of the Scottish king James V and his wife, the French Mary of Guise, Mary Stewart (alternatively, Stuart) married the French dauphin (later François II), thereby ultimately becoming the queen of France. Her Tudor ancestry in combination with doubts about Elizabeth I's legitimacy made her a strong candidate for the English crown following the 1558 death of England's Queen Mary. With the death of François II in 1560, she returned to Scotland, where her attempts to restore Catholicism presented a major impediment to her quest for the English throne.

Louis Lang addressed the theme of the tragic queen on three occasions during the 1860s, the first of which was *The Last Supper of Mary Queen of Scots* (unlocated), which was shown at the 1860 National Academy of Design annual, where Emanuel Leutze's *Princess Elizabeth in the Tower* (cat. 28), owned by Robert L. Stuart, was also on view.[3] By December 1860 Lang was working on *Mary, Queen of Scots Dividing Her Jewels*, a commission from Stuart, who had likely appreciated Lang's earlier treatment of the theme.[4] All of Lang's "Marian" paintings feature her imprisonment following her conviction for plotting against the English Queen Elizabeth. More than simply a challenge for the

crown, the staunchly Catholic Mary was a threat to the foundations of Protestant Tudor power. Although Elizabeth was reluctant to execute another queen (her mother, Anne Boleyn, had been executed on the orders of her father, Henry VIII), political pressures demanded otherwise, and, after a period of house arrest, Mary, Queen of Scots was beheaded. Here, Lang portrayed the noted beauty distributing her famous jewels to her loyal entourage on the night before her execution on February 17, 1587.

The painting was shown at Goupil's Gallery at 772 Broadway, New York, in March and April 1861, accompanied by an explanatory text that identified the various personages portrayed and emphasized the dignity of the condemned monarch.[5] Although one critic considered Lang's draftsmanship faulty, the painting was judged to be "interesting for the manner in which this affecting episode is treated and pleases the eye."[6] The queen's renowned piousness also recommended the painting, and, as one writer put it, "Those who deprive themselves of amusements during the season of Lent, should by all means see this magnificent painting, which is calculated to inspire the beholder not only with love of true art, but also with piety."[7]

Mary, Queen of Scots Dividing Her Jewels was subsequently displayed at the 1863 Artists' Fund Society exhibition and the Metropolitan Sanitary Fair of 1864. Despite this remarkable public visibility and the implicit credit accruing to it from its ownership by Stuart, the painting failed to attract significant commentary. The major exception to this was a vitriolic review written in 1863 that characterized the painting

as a formulaic Düsseldorf picture.[8] Although pegged a "mere costume painting," Lang's depiction of the queen's last moments with her retinue enjoyed a modicum of public favor, as witnessed by the fact that the work was rehearsed in the form of a tableau vivant staged by New York schoolchildren in aid of the Union troops in 1864.[9]

Perhaps it was Robert Stuart's own Scottish heritage and, indeed, his shared name with the monarch that piqued his interest in the popular theme. Certainly Lang's painting of Mary, Queen of Scots complemented Leutze's *Princess Elizabeth in the Tower* already in Stuart's collection, inasmuch as both works addressed the theme of royal imprisonment and because it was Elizabeth who sealed Mary's fate. Then, too, Stuart may have been drawn to Stuart and Tudor subjects because their themes of social division and religious dissonance corresponded to the contemporaneous turmoil of the Civil War as well as to the religious intolerance dividing Protestants and Catholics in the United States at the time.[10] —BDG

1. Scott's novels *The Monastery* and *The Abbot* were inspired by the life of Mary, Queen of Scots. Originally published in Britain in 1820, both were immediately taken up by American publishers. Very influential was Agnes Strickland, *Lives of the Queens of Scotland and English Princesses Connected with the Regal Succession of Great Britain*, 8 vols. (New York: Harper & Brothers, 1851–59).
2. Roy Strong, *Painting the Past: The Victorian Painter and British History* (London: Pimlico, 2004), 134.
3. The third painting is *Mary Queen of Scots Teaching Her Little God-Daughter, Bess Pierrepont* (unlocated), shown at the Artists' Fund Society, New York, 1866.
4. The painting, noted as Lang's "happiest effort," was mentioned as being in progress in the *Crayon*, December 7, 1860, 353.
5. *On Exhibition at Goupil's . . . the Historical Painting of Mary Queen of Scots, Dividing Her Wardrobe and Jewelry among Her Friends, the Day before Her Execution, 17th Feb., 1587. By Louis Lang* (n.p.: John A. Gray Printer, n.d.).
6. "Fine Arts," *NYH*, March 26, 1861, 7.
7. "Art and Literary Gossip," *Spirit of the Times* 31, no. 7 (March 23, 1861): 112.
8. "The Artists' Fund," *NYT*, November 21, 1863, 5.
9. "Chit-Chat with the Ladies," *Frank Leslie's Illustrated Newspaper*, June 4, 1864, 163.
10. See, for instance, the review of Bell's *Life of Mary, Queen of Scots* ("Mary Queen of Scots," *North American Review* 34, no. 74 [January 1832]: 146), in which the author stated, "The prejudice against the Catholics has had the most decided effect upon historical representations. We have no sympathy with the Roman faith . . . but every Enlightened Protestant now admits, that the feeling of the reformers . . . was far too indiscriminate and unsparing in its condemnation . . . and amounted at last to intolerance much resembling that which they condemned in the Catholics themselves."

27

Louis Lang (1814–1893)
Return of the 69th (Irish) Regiment, N.Y.S.M., from the Seat of the War, N.Y.
1862

Oil on canvas, 87 × 140 in. (221 × 355.6 cm)
Signed lower right: *Lang*
Gift of Louis Lang, 1886.3

For color, see page 97

Louis Lang's massive canvas depicting the return of New York's Sixty-ninth Irish Regiment from Civil War combat held the place of honor at the 1862 Artists' Fund Society exhibition, where it was declared "itself an exhibition."[1] Filled with portraits of the city's Irish notables and returning heroes and their families, the painting portrays a scene of physical and emotional tumult against the backdrop of New York Bay, framed by Castle Garden on the left and the Washington Hotel on the right.

The Sixty-ninth Regiment of the New York State Militia was formed in 1851 and, from 1859, was under the leadership of Colonel Michael Corcoran, an Irish émigré who had settled in New York in 1849.[2] Three days after the Confederates fired on Fort Sumter on April 12, 1861, President Abraham Lincoln called for volunteers to quash the insurrection. On April 23 the regiment's one thousand men departed for Washington, D.C. Over the next three months, their movements were regularly reported in the press, including the saga of Corcoran's capture at the first battle of Bull Run.[3]

The regiment returned to New York City on July 27, 1861, passionately greeted as they marched from the Battery to Union Square, down Fourth Avenue and the Bowery to Grand Street, and finally to their armory on Essex Street. According to the press, the surging crowds that lined the streets were primarily Irish. One reporter observed:

> Certainly it seemed as if every Biddy [a stereotypical name referring to female Irish servants] in the land had suddenly and mysteriously burst into sight for the express gratification of the gallant Sixty-ninth.

Some of them, to be sure, presented a rather dishevelled appearance, but there was an eager gladness in their eyes which compensated for defects of toilet. . . . The scene cannot adequately be described; but those who know the warm-hearted and impulsive character of the Irish, will understand that the enthusiasm was of a kind not often witnessed.[4]

The painting debuted at Goupil's Gallery in October 1862, accompanied by a pamphlet that identified many of the people portrayed: on the baggage wagon at the left are the wounded Captain Braslin and Sergeant Tracy; astride his horse, waving his hat to the crowd, is Brigadier General Thomas Francis Meagher (who had replaced the captured Corcoran); on the balcony of the Washington Hotel are prominent Irish citizens; and at the center left foreground is Private White, reunited with his wife and children.[5] Still imprisoned in Richmond, the hero Corcoran is present by proxy in the portrait prints sold by the boy in the right foreground.

The painting received only qualified praise; high marks were awarded its patriotic subject. Deemed "singularly clever," the composition was thought to appeal directly to the sympathies of Irishmen and women. The same writer concluded, however, "Upon the finish of this vast series of portraits and ideal personages we cannot say that great palms have been bestowed. But, take the picture as it is, we must say that it is well worth a visit, and repeat that it does the artist much credit."[6] Much of the commentary revolved around the character of Irish immigrants. With the painting acting as an apologia of sorts, the

Irish soldiers' valor affirmed the feeling "that well may our adopted citizens be proud of a regiment that has nobly sustained the glory and heroism of their native land, while defending the flag of their adoption."[7] The following month the painting was shown at the Artists' Fund Society, where it elicited little comment.

In 1864 Lang exhibited the painting at the Great Central Fair in Philadelphia. He must have been disappointed by the painting's reception, especially in light of the opinions aired in the Round Table, which contended, "The few [artists] who have illustrated episodes of the war have selected those of a grotesque or humorous character or occasionally those appealing to the sentimental or pathetic springs of the heart. . . . Pictures like Lang's 'Return of the Sixty-ninth Regiment' of which, fortunately, few have been produced, are scarcely worthy of serious criticism."[8] Why Lang's ambitious canvas failed to attract critical approval may partially hinge on the backlash against the Irish, who were implicated in starting the bloody, three-day draft riots in New York in July 1863.[9] Then, too, it might have been that Lang's densely populated, panoramic image lacked the emotional gravity some critics thought was required to treat the theme of war; the overwhelming assortment of narrative details diminished the momentousness of the event. —BDG

1. "Fine Arts: The Artists' Fund Society," Albion 40, no. 47 (November 22, 1862): 561.
2. "Brig.-Gen. Michael Corcoran," Frank Leslie's Illustrated Newspaper, September 6, 1862, 361; and "Gossip from Gotham," San Francisco Daily Evening Bulletin, October 2, 1862, 1.
3. See, for example, "New York Troops at the Capital," NYH, May 12, 1861, 1; and "New York Soldiers in Battle," NYT, July 24, 1861, 4.
4. "Our War-Worn Heroes," NYT, July 28, 1861, 1.
5. Great Historical Picture of the Gallant 69th Irish Regiment on Their Return to New York from the Seat of War, July 27, 1861, Painted by Louis Lang, Now Exhibiting at Goupil's Gallery (n.p., n.d.). The approximate date of the exhibition is established by an announcement of the private view; NYDT, October 13, 1862, 5.
6. "Fine Arts," Albion 40, no. 42 (October 18, 1862): 501.
7. Great Historical Picture of the Gallant 69th Irish Regiment.
8. "Painting and the War," Round Table 2, no. 32 (July 23, 1864): 90.
9. See Jean H. Baker, "We Are Lincoln Men," in Lincoln and New York, ed. Harold Holzer (New York: New-York Historical Society; London: Philip Wilson Publishers, 2009), 34.

Emanuel Gottlieb Leutze

(1816–1868)

Arguably the most accomplished history painter of his generation in America, Emanuel Gottlieb Leutze exerted considerable influence on both sides of the Atlantic as a major representative of Düsseldorf training. Vibrant and theatrical, Leutze's paintings of European and American events prompted Henry T. Tuckerman to assert that Leutze's "forte is the dramatic."[1]

The nine-year-old Leutze arrived with his family in the United States from his native Swabia (now Germany) in 1825, when his artisan father emigrated, most likely for political reasons.[2] After settling first in Fredericksburg, Virginia, the Leutzes moved to Philadelphia, where the young Leutze soon had to support the family following his father's death. After training briefly with John Rubens Smith (1775–1849), starting in 1834 Leutze drew portraits for Longacre and Herring's *National Portrait Gallery of Distinguished Artists* until 1837.[3] For the next four years he made a living as a portraitist, securing many of his commissions in the Fredericksburg area.

With the financial assistance of the Philadelphians Edward Carey and Joseph Sill, Leutze went to Europe in 1841 and enrolled in the Königliche Kunstakademie in Düsseldorf. After a year of rigorous training, he left Düsseldorf and shifted from Munich to Venice and then to Rome for extended periods over the next two years. Throughout the early 1840s, Leutze established his reputation in Europe and in the United States with a series of paintings focusing on Christopher Columbus as well as on subjects drawn from English history. He was elected an honorary member of the National Academy of Design in 1843 (achieving full academic status in 1860)

and also derived significant attention through the American Art-Union. By 1845 he had returned to Düsseldorf and that year married Juliane Lottner, the daughter of a Prussian army officer. Leutze assumed a prominent role in Düsseldorf art circles. He was elected president of the Union of Düsseldorf Artists for Mutual Aid and Support, in 1848 was a founder of the artists' group the Malkasten, and in 1856 helped establish the German Art Union. His studio was a gathering place for American artists, including Eastman Johnson and Worthington Whittredge, both of whom witnessed Leutze's progress on his monumental *Washington Crossing the Delaware* (see fig. 21, p. 90), which he shipped to the United States in 1851 and exhibited in New York and Washington.

Leutze returned to his family in Düsseldorf in 1852 and remained there until 1859, when he went back to New York and took a studio in the Tenth Street Studio Building. In 1861 he secured the prestigious commission to paint a mural for the U.S. Capitol, *Westward the Course of Empire Takes Its Way*, completed in late 1862. He made a final trip to Düsseldorf in 1863 to organize the move of his wife and children to the United States, where he spent the remainder of his life in New York and Washington. Shortly after his 1868 death in the latter city, one writer recalled, "Though a German by birth, and educated at a German art school, Leutze lived long enough in this country to be called an American artist, though in his habits of thought and style of working he never ceased to be a German."[4]

1. Tuckerman 1867, 344.
2. The principal publication devoted to Leutze's life and art is Barbara S. Groseclose, *Emanuel Leutze, 1816–1868: Freedom Is the Only King* (Washington, D.C.: National Collection of Fine Arts, Smithsonian Institution, 1975).
3. James Herring, ed., *The National Portrait Gallery of Distinguished Americans, Conducted by James B. Longacre and James Herring under the Superintendence of the American Academy of the Fine Arts* (New York: Bancroft, 1834–39).
4. "Leutze and Elliott," *Galaxy* 6, no. 4 (October 1868): 573.

28

Emanuel Gottlieb Leutze (1816–1868)

Princess Elizabeth in the Tower

1860

Oil on canvas, 36¼ × 48 in. (92.1 × 121.9 cm)
Signed and dated lower right: *E. Leutze, 1860*
The Robert L. Stuart Collection, S-187

For color, see page 162

Emanuel Leutze completed *Princess Elizabeth in the Tower* in 1860 in time to show it that spring at the annual exhibition of the National Academy of Design. Painted to order for the New York collector Robert L. Stuart, the image of the future English queen was among the last of numerous works from Leutze's hand that depict episodes from Tudor, Stuart, and Cromwellian history.[1]

The painting fared well with the critics, and, after praising it along with Louis Lang's *Mary Queen of Scots* (unlocated, also known as *The Last Supper of Mary Queen of Scots*), the writer for the *New York Herald* continued, "Mr. Leutze's picture abounds with evidence of masterly treatment, and is in its color all one could desire."[2] The most extensive appraisal of the painting located thus far is that printed in the *Crayon*. Likely written by John Durand (who also gave high marks to Lang's picture), the review commended the artist for his skill in rendering the character of his female protagonist.[3]

Even without direct knowledge of Leutze's intensive training at the Düsseldorf academy—then Germany's most respected art training ground—the artist's emphasis on color, detail, and historical drama are enough to locate the painting's stylistic ancestry in the Düsseldorf School.[4] Leutze's penchant for a variety of historical subjects had grown out of his academic experience and was especially sharpened during the two decades he spent in Europe's highly politicized atmosphere leading up to the revolutions of 1848. As a matter of course, the history paintings produced in the Düsseldorf manner were expected to embody parallel meanings—one directly concerned with the scene presented and the other meant to allude to topical events.[5] Leutze considered himself a painter-poet, who "should first form the clear thought as the groundwork and then adopt or create some anecdote from history or life, since painting can be but partially narrative, and is essentially a contemplative art."[6]

Here, Leutze chose to illustrate the anecdote of the termination of Elizabeth's interrogation by the privy

council that was conducted while she was detained in the Tower by order of her half sister, Queen Mary, in 1554. Suspected of colluding in the rebellion headed by Sir Thomas Wyatt, Elizabeth was imprisoned in the same rooms that her mother, Anne Boleyn, had occupied immediately before her execution. The crux of the matter surrounding this episode not only encompassed the question of royal succession but also hinged on Elizabeth's loyalty to the Protestant cause in the face of her sister's militant Catholicism.[7] Elizabeth's near martyrdom registered strongly with her supporters, and within a short time, she was associated with the hundreds of Protestant martyrs who had been burned at the stake under Mary's rule. Elizabeth's popularity crossed the Atlantic and flourished in the minds of nineteenth-century American readers.[8] As familiar a figure as Elizabeth was, however, it is doubtful that visitors to the National Academy display would have known this narrative in such detail. Instead, as suggested by the commentary in the *Crayon*, the emotional pathos exhibited by the princess was at the core of the critic's reaction, a response in keeping with Leutze's ideal of idea over narrative.

The artist explained his intentions in comments he made on his return from his first stay in Europe in 1851 when, on the trip home he thought

how glorious had been the course of freedom from these small isolated manifestations of the love of liberty to where it has unfolded all its splendor in the institutions of our own country. . . . This course represented itself in pictures to my mind, forming a long cycle, from the dawning of free institutions in the middle ages, to the reformation and revolution in

England, the causes of emigration including the discovery and settlement of America, the early protestation against tyranny, to the Revolution and Declaration of Independence.[9]

In this context, therefore, Leutze must have believed that the entire corpus of his history paintings contributed to explicating this grand historical cycle, which, in this case, led incrementally to freedom.[10]

The question remains as to what the "idea" was for American viewers in 1860. If Elizabeth was identified as an analogue for religious liberty, then Northerners were free to expand on the idea and find her symbolic of the antislavery movement in the months before the Civil War. In more general terms, she was celebrated as having granted Sir Walter Raleigh the first charter to found a settlement in North America, an event still celebrated by the Old Dominion Society in New York in 1860.[11] Southerners, however, were likely to justify slavery—or at least absolve themselves of responsibility for establishing the institution—by claiming that the system was introduced to the New World during Queen Elizabeth's reign.[12] A more complex political reading is suggested in the Protestant Elizabeth's shrewd maneuver to save herself by surrounding herself with the outward trappings of Catholicism—the Latin Bible, the rosary on the prie-dieu, and the statue of the Virgin and Child—all signs of her seeming capitulation to her sister's faith. As one nineteenth-century writer explained, Elizabeth's apparent religious ambivalence "proved that her adherence to the principles of the reformation was not so much in her mind a matter of essential belief, as of preference between a good system and a bad system."[13]

For Stuart, a fervent Presbyterian and the commissioner of the painting, the matter of religious freedom was probably of paramount importance. Yet, on a secondary level, the murky issue of slavery must have loomed large for him, since his sugar-refining fortune rested on slave labor. Thus, the hypocrisy and compromise associated with Elizabeth's character may have reverberated strongly with him as he doubtless wrestled with his own moral stance on slavery. —BDG

1. For a list of known works by Leutze, see Barbara S. Groseclose, *Emanuel Leutze, 1816–1868: Freedom Is the Only King* (Washington, D.C.: National Collection of Fine Arts, Smithsonian Institution, 1975).
2. "Fine Arts: National Academy of Design; Second Notice," *NYH*, April 24, 1860, 2.
3. [John Durand?], "National Academy of Design: Second Notice," *Crayon* 7 (June 1860): 171.
4. See William H. Gerdts, "The Düsseldorf Connection," in Gerdts and Mark Thistlethwaite, *Grand Illusions: History Painting in America* (Fort Worth, Tex.: Amon Carter Museum, 1988), 125–68.
5. Ibid., 148.
6. Quoted in Tuckerman 1867, 339.
7. Wendy Greenhouse, "The American Portrayal of Tudor and Stuart History, 1835–1865" (Ph.D. diss., Yale University, 1989), 177–78, cites Agnes Strickland, *Lives of the Queens of England, from the Norman Conquest* (1840; London: Henry Colburn, 1859), as a probable source of Leutze's imagery.
8. See, for instance, Jacob Abbott, *History of Queen Elizabeth* (New York: Harper & Brothers, 1849), the notice for which stated, "The narratives are not tales founded upon history, but history itself, without any embellishment or deviation from the strict truth"; "Critical Notices," *American Whig Review* 10, no. 20 (August 1849): 217.
9. "Return of Mr. Leutze," *Bulletin of the American Art-Union*, September 1851, 95–96, quoted in Jochen Wierich, "Struggling through History: Leutze, Hegel, and Empire," *American Art* 15, no. 2 (Summer 2001): 55.
10. Wierich, "Struggling through History," provides a stimulating discussion of the possible influence of Georg Friedrich Hegel's theory of universal history on Leutze and differentiates between North American and European formulations of cyclical history.
11. "The Old Dominion Society," *NYH*, May 11, 1860, 8.
12. This idea was a main theme of the speech by A. B. Vance of North Carolina delivered in the House of Representatives, March 16, 1860, and reproduced in the *Weekly Raleigh Register*, April 18, 1860, 1.
13. "Souvenirs of Historical Characters: No. VIII.—Queen Elizabeth," *Arthur's Home Magazine* 7 (June 1856): 356, quoted in Greenhouse, "The American Portrayal of Tudor and Stuart History," 180.

Tompkins Harrison Matteson

(1813–1884)

Tompkins Harrison Matteson's Democratic Party preferences merged with his roles as painter, illustrator, and politician, through which he expressed common national ideals that would appeal to the ordinary citizen. Noted by Henry T. Tuckerman as a "pioneer" genre painter, Matteson addressed patriotic and domestic themes that were popular at the American Art-Union, where his works were featured from 1845 to 1852.[1]

Born in Peterboro, New York, Matteson was the son of a politician, John Matteson, who moved the family to nearby Morrisville in 1815, when he took the post of sheriff.[2] The young Matteson received his first informal art training from Abe Antone, a local Indian who was held in the Morrisville jail, charged with murder. Matteson was also influenced by an itinerant silhouette limner but seems to have been unable to focus on a career in the arts inasmuch as he also clerked in a drugstore, worked as a tailor's apprentice, and traveled briefly with a theatrical troupe. Mention is also made of an early, albeit failed attempt to paint portraits, which ended with the destitute Matteson's return home. He continued his episodic pursuit of art with brief training under the portrait painter Alvah Bradish (1806–1901), in Cazenovia, New York, where he set up his own studio for a short time. His picaresque career path also took him to New York City in 1833 (when he was listed as a portrait painter in the city directory), to Sherburne, New York (where he married Sarah Elizabeth Merrill in 1839), and to Geneva, New York (where he made a living as a portraitist for two years).

By 1841 Matteson appears to have committed himself fully to the painting profession and went to New York City, attending classes at the National Academy of Design from 1841 to 1845. He began exhibiting at the academy's annuals in 1841, appearing there regularly through 1849 and thereafter only in 1860, 1868, and 1870. In 1842 he received especially positive critical notices for his five-painting Hogarthian series The Drunkard's Progress, shown at the American Institute Annual Fair, but the true watershed of his career was his "discovery" by Francis W. Edmonds, who spotted his Spirit of '76 at the academy and purchased it for the American Art-Union in 1845.[3] Matteson's acceptance in the artistic community was probably the impetus for his short-lived tenure as an art critic, evidenced by his authorship of nine reviews of the 1846 academy exhibition for Morris's National Press.[4] It was also at this time that he embarked on his career as an illustrator, providing material for such periodicals as the Whig Review, Columbian Lady's and Gentleman's Magazine, and Sartain's Union Magazine of Literature and Art as well as numerous books. He was made an associate of the National Academy of Design in 1847.

Matteson moved to Sherburne, New York, in 1850 and thereafter divided his time between painting, illustrating, and pursuing his new venture as an art instructor (his most notable student was Elihu Vedder [1836–1923]) along with dealings in civic affairs. His political life included his election to the New York State Legislature in 1855. Although personally absent from New York City, his art remained in the public eye through a series of history paintings featuring colonial themes executed for the dealer William Schaus and occasional displays at, for example, the Brooklyn Art Association and the American Society of Painters in Water Colors. Most of his patronage, however, came from collectors in the Albany area. He died in Sherburne in 1884.

1. Tuckerman 1867, 343.
2. See Cynthia Seibels's entry for the artist in American National Biography Online, 2000, http://www.anb.org/articles/17/17-00558.html; and Dearinger 2004, 381–82.
3. For a detailed description of The Drunkard's Progress, see "The World of Art," New World 5, no. 20 (November 12, 1842): 320.
4. For full citations for these articles, see James T. Callow, Kindred Spirits: Knickerbocker Writers and American Artists, 1807–1855 (Durham: University of North Carolina Press, 1967), 244; see also Emily Julia Halligan, "Art Criticism in America before The Crayon: Perceptions of Landscape Painting, 1825–1855" (Ph.D. diss., University of Delaware, 2000), 111–12.

29

Tompkins Harrison Matteson (1813–1884)

The Last of the Race

1847

Oil on canvas, 39¾ × 50 in. (101 × 127 cm)
Signed and dated lower center (on rock): *T. H.
 Matteson / 1847*
Gift of Edwin W. Orvis, 1931.1

For color, see page 139

Tompkins Harrison Matteson usually focused on subjects inspired by colonial and federal history; *The Last of the Race* thus represents a departure for him in that it addresses a topical theme that weighed heavily on the minds of Americans at the time. In 1847, two years after the phrase "Manifest Destiny" had been coined, the iconography centering on the dispossessed Indian nations reached its peak.[1] Visitors to the National Academy of Design that spring had probably seen James H. Beard's (1812–1893) *The Last of the Red Men* (unlocated). Beard's painting was accompanied by the following lines from William Cullen Bryant's 1824 poem "An Indian at the Burial-Place of His Fathers," which describes the inexorable western movement of white settlers as they pushed the Indian to the edge of the continent:

> They waste us—ay—like
> April snow
> In the warm noon we shrink away;
> And fast they follow, as we go
> Towards the setting day,—
> Till they shall fill the land, and we
> Are driven into the western sea.[2]

Several months later, an article announced that Matteson was at work on a "picture of Indian character, 'The Last of their Race:' the subject is of a more elevated and poetical nature than his former works, and he has worthily treated it."[3] Clearly, Matteson was responding to the proliferating imagery embodied in Bryant's words if not directly to Beard's painting, which was described as depicting "a family of Indians . . . on a rock on the extremist verge of the Pacific coast."[4]

Like his contemporaries, Matteson played on the

wishful, unrealistic attitudes of white Americans, who could interpret his painting as a forecast of a Romantically serene denouement in the drama of Indian removal. Sympathetic in its portrayal of the Indian family as dignified and stoical, Matteson's painting is nonetheless unequivocal in affirming that the day of the Indian had come to an end. Moreover, the visual metaphor of the setting sun in the painting also implied that the outcome was part of an inevitable natural cycle, thus absolving viewers of culpability for supporting the expansionist drive. Indeed, the implicit message was that America's aborigines were already consigned to history, a theme consonant in lines from another of Bryant's poems, "The Disinterred Warrior":

> A noble race! But they are gone,
> With their old forests wide and deep,
> And we have built our homes upon
> Fields where their generations sleep.[5]

Despite the similarities linking Beard's and Matteson's paintings, the former was deemed "vulgar" owing largely to the nudity of the figures. The *Literary World*'s writer predicted that "no gentleman will ever purchase the picture to be hung in his house."[6] By contrast, Matteson's *The Last of the Race* proved popular. Acquired by the American Art-Union in 1847, the painting next entered the collection of J. M. Orvis of Troy, New York.[7] However, it was not long before the ideal of the passive Indian proved untenable in the face of the violent Indian conflicts. —BDG

1. See Gail E. Husch, "'Poor White Folks' and 'Western Squatters': James Henry Beard's Images of Emigration," *American Art* 7, no. 3 (Summer 1993): 29.
2. The same lines headed the review for the work in "The Fine Arts," *LW* 1, no. 16 (May 22, 1847): 371.
3. "Fine Art Gossip," *LW* 2, no. 35 (October 2, 1847): 205.
4. *Louisville Journal*, reprinted in the *Cincinnati Gazette*, September 21, 1850, 2, quoted in Husch, "'Poor White Folks,'" 29. Husch also points out that Bryant's poem was included in an 1847 edition of his poetry that was illustrated with engravings after Emanuel Gottlieb Leutze.
5. The poem was included in William Cullen Bryant, *Poems* (New York: Harper and Brothers, 1840).
6. "The Fine Arts," *LW* 1, no. 16 (May 22, 1847): 371.
7. Asher B. Durand's *The Indian's Vespers* (1847, The White House Collection, Washington, D.C.) was also part of the American Art-Union's offerings that year, although Husch ("'Poor White Folks,'" 29) incorrectly states that it was shown at the academy.

Samuel Finley Breese Morse

(1791–1872)

The artist and inventor Samuel F. B. Morse championed the development of the fine arts in America, leaving as perhaps his greatest legacy the National Academy of Design, which he cofounded in 1826 and served as president from 1826 to 1845 and again from 1860 to 1861. Despite his involvement with the academy, the moralizing and highly politicized attitudes that shaped his aesthetics proved a barrier to his success as a painter.

The eldest son of the prominent Charleston, Massachusetts, Congregationalist minister Jedidiah Morse, Samuel attended Phillips Academy and graduated from Yale University in 1810.[1] He received his first serious art training from Washington Allston (1779–1843), whose affinity for grand-manner themes deeply influenced him. In 1811 Morse accompanied Allston to England and was admitted to the Royal Academy Schools in London, where he received encouragement from Benjamin West. Morse's overriding desire to create grand-manner canvases is revealed in the paintings he executed during the five years he spent abroad, particularly *Dying Hercules* (1812, Yale University Art Gallery), which garnered considerable praise at the 1813 Royal Academy exhibition. In England Morse met a stellar group of personalities, including the Romantic poet Samuel Taylor Coleridge. Despite the great benefits he derived from his European experience, Morse left England in 1815, convinced that the United States was in danger of political and cultural contamination from abroad.

When he returned to the United States, Morse traveled in search of portrait commissions, discovering substantial demand in Charleston, South Carolina, where he helped found the South Carolina Academy of the Fine Arts. By late 1821 he was in Washington, D.C., working on the monumental *The House of Representatives* (1822–23, Corcoran Gallery of Art, Washington, D.C.). In New York City by 1824, Morse immersed himself in the city's burgeoning cultural life. He was a leading figure in the 1825 formation of the New York Drawing Association, which evolved into the National Academy of Design the following year. His tenacious advocacy of cultural nationalism was transmitted in his art, essays, and lectures and fueled his unsuccessful 1836 campaign for the mayoralty of New York on the Native American Party platform.

In 1829 Morse went to Europe. During his three-year stay, he visited England, France, Italy, and Switzerland. Returning to New York in 1832, he completed the large *Gallery of the Louvre* (see fig. 3, p. 27), which, when it was displayed in New York in 1833, drew critical acclaim but no financial profit. Nonetheless, he remained devoted to history painting. In 1837 he encountered another major disappointment when he failed to obtain a commission for one of the U.S. Capitol Rotunda murals. This prompted him to turn to science. Although known primarily as the inventor of the telegraph (first demonstrated in 1844), he also explored the potential of what was known as heliographic art, a photographic process inspired by the work of Louis-Jacques Mandé Daguerre (1789–1851), whom he had met in Paris in 1838–39. He died in New York in 1872, celebrated as the man whose name would "be imperishably connected with the greatest of all modern inventions."[2]

1. See Paul J. Staiti, *Samuel F. B. Morse* (Cambridge: Cambridge University Press, 1989).
2. Untitled article, *NYT*, April 3, 1872, 4.

30

Samuel Finley Breese Morse (1791–1872)

Landscape Composition: Helicon and Aganippe (Allegorical Landscape of New York University)

1836

Oil on canvas, 22½ × 36¼ in. (57.2 × 92.1 cm)
Purchase, The Louis Durr Fund, 1917.3

For color, see page 136

This highly unusual allegorical work, although commissioned, is infused with a visual rhetoric that reflects Samuel F. B. Morse's cultural philosophy. Using a compositional formula derived from the landscapes of the French artist Claude Lorrain (1600–1682), Morse constructed an imaginary vista in which the territories of ancient Greece and New York City merge to form an iconography extolling the superiority of American educational and political institutions over their European counterparts.

The painting was commissioned by Alfred S. Vail for the Eucleian Society, a literary club affiliated with the newly founded University of the City of New-York (now New York University), from which Vail graduated in 1836.[1] By the time Morse executed the work, Vail had become his partner of sorts, working with him on developing the telegraph in Morse's rented rooms in the new Gothic Revival–style University Building on the east side of Washington Square. Designed by James Dakin (1806–1852) and Ithiel Town (1784–1844), it appears on the left side of the painting.

Morse's writings at this time reveal his concerns about his future as an artist and especially about the fate of American culture. He particularly feared that democracy spawned a culture rife with "low and vulgar pleasures and pursuits" and hypothesized that "contact of those more cultivated in mind and elevated purpose with those who are less so . . . necessarily debase that cultivated mind and that elevation of purpose."[2] However, he qualified his opinion, saying, "but I believe in the possibility, by the diffusion of the highest moral and intellectual cultivation through every class, of raising the lower classes in refinement."[3] The latter statement relates

directly to the principles on which the university was established, since its philosophy diverged from the European system of elitism and aspired to provide education to all, regardless of social or economic status.

Landscape Composition: Helicon and Aganippe conveys a consonant message about American culture, but to understand the meaning of its imagery requires knowledge of classical Greek mythology (part of the traditional European curriculum), the key to which is the statue of the goddess Athena. As the acknowledged source of American democracy, ancient Greece and its influence are embodied by the goddess of wisdom, whose position overlooking the waters situates her as the mediator between the Old World and the New, represented by Mount Helicon on the right and the University Building on the left. Both Helicon (the mountain sacred to the Muses) and the university (the new democratic seat of learning) were to be read as sites of inspiration, a meaning reinforced by the title's reference to Aganippe, a naiad who lived in the spring at the base of Mount Helicon whose waters inspired those who drank from them.

The meaning of *Landscape Composition: Helicon and Aganippe* was doubtless apparent to the scholarly members of the Eucleian Society, but it seems to have been lost on the critics who saw the painting at the 1836 exhibition of the National Academy of Design. The reviewer for the *New York Herald* averred, "There is poetry in this composition, but not that truth and excellency of color that we should wish to see. The sky is rather fiery, even for a sunset, and it strikes us that the introduction of the New York University into a romantic oriental landscape, is rather *recherchée* [*sic*]."[4] Similar

remarks were offered in the *New York Evening Post*, whose critic called it "a fine composition, though the introduction of the New York University in the picture we consider as very unreasonable, though done by request."[5] Neither critic mentioned *Landscape Composition: Helicon and Aganippe* in conjunction with Morse's now unlocated *Sunset, View of St. Peter's at Rome*, which was also on view in the same exhibition and received much the same critical reaction. As the writer for the *Herald* concluded, "Whatever may be the character of Oriental scenery, whatever may be the splendor of an Italian sunset, certain are we, that in this, we have but a gaudy and untrue representation of their magnificence."[6] Most contemporary descriptions of *Landscape Composition: Helicon and Aganippe* place the time of day as sunrise and, if this was Morse's intention, then it is also possible to speculate that the two works were meant as a pair, with the sun setting on the Old World of Rome and rising on the new American systems of democracy and education. —BDG

1. The New-York Historical Society's manuscript collection contains Morse's receipt for the painting, which reads: "Received of Mʳ. Vail, New York June 14ᵗʰ 1836 / Sixtyfive dollars in full for the picture for the / Eucleian Society of the University of the city of N. York. / $65.00 / Samˡ. F. B. Morse."
2. Letter of October 1833, quoted in *Samuel F. B. Morse: His Letters and Journals*, ed. and supplemented by his son Edward Lind Morse (1914; London: BiblioBazaar, n.d.), 2:39.
3. Ibid.
4. "National Academy of Design," *NYH*, May 12, 1836, 1.
5. "National Academy of Design," *NYEP*, May 25, 1836, 2.
6. "National Academy of Design," *NYH*, May 19, 1836, 1.

William Sidney Mount

(1807–1868)

Recognized as America's first genre specialist, William Sidney Mount spent most of his life in the rural Long Island region of his birth, where, as Henry T. Tuckerman noted, he recorded "the arch, quaint, gay and rustic humors seen among the primitive people of his native place."[1] Despite Mount's apparent aversion to travel, the correspondence and diaries of this lifelong bachelor confirm his lively interest in politics, music, and his professional interaction with the New York art community.[2]

Born in Setauket, Mount was the son of an innkeeper and farmer. His early interest in theater and music was fostered by an uncle with whom he lived for a year in New York City, but his urban life was halted when he returned in 1816 to Long Island to live on his grandparents' farm in Stony Brook. Mount's passion for art was doubtless sparked by the pursuits of his siblings. A younger sister took watercolor instruction, his eldest brother, Henry (1802–1841), was a sign painter in New York, and another brother, Shepard Alonzo (1804–1868), established a creditable career as an artist. In 1824 William began a three-year apprenticeship with his brother Henry in New York. He also enrolled in the antique classes of the newly formed National Academy of Design, studying there in 1826 and 1827, but poor health forced him to return to Stony Brook in 1827. Left to his own devices, he began painting portraits of family and friends. Harboring ambition for greater achievement, he also experimented with history painting; *Christ Raising the Daughter of Jairus* (1828, The Long Island Museum, Stony Brook, N.Y.) marked his debut at the National Academy of Design in 1828.

Disappointed by the poor reception of his efforts in history painting, Mount and his brother Shepard opened a portrait studio in New York in 1829. When the short-lived project failed, he turned to genre subjects that reveal the influence of his study of engravings, especially those made after works by the Scottish painter Sir David Wilkie (1785–1841), a partiality that ultimately led to Mount's reputation as the "American Wilkie."[3] His first major work in this manner, *Rustic Dance after a Sleigh Ride* (1830, Museum of Fine Arts, Boston), established him as the country's rising talent in the field of genre. By 1835 his humorous, sometimes politically charged images of rustic American life had attracted numerous admirers, including the collector Luman Reed and the novelist Washington Irving.

From 1830 until 1837 Mount commuted between New York and Long Island, but from the latter year until his death, he rarely ventured from his home in Stony Brook. His reputation as a sympathetic delineator of African Americans was cemented in the late 1840s with *The Power of Music* (1847, The Cleveland Museum of Art), which heralded a popular series of works: fictive portraits of young black men playing musical instruments, which were distributed as lithographic reproductions by Goupil & Co.

Mount's love of music was also manifested in his invention called the Cradle of Harmony, a type of violin that amplified the instrument's sound. He also collected and documented folk music. His art grew stale in later years, doubtless owing to his rural isolation, chronically poor health, and slow working process. He died of pneumonia at his brother Robert's home in Setauket.

1. Tuckerman 1867, 421.
2. The standard source for Mount is Alfred Frankenstein, *William Sidney Mount* (New York: Harry N. Abrams, 1975).
3. See Catherine Hoover, "The Influence of David Wilkie's Prints on the Genre Paintings of William Sidney Mount," *American Art Journal* 13, no. 3 (Summer 1981): 4–33.

31

William Sidney Mount (1807–1868)
Farmers Bargaining (*later known as* Bargaining for a Horse)
1835

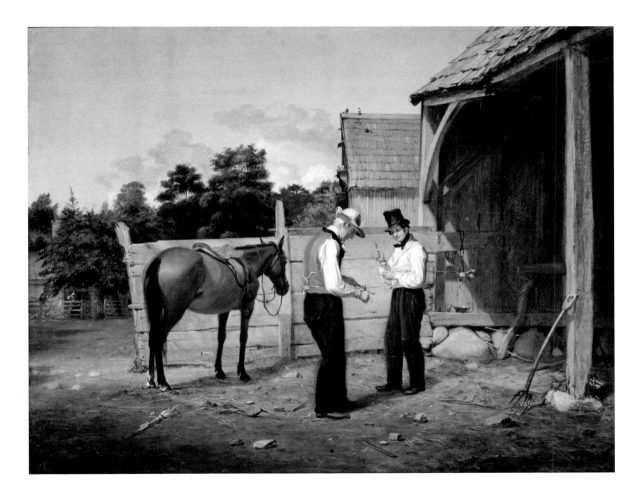

Oil on canvas, 24 × 30 in. (61 × 76.2 cm)
Signed and dated lower left: *Wm. S. Mount / 1835*
Gift of The New-York Gallery of the Fine Arts, 1858.59

For color, see page 161

William Sidney Mount's *Farmers Bargaining* attracted considerable attention when it was displayed at the 1836 annual exhibition of the National Academy of Design. The image of two men cagily negotiating the sale of the nearby horse was characterized by one reviewer as "an image of pure Yankeeism, and full of wholesome humor . . . ; yeomen [who] seem to be 'reckoning,' both whittling, both delaying."[1] The very words used by the writer to describe the painting—"yeomen" and "Yankeeism"—imply that the artist's use of the stock type of the Yankee farmer held particular meaning for the contemporary audience, associations that have been interpreted to embrace the concepts of Jeffersonian republicanism and the rapidly accelerating shift from an agrarian to an urban economy.[2] Moreover, as Elizabeth Johns has suggested, Mount's focus on bargaining reverberates with the notion of "horsetrading," a word that had recently achieved special currency and referred to Democratic political party deal-making.[3]

Mount's imagery centering on rural habits and types grew out of his youth spent on a Long Island farm. His attitudes were shaped additionally by a period of residence in New York City early in his career, when he lived with an uncle, Micah Hawkins, whose theatrical pursuits at the time included writing the comic opera *The Saw Mill: or a Yankee Trick*, which debuted at the Chatham Theatre in 1824. One of a number of theatrical vehicles featuring the quintessential Yankee type, Hawkins's production and others likely cemented Mount's conception of the Yankee farmer as an awkward character whose occasionally comic behavior was offset by an inherently shrewd nature. Such

connections between popular culture and Mount's *Farmers Bargaining* were amplified when the *New-York Gazette* published an article by the popular imaginary Yankee character Jack Downing that provided a fictionalized account of a meeting between two rural denizens who argued the merits of current political systems within a setting whose details paralleled and, indeed, seemed to be extracted from the scheme presented in Mount's painting.[4]

By the time Mount painted *Farmers Bargaining*, he had returned to Setauket, Long Island, where he would reside for the rest of his life. The dramatic contrasts between urban and rural lifestyles were fresh in his mind and likely did much to inspire this initial exploration of the unique character of the Yankee farmer in visual terms. He had already essentially committed himself to focusing only on distinctly vernacular subjects, fearing that the "splendor of European art" would somehow taint his vision.[5] Ironically, however, Mount's blending of seventeenth-century Dutch art as filtered through the work of the Scottish painter Sir David Wilkie (1785–1841) with his knowledge of contemporary stage design used in Yankee theater formed the basis for his compositions.[6] What is more, his determinedly populist views about the direction his art should take were forming at this time and gathered strength in subsequent decades as he strove to create pictures that "speak at once to the spectator, scenes that are most popular—that will be understood on the instant."[7]

Mount's incipient tendencies were rewarded by patronage from the collector Luman Reed, for whom *Farmers Bargaining* was painted. Like Mount, Reed had come from a farming family and, after establishing a thriving business in New York City, turned his attentions to collecting art. On receiving the painting from Mount, Reed wrote to the artist, conveying his appreciation for the "beautiful picture" with which he was "very much pleased." Reed continued, saying that the "subject 'comick' is a pleasing one and I would rather laugh than cry any time."[8] Clearly, the self-made Reed derived pleasure from *Farmers Bargaining*, but not in the previously prescribed or traditional ways that stipulated appreciation for the fine arts in terms of refinement or gentility. A novice in the realm of the arts, Reed was unencumbered by formulas defining what made a picture good and schooled himself as he acquired paintings. In doing so, he not only supported a new generation of American painters but also helped to validate new forms of content that elevated the commonplace in art and conversely created an art that appealed to a broad swath of the viewing public. Not surprisingly, some critics were at a loss to deal with this new form of imagery. As one reviewer stated about Mount's *Farmers Bargaining* and *Undutiful Boys* (a work also painted for Reed), "The genius of this artist is of a most eccentrick kind, delighting in the ludricous [sic] scenes of a rustick life, and in these paintings we have admirable specimens of his inclination for such subjects. We shall not pretend to critisise [sic] them, but content ourselves with a simple acknowledgement of their superiour merits."[9] —BDG

1. "National Academy," *NYH*, May 17, 1836, 1.
2. See esp. Elizabeth Johns, "Farmers in the Works of William Sidney Mount," in *Art and History: Images and Their Meanings*, ed. Robert I. Rotberg and Theodore K. Rabb (Cambridge: Cambridge University Press, 1988), 257–81. Johns points out (268) that farming itself was rapidly changing at this time, "shifting from a self-sufficient to a commercial enterprise."
3. Johns 1991, 29.
4. "Jack Downing's Journal," *New-York Gazette*, October 28, 1835, cited in Foshay 1990, 169, 212. The "Downing" text and Mount's painting continued to be linked; a passage from the column accompanied the painting (then titled *The Bargaining*) when it was displayed at the New-York Gallery of the Fine Arts in 1846.
5. Mount, quoted in Alfred Frankenstein, *William Sidney Mount* (New York: Harry N. Abrams, 1975), 49.
6. For the influence of Wilkie on Mount, see Catherine Hoover, "The Influence of David Wilkie's Prints on the Genre Paintings of William Sidney Mount," *American Art Journal* 13, no. 3 (Summer 1981): 4–33.
7. Diary entry July 1, 1850, quoted in Frankenstein, *Mount*, 241.
8. Reed to Mount, September 24, 1835, quoted in ibid., 69.
9. "National Academy of Design," *NYEP*, May 25, 1836, 2.

(Michel-)Victor Nehlig
(1831–1909)

Although Victor Nehlig was born in Paris to German parents, his specialty as a painter of subjects drawn from American history led the eminent critic Henry T. Tuckerman to write, "Mr. Nehlig is another of our native artists whose works will do honor to his country."[1] In 1847 Nehlig entered the École des Beaux-Arts in Paris, where he studied with François-Henri Mulard (1769–1850) and later with Léon Cogniet (1794–1880) and Abel de Pujol (1785–1861). Accounts vary, but he may have left Paris for Cuba in 1850; it is certain that he was living in New York City by 1861.[2] His superior academic training won him immediate respect, and he was elected an associate of the National Academy of Design in 1863, just a year after debuting at the academy's annual exhibition. He also exhibited his work in other cities. In Boston he showed with Childs and Jenks Gallery and in Philadelphia with the Sketch Club.

In August 1865 Nehlig's studio at 650 Broadway was destroyed by fire. The devastated artist, describing himself a "ruined man," wrote a letter to the editor of the *New York Times* to remedy an incorrect report that the studio contents had been insured. In addition to listing his highly anticipated canvas depicting the battle of Gettysburg, Nehlig catalogued among his losses his "collection of ancient relics, dresses, furniture, etc., [that] have cost me many thousands of dollars, besides fifteen years of research."[3] His movements in the decade following the fire are poorly documented. It is known that he spent part of 1870 in Frankfort, Kentucky. Perhaps in response to his 1870 election to full academic status in the National Academy of Design, he seems to have returned to New York. His work as an illustrator for William Cullen Bryant's "Song of the Sower" (with Winslow Homer [1836–1910] and William Hennessey [1839–1917], among others) signals his activity in commercial projects. Scattered press notices throughout 1871 point to his residence in New York by reporting his vice presidency of the newly formed Palette Club (founded by twenty artists of mainly German origin) and advertising his headway on the large allegorical canvas *The Progress of the Arts in America* (unlocated). By March 1871 he was head of the drawing schools of the Cooper Union.[4] He lived in Louisville, Kentucky, from about 1872 to 1874, in Cincinnati, Ohio, from about 1874 to 1876, and in Philadelphia from about 1878 to 1879. His work could still be seen occasionally in New York, as witnessed by the display of *Miles Standish* at the Salmagundi Club in 1879.[5]

In September 1880 it was announced that Nehlig had returned to New York, where he opened a studio on Seventeenth Street near Union Square.[6] His residence was brief, however, since he sailed for Le Havre on the steamship *France* in February 1881.[7] How the artist spent the remainder of his life is undocumented.

1. Tuckerman 1867, 492.
2. For Nehlig's career, see Dearinger 2004, 413–14. Additional information about his early years has been taken from David Karel, *Dictionnaire des artistes de langue française en Amérique du Nord* (Québec City, Québec: Les Presses de l'Université Laval, in association with the Musée du Québec, 1992), 593, which provides an exact birthdate of February 10, 1831.
3. M. Nehlig, "The Late Fire on Broadway," *NYT*, August 8, 1865, 3.
4. "Art Matters in New York," *Old and New* 3, no. 3 (March 1871): 355.
5. "The Salmagundi Club," *NYT*, February 13, 1879, 5.
6. "Victor Nehlig," *Art Amateur* 3, no. 4 (September 1880): 71.
7. "Passengers Sailed," *NYT*, February 16, 1881, 8.

32

(Michel-)Victor Nehlig (1831–1909)

An Episode of the War—the Cavalry Charge of Lt. Henry B. Hidden

1862

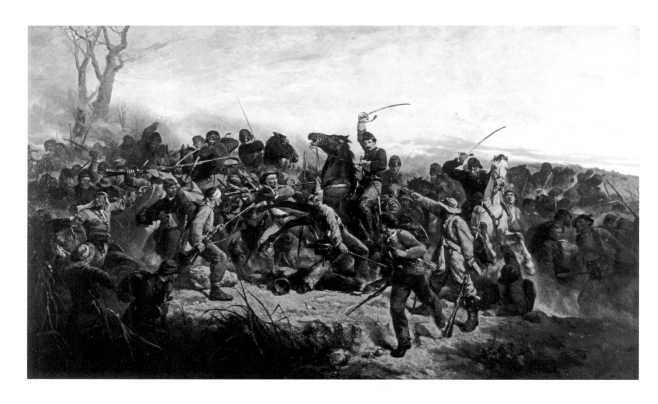

Oil on canvas, 45¾ × 75 in. (116.2 × 190.5 cm)
Signed, inscribed, and dated lower right: *V. Nehlig, N.Y. 1862*
Gift of William H. Webb, 1875.2

For color, see page 98

In this work, French grand-manner history painting and American myth-making combine in a rare contemporaneous image of the Civil War and, rarer still, a depiction of battle. When the war began in April 1861, most Americans, on both sides, expected the conflict to be glorious, but brief. As the months wore on and lives were lost, surprisingly few artists attempted to depict scenes of the war. The handful who took on such subjects, among them Winslow Homer (1836–1910) and John Rogers, tended to focus on innocuous and even humorous scenes of camp life that provided comfort and reassurance to those at home.[1] Victor Nehlig's sweeping battle scene is a striking contrast.

Léon Cogniet (1794–1880), one of Nehlig's teachers, had studied with Pierre-Narcisse Guérin (1774–1833) alongside the French Romantic painters Eugène Delacroix (1798–1863) and Théodore Géricault (1791–1824). Hints of the training that shaped their work can be seen in Nehlig's painting. Like them, the young painter embraced the French tradition of depicting contemporary war scenes in the large, ambitious format of history painting.

In the spring of 1862 Nehlig would have heard accounts of a cavalry skirmish between Union and Confederate soldiers during the Southern withdrawal from Centerville and Manassas, Virginia. On March 9 a party of fifteen to twenty soldiers of the First New York Cavalry, known as the Lincoln Cavalry, was sent to scout out enemy activity. The detachment was commanded by Lieutenant Henry B. Hidden, son of a wealthy New York family. On encountering an estimated 150 Confederates, Hidden ordered a charge, and, in spite of the great numbers against them, his men took

thirteen prisoners. The twenty-four-year-old Hidden was shot in the neck during the skirmish and died soon afterward.[2]

Hidden was heralded as the first officer of the Army of the Potomac killed in battle and, it was believed, the first Union officer killed in the Civil War. The combination of an elite New York pedigree and exemplary heroism gave the incident a Romantic pathos that inspired Americans struggling to understand the implications of the conflict. It is said that a poem entitled "First to Fall" memorialized him in the *New York Evening Post*.[3]

In the tradition of Delacroix and Géricault, Nehlig used loose brushwork rather than a careful finish. Like such midcentury French academic artists as Thomas Couture (1815–1879), he laid in dark compositional masses. One of a painter's fundamental difficulties in depicting a battle scene is how to convey the terror and confusion of the fighting while drawing the eye to the focus of the action. Nehlig used dramatic lighting at the center of the painting to highlight Hidden on his mount. His horse rears as an enemy soldier on foot grabs the reins. Hidden is about to attack him, but to the right a soldier in rough clothes, his face in shadow, prepares to take the fatal shot. Behind him, a Union cavalryman is about to strike down the attacker, but the viewer knows that the blow will come too late.

The painting was exhibited at the National Academy of Design in the spring of 1863 to glowing reviews. The *New York Times* critic declared, "for power of expression and picturesque action nothing in the exhibition compares with it," and the *New York Evening Post* agreed that the painting "deserves all praise" as "one of the most spirited contributions to the artistic history of Freedom's war."[4] William H. Webb, the owner of the painting, was a wealthy New York shipbuilder, staunch Unionist, and Hidden's brother-in-law; it is likely that he commissioned the work to honor his relative's bravery. In 1864 Webb exhibited the picture along with Benjamin West's *Chryseis Returned to Her Father* and *Aeneas and Creusa* (cats. 49, 50) at New York's Metropolitan Fair, a benefit for the United States Sanitary Commission to aid Union troops. The following year he gave the picture to the New-York Historical Society. —KPO

1. Both Homer and Rogers occasionally confronted the realities of war, though somewhat obliquely; see Homer's *The Sharpshooter on Picket Duty* (1863, Portland Museum of Art, Maine) and Rogers's *Wounded to the Rear, One More Shot* (1864, N-YHS).
2. Koke 1982, 3:5.
3. Michael Hammerson, "The First to Fall," *Military Images* 24 (March–April 2003): 26, refers to the poem, which in turn names Hidden, but does not give the date it appeared in the *New York Evening Post*. Efforts to locate the poem have been unsuccessful.
4. "The National Academy of Design," *NYT*, June 24, 1863, 2; and "The National Academy of Design," *NYEP*, May 14, 1863, 1.

Thomas Satterwhite Noble

(1835–1907)

A respected artist and instructor, Thomas Satterwhite Noble gained critical and public attention with his works focusing on slavery, all of which were executed during the early years of Reconstruction. Noble's motivation to concentrate on the plight of African American slaves is often deemed incongruous inasmuch as he was born in the South, the son of a slaveholder, and because he fought for the Confederacy during the Civil War.

Noble was born in Lexington, Kentucky, where his father cultivated hemp.[1] His family moved to Louisville in 1849, where he received his first art instruction from Samuel Price (1828–1918), through whom he probably met George Peter Augustus Healy (1813–1894). It was almost certainly Healy who encouraged Noble to study with Thomas Couture (1815–1879) in France, which he did, from 1856 to 1859. By the time Noble returned to the United States in 1859, his family had settled in Saint Louis, Missouri, where the artist's father had established a thriving business manufacturing rope and cotton bagging. The artist enlisted in the Confederate army at the outset of the Civil War and achieved the rank of captain with his final posting in New Orleans. Returning to Saint Louis at the war's conclusion, Noble immediately began to address the subject of slavery in his art in a series of works, one of the most notable of which was *The Last Sale of Slaves in St. Louis* (1865, destroyed in the Chicago Fire and known through an 1870 replica). The painting was shown at several venues throughout 1866 and 1867, including the 1866 Artists' Fund Society exhibition in New York, where

the artist had moved that year. The display of his *Margaret Garner* (private collection) at the National Academy of Design in 1867 drew extraordinary response from New York audiences, whose sympathy was stirred by the violence of the narrative, torn from the headlines, recounting the tragedy of an enslaved mother who killed her child to save it from a life of servitude. Noble was elected an associate of the academy that year on the strength of this showing, a title that was rescinded in 1884 because of his failure to submit works for display.

In 1869 Noble was named head of the McMicken School of Design in Cincinnati, Ohio. The subject matter of his art shifted from slavery to embrace such broader social issues as immigration and poverty. The intermittent presence of many Munich-trained artists in Cincinnati sparked Noble's interest in the training offered at the Königliche Akademie der Bildenden Künste in Munich, and in 1881 (the same year an article about Munich by Frank Duveneck [1848–1919] appeared in the *Cincinnati Gazette*), Noble took a leave of absence from McMicken to enroll at the Munich academy, where he studied with Alexander von Wagner (1838–1919).

He resumed his duties at McMicken (by then the Cincinnati Academy of Art) in 1883 and remained there until his retirement in 1904. Throughout his last years in Cincinnati, much of his attention was directed to portraiture. After he moved to Bensonhurst, Brooklyn, about 1904, he began to paint small seascapes. He died of appendicitis in Brooklyn in 1907.

1. The primary published source on Noble's career is James D. Birchfield, Albert Boime, and William J. Hennessey, *Thomas Satterwhite Noble, 1835–1907* (Lexington: University of Kentucky Art Museum, 1988).

33

Thomas Satterwhite Noble (1835–1907)

John Brown's Blessing

1867

Oil on canvas, 84¼ × 60¼ in. (214 × 153 cm)
Signed and dated lower right: *T. S. Noble 1867.*;
 inscribed on back of canvas: *T. S. Noble* and *John Brown / by T. S. Noble / C[incinnati], U.S.A.*
Gift of the children of Thomas S. Noble and Mary C.
 Noble, in their memory, 1939.250

For color, see page 78

Painted in the same year that Congress enacted
Reconstruction, *John Brown's Blessing* depicts the
abolitionist leader John Brown as he heads for the
gallows, where he was hanged on December 2, 1859,
convicted on the counts of murder, treason, and
inciting slave insurrection. Brown's mission had been
the violent liberation of Southern slaves and
consisted of guerilla attacks on proslavery settlers in
Kansas. It culminated with his 1859 taking of the
federal arsenal at Harper's Ferry, Virginia. Brown
and his small party were finally captured by U.S.
Marines headed by Colonel Robert E. Lee on the
third day of their occupation.

 Despite his radical methods, Brown's objectives—
done in the name of God—had found a modicum of
support in the North, mainly among wealthy New
England businessmen (called the "Secret Six"). Even
before the conclusion of Brown's trial, the poet and
philosopher Ralph Waldo Emerson had referred to
him as "[t]he Saint whose fate yet hangs in suspense,
but whose martyrdom, if it shall be perfected, will
make the gallows as glorious as the cross."[1] Three
weeks after his execution, Brown's heroic status was

again confirmed with the publication of John Greenleaf Whittier's poem "Brown of Ossawatomie."[2] Public fascination with Brown persisted; the abolitionist and reformer Gerrit Smith wrote in 1867, "It is quite probable that John Brown will be the most admired person in American history. Washington worked well—but it was for his own race—only for his equals. William Lloyd Garrison has lived for a despised and outraged race. John Brown both lived and died for it and few names, even in the world's history, will stand as high as his."[3]

The growing mythology surrounding Brown's life provides the context in which Noble's painting can be interpreted. Noble's inherent empathy with Brown's cause stemmed from his own childhood experiences, when he lived in the border state of Kentucky and spent time with the slaves who worked in his father's hemp factory. His service in the Confederate army notwithstanding, Noble's sympathies rested with the antislavery movement and doubtless account for the eight paintings he dedicated to the theme beginning in 1865. Yet the apparent contradictions in Noble's sentiments (loyalty both to the South and to the abolitionist cause) may signal the ambivalence that pervades the imagery in *John Brown's Blessing*.

The composition is dominated by the towering figure of Brown, who places his left hand on the head of an infant offered up by a black woman for his blessing. The motif finds its immediate source in Whittier's poem, which, although it describes Brown kissing the child (based on an apocryphal account in a newspaper article), establishes the tone and moment of the painting's narrative.[4] As Albert Boime observed,

Brown's powerful physical presence and bearded face conform to the typology of the Old Testament prophets.[5] Yet Boime's characterization can be refined, for Noble's paternalistic Brown evokes associations with the bearded prophet Moses, who led his own people from slavery. Paternalism is the operative word here. Although the supplicating woman at Brown's feet and the older black woman behind her (who tends to two white boys) may have escaped the bonds of slavery, they are still subject to the laws of the governing class and were deemed incapable of self-determination. Indeed, Noble portrays the two according to the deep-seated stereotype of the nurturing black female or "mammy."[6]

Noble had high expectations for *John Brown's Blessing* and exhibited it first in December 1867 at Boston's DeVries, Ibarra & Co., perhaps thinking that the subject would especially appeal to a Boston audience because Brown's major financial backers were from that area. The painting was billed as the "greatest historical picture of John Brown" and drew mixed critical reactions with respect to composition and technique.[7] Most critics focused on Noble's identity as a "reconstructed" man, who had fought for the Confederacy and lost "friends and position at home by representing so unwelcome a matter in the south."[8] By February 1868 the painting was on view in New York at G. P. Putnam & Son, coinciding with the publication of a lithographic reproduction of it.[9] This was followed by display at Wiswell's Gallery in Cincinnati in January 1869.[10] After traveling to the 1873 Vienna Universal Exhibition, it remained with the artist. —BDG

1. Ralph Waldo Emerson, speech delivered at Tremont Temple, Boston, in the *Liberator* 29, no. 45 (November 11, 1859): 178.
2. *New York Independent*, December 22, 1859, quoted in Albert Boime, *The Art of Exclusion: Representing Blacks in the Nineteenth Century* (Washington, D.C.: Smithsonian Institution Press, 1990), 140.
3. "Gerrit Smith on John Brown," *Daily Cleveland Herald*, August 22, 1867, 1. Smith had sold Brown property in New Elba, New York, and it was probably he who introduced Brown to Frederick Douglass.
4. By this time, the motif of Brown's last moments had assumed iconic status. See, for instance, Lydia Maria Child's poem "A Hero's Heart" and Louis Ransom's painting *John Brown on His Way to Execution*, 1860, which was reproduced and distributed by Currier & Ives in 1863.
5. Boime, *The Art of Exclusion*, 139.
6. Leslie Furth, "'The Modern Medea' and Race Matters: Thomas Satterwhite Noble's 'Margaret Garner,'" *American Art* 12, no. 2 (Summer 1998): 51.
7. "Mr. Noble's 'John Brown,'" *Boston Daily Advertiser*, December 12, 1867, 1; and untitled article, *Congregationalist and Boston Recorder*, December 19, 1867, 268.
8. *Commonwealth*, December 1867, quoted in Boime, *The Art of Exclusion*, 240.
9. "Art Gossip," *Frank Leslie's Illustrated Newspaper*, February 8, 1868, 323.
10. "Editor's Table," *Ladies' Repository* 3, no. 1 (January 1869): 79.

Johannes Adam Simon Oertel

(1823–1909)

The German émigré Johannes Adam Simon Oertel addressed a full range of subject matter in the more than 1,500 works he created over his lifetime. He was best known, however, for his depictions of Christian themes, content that corresponded with his fervent religious beliefs, which led to his becoming an Episcopal priest in 1871.

Oertel was born in Fürth, Bavaria (now Germany).[1] Despite his intentions to go into missionary work, he was directed by one of his teachers toward a career in the arts. After attending the Polytechnikum in Nuremberg, he studied at the Königliche Akademie der Bildenden Künste in Munich, where he specialized in steel engraving under Johannes Michael Enzing-Müller (1804–1855). With the onset of the 1848 revolutions, Oertel left his native land, traveling with Enzing-Müller and several others to the United States. Without contacts or a thorough knowledge of English, Oertel's first months were difficult. He found work teaching drawing at a young ladies' seminary in Newark, New Jersey, and engraving banknotes. In 1851 he married Julia Adelaide Torrey (with whom he would have four children). He also began to concentrate on oil painting, and a few examples of his work were eventually shown through the American Art-Union and, beginning in 1854, at the National Academy of Design.

Oertel was living in Brooklyn by 1852 and for a time actively participated in the city's lively art community; he was a founding member of the Brooklyn Sketch Club and the first vice president of the Brooklyn Art Association. By 1855 his reputation was shaped by his religious subjects, and, as one reporter put it, "Too limited in pecuniary means to give himself to the high themes which do not find ready appreciation, he supports himself in part by engraving, and devotes his evenings to his favorite sacred labors."[2] These sacred labors included a series of elaborate paintings: *The Dispensation of the Law*, *Redemption*, *The Propagation of the Gospel*, and *The Consummation of Redemption*. In 1857 Oertel received a commission to design ceiling decorations for the U.S. House of Representatives, but although he worked in Washington, D.C., in 1857 and 1858, the project never came to fruition. He moved to Westerly, Rhode Island, in 1861. During the Civil War he spent three months with a Rhode Island cavalry regiment in Virginia, and two of the paintings "showing the living realities of . . . [the] great war" based on his sketches made on-site were displayed in New York in 1865.[3] While living in Westerly, he also painted the first of several versions of his most famous work, *Rock of Ages*, a painting that became widely known through chromolithographic reproduction.

The close of the Civil War marked the beginning of a change in Oertel's life. He was increasingly involved in spiritual matters and, although he continued to paint, the bulk of his time was given to ministering in churches (some of which he designed) throughout the southern United States after his ordination in 1871. In addition to serving in various parishes, Oertel occasionally taught art at the University of the South, Sewanee, Tennessee, and at Washington University, Saint Louis, Missouri. He retired in 1895 and died in Vienna, Virginia, in 1909.

1. For Oertel's life and career, see John Frederick Oertel, *A Vision Realized: A Life Story of Rev. J. A. Oertel, D.D., Artist, Priest, Missionary* (Milwaukee: Young Churchman Company, 1917); Katharina Bott and Gerhard Bott, eds., *ViceVersa: Deutsche Maler in Amerika/Amerikanische Maler in Deutschland, 1813–1913* (Munich: Hirmer Verlag, 1996), 234–36; and Dearinger 2004, 426–27.
2. "Christian Artists," *New York Evangelist* 26, no. 48 (November 29, 1855): 1.
3. "War-Pictures," *NYT*, August 21, 1865, 5.

34

Johannes Adam Simon Oertel (1823–1909)

Pulling Down the Statue of King George III, New York City

1852–53

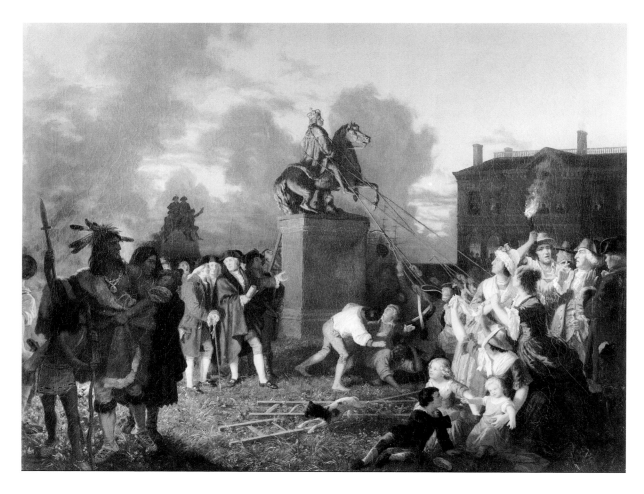

Oil on canvas, 32 × 41¼ in. (81.3 × 104.8 cm)
Gift of Samuel Verplanck Hoffman, 1925.6

For color, see page 92

The incident Johannes Adam Simon Oertel depicted in this painting took place on July 9, 1776. The Declaration of Independence was read before each brigade of the Continental Army in New York. That evening a group of zealous patriots gathered in Bowling Green to pull down the statue of George III by the English sculptor Joseph Wilton (1722–1803), which had been placed there just six years before. Its gold leaf was removed, and large iron fragments were ferried to Staten Island, where they were cast into bullets for the Continental Army. However, a few pieces survived and are now in the collection of the New-York Historical Society.[1]

Oertel's rendering, dramatically illuminated by the light of the moon and torches, reads as an allegory rather than an accurate re-creation of the event. Wilton's sculpture was described as an equestrian statue modeled after that of the Roman emperor Marcus Aurelius at the Campidoglio in Rome, but no images exist to record its actual appearance. Oertel depicted the king on a rearing horse wearing a crown and ermine-trimmed cape that, instead of being appropriate riding attire, denote the royal power that had aroused the colonists' wrath. The artist represented not only those who would have been present but also the range of citizens who would be affected by the coming revolution. At the far right stand two men and two women dressed in rich silks and frilled shirts; one exaggeratedly effete man wears a dismayed expression. At their feet, a modestly dressed mother waves her kerchief and shouts encouragement to the rebels. Her arms encircle her children, future United States citizens. Across from them at left is a family of Indians who, though rendered at large scale, are in shadow. The

father looks over his shoulder as they leave the scene, in a pointed reference to their marginalized role in the nation's future. At the left of the pedestal is a group of three men gesturing their approval. One has a rolled document in his hand, no doubt a copy of the Declaration of Independence. In front of the pedestal, three men cower in almost comic trepidation of the statue toppling down on them. One of them is an African American. Slavery was not abolished in New York until 1827, so his status is unclear, and still less clear is Oertel's intention in placing him there. He may be part of the first salvos of American freedom, but at the time the picture was painted, the status of his race was dividing the nation.

The artist may have been inspired to take on this uncharacteristic subject by Emanuel Gottlieb Leutze's *Washington Crossing the Delaware*.[2] Leutze might have aroused an interest in Revolutionary themes. Oertel was not the only painter to depict the toppling of the statue of King George. In 1854 William Walcutt (1819–1882) painted *Bowling Green—Pulling Down the Statue of George III* (Lafayette College, Easton, Pa.).[3]

Oertel may have also been angling for a commission to work on the decoration of the Capitol building. Such mural commissions had caused a stir in the artist community in the 1830s (see cat. 6), and in the early 1850s construction began on a new wing that would eventually require embellishment. Oertel was engaged to work on designs for the corridor in 1857, but, to his indignation, he was replaced by Constantino Brumidi (1805–1880).[4]

Whatever Oertel's intentions, his picture took on other meanings when it was engraved by John C. McRae of New York (ca. 1816–1892) in 1859 (see fig. 23, p. 93). McRae introduced ominous overtones. At left, the suggestion of torchlight in Oertel's painting has become flames burning at a fearful height. One of the new figures, rendered in heroic proportions, waves his hat to hail the toppling of an oppressive authority. The figure's dark skin and hair may denote him as an African American. Here, too, the engraving sends a mixed message that highlights the complexities that arise when historical events are pressed into service as propaganda: What institution should be toppled, slavery or the United States government? And what kind of violence and destruction might result from the attempt?—KPO

1. For a full account, see A. J. Wall, "The Statues of King George III and the Honorable William Pitt Erected in New York City 1770," *New-York Historical Society Quarterly Bulletin* 4 (April 1920): 37–57.
2. John Caldwell and Oswaldo Rodriguez Roque, *American Paintings in the Metropolitan Museum of Art*, vol. 1, *A Catalogue of Works by Artists Born by 1815* (New York: Metropolitan Museum of Art, in association with Princeton University Press, 1994), 16–24.
3. See Arthur S. Marks, "The Statue of King George III in New York and the Iconology of Regicide," *American Art* 13 (Summer 1981): 61–82. Marks dates the painting in the New-York Historical Society to 1848, the year Oertel arrived in the United States, and posits a link to revolutions in his German homeland, but Oertel's son, in John Frederick Oertel, *A Vision Realized: A Life Story of Rev. J. A. Oertel, D.D., Artist, Priest, Missionary* (Milwaukee: Young Churchman Company, 1917), 34, suggests a date between 1852 and 1853.
4. Charles E. Fairman, *Art and Artists of the Capitol of the United States of America* (Washington, D.C.: United States Government Printing Office, 1927), 190–91.

Rembrandt Peale

(1778–1860)

The artist, writer, lecturer, and museum proprietor Rembrandt Peale devoted himself to promoting the arts in the United States. Influenced by the Enlightenment attitudes of his father, the artist Charles Willson Peale (1741–1827), Rembrandt was an important member of the Peale dynasty of artists and cultural entrepreneurs.

Rembrandt Peale was born in Bucks County, Pennsylvania, and raised in Philadelphia.[1] Much of his early career followed the pattern set by his father: he produced portraits of Revolutionary War heroes on commission for his father's Philadelphia museum; he and his brother Raphaelle (1771–1825) supervised the tour of their father's Portraits of Patriots, showing them in Charleston, Savannah, and Baltimore, while painting portraits along the way; and the two operated their own museum of portraits and natural science in Baltimore from 1796 to 1799. He married Eleanor Mary Short, the daughter of the Peale family's housekeeper, and when the Baltimore museum project failed in 1799, the couple moved to Philadelphia.

At this point Peale's career entered a lull, broken mainly by activities in connection with his father's 1801 excavation of a mastodon skeleton, which Rembrandt took on tour to England in 1802 and 1803. Peale flourished during this English sojourn. Benjamin West took him under his wing, he attended drawing classes at the Royal Academy in London, and two of his paintings were displayed in the academy annual in 1803. Once back in the United States, he pursued a portrait specialty.

Peale made two extended trips to France (1808 and 1809–10), commissioned by his father to paint portraits of noted Frenchmen for his Gallery of Great Men in the Peale Museum in Philadelphia. In Paris Peale paid particular attention to the works of the old masters and was also attracted to the restrained linear style and the grand moralizing subjects of Neoclassicism. Influenced especially by Jacques-Louis David (1748–1825) and John Vanderlyn, Peale's enthusiasm for creating Salon-style history paintings initiated a nearly fifteen-year period during which he concentrated on producing such works as *The Roman Daughter* (1811, Smithsonian American Art Museum) and *The Court of Death* (1820, The Detroit Institute of Arts).

After returning to Philadelphia, Peale opened his Apollodorian Gallery, but he soon moved to Baltimore to open Peale's Baltimore Museum and Gallery of Painting. Plagued by financial setbacks, he sold the museum to his brother Rubens (1784–1865). By 1822 he was living in New York City but soon returned to Philadelphia. Restless and disappointed by the reception of art in America, Peale and his son Angelo (1814–1833) toured Italy from 1828 to 1830. There he painted copies of Italian old masters, which he later billed as Peale's Italian Gallery, an enterprise designed to develop the taste of the American public. Although he continued to paint portraits, much of his time from the 1830s on was consumed by efforts to educate and expand the American audience for art through writing (such as his book *Graphics: A Manual of Drawing and Writing for the Use of Schools and Families*, 1834) and lecturing. The 1830s were also punctuated by periods in England, Boston, New York, and Washington. His first wife died in 1836, and in 1840 he married the artist Harriet Cany (1800–1869). He spent most of the 1840s and 1850s in Philadelphia, where he died in 1860.

1. For Rembrandt Peale's life and art, see Carol Eaton Hevner and Lillian B. Miller, *Rembrandt Peale (1778–1860): A Life in the Arts* (Philadelphia: Historical Society of Pennsylvania, 1985); and Lillian B. Miller, *In Pursuit of Fame: Rembrandt Peale, 1778–1860* (Washington, D.C.: National Portrait Gallery, 1992).

35

Rembrandt Peale (1778–1860)

George Washington

1853

Oil on canvas, 35½ × 29 in. (90.2 × 73.7 cm)
Bequest of Caroline Phelps Stokes, 1910.3

For color, see page 91

Rembrandt Peale's portrait of George Washington attests to the artist's nearly lifelong quest to capture a perfect likeness of a revered figure, and to earn a living from the enterprise. Peale described his enduring interest in Washington: born on the same day as the first president, as a boy Peale took every opportunity to see him. Peale sat behind the chair of his father, Charles Willson Peale (1741–1827), when he painted Washington in 1786 and "longed for no greater honor" than to paint the man himself. Rembrandt had his chance in September 1795, when Washington gave him three sittings of three hours each. Peale persuaded his father to paint beside him to keep the conversation lively.[1] Rembrandt made ten copies of that 1795 original life portrait (Historical Society of Pennsylvania, Philadelphia) the next year.

In 1823 Rembrandt returned to the subject and studied every portrait, bust, medallion, and print of Washington he could find. After Rembrandt had worked on his portrait for three months, the elder Peale declared, "You have it now—that is indeed Washington."[2] This new version of George Washington, painted decades after the sitter's death, was entirely different in its aims from Peale's portrait of 1795. Rather than striving for an accurate likeness from life, which was of course no longer possible, the artist looked not only to his own impressions of the man but to those of others. While aiming for verisimilitude, Peale also adopted the remarkably modern stance that a representation of a person or event cannot be conveyed with perfect objectivity, but that a measure of truth can be realized by drawing on a range of perspectives. The later version also differs from the 1795 portrait significantly in style, exhibiting the suave fluidity of Rembrandt's training in

France during the intervening years. The addition of the stone oval, a common device in seventeenth-century European portraiture, probably recalls Continental conventions.[3]

Peale wasted no time in capitalizing on his achievement. He took his new likeness to the nation's capital, where it was hung in the vice president's chamber. In 1832 the United States Senate purchased the painting for two thousand dollars.[4] Peale solicited glowing testimonials regarding the portrait's accuracy from eminent men who had known Washington, which he published in a pamphlet. In it, he asserted that since he was "the *only* Painter living who ever saw Washington, the reduplication of his work, by his own hand, should be esteemed the most reliable." It also described his plans for an engraving of the subject.[5] His efforts met with success, and reproducing the portrait became one of his primary sources of income in his later years.[6] He presented a series of lectures in East Coast cities beginning in 1854, including one at the New-York Historical Society on June 16, 1857.[7] In these lectures he showed the copies he had made of other artists' portraits of Washington, comparing them unfavorably with his.[8]

By the time he died in 1860, Peale had made at least seventy-nine copies of the portrait he painted in 1823, which later became known as the porthole portrait because of the trompe l'oeil stone oval surround. Peale's practice of making numerous versions in response to demand was common in Europe and the United States. For instance, Gilbert Stuart (1755–1828) painted about one hundred versions of his iconic Washington portrait. In fact, Peale himself made twenty copies of Stuart's portrait and thirty-nine copies of his father's rendering.[9]

Most of Peale's copies of his own painting are now in private hands or made their way to museums as gifts from individuals, suggesting that most of Peale's original patrons were private citizens. The painting in the New-York Historical Society is one such instance, having been commissioned by a Mrs. Campbell of New York for $125.[10] These versions appeared occasionally at fairs and art exhibitions ranging across the country, keeping Peale's image of Washington in the public eye.[11] —KPO

1. Quoted in C. Edwards Lester, *The Artists of America* (New York: Baker & Scribner, 1846), 204–5. The elder Peale's rendering from those sessions is now in the New-York Historical Society's collection (1867.299).
2. Ibid., 210–11.
3. John Caldwell and Oswaldo Rodriguez Roque, *American Paintings in the Metropolitan Museum of Art*, vol. 1, *A Catalogue of Works by Artists Born by 1815* (New York: Metropolitan Museum of Art, in association with Princeton University Press, 1994), 286.
4. Lester, *The Artists of America*, 211–12.
5. Rembrandt Peale, *Washington* (Philadelphia, 1857?).
6. Caldwell and Roque, *American Paintings in the Metropolitan Museum of Art*, 282.
7. *Catalogue of American Portraits in the New-York Historical Society* (New Haven: Yale University Press, 1974), 2:862–63.
8. Dunlap 1834, 2:55. Dunlap disagreed with Peale's testimonials, flatly calling Peale's portrait "not a likeness of Washington" and criticizing Peale's unflattering remarks about Stuart's Washington portrait.
9. Caldwell and Roque, *American Paintings in the Metropolitan Museum of Art*, 284.
10. Dorothy C. Barck, "Washingtoniana of the New-York Historical Society," *New-York Historical Society Quarterly Bulletin* 15 (January 1932): 130.
11. Versions appeared at the Western Art Union, Cincinnati, 1850; Cosmopolitan Art Association, Sandusky, Ohio, 1858; National Academy of Design, 1860; Pennsylvania Academy of the Fine Arts, 1862 and 1865; Cincinnati Industrial Exposition, 1872; San Francisco Art Association, 1872; Louisville Industrial Exposition, 1878. See the Smithsonian American Art Museum Pre-1877 Art Exhibition Catalogue Index at http://www.siris.si.edu/.

John Rogers
(1829–1904)

The enormous popular appeal of John Rogers's small, anecdotal sculpture groups earned him the epithet "the people's sculptor."[1] From the time his hallmark plaster statuettes first appeared in 1859 to his retirement in 1893, the essentially self-trained sculptor was responsible for the manufacture of nearly eighty thousand casts based on more than eighty groups of his creation. With the average price of fifteen dollars per group, Rogers's works were as accessible financially as they were in terms of storytelling content—factors that led to the rare merger of popular and fine art.

Rogers was born in Salem, Massachusetts, the son of a Boston merchant of a distinguished family background, whose financial circumstances were nonetheless strained.[2] Rather than going to Harvard to pursue the business career his father envisioned for him, Rogers trained as a master mechanic at the Amoskeag Works in Manchester, New Hampshire. When he completed the program, he obtained a position working for the Hannibal and St. Joseph Railroad in Missouri but lost that job during the economic panic of 1857. It was then that he decided to parlay his hobby of sculpting clay figures (begun in 1849) into a profession.

With the help of funds provided by family members, in 1858 Rogers went to Europe, seeking instruction in his newly chosen field. After studying for a few months with Antoine Laurent Dantan (1798–1878) in Paris, Rogers went to Rome, where he trained briefly with the English sculptor Benjamin Edward Spence (1822–1866). Rogers's scant instruction from these relatively minor European sculptors failed to fire his passions; the two teachers shared a taste for the prevailing Neoclassical aesthetic, which even then countered Rogers's desire for

narrative content. Disillusioned by what he saw and learned in Europe, Rogers returned to the United States in the spring of 1859 and took a job as a draftsman in Chicago. William Ordway Partridge (1861–1930), who wrote an early appreciation of the sculptor, notes that the fine work required for mechanical drawing became burdensome and cites it as a factor in Rogers's final decision to try to make a living as a sculptor. Then, too, Rogers had received encouragement from the warm reception given to his *Checkers on the Farm* at a local Chicago charity bazaar. What turned out to be a thriving enterprise was aided enormously by the recent invention of gelatin molds, which permitted the reproduction of sculpted models accurately and cheaply.

Rogers was in New York City by the early 1860s and, with the outbreak of the Civil War, found his thematic metier with such subjects as *One More Shot* and *Union Refugees*, the latter of which was exhibited at the National Academy of Design and earned him the votes necessary for election as an academician. As the first American sculptor to market his work through mass production, Rogers eventually came up against elitist critics who claimed that his work pandered to simple, naïve tastes and did not qualify as high art. Other writers, however, praised him for creating a "democratic" art: affordable objects whose subjects— often gleaned from popular literary sources or common life experiences—were immediately understood.

Rogers occasionally attempted large-scale works, one of which was *Abraham Lincoln*, an overlife-size seated portrait that won him a bronze medal at the 1893 World's Columbian Exposition in Chicago (the plaster is now unlocated; a 1910 bronze cast is owned by Central

High School, Manchester, N.H.). That same year Rogers was forced to retire owing to the onset of paralysis stemming from an unspecified condition. He died in New Canaan, Connecticut.

1. The phrase seems to have first appeared in William Ordway Partridge, "John Rogers, the People's Sculptor," *New England Magazine*, n.s., 13, no. 6 (February 1896): 705–21.
2. See David H. Wallace, *John Rogers: The People's Sculptor* (Middletown, Conn.: Wesleyan University Press, 1967) and Kimberly Orcutt, ed., *John Rogers: American Stories* (New York: New-York Historical Society, in association with Philip Wilson Publishers, 2010).

36

John Rogers (1829–1904)

Uncle Ned's School

1866

Bronze, 19¾ × 14 × 9 in. (50.2 × 35.6 × 22.9 cm)
Signed and inscribed on front of base: *JOHN ROGERS / NEW YORK*;
 inscribed on rear of cabinet: *PATENTED / JULY 3ᴰ / 1866*
Purchase, 1936.656

For color, see page 76

In the 1860s John Rogers's works addressed key social issues. With *Uncle Ned's School*, he took on the difficult question of freed slaves' education and their future opportunities as new United States citizens. In the years after the Civil War, former slaves organized many schools that ranged from brand-new structures to improvised classrooms in cellars or old sheds.[1] In this master bronze, Rogers showed one such informal school in his only group made up entirely of African Americans. The elderly cobbler Uncle Ned pauses in his work and leans on a ramshackle cabinet to assist one of his students with a question about her studies. At his feet a young boy with a tattered book open on his lap mischievously tickles the cobbler's foot with a feather. Though the girl is respectably dressed, the man and boy wear ragged, patched clothing, and all are barefoot. In depicting a cobbler and his charges without shoes of their own, Rogers pointed out their continued poverty, emphasizing the need for education to better their situation.

Rogers knew that his audience would be familiar with the character of Uncle Ned from the popular 1848 Stephen Foster song of that name. In the song, the title character is a docile, obedient, aging slave who is blind.[2] Rogers turned the caricature on its head by showing Uncle Ned perpetrating what would have been a crime in some Southern states when Foster's song was written: teaching a slave to read.[3] However, the figure of the boy who has stopped studying to tease his teacher presents another stereotype that raises questions about Rogers's intentions. Does the boy represent harmless comic relief, or does he allude to concerns that African Americans lacked the determination and persistence to learn? The

present-day scholar Kirk Savage has suggested that
Rogers may have juxtaposed the boy and girl to
pose a subtle question about which stereotype
would prevail: the lazy scamp or the earnest pupil.[4]
Rogers's sales catalogues noted that the older man
was "too much occupied to attend to" the boy's
mischief, suggesting that Uncle Ned will not be
deterred in his efforts.

Uncle Ned's School was widely praised for its
nuanced depiction of a momentous issue. Rogers
himself considered it an important work; he
exhibited the sculpture at the National Academy of
Design, his first contribution in three years. A
Philadelphia writer called it much better than any
of his previous groups.[5] Rogers presented a copy to
the abolitionist Henry Ward Beecher, who
responded, "I am pleased with the complete
rendering of the story, with a few means, and
without exaggeration. Its simplicity is as agreeable
as its errand is noble."[6] —KPO

1. Albert Boime, *The Art of Exclusion: Representing Blacks in the Nineteenth Century* (Washington, D.C.: Smithsonian Institution Press, 1990), 104.
2. Leo Mazow, "Read, Look, and Listen: Literary Motives in John Rogers' America," in *John Rogers: American Stories*, ed. Kimberly Orcutt (London: Philip Wilson Publishers, 2010), 113.
3. A few modern scholars have misinterpreted Uncle Ned as the student, enfeebled, unintelligent, and struggling vainly to learn, but Rogers's sales catalogues stated and contemporary critics clearly understood that Uncle Ned was the teacher. See Boime, *The Art of Exclusion*, 104–5, 197–98, who discusses Freeman Murray's analysis from his *Emancipation and the Freed in American Sculpture* (Washington, D.C.: Freeman Henry Morris Murray, 1916).
4. Kirk Savage, "John Rogers, the Civil War, and the 'Subtle Question of the Hour,'" in Orcutt, *John Rogers: American Stories*, 73–74.
5. "Pictures at Earle's," *Philadelphia Daily Evening Bulletin*, September 7, 1866, 4.
6. Henry Ward Beecher to Rogers, September 1866, Rogers Family Papers, N-YHS.

37

John Rogers (1829–1904)

The Fugitive's Story

1869

Bronze, 21⅞ × 16 × 12 in. (55.6 × 40.6 × 30.5 cm)
Signed and inscribed on front of base: *JOHN ROGERS / NEW YORK*;
 inscribed on rear of base at left: *PATENTED / SEP. 7, 1869*
Purchase, 1936.630

For color, see page 75

John Rogers built his early fame on his Civil War subjects, beginning with *The Slave Auction* of 1859, which condemned the evils of slavery in the days leading up to the war. *The Fugitive's Story* was his last Civil War–related subject and represented a fitting conclusion to his acclaimed series, since it memorialized the triumph of the abolitionist cause. Rogers's biographer, David Wallace, called it a "civilian counterpart" to the artist's 1868 sculpture *The Council of War*, which depicts the war's highest military officials: General Ulysses S. Grant, Secretary of War Edwin M. Stanton, and President Abraham Lincoln.[1] This master bronze of *The Fugitive's Story* in turn pays tribute to the public leaders of the abolitionist movement: the poet John Greenleaf Whittier, the editor William Lloyd Garrison, and the preacher Henry Ward Beecher.

The three men are gathered around a desk listening to the tale of a slave who has escaped to the North with her baby. A small bundle containing her worldly possessions lies at her feet, and she clasps her child to her shoulder. Her head is inclined toward Garrison, seated at his desk, and all three men gaze at her with expressions of deep interest and concern, likewise drawing the viewer's eye to her earnest face. Whittier (at left) and Garrison (at right) hold papers that suggest their role as writers in the fight against slavery; Rogers further emphasized the point with the inkpot and papers on Garrison's desk. The artist often incorporated portraits into his narrative groups, but this is the only instance in which he inscribed the names of the sitters on the base to make his subject perfectly clear. The story reportedly had a powerful effect on the former slave Sojourner Truth: the abolitionist newspaper the *Independent* reported that

when she saw the work, she burst into tears, remembering her own escape with her small child.[2]

Rogers's convictions about abolition are evidenced in the time and care that he took preparing the group, and in his later memories of it. The artist wrote to Beecher and secured his enthusiastic approval for the idea. He interviewed each of his three sitters and took detailed measurements, secured photographs, and even took life masks of Beecher and Garrison. Both men wrote to Rogers with suggestions for the composition and for his portrayals of them. There were reports from all three that they were satisfied with the likenesses. For instance, Garrison called the sculpture "a marked success, both in regard to the likenesses and as a work of art."[3] William Cullen Bryant wrote to Rogers in relation to *The Fugitive's Story*: "You have succeeded in a higher degree than almost any artist in making sculpture a narrative art."[4] Public reaction was equally enthusiastic, and critics were quick to connect this valedictory work with Rogers's humble *The Slave Auction* of little more than a decade earlier, when he could not induce stores to carry the sculpture for fear of offending their Southern customers.[5]

The subject apparently had strong poetic resonances for his viewers. Rogers was compared to Whittier, the poet he portrayed, with one commentator declaring, "What Whittier is in verse Rogers is in sculpture." The *Boston Advertiser* called the group "a perfect poem of our history."[6] Yet another writer connected it with efforts to establish a colony for former slaves in Liberia, in western Africa, writing a poem from the point of view of the fugitive as a wife looking forward to a reunion with her husband, who was preparing a home for them there.[7] —KPO

1. David H. Wallace, *John Rogers: The People's Sculptor* (Middletown, Conn.: Wesleyan University Press, 1967), 222.
2. "The Fugitive's Story," *Independent*, October 14, 1869, Scrapbooks of Miscellaneous Clippings, etc., about John Rogers, vol. 3, N-YHS Library.
3. Wallace, *Rogers*, 222.
4. William Cullen Bryant to Rogers, October 18, 1869, Rogers Family Papers, N-YHS.
5. "The Fugitive's Story," *Independent*, October 14, 1869, Scrapbooks, vol. 3; and "John Rogers's 'Slave Story,'" *New York Tribune*, October 29, 1869, Scrapbooks, vol. 3.
6. "The Fugitive's Tale," *Charleston (S.C.) Register*, November 1869, Scrapbooks, vol. 3; and clipping, *Boston Advertiser*, November 1869, Scrapbooks, vol. 3.
7. "The Fugitive's Story," unattributed article, Scrapbooks, vol. 3.

38

John Rogers (1829–1904)

"Ha! I Like Not That!"

1882

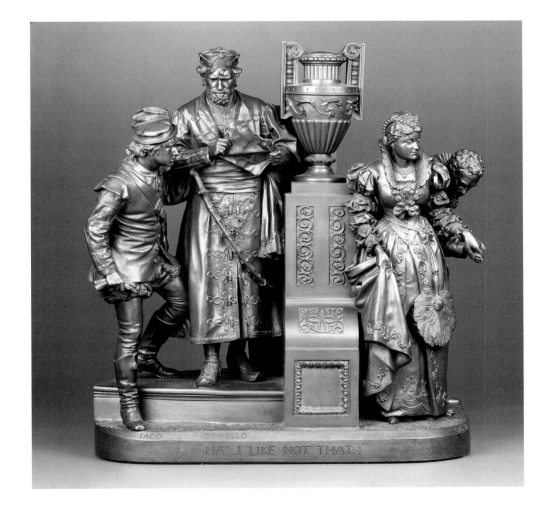

Bronze, 22 × 19¼ × 13 in. (55.9 × 48.9 × 33 cm)
Signed, inscribed, and dated on front of base: *JOHN
ROGERS / NEW YORK / 1882*
Purchase, 1936.658

For color, see page 49

Rogers contemplated the plays of Shakespeare as a
potential subject from the earliest years of his
professional career. In 1861 he wrote of his plans for a
series, and he attempted a handful of such themes in
1862, including one titled *The Merchant of Venice*,
which he showed at the National Academy of Design (to
his dismay, it went unnoticed). No examples of these
early groups survive.[1] The Bard did not resurface in
Rogers's work until almost twenty years later, and by
that time the artist's skills and ambition had grown
considerably. This master bronze for *"Ha! I Like Not
That!"* taken from *Othello* represents the third
Shakespearean group of his mature career, after *"Is It So
Nominated in the Bond?"* (1880, N-YHS) from *The
Merchant of Venice* and *The Wrestlers* (1881, N-YHS)
from *As You Like It*.

Rogers's latest Shakespearean work was considered a
companion to *"Is It So Nominated in the Bond?"*—a
group similar in size and format. The pair embraced
two of the playwright's best-known works, one
classified as a comedy and the other as a tragedy. Where
the scene from *The Merchant of Venice* depicts the tense
moments before the villainous Shylock is foiled and all
is happily resolved, Rogers chose a scene from *Othello*
that sets in motion events that lead to murder. Rogers
capitalized on the play's success and heightened his
sculpture's popular appeal by modeling the characters
after actors famous for their performances in the play.
The acclaimed American performer Edwin Booth posed
for Iago, and the Italian Tommaso Salvini was said to
have posed for Othello.[2]

Rogers ordinarily attempted to convey an entire
narrative within each sculpture, but in these groups he

presented a small slice of a much larger narrative, and his concern for intelligibility is evident in the extra aids that he provided. Though most middle-class late-nineteenth-century Americans were familiar with the story, Rogers took care to situate the viewer in the action of the play. As was the case with his other Shakespearean subjects, his sales catalogue included an unusually long and elaborate explanation of the moment depicted. The title is a key line from that scene, and the base of the group, normally reserved for the title alone, also bears the names of the characters.

In this vignette from act 3, scene 3, Desdemona and Cassio are conferring in the garden. On Iago's advice, Cassio entreats her to help restore him to her husband Othello's good graces. Othello and Iago are walking together in the garden, and, when Iago sees his commander's wife with his rival, he exclaims his titular line in an attempt to arouse Othello's suspicions about their relationship. The climactic moment when Othello kills his wife in a rage, thinking her unfaithful, would have made a grisly subject for middle-class parlors, so Rogers showed what a contemporary writer called the "keystone of the tragedy,"[3] knowing that his viewers were aware of the events that followed.

The action takes place in a squared-off stagelike space. As in a theater production, the garden is suggested by a few minimal props: the grassy surface of the base and the vase placed on an elaborate pedestal that separates Iago and Othello from Desdemona and the departing Cassio. Rogers's mastery of costume and detail is on display, particularly in Othello's exotic cloak, sword, and cap and Desdemona's richly decorated dress. The artist created a dynamic composition by placing the

figures at different heights and in a variety of poses: Othello harks to Iago's words as he gazes across at the others; Cassio is bowing in gratitude, but his posture might be misinterpreted for affection; and Desdemona is pulling away from him, moving toward her husband. —KPO

1. David H. Wallace, *John Rogers: The People's Sculptor* (Middletown, Conn.: Wesleyan University Press, 1967), 193.
2. Ibid., 250.
3. "Gotham Gossip," *New Orleans Daily Picayune*, July 15, 1882, Scrapbooks of Miscellaneous Clippings, etc. about John Rogers, vol. 4, N-YHS Library.

39

John Rogers (1829–1904)

"Why Don't You Speak for Yourself, John?"

1884

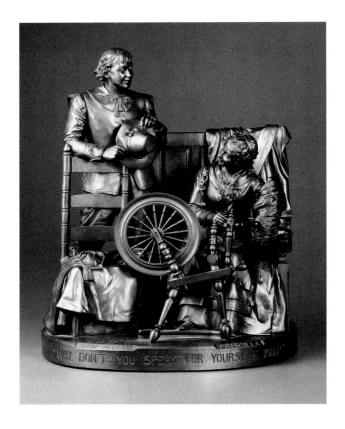

Bronze, 21¾ × 16¼ × 11¾ in. (55.2 × 41.3 × 29.8 cm)
Signed and inscribed on front of base: *JOHN ROGERS / NEW YORK / 11 W 12ST*; inscribed on rear of base: *PATENTED FEB. 20, 1885*
Purchase, 1936.660

For color, see page 84

Rogers's mature oeuvre includes a number of successful sculptures inspired by theatrical and literary themes. This bronze is the master used to cast the thousands of plasters that populated middle-class Victorian homes. It depicts a subject from Henry Wadsworth Longfellow's 1858 poem *The Courtship of Miles Standish*, which relates the story of a love triangle among three Pilgrims of the Plymouth Colony, Miles Standish, John Alden, and Priscilla Mullins. The author, an Alden descendant, claimed that the narrative was based on family tradition. Although the nuances of the story cannot be confirmed, all three were recorded inhabitants of the colony, and John and Priscilla married, as they did in Longfellow's poem.

Rogers depicted the crucial moment when Alden has gone to Priscilla to press the suit of his captain, Miles Standish. Alden's heart is heavy because of his own love for Priscilla when, as Longfellow related, "Archly the maiden smiled, and, with eyes overrunning with laughter / Said, in a tremulous voice, 'Why don't you speak for yourself, John?'" The artist created a stagelike space with a turned chair and a high-back bench on which Priscilla sits. Rogers chose not to include the "carded wool like a snow-drift piled at her knee" that Longfellow described. Rather, he placed a beautifully shaped bundle of wool on the spindle of her spinning wheel. Rogers asked a friend's mother about the mechanics of spinning so that he could depict Priscilla's actions in a convincing way. In his further concern for accuracy, Rogers created a spinning wheel so remarkably detailed that he had to fabricate it in

metal, as he sometimes did for the fragile parts of his groups.[1] Priscilla has been interrupted singing the one hundredth psalm; her psalm book lies in her lap.[2] She turns toward Alden with a coquettish smile as if she is about to speak. Alden stands awkwardly fumbling with his hat and, according to the poem, will turn and rush out of the room in confusion after Priscilla has spoken.

Longfellow's poem was considered to bring the country's early history alive; it met with instant acclaim and huge popularity. Responding to Rogers's latest work, one commentator confirmed the poem's ubiquity asking, "Who has not read Longfellow's 'Miles Standish' time and again, until the story has almost assumed the dignity of history."[3] The poem was commonly taught in schools, and Rogers's sculpture was suggested as a useful educational aid.[4] In choosing a familiar and distinctly American subject, Rogers appealed to the current interest in the country's early days, and he created a scene of flirtation and courtship that struck a chord with his audience. *"Why Don't You Speak for Yourself, John?"* became one of his most popular groups. The writer for the *New Orleans Picayune* blithely called it "the pre-eminent poetry of Puritanic 'popping,'" using what may have been a picturesque vernacular term for courtship.[5] However, a Boston critic's response reflected a growing weariness with Rogers's works after a long career, commenting, "Save for the lettering at the base, this group differs little from several dozen of its predecessors."[6] —KPO

1. David H. Wallace, *John Rogers: The People's Sculptor* (Middletown, Conn.: Wesleyan University Press, 1967), 251–52.
2. Psalm 100 (King James Version) reads: "Make a joyful noise unto the Lord, all ye lands. Serve the Lord with gladness: come before his presence with singing. Know ye that the Lord he is God: it is he that hath made us, and not we ourselves; we are his people, and the sheep of his pasture. Enter into his gates with thanksgiving, and into his courts with praise: be thankful unto him, and bless his name. For the Lord is good; his mercy is everlasting; and his truth endureth to all generations."
3. Untitled article, *Railway Review*, December 12, 1885, Scrapbooks of Miscellaneous Clippings about John Rogers, etc., vol. 4, N-YHS Library.
4. "Groups of Statuary," *New England Journal of Education*, November 1887, Scrapbooks, vol. 1.
5. "Gotham Gossip," *New Orleans Daily Picayune*, December 6, 1886, Scrapbooks, vol. 4.
6. "National Academy of Design," *Boston Daily Evening Transcript*, November 29, 1884, 6.

Peter Frederick Rothermel

(1812–1895)

Peter Frederick Rothermel specialized in large-scale history paintings of subjects ranging from the tortures of Christian martyrs in ancient Rome to the bloody Civil War battlefield of Gettysburg. Known for his painterly technique marked by "nervous force and fine color," Rothermel infused his images with a level of melodrama that separated his art from that of Emanuel Gottlieb Leutze, the other major American practitioner of history painting of the period.[1]

Rothermel received what was described as a "common school education" in his native Nescopeck, Pennsylvania, and subsequently lived in various places throughout the state according to his father's movements before settling in Philadelphia.[2] He trained as a land surveyor and in Philadelphia took drawing lessons from John Rubens Smith (1775–1849) to enhance his surveying skills. Reportedly inspired by a visit to an exhibition of the Philadelphia Artists' Fund Society, he decided to become an artist and to that end trained with Bass Otis (1784–1861) and also enrolled in the Pennsylvania Academy of the Fine Arts. Rothermel quickly progressed from sign painting to portraiture and, probably influenced by Leutze whose studio was in the same building as his, switched to subjects inspired by literary sources. His reputation as a history painter was consolidated with *De Soto Discovering the Mississippi* (1843, St. Bonaventure University, Allegany, N.Y.), which was displayed at the American Art-Union in 1844.

By the mid-1840s Rothermel was the leading artist in Philadelphia, especially after Leutze left the city for Europe in 1843. Rothermel was appointed director of the Pennsylvania Academy of the Fine Arts in 1847 and served in that position until 1855, when he resigned in anticipation of his own European sojourn begun in 1856. After a period of travel that took him to London and Belgium, he lived in Rome from about 1857 to 1859. He also spent time in Paris in 1859, displaying three works at the Salon that year. In Paris he met Eugène Delacroix (1798–1863), whose emphasis on brilliant color, energetic brushwork, and scenes of brutality doubtless reinforced Rothermel's already strong predilections along those lines.

Rothermel returned to Philadelphia in 1859 and resumed his place as the city's foremost painter. With the onset of the Civil War, he began to depict scenes from colonial history as well as contemporary battles. The most important commission of his life, secured with the help of his patron Joseph Harrison, was from the Commonwealth of Pennsylvania to paint *The Battle of Gettysburg* (1870, Pennsylvania Historical and Museum Commission, William Penn Memorial Museum, Harrisburg), for which he was paid twenty-five thousand dollars. The mammoth canvas toured the country from 1870 to 1873 and was prominently displayed in the installation of American works at the Philadelphia Centennial Exhibition in 1876. By this time, however, Rothermel's career was on the wane, and he moved to Grassmere, his Linfield, Pennsylvania, estate, in 1877. His last years were marked by illness, and he died at Grassmere in 1895.

1. The description of Rothermel's style is from "The Academy of Fine Arts," *North American and United States Gazette*, April 28, 1868, 1.
2. See Mark Thistlethwaite, *Painting in the Grand Manner: The Art of Peter Frederick Rothermel (1812–1895)* (Chadds Ford, Pa.: Brandywine River Museum, 1995). Most sources published before Thistlethwaite's study give Rothermel's birth year as 1817.

40

Peter Frederick Rothermel (1812–1895)

Cortés's First View of the City of Mexico

1844

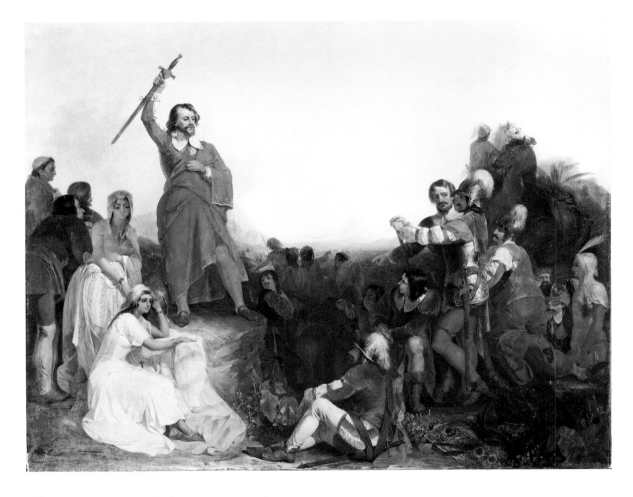

Oil on canvas, 39 × 49 in. (99.1 × 124.5 cm)
Signed and dated lower left: *P. F. Rothermel / 1844*
Gift of Mrs. Louise A. Gillet, 1945.454

For color, see page 143

Peter Frederick Rothermel drew the subject for this painting from William Hickling Prescott's widely popular *History of the Conquest of Mexico*, published in 1843. The book's fame was no doubt stimulated by growing tensions between the United States and Mexico. Texas had declared its independence in 1836, and in 1845, the year after Rothermel painted this work, the United States annexed the renegade state. The Mexican War erupted in 1846. Prescott's account of the European conquest of a seemingly primitive civilization offered an epic precedent for the United States' actions. The subject was a natural choice for Rothermel, who had already demonstrated what one critic called a "penchant for the heroic age of our western world" in his recent works *Columbus before the Queen* (1842, Smithsonian American Art Museum) and *De Soto Discovering the Mississippi* (1843, St. Bonaventure University, Allegany, N.Y.).

In 1518 Diego Velázquez, Spanish conquistador and governor of Cuba, sent his countryman Hernán Cortés (1485–1547) to establish a colony in newly discovered Mexico. Cortés confirmed Velázquez's fears that he would exceed his orders when he defeated the Aztec Empire in a series of bloody battles between 1519 and 1521. Rothermel gave his depiction of Cortés an air of religiosity that seems to sanctify his mission. The explorer stands atop a rock exhorting his men. His sword points toward a friar at far left, perhaps the Spanish priest Father Olmedo who, in Prescott's account, attempted to convert the native peoples. Cortés and his men had been routed in an earlier attempt to capture the Aztec capital, now at the heart of Mexico City. According to Prescott, the Spaniard gave a rousing

speech, saying, "A few days will place you before the gates of Mexico,—the capital from which you were driven with so much ignominy. . . . We are fighting the battles of the Faith, fighting for our honor, for riches, for revenge. I have brought you face to face with your foe. It is for you to do the rest."[1] Sharing the illuminated foreground with Cortés and his men is his mistress Marina, an Aztec maiden who served as interpreter and was said to have saved the Spaniards from Aztec spies and conspiracies. Dressed in pure (if not virginal) white, she wears a cross that signals the hoped-for conversion of the native peoples.

During the 1840s interest in history painting remained high, and Rothermel may have chosen his subject to distinguish himself from Emanuel Gottlieb Leutze. Like Rothermel, Leutze specialized in subjects from the continent's early history. The two men were often compared in the press,[2] and they even lived in the same Philadelphia neighborhood for a time before Leutze departed for Europe in 1843.[3] In doing so, he left the field open for Rothermel, who painted several other subjects from Prescott's book, including *Surrender of Gautemozin* (Kennedy Galleries, New York, as of 1995), *Cortez Burning His Fleet* (destroyed), *Launch of the Brigantines* (unlocated), *Noche Triste: The Morning of the Retreat on the Causeway* (unlocated), and *Cortez before Tenochtitlan* (Lowe Art Museum, Coral Gables, Fla.).[4]

However, the popularity of history painting would soon pass its apex, and the mixed criticism and skepticism that Rothermel encountered in relation to these Mexican subjects hinted at the genre's imminent decline. The exhibition of his *Cortés Burning His Fleet* at the National Academy of Design in 1847 launched the critic of the *Literary World* on a disquisition about the requirements of history painting: the subject must be easily intelligible without extended textual explanation, and the artist should avoid exaggerated, vulgar expressions and actions. He concluded that Rothermel's painting fell short on both counts.[5] Thomas Dunn English mentioned in *Sartain's Union Magazine* that "some ill-natured individuals" thought the paintings repetitive and accused the artist of lacking the imaginative ability to treat any other subject. English defended Rothermel, pointing out that he began painting these subjects of his own choice, even if the later works were commissions. He mentioned the New-York Historical Society's painting as the first such subject, taken up on his own initiative.

Rothermel may have lent *Cortés's First View of the City of Mexico* for exhibition at the New-York Gallery of the Fine Arts in 1848 under the title *Cortés Discovering Mexico*.[6] The painting was later purchased by Warrington Gillette, then of Baltimore, later a New Yorker.[7] His granddaughter-in-law gave the painting to the Society almost a century later. —KPO

1. William H. Prescott, *History of the Conquest of Mexico* (New York: Harper and Brothers, 1843), 3:92–93.
2. Thomas Dunn English, "Peter F. Rothermel," *Sartain's Magazine* 10 (January 1852): 13.
3. Mark Thistlethwaite, *Painting in the Grand Manner: The Art of Peter Frederick Rothermel (1812–1895)* (Chadds Ford, Pa.: Brandywine River Museum, 1995), 13. In the 1850s and 1860s the two competed fiercely for a mural commission at the United States Capitol.
4. Ibid., 43n4.
5. "The Fine Arts," *LW* 1 (April 27, 1847): 279.
6. *Catalogue of the Exhibition of the New-York Gallery of the Fine Arts* (New York: E. B. Clayton & Sons, 1848), 10.
7. English, "Peter F. Rothermel," 15.

Augustus Saint-Gaudens

(1848–1907)

Augustus Saint-Gaudens was the foremost portrait sculptor of Gilded Age America. A founding member of the Society of American Artists in 1877, he was also admitted to the National Academy of Design, to which he was elected an associate in 1888 and an academician in 1889.[1]

Saint-Gaudens's parents (a French shoemaker and an Irish woman) left the sculptor's native Dublin, Ireland, when he was six months old, and, except for a brief time in Boston, he was raised in New York City. After apprenticing with the cameo cutter Louis Avet from 1861 to 1864, he worked in the studio of Jules Le Brethon, cutting portrait cameos while taking evening classes at the Cooper Institute and the National Academy of Design. In 1867 he went to Paris, where he attended the Petite École and then trained with François Jouffroy (1806–1882) at the École des Beaux-Arts. With the outbreak of the Franco-Prussian War in 1870, Saint-Gaudens went to Rome, where he opened a studio and supported himself with commissions from visiting Americans for cameo portraits and copies of classical sculptures. His European sojourn was interrupted in 1872 by a trip to New York from which he returned to Rome in 1873 with several substantial commissions in hand.

Saint-Gaudens's career began to flourish when he returned to New York in 1875. A chance meeting with Stanford White (1853–1906) that year was the beginning of a long friendship and a primary source for the advantageous social and professional contacts that would propel the sculptor to fame. Saint-Gaudens and White soon began work on the design for a memorial to the Civil War hero Admiral David G. Farragut (erected 1881, Madison Square Park, New York City), the first of their many collaborative projects. Saint-Gaudens married Augusta Homer (a cousin of the artist Winslow Homer) in June 1877, and the couple left immediately for Europe, where they lived for two years.

From the time of his return to New York in 1880 until his death, Saint-Gaudens received a seemingly endless stream of commissions, both public and private. His work was shown at important American venues as well as at the Paris Salon, the London Royal Academy, and the Grosvenor Gallery, also in London. Although he maintained a studio in New York City until 1897, he spent much of his time in Cornish, New Hampshire, where the house and studio he purchased in 1891 were at the hub of the summer art colony that developed there. From 1897 to about 1901 he was based primarily in Paris, where he conducted most of the work for the *Sherman Monument* (erected 1903, Grand Army Plaza, New York), which was awarded a grand prize at the Paris Universal Exposition of 1900 and a gold medal of honor at the 1901 Pan-American Exposition in Buffalo, New York. Saint-Gaudens also devoted himself to advancing the state of the American arts through membership in a variety of organizations, including the National Academy of Design, the National Arts Club, and the National Sculpture Society. Although he continued to work, his health steadily declined over the last six years of his life, and he died at his Cornish, New Hampshire, home, in 1907.

1. Most studies of the sculptor expand on Homer Saint-Gaudens, ed., *The Reminiscences of Augustus Saint-Gaudens*, 2 vols. (New York: Century Co., 1913). See esp. John H. Dryfhout, *The Work of Augustus Saint-Gaudens* (Hanover, N.H.: University Press of New England, 1982); Kathryn Greenthal, *Augustus Saint-Gaudens: Master Sculptor* (New York: Metropolitan Museum of Art, 1985); and Thayer Tolles, ed., *American Sculpture in the Metropolitan Museum of Art*, vol. 1, *A Catalogue of Works by Artists Born before 1865* (New York: Metropolitan Museum of Art, 1999), 243–44.

41

Augustus Saint-Gaudens (1848–1907)

The Puritan

1899

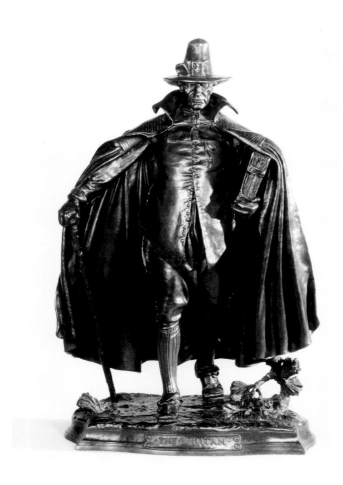

Bronze, 30½ × 18 × 13 in. (77.5 × 45.7 × 33 cm)
Signed on base at right: *AUGUSTUS SAINT GAUDENS*; inscribed on
 rear of base: *COPYRIGHT BY / AUGUSTUS SAINT GAUDENS /
 MDCCCXCIX*
Gift of Mr. James Hazen Hyde, 1946.253

For color, see page 85

A reduction from an earlier full-size bronze, *The Puritan* illustrates Saint-Gaudens's ability to discern the intellectual undercurrents of his time, particularly among his elite patrons, and translate a monumental portrayal of a specific man into a personal-size reassurance of traditional American ideals. Nearly two decades before this bronze was cast, the railroad promoter and Springfield, Massachusetts, congressman Chester W. Chapin approached the artist to commission a life-size bronze of his ancestor Deacon Samuel Chapin (1595–1675), a prominent figure in Springfield history who held several offices in the mid-seventeenth century, including selectman, magistrate, and deacon. The statue was one of three planned to commemorate the founders of the city. Saint-Gaudens researched his subject carefully, studying seventeenth-century woodcuts for the costume. Since there are no known depictions of Chapin, he modeled a bust of Chester Chapin in 1881 (destroyed) on the premise that he carried some of his predecessor's physical characteristics.[1]

The monument was unveiled in Springfield's Stearns Square on Thanksgiving Day 1887. It excited several newspaper notices but surprisingly little critical comment, given Saint-Gaudens's fame during this period. Nonetheless, Kenyon Cox (1856–1919), a painter and friend of Saint-Gaudens's, called the sculpture "the finest embodiment of Puritanism in our art."[2] Cox addressed the sculpture's subject rather than issues of technique, as might be expected of a fellow artist. Like Saint-Gaudens, he was no doubt aware of a rising nationalism and an interest in the country's early history. In the face of widespread immigration, many elites became concerned with religious and social purity, and they turned to the

country's New England roots as an artistic and intellectual touchstone. The work was acclaimed in later decades when it won grand prizes as a plaster at the 1900 Paris Universal Exposition and the 1904 Louisiana Purchase Exposition in Saint Louis.[3]

In 1894 Saint-Gaudens began to issue smaller versions of some of his best-known works, including *The Puritan*. In reducing its size and making it available to a broader audience, the artist transformed the work from an attempted portrait of a specific founding father to a generalized tribute to the ideals that many Americans associated with the New England settlers. Even as he created the original monument, the sculptor recalled that, though he had planned to depict Samuel Chapin, "I developed it into an embodiment, such as it is, of 'The Puritan.'"[4]

Three years passed before Saint-Gaudens, by then living in Paris, was able to rework the model for reduction.[5] To effect this conceptual evolution from the specific to the general, he changed the inscription: rather than referencing Samuel Chapin, it reads simply "The Puritan." Though reduced to less than one-third its original size, *The Puritan* retains the imposing character of its first iteration and affirms the austere and fervent determination that Americans attributed to early New Englanders. The figure's face remains severe, and his heavy-lidded eyes are cast down. The cloak that flows behind him, and the determined forward set of his head suggest that he is walking into the wind, braving nature's resistance to his efforts. The large book he carries under his arm adds heft to his mission (it is likely a Bible, since the book was labeled as such in a 1905 version for Philadelphia's City Hall).

This version is of French origin. It is dated 1899, during the period when bronzes of *The Puritan* were cast by Barbedienne in Paris and two other foundries in that city. Casts of *The Puritan* from this time were sold at Boston's Doll and Richards Gallery. Saint-Gaudens judged his audience well: at least twenty-seven bronzes were sold, making *The Puritan* his most commercially successful statuette, and providing the sculptor with a steady income from the 1890s on.[6] —KPO

1. John H. Dryfhout, *The Work of Augustus Saint-Gaudens* (Hanover, N.H.: University Press of New England, 1982), 162.
2. Thayer Tolles, "Augustus Saint-Gaudens, His Critics, and the New School of American Sculpture" (Ph.D. diss., Graduate Center, City University of New York, 2003), 270; and Kenyon Cox, "Augustus Saint-Gaudens," *Century Illustrated Monthly Magazine* 35 (November 1887): 30.
3. Lois Goldreich Marcus, "Studies in Nineteenth-Century American Sculpture: Augustus Saint-Gaudens (1848–1907)" (Ph.D. diss., Graduate Center, City University of New York, 1979), 159.
4. Homer Saint-Gaudens, ed., *The Reminiscences of Augustus Saint-Gaudens*, 2 vols. (New York: Century Co., 1913), 1:354.
5. Thayer Tolles, ed., *American Sculpture in the Metropolitan Museum of Art*, vol. 1, *A Catalogue of Works by Artists Born before 1865* (New York: Metropolitan Museum of Art, 1999), 287.
6. Kathryn Greenthal et al., *American Figurative Sculpture in the Museum of Fine Arts, Boston* (Boston: Northeastern University Press, 1986), 238. Thayer Tolles, "Augustus Saint-Gaudens in the Metropolitan Museum of Art," *Metropolitan Museum of Art Bulletin* 66, no. 4 (Spring 2009): 69; and Tolles, *American Sculpture in the Metropolitan Museum of Art*, 244.

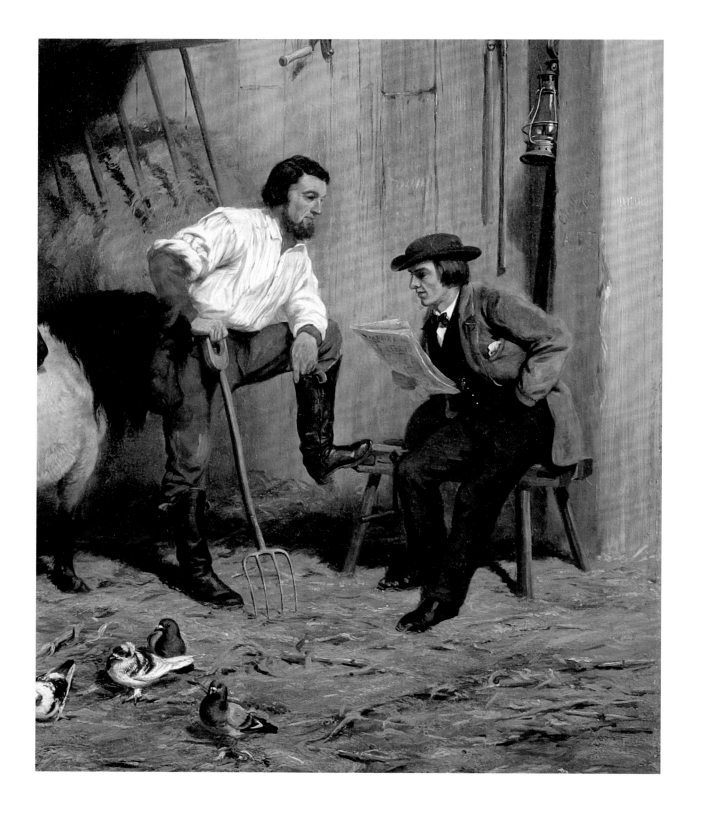

Arthur Fitzwilliam Tait

(1819–1905)

A specialist in sporting and animal subjects, Arthur Fitzwilliam Tait was the principal proponent of those genres in the United States, having transmitted that tradition from his native England. His widespread popularity in the third quarter of the nineteenth century owed much to the distribution of his images through lithographic reproductions.

Tait was born at Livesey Hall, near Liverpool, England, a son of William Watson Tait, whose once thriving shipping enterprise failed after the Napoleonic Wars.[1] Sent to live with an aunt near Lancaster, the twelve-year-old Tait was left to carve out a future for himself. He was in Manchester by about 1831, clerking for Agnew and Zanetti's Repository of Arts and, in his free time, training himself for a career as a painter. This independent pursuit included evening sketching sessions at the Manchester Royal Institution, where he exhibited his first work (*Pencil Landscape*) in 1839. That year he began working for an architectural firm as a draftsman and lithographer, a move that put him on course for the next decade, during which he created mainly architectural and topographic subjects. At the same time, he was developing a taste for what would become his signature subject matter, as evidenced by his prints after works by the animal specialists Richard Andsell (1815–1885) and Sir Edwin Landseer (1803–1873).

Tait and his wife, Marian, whom he had married in 1838, sailed for the United States in 1850. Although he had painted in oils infrequently before arriving in New York, he began to focus on working in the medium and soon found a market for his paintings of dead-game and hunting images. In 1852 he began showing his work at the National Academy of Design (to which he was elected an associate in 1855 and an academician in 1858) and at the Pennsylvania Academy of the Fine Arts. It was also in 1852 that Tait made the first of many trips to the Adirondack wilderness, an event that resulted in a greater emphasis on hunting, trapping, and fishing in his visual repertoire. Many of his paintings of these subjects were popularized through his association with Currier & Ives (from 1852 to 1866), Goupil in 1856, and Louis Prang beginning in 1866. In 1859 Tait and his wife moved to Morrisania (now in the Bronx), and he applied himself to pursuits other than art, as witnessed by the 1863 announcement of his recent patent application for a fire-arm primer.[2]

Although Tait had a coterie of loyal patrons, and the receipts from Currier & Ives and later Louis Prang were adequate, demand for his sporting subjects had waned by the early 1870s, and he focused on painting smaller works featuring barnyard animals. His first wife died in 1872, and he married her niece in 1873. From 1874 to 1877 the couple lived in a house on Long Lake in the Adirondacks. After the 1880 death of his second wife, Tait married her sister, sold the house at Long Lake in 1882, and moved to Manhattan. Tait made his final home in Yonkers, New York, where he continued to paint until he died in his eighty-fifth year.

1. The principal publication devoted to Tait is Warder H. Cadbury and Henry F. Marsh, *Arthur Fitzwilliam Tait: Artist in the Adirondacks* (Newark, Del.: Associated University Presses, 1986).
2. "Recent American Patents," *Scientific American*, n.s., 8, no. 25 (June 20, 1863): 394.

42

Arthur Fitzwilliam Tait (1819–1905)

The Latest News

1862

Oil on canvas, 22⅛ × 34 in. (56.2 × 86.4 cm)
Signed, inscribed, and dated lower left: *A. F. Tait /
N.Y. / 1862*; inscribed on reverse: *"The Latest
News" / A. F. Tait, N.A. / Morrisania / N.Y. /
April 1862 / No. 209*
The Robert L. Stuart Collection, S-175

For color, see page 95

The New York collector Robert L. Stuart purchased *The
Latest News* directly from Arthur Fitzwilliam Tait in
1862, the year the painting was executed.[1] By this time,
Tait had acquired a position of unassailable dominance
within the admittedly small cadre of American animal
specialists. As a writer declared in 1859, "Mr. Tait
unquestionably stands at the head of American painters
of wild animals, hunting pieces, bird compositions, etc.
There is a power in his brush for reproducing the very
texture of flesh, and feathers, and hair, which seems
marvelous."[2] Given Tait's popularity throughout the
1850s and early 1860s, it stands to reason that Stuart
would seek to acquire a superior example of the artist's
work to add to his steadily growing assemblage of
American and European art. The collector may have
been aware of Tait's liberal patronage from the Brooklyn
liquor and wine importer John Osborn, a "gentleman of
liberal means and fine taste," since many of the thirteen
works by Tait purchased by Osborn between 1851 and
1856 had been shown at the National Academy of
Design annuals.[3] Tait had also gained important
exposure from having his paintings reproduced by the
lithographic firm of Currier & Ives and from favorable
critical reactions to his oil paintings, which were
exhibited at the National Academy of Design and
promoted through the American Art-Union and the
Cosmopolitan Art Association.

If Tait's paintings of frontiersmen and Adirondack
hunters were the primary sources of his critical and
popular acclaim in the 1850s, *The Latest News* departs
from his established iconography of men braving the
wilderness and transports the imagery of male society to
the domesticated arena of the farmyard. Although the

largest portion of the composition is given over to an assortment of rather artificially arranged and oddly out-of-scale animals—cattle, sheep, ponies, roosters, hens, and chicks—the true subject of the painting is the two men who engage in an intense conversation likely stimulated by the newspaper held by the citified man on the right.[4] The inclusion of the newspaper, a common motif in midcentury genre painting, reveals a rare bid on Tait's part to inject his art with a discernible layer of topicality. But the scope of Tait's intended meaning is unknown. On the one hand, the painting may only be a general comment on the dissemination of information to rural areas—bucolic "peaceable kingdoms"—that still enjoyed a relatively calm existence while much of the nation was in the grip of the Civil War. On the other hand, the painting may refer to the debates surrounding the passage of the 1862 Homestead Act, which promoted the agrarian settlement of western lands. Favored by the North, the Homestead Act was meant to provide for the free distribution of land to individuals who would farm it and thereby establish an agricultural base against which the economies of proslavery states would eventually struggle and fail. —BDG

1. According to Paul Spencer Sternberger's research, Stuart purchased *The Latest News* from Tait for $350 on April 23, 1862. Sternberger, "Portrait of a Collector and Patron: Robert Leighton Stuart," undated typescript, 19, N-YHS, Museum Department files.
2. "Catalogue of Premiums," *Cosmopolitan Art Journal Supplement* 3, no. 5 (December 1859): 247.
3. "Arthur F. Tait," *Cosmopolitan Art Journal* 2, nos. 2–3 (March–June 1858): 103.
4. The group of animals that dominates the composition recalls that of a contemporaneous painting by Tait titled *The Farmyard* (1862, Christie's, New York, December 6, 1996, lot 13), in which the cattle (the larger two in reverse) are shown in an open field. In the background is a farm building similar to the one visible through the stable door on the left of *The Latest News*. Tait's focus on barnyard scenes such as these may have been the product of his move to then rural Morrisania in 1859.

Jesse Talbot

(ca. 1806–1879)

Documentation on the career of Jesse Talbot is scattered, and few of his works are now located. Although reportedly a New Englander, the artist seems to have spent most of his life in or near New York City, and a listing in an 1840 New York city directory suggests that he began his professional life as a miniature painter. Information regarding any training he may have had is lacking, yet he was sufficiently skilled to warrant having a portrait and a landscape displayed at the National Academy of Design in 1838. His work appeared regularly at the academy annuals for the next two decades and infrequently from 1865 to 1876. Many of his paintings were also distributed through the Apollo Association (later the American Art-Union) and the Cosmopolitan Art-Union.

In 1843 Talbot was noticed for his talent as a landscapist in the *New World*, with the writer adding, "Mr. Talbot deserves the reputation he is rapidly acquiring, for he has probably labored with greater energy and attention than any other of our artists, for the past five years."[1] Two years later he was elected an associate in the academy, an event that may have been commemorated by the undated portrait of him by Tompkins Harrison Matteson that was deposited at the academy in 1846 as Matteson's diploma piece.[2] After having a studio in the prestigious New York University Building from 1840 to 1843, Talbot inexplicably moved to Paterson, New Jersey, where he remained from 1844 to 1847. This move may have been precipitated by his marriage to Mary A. Sleuter, but no details regarding the date of their wedding have surfaced.[3]

The scenes depicted in Talbot's landscapes reveal that he traveled to popular northeastern sketching grounds for his material. He also addressed subjects drawn mainly from *Pilgrim's Progress*, one of which was owned by his friend the journalist and poet Walt Whitman, with whom he probably became acquainted after moving to Brooklyn about 1850.[4] In the 1850s Talbot apparently expanded his ambitions and devoted himself mainly to history painting. Announcements of his work on a series of three paintings based on the "reading of the Mosaic narrative of the dispersion of the human family after the Deluge" appeared in 1854.[5] Although long presumed unfinished, the completed series was the subject of an 1862 petition submitted by enthusiastic Brooklynites who proposed that a Reverend Samuel Hanson Cox give a number of lectures based on the paintings.[6] Apart from spending time in Rondout, New York (probably in summer months), Talbot lived out his life in Brooklyn, where he was listed as living on DeGraw Street (1850–51), Wilson Street (1854–55), and on Lafayette Avenue at the time of his death at seventy-three, the result of a fall on icy Brooklyn streets.[7]

According to the few newspaper mentions of his activity, Talbot continued to paint well into the 1870s. His fortunes were at a low, however, as witnessed by the fact that it was necessary for the Council of the National Academy to contribute fifty dollars toward the cost of his funeral.[8]

1. "The World of Art," *New World* 6 (February 18, 1843): 216.
2. Dearinger 2004, 382–83.
3. For Mary Sleuter Talbot, see "Obituaries," *NYT*, January 4, 1884, 5.
4. David S. Reynolds, *Walt Whitman's America: A Cultural Biography* (New York: Vintage Books, 1995), 367.
5. "Paintings," *NYT*, November 3, 1854, http://www.nytimes.com (archive). See also "Talbot's Pictures," *Cosmopolitan Art Journal* 2 (March–June 1858): 148.
6. "Talbot's Great Paintings," *Brooklyn Eagle*, April 18, 1862, 2.
7. "Fatal Effects of a Fall," *Brooklyn Eagle*, January 30, 1879, 4.
8. Dearinger 2004, 383.

43

Jesse Talbot (ca. 1806–1879)

Indian on a Cliff

ca. 1840s

Oil on canvas, 20 in. (diameter) (50.8 cm)
The Robert L. Stuart Collection, S-172

For color, see page 69

Jesse Talbot was known primarily as a landscapist in the 1840s, yet this painting and two others executed between 1842 and 1858 reveal his occasional interest in exploring the theme of Native Americans and their relation to the land. Talbot's image of a lone brave at the brink of a cliff partakes of a Romanticizing iconography that positioned American Indians as a vanishing race. As Julie Schimmel has pointed out, the theme of the "doomed Indian" emerged in the seventeenth century, but it took on added cultural relevance with the events of the 1830s.[1] In that context, Talbot joined a number of American painters (including Tompkins Harrison Matteson, see cat. 29) who responded to the changing status of Native Americans as a result of the United States government's expansionist policies implemented largely through the Indian Removal Act signed by President Andrew Jackson on May 28, 1830.

After nearly a decade of conflict that saw thousands of Indians displaced from their ancestral territories, Jackson concluded in his 1837 farewell address that the eastern tribes had been "placed beyond the reach of injury or oppression, and that paternal care of the General Government will hereafter watch over them and protect them."[2] Such sentiments were compromised, as witnessed by, among other things, the army's forced removal of fifteen thousand Cherokee from Georgia in 1838, setting them westward on the infamous Trail of Tears. Talbot may have been particularly interested in the fate of the Indians because of his involvement with the Foreign Missionary Society (which also funded domestic or "home" missions).[3] The various missionary societies, although largely unconcerned with indigenous American cultures, were nonetheless opposed to the government's

cruel treatment of Indians, seeing it as an immoral breach of the legal, albeit specious treaties on which removal was predicated.[4]

No contemporaneous references to the present work have been located, and its descriptive title—*Indian on a Cliff*—is probably not original to the painting, the date of which also remains a matter of speculation. The painting is, however, almost identical to Talbot's *The Indian's Last Gaze* (Debra Force Fine Art, New York), likely the same work as that shown under the title *The Chieftain's Last Gaze* at the National Academy of Design in 1859 (cat. 324, then owned by James B. Pinneo). Although also undated, *The Indian's Last Gaze* may be fairly securely identified thanks to an 1858 article announcing Talbot's completion of a painting of that title, which describes the work: "An Indian is seated upon a rock projecting boldly from the steep mountainside, gazing down upon the sun, just fading in the west. The figure is forcibly drawn, and imposingly disposed; while the distance below him, and the splendour of the sunset, give a strong solemnity to the scene."[5] Whereas the mood of resignation was readily perceived in the 1858 canvas, the far more energized pose of the spear-wielding warrior in *Indian on a Cliff* suggests, perhaps, that the painting dates to the 1840s, when the notion of the "noble savage" still held currency in both the visual and the literary arts. What is more, the present work is consonant with earlier descriptions of Talbot's palette as being subdued, with one critic observing that although the artist had "put [Thomas] Cole's spectacles before his eyes," he had gone to the other extreme "to avoid that painter's [Cole's] absurb [*sic*] gaudiness of colors."[6]

Indian on a Cliff was one of two works by Talbot acquired by Robert L. Stuart, although just when and through what means they entered the collection remain a mystery. It is possible that Stuart's strict Christian beliefs left him sympathetic to the plight of the Indian and therefore explain why he may have been particularly attracted to this painting. —BDG

1. Julie Schimmel, "Inventing 'the Indian,'" in *The West as America: Reinterpreting Images of the Frontier, 1820–1920*, ed. William Truettner (Washington, D.C.: Smithsonian Institution Press, 1991), 168–69.
2. Quoted in James West Davidson et al., *Nation of Nations: A Concise Narrative of the American Republic* (New York: McGraw-Hill College, 1999), 284.
3. In 1836 Talbot was secretary of the Foreign Missionary Society of New-York and Brooklyn (an auxiliary branch of the American Board of Commissioners for Foreign Missions). "Foreign Missionary Meeting," *New York Evangelist* 7, no. 17 (April 23, 1836): 66.
4. See Daniel Walker Howe, *What Hath God Wrought: The Transformation of America, 1815–1848* (New York: Oxford University Press, 2007), 348–50.
5. "Our Artists and Their Whereabouts," *Cosmopolitan Art Journal* 11, no. 4 (September 1858): 209.
6. "National Academy of Design—Cutting Criticism," *NYH*, June 13, 1842. The comments were aimed at Talbot's *Indian Hunting Grounds* and *View on Saco River*.

Luther Terry

(1813–1900)

Luther Terry spent most of his career in Italy at the center of the American expatriate community in Rome. It is because of this prolonged absence from the United States that few of his works—portraits and history and genre subjects—are now known in the country of his birth.[1] His studio, however, was a popular attraction for American tourists, many of whom, according to Henry T. Tuckerman, "enjoyed the hospitable guidance" of the artist.[2]

Terry was born and raised on the family farm in Enfield, Connecticut. Although his parents were not particularly well off, his mother claimed a distinguished family lineage reaching back to the colonial governor William Bradford.[3] After apprenticing with a bookbinder, Terry received instruction from the obscure Hartford artist Philip Harris (1824–1884). This was followed by two years working as a portrait specialist in Baltimore, Maryland, from 1836 to 1838. In 1838 he went to Italy, where he studied in Florence at the Accademia delle Belle Arti. Within a short time, he moved to Rome, the city that would be his home for the rest of his life. In Rome he studied with the history painter Vincenzo Camuccini (1775–1844) and attended life classes at the Académie de France. By the early 1840s Terry was a part of the Sketch Club of American Artists at Rome, whose membership included Daniel Huntington, Emanuel Gottlieb Leutze, and Louis Lang.[4]

It appears that most of Terry's income was from the portraits, Italian genre subjects, and copies of old master paintings that appealed to the tourist market. He nevertheless maintained a presence in the United States through the large religious paintings that he occasionally sent to such venues as the National Academy of Design,

the Boston Athenæum, the Pennsylvania Academy of the Fine Arts, and the American Art-Union. His most concentrated American exhibition activity occurred in the mid-to-late 1840s, when he maintained a studio in New York City, and is reflected in his appointment to honorary membership in the National Academy of Design in 1846. The date of his return to Rome is not known, but it is likely that he waited until the revolutionary turmoil that swept Italy with the fall of the Austrian Empire had abated. After this, he reportedly traveled to the United States "triennially" but by 1856 was firmly reestablished in Rome, where he was "ever an attentive cicerone to his country-men, and especially, country-women . . . in a handsome studio of the Eternal City, very comfortable are his artistic receptions, where rides to the Appian Way, a party to witness the illumination of St. Peter's, or join in a ball at Torlonia's, are talked over by fair visitors to their hearts' content."[5]

Terry's friendship with the sculptor Thomas Crawford (1814–1857) was especially close, and Terry accompanied Crawford when he sought treatment in Paris for the brain tumor that eventually killed him. In 1861 Terry married Crawford's widow, Louisa, in a ceremony at Leghorn conducted by the Reverend Huntington (most likely Daniel Huntington's brother, Jedediah). Louisa's elevated social standing in intellectual expatriate circles (she was a sister of Julia Ward Howe) meshed well with Terry's lifestyle, and in 1865 the two moved into the Palazzo Odescalchi, an imposing Baroque edifice that had been designed by Gianlorenzo Bernini (1598–1680) and owned over the centuries by the Colonna, Ludovisi, and Chigi families.[6]

According to Terry's daughter Margaret, he spent

the last twenty-five years of his life content to paint portraits of friends.[7] By then Terry's art had virtually disappeared from view in the United States. He died in Rome in 1900.

1. The most reliable summary of Terry's life to date is the entry in Elizabeth Mankin Kornhauser, ed., *American Paintings before 1845 in the Wadsworth Atheneum* (Hartford, Conn.: Wadsworth Atheneum; New Haven: Yale University Press, 1996), 2:713–14.
2. Tuckerman 1867, 451.
3. Margaret Terry Chanler, *A Roman Spring: The Memoirs of Mrs. Winthrop Chanler* (Boston: Little, Brown and Company, 1934), 1.
4. Avis Berman, "Sketch Club of American Artists at Rome," *Archives of American Art Journal* 40, nos. 1–2 (2000): 2–3.
5. An Old Contributor, "New York Artists," *Knickerbocker* 48, no. 1 (July 1856): 27.
6. For descriptions of nineteenth-century American society in Rome and information regarding the Crawford and Terry children's memories of their life in the Palazzo Odescalchi, see William Vance, *America's Rome*, vol. 2, *Catholic and Contemporary Rome* (New Haven: Yale University Press, 1989), 216–20.
7. Chanler, *A Roman Spring*, 5.

44

Luther Terry (1813–1900)

Jacob's Dream

ca. 1852

Oil on canvas, 51 × 70 in. (129.5 × 177.8 cm)
Gift of Luther Terry, in the name of the late Mrs.
Eliza Hicks Rieben, 1871.3

For color, see page 103

Luther Terry was raised in a fervently Protestant family: he was named after Martin Luther, leader of the Reformation, and one of his two brothers was named Calvin after John Calvin, an important Reformation theologian. Both brothers became ministers. By 1879 it was said that Luther's ideal subjects, and particularly his religious themes, were owned by collectors throughout the country.[1] He propagated *Jacob's Dream* in multiple versions in the same way that his brothers carried out their evangelistic mission.

Jacob's Dream exemplifies the established but little-known midcentury practice of artists reproducing popular religious subjects. In the case of Daniel Huntington's acclaimed *Mercy's Dream* (1841, Pennsylvania Academy of the Fine Arts), an episode from John Bunyan's *Pilgrim's Progress*, the artist painted three versions and authorized engravings of all of them.[2] The artist and minister Johannes Oertel painted his famous *Rock of Ages* (Harvard Art Museum) in 1867 and reproduced it at least ten times in response to demand.[3]

Terry took his subject from Genesis 28:11–12: "And he [Jacob] lighted upon a certain place, and tarried there all night, because the sun was set; and he took of the stones of that place, and put them for his pillows, and lay down in that place to sleep. And he dreamed, and behold a ladder set up on the earth, and the top of it reached to heaven: and behold the angels of God ascending and descending on it."[4] In the following verses God promised to make Jacob's descendants a great nation and give them the land he lay on.

In Terry's ambitious, large-scale painting, Jacob reclines in a classicized pose in the foreground beneath a tree. Jacob's staff, cloak, and water jug allude to his

flight from home after tricking his brother Esau out of his birthright. Behind him a bank of clouds separates the terrestrial from the heavenly worlds. The composition focuses on three angels who have encountered Jacob slumbering; the one at right admonishes the others not to wake him. Behind them is Jacob's vision. Rather than a ladder, Terry rendered a great staircase with angels moving companionably up and down it. A white-robed figure stands at the top. Though the biblical account has the Lord (or Jehovah) speaking to Jacob in his dream, the figure's robe, beard, and outstretched arms suggest representations of Christ, offering a Christianized, New Testament reading of an episode in early Hebraic history.

The first American appearance of *Jacob's Dream* was in 1847, when a shipment of pictures by American artists working in Rome arrived in New York.[5] In the spring of the following year, Terry displayed a version of the painting at the National Academy of Design. Responses were distinctly mixed. They demonstrate a shift in art criticism toward valuing technical accomplishment and away from esteeming the moral uplift that the subject promised. The *New York Tribune* praised the painting's "air of purity and grace" but gave it low marks for drawing and color.[6] The *Literary World* called the figures wooden and proclaimed that the picture "shows all the inconsistencies of the old masters without any of their power."[7]

In spite of the lukewarm critical response, Terry's scriptural theme struck a chord with collectors. In the spring of 1852 it was reported that he had so many orders for the picture that it would take several years to fulfill them.[8] In 1855 an American visitor to Terry's studio in Rome observed that the artist was working on

a copy of the well-known painting and that he had already executed several others for residents of New York State.[9] One was owned by James Robb, who lent it to the Pennsylvania Academy of the Fine Arts exhibition of 1852. Now at Victoria Mansion, Portland, Maine, it is the only other version currently located.[10]

The artist gave the painting to the New-York Historical Society in 1871 in memory of Eliza Hicks Rieben. She had died in 1855, and her will included a legacy to Terry of one thousand dollars. The bequest suggests a personal relationship, though her name does not appear in the recollections of the artist's family. It also stipulated that Terry donate the painting to a public institution of his choice.[11] Terry made the gift sixteen years later. The date of *Jacob's Dream* is uncertain; it was executed before Rieben's death in 1855, and it may well be the painting that Terry exhibited at the National Academy of Design in 1852. —KPO

1. H. W. French, *Art and Artists in Connecticut* (New York: Da Capo Press, 1970), 84.
2. See William H. Gerdts, "Daniel Huntington's *Mercy's Dream*: A Pilgrimage through Bunyanesque Imagery," *Winterthur Portfolio* 14 (Summer 1979): 171–94. The three versions are dated 1841 (Pennsylvania Academy of the Fine Arts), 1850 (Corcoran Gallery of Art, Washington, D.C.), and 1858 (The Metropolitan Museum of Art).
3. Kevin Moore, "Johannes Oertel," in *American Paintings at Harvard*, vol. 1 (forthcoming).
4. King James Bible.
5. "Fine Art Gossip," *LW* 2 (October 1847): 205.
6. "The Fine Arts," *New York Tribune*, June 7, 1852, 5.
7. "The Fine Arts," *LW* 11 (May 1, 1852): 316.
8. Rome, March 23, 1852, quoted in Thurlow Weed, *Letters from Europe and the West Indies, 1843–62* (Albany, N.Y.: Weed, Parsons and Co., 1866), 558.
9. Orville Horwitz, *Brushwood Picked Up on the Continent* (Philadelphia: Lippincott, 1855), 153.
10. The Victoria Mansion painting is slightly smaller than the Society's version and differs only in minor details, such as the positioning of the rocks and foliage in the foreground.
11. Oliver L. Barbour, *Reports of Cases in Law and Equity Determined in the Supreme Court of the State of New York* (Albany, N.Y.: W. C. Little, 1865), 43:64.

John Vanderlyn

(1775–1852)

A gifted painter of history subjects and portraits, John Vanderlyn met with extraordinary success at the Paris Salon in the early years of his career. Although praised in Europe, he found the cultural atmosphere of the United States unwelcoming and died an embittered and impoverished man.

Vanderlyn was the grandson of the painter Pieter Vanderlyn (1667–1778) and a son of Nicholas Vanderlyn, an art supplier.[1] After receiving a classical education in local private schools, he left his native Kingston, New York, in 1792 for New York City, where he worked for the print seller and art supply dealer Thomas Barrow. Barrow introduced Vanderlyn to men of influence, including John Pintard (a founder of the New-York Historical Society) with whose financial help he attended the Columbian Academy of Painting operated by the Scottish artists Archibald (1765–1835) and Alexander (1772–1841) Robertson. Vanderlyn's copy of Gilbert Stuart's (1755–1828) portrait of Aaron Burr attracted the sitter's attention, and the politician became Vanderlyn's most important patron. He enabled Vanderlyn to study with Stuart in Philadelphia for nearly a year, and in 1796 he subsidized the artist's first trip to Europe.

In Paris Vanderlyn studied with François-André Vincent (1746–1816) at the École des Beaux-Arts, where he acquired a rigorous Neoclassical style. Vanderlyn debuted at the Paris Salon in 1800 with several oil portraits and returned to New York in 1801. Charged with the task of buying antique casts and copies after the old masters for the American Academy of the Fine Arts, he again sailed for Europe in 1803. In London he met Benjamin West and developed a firm friendship with

Washington Allston (1779–1843), with whom he would travel the Continent. He resettled in Paris, where, through his friend Robert Fulton (1765–1815), he secured a commission from the United States ambassador to France, Joel Barlow, to illustrate Barlow's poem "The Columbiad." The result—*The Death of Jane McCrea* (1804, Wadsworth Atheneum Museum of Art, Hartford, Conn.)—was shown at the Salon of 1804; it was followed in 1808 by *Caius Marius amid the Ruins of Carthage* (see fig. 4, p. 29). Except for a time in Rome, where he lived from 1805 to 1807, Vanderlyn spent the majority of his second European sojourn in Paris. The last major accomplishment of this period was *Ariadne Asleep on the Island of Naxos* (1809–12, Pennsylvania Academy of the Fine Arts).

Vanderlyn returned to the United States in 1815, anticipating that his European triumphs had whetted the American appetite for the grand, Neoclassical canvases he preferred to paint. He leased a portion of City Hall Park in New York, where he constructed the New York Rotunda, a gallery for the display of panoramas (including his *Palace and Gardens of Versailles*, 1818–19, The Metropolitan Museum of Art).[2] This speculative venture was a failure and left him bankrupt as well as intensely critical of the American public's capacity to appreciate high art. Although he was awarded a commission for one of the U.S. Capitol Rotunda panels in 1837, he continued to be sharply dismissive of the country's cultural potential. His last years were blighted by financial problems, which he attempted to solve with commissions for portraits, but sadly these did not attain the level of his early artistic promise. He died in Kingston, New York.

1. See Kenneth C. Lindsay, *The Works of John Vanderlyn, from Tammany to the Capitol* (Binghamton: University Art Gallery, State University of New York at Binghamton, 1970); Louise Hunt Averill, "John Vanderlyn, American Painter" (Ph.D. diss., Yale University, 1949); and Salvatore Mondello, *The Private Papers of John Vanderlyn (1775–1852): American Portrait Painter* (Lewiston, N.Y.: Edwin Mellen Press, 1990).
2. See Kevin J. Avery and Peter Fodera, *John Vanderlyn's Panoramic View of the Palace and Gardens of Versailles* (New York: Metropolitan Museum of Art, 1988).

45

John Vanderlyn (1775–1852)

Ariadne Asleep on the Island of Naxos

ca. 1811–31

Oil on canvas, 70 × 87 in. (177.8 × 221 cm)
Gift of Mrs. Lucy Maria Durand Woodman,
 1907.28

For color, see page 31

Accounts of the reception and fame of John Vanderlyn's various iterations of *Ariadne Asleep on the Island of Naxos* constitute an important chapter in the history of the artist's near obsession with promoting his affiliation with the European grand style. In many ways, the story of Vanderlyn's preoccupation with the Ariadne theme is as labyrinthine as the maze from which the mythological Minoan princess engineered the rescue of her lover Theseus, who later abandoned her on Naxos.[1]

The painting in the New-York Historical Society is an unfinished copy of the work Vanderlyn showed at the Paris Salons of 1810 and 1812 that is now in the collection of the Pennsylvania Academy of the Fine Arts. Trained in Paris and intimately familiar with classical and Renaissance masterworks, Vanderlyn brought his knowledge of the extensive iconography of the sleeping nude female to bear on his own variation of the theme in the most up-to-date Neoclassical manner. While he was working on *Ariadne*, Vanderlyn copied Correggio's (1489–1534) *Venus, Satyr, and Cupid* (ca. 1524–25, Musée du Louvre, then called *Jupiter and Antiope*; see fig. 5, p. 30, for Vanderlyn's copy), which he may have interpreted as a conceptual twin to his *Ariadne* because of its focus on a similarly dozing nude woman and mythological narrative.[2] Vanderlyn's endeavors along these lines—copying canonical masterworks in the Louvre and creating original paintings rooted in Europe's high-art tradition—reveal his strong desire to establish himself as a direct inheritor and practitioner of the uppermost branch of art in the academic hierarchy.

When Vanderlyn returned to the United States in 1815, he counted on his European productions to demonstrate his artistic prowess and to aid in elevating

the taste of the general public. *Ariadne* was placed on view at the Rotunda in New York's City Hall Park that the artist had constructed to display his large panorama of the Palace of Versailles (1818–19, The Metropolitan Museum of Art), and from there it occasionally toured to such major cities as Boston, Washington, D.C., and Baltimore. Although Vanderlyn anticipated that his nude *Ariadne* might "not be chaste enough for the most chaste and modest Americans," he also hoped that the display of the provocative painting would bring him badly needed income.[3] In the end, the public proclaimed the subject indecent, a situation that enhanced the amusement value of the painting but not its reputation as an example of high aesthetic merit.[4]

Ariadne did, however, appeal to a number of Vanderlyn's colleagues and patrons, for some of whom he executed smaller, sometimes truncated, sometimes draped, versions of the abandoned beauty.[5] In 1831 the embittered and virtually destitute Vanderlyn sold the original painting and this unfinished copy to Asher B. Durand for six hundred dollars and fifty dollars, respectively. Using these and his own painted copy at a reduced scale as guides, Durand produced what is widely considered the finest engraving made in nineteenth-century America. Published in 1835, Durand's *Ariadne* was a critical success, but, like Vanderlyn's original, it failed to find purchasers because it depicted a sensuous female nude. It is not known why Durand felt the need to acquire from Vanderlyn both the original and the unfinished copy of *Ariadne*. It may be that, as an engraver, he wanted to retain as much control over the image as possible. After owning what he eventually admitted was a white elephant for thirty years

or more, Durand claimed the painting from storage at the New-York Historical Society and sold it at auction for five thousand dollars to Joseph Harrison of Philadelphia. The unfinished copy remained in Durand's possession and, when it entered the Society's collection in 1907 as a gift from Durand's daughter, Lucy Maria Durand Woodman, the painting was attributed to Durand. —BDG

1. See, for instance, William H. Gerdts, *The Great American Nude: A History in Art* (New York: Praeger Publishers, 1974), 52–61; and David M. Lubin, *Picturing a Nation: Art and Social Change in Nineteenth-Century America* (New Haven: Yale University Press, 1994), 1–53.
2. Vanderlyn's copy, *Antiope*, is in the collection of the Century Association, New York.
3. Vanderlyn to John R. Murray, July 3, 1809, quoted in Lubin, *Picturing a Nation*, 12.
4. For examples of public reaction, see E. McSherry Fowble, "Without a Blush: The Movement toward Acceptance of the Nude as an Art Form in America, 1800–1825," *Winterthur Portfolio* 9 (1974): 120–21.
5. See Kenneth C. Lindsay, "John Vanderlyn in Retrospect," *American Art Journal* 7, no. 2 (November 1975): 79–90.

John Quincy Adams Ward

(1830–1910)

Hailed as the "Dean of American Sculptors" at the time of his death, John Quincy Adams Ward created an impressive body of sculpture that fused his extensive knowledge of antique, Renaissance, and contemporary Beaux Arts traditions to create a vigorous naturalism that appealed to the American public.[1] He was held in high regard among his colleagues, as witnessed by his election to the presidency of the National Academy of Design in 1873, the first sculptor to attain that honor.

Ward was born in Urbana, Ohio, the son of a farmer whose Whig sentiments inspired him to name the boy after the anti-Jacksonian John Quincy Adams.[2] Although he exhibited talent for modeling in his early years, it was not until he started working in Henry Kirke Brown's (1814–1886) Brooklyn studio in 1849 that he actively pursued a sculpting career. Ward remained under Brown's tutelage until 1856 and opened his own studio in Brooklyn in 1857. After going to Washington, D.C., with the hope of obtaining a government commission, which failed to materialize, Ward went to Columbus, Ohio, living there only briefly before setting up residence in New York City in 1860.

Ward gained critical notice with the display of his bronze *The Indian Hunter* at the National Academy annual of 1862. He was elected an academy associate that year and attained the rank of full academician in 1863, the year in which he displayed *The Freedman*. According to most sources, the watershed in Ward's fortunes occurred when the banker August Belmont saw a plaster version of *The Indian Hunter* in 1865 and subsequently commissioned Ward to sculpt a portrait statue of Belmont's father-in-law, Commodore Matthew Perry, which now stands in Washington Square, Newport, Rhode Island. Belmont's patronage prompted a flow of public and private commissions for portraits that remained unabated through Ward's career.

Although he generally adhered to Brown's belief that American artists should address American subjects, Ward was not blind to the benefit of studying the art of the past. He oversaw the restoration of the National Academy of Design's collection of plaster casts from the antique in 1865, and he traveled to Europe twice—in 1872 and 1887—purchasing plaster casts for the academy on both trips. Ward was also affiliated with other New York professional and social organizations, including the Municipal Art Society, the National Sculpture Society (which he served as president from 1893 to 1905), the Metropolitan Museum of Art (as a member of the board of trustees), the Century Association, and the Union League Club.

Ward's mature work, marked by active surfaces and a high degree of realism, reflects his adaptation of a contemporary Beaux Arts style and is often interpreted as the denouement in the shift in American taste from Neoclassicism to naturalism. His influence can be found in the art of his former student Daniel Chester French (1850–1931), who carried the ailing Ward's final commissions to completion. Ward sold his New York studio in 1908 and moved to a boardinghouse at 296 Manhattan Avenue, where he died after a long illness. His first two wives had died, and his third wife, Rachel Smith, whom he married in 1906, was instrumental in depositing his art and papers with key public institutions.

1. "J. Q. A. Ward Dead at the Age of 80: Dean of the American Sculptors Passes Away at His Home Here," *NYT*, May 2, 1910, 9.
2. The principal published source for Ward's career is Lewis I. Sharp, *John Quincy Adams Ward: Dean of American Sculpture* (Newark: University of Delaware Press, 1985).

46

John Quincy Adams Ward (1830–1910)
The Indian Hunter
1860

Bronze, 16 × 14 × 10 in. (40.6 × 35.6 × 25.4 cm)
Signed and dated on upper base: *J. Q. A. WARD / 1860*
Gift of Mr. George A. Zabriskie, 1939.390

For color, see page 140

John Quincy Adams Ward's *The Indian Hunter* was widely heralded as a turning point both in the artist's oeuvre and in the history of American sculpture. The acclaimed sculptor Augustus Saint-Gaudens called it a revelation, and an enlarged version was the first sculpture by an American artist to be installed in Central Park.[1] Ward's vehement rejection of the long-reigning Neoclassical style and his embrace of realism were hailed as distinctly American. His rendering of the subject and its development over time demonstrate his stylistic transition during a period when Americans began to admire native subjects, realistically treated. Though Ward cast off Neoclassicism, he continued to borrow subtly from its source, the art of antiquity, and he found a fruitful common ground between the real and the ideal.

About 1857, when Ward left the studio of his mentor, the esteemed American sculptor Henry Kirke Brown (1814–1886), he began modeling a plaster that was exhibited at the Washington Art Association in 1859 as *The Hunter* (Erving and Joyce Wolf Collection). It was also displayed at the Pennsylvania Academy of the Fine Arts that year, and the *Crayon*'s writer expressed the prescient wish that "some amateur would show his appreciation of it, and secure its execution in marble or bronze upon a larger scale."[2]

At least fifteen bronzes evolved from the plaster bearing the title *The Indian Hunter*. All were dated to the following year, though they were cast over the course of Ward's life by four different foundries.[3] They were conceived before the artist developed the subject into the life-size bronze installed in Central Park in 1869, and they still bear the stamp of, if not Neoclassicism, then

antiquity. The Indian's muscularity and pose recall the Borghese Gladiator in the Musée du Louvre, Paris; Ward would have seen a cast of the sculpture in Brown's studio.[4] Both man and dog are arrested in watchful poses, as if they have just heard the movement of their prey. The Indian has refined features and straight, flowing tresses. His long loincloth is draped in an elaborate, even classicized manner, modestly downplaying his near-nudity.[5] Ward showcased his technical skills in the contrast of textures, playing the roughness of the dog's fur, the animal skin, and the forest floor against the gleaming surfaces of the man's skin. In 1862 the sculpture was exhibited at the National Academy of Design, where it paved the way for Ward's election as an associate academician that year.[6]

In 1864 Ward traveled to the Dakotas in quest of greater realism, making pencil and wax sketches of Native Americans there (American Academy of Arts and Letters). The art critic Henry T. Tuckerman admired Ward's wax models of heads, considering them "amongst the most authentic aboriginal physiognomical types extant in plastic art."[7] The sculptor incorporated them into an enlarged, more naturalistic rendering of his Indian, making the facial features broader, the hair tousled, and the loincloth much reduced. The life-size plaster was immediately hailed as "tremendous in impression of physical force."[8] It enjoyed considerable attention while on view at Snedecor Gallery in New York. The *New York Evening Post* admired the figure's "bursting energy," "superb movement," and "splendid and sufficient physical life."[9] *Harper's Weekly* declared, "[I]ts merit is so conspicuous that its appropriateness for a position in the Central Park ought to secure its

perpetuation in marble."[10] Ward soon attracted the patronage of the wealthy collector August Belmont and the admiration of twenty-three private citizens who contributed ten thousand dollars toward a bronze cast of the life-size statue.

The full-size bronze was exhibited at the 1867 Universal Exposition in Paris, and the following year it was installed in Central Park to great acclaim.[11] Because it was the first American sculpture installed in the park, responses naturally focused on its nationalist subject and its rigorous accuracy.[12] New York writers also noticed the influence of early Greek sculpture. One noted that though "[h]is face, which is of the pure Indian type, [is] subdued to no fancied requirement of the classic ideal," still, it had "all the serenity, the unconsciousness, the elevation of the best Greek statues, without in the faintest way recalling any one of them."[13] Yet the Indian was a paradoxical choice as a distinctly American subject. At this time, perceptions of Native Americans oscillated between feared menace and doomed noble savage. One writer captured that tension in his comment, "Your young Sioux may be an unreclaimable savage, belonging to a race from which the world has nothing to expect, but he may still be a brave fellow, capable of wonderful endurance and fortitude, a mighty hunter, cunning, quick, and bold, in splendid physical condition."[14] *Harper's Weekly*, while admiring Ward's creation, also noted, "It has the sinister aspect which we associate with the Indian."[15] —KPO

1. Lewis I. Sharp, *John Quincy Adams Ward: Dean of American Sculpture* (Newark: University of Delaware Press, 1985), 47; Thayer Tolles, ed., *American Sculpture in the Metropolitan Museum of Art*, vol. 1, *A Catalogue of Works by Artists Born before 1865* (New York: Metropolitan Museum of Art, 1999), 137.
2. "The Pennsylvania Academy of the Fine Arts," *Crayon* 6 (June 1859): 193.
3. Tolles, *American Sculpture*, 139.
4. Sharp, *Ward*, 38.
5. The draped animal skin not only was an aesthetic choice but also provided necessary structural support.
6. It seems surprising that the sculpture was not mentioned in reviews of the 1862 exhibition. However, there were far fewer notices of the National Academy's shows than in 1861 and 1863, probably because 1862 was the first year that the United States was fully engaged in the Civil War during the run of the exhibition. In addition, sculpture was often neglected in reviews of the period.
7. Tuckerman 1867, 582.
8. "Art: Artists' Reception," *Round Table* 1 (March 5, 1864): 184.
9. Sordello, "The New Statue: J. Quincy Ward's 'Indian Hunter,'" *NYEP*, November 3, 1865, 1.
10. "Ward's Statue," *Harper's Weekly* 9 (December 23, 1865): 812.
11. Sharp, *Ward*, 44.
12. "Presentation of Ward's 'Indian Hunter' to the Central Park," *NYT*, February 5, 1869, 2, where it was praised for being "so truly an American subject."
13. "Art: Mr. Ward's 'Indian Hunter,'" *Round Table*, October 28, 1865, 8. Also see Sordello, "The New Statue."
14. "Fine Arts: Mr. Ward's Indian Hunter," *Nation* 1 (October 19, 1865): 506–7.
15. "Ward's Statue," *Harper's Weekly*, December 23, 1865, 812.

Robert W. Weir

(1803–1889)

The painter and art instructor Robert W. Weir was an integral member of a pioneering generation of artists who strove to cultivate the arts in the United States. A native New Yorker, Weir was the son of a Scottish émigré whose shipping business failed in 1811.[1] Weir reportedly became interested in the arts after visiting the studio of the New York portraitist John Wesley Jarvis (1780–1840) about 1817. There he met Jarvis's apprentice Henry Inman (1801–1846), who would become his close friend and colleague.

In 1821 Weir made a tentative move toward the arts by training with Robert Cooke, a British heraldic painter then active in New York. He also drew from casts at the American Academy of the Fine Arts and attended the anatomy lectures of Dr. Wright Post at the Medical School of New York University. However, the paucity of training available in the United States made it clear that he needed to go to Europe to succeed in his chosen specialty of history painting. With the financial help of the Philadelphian Henry Carey (a publisher and brother-in-law of the American expatriate painter Charles Robert Leslie [1794–1859]) and the New Yorker John Delafield, Weir sailed for Europe, landing at Leghorn in 1824. In Florence he studied with Pietro Benvenuti (1769–1844), concentrating on history and religious subjects. He went on to Rome, sharing rooms with the sculptor Horatio Greenough (1805–1852). In addition to studying the old masters, Weir drew from casts at the Académie de France and from life at the English

Academy. Weir's Italian sojourn ended in 1827, when he accompanied the ailing Greenough home to Boston.

Weir soon returned to New York, where he assumed a prominent place in the heart of Knickerbocker culture, namely through his membership in the Sketch Club and the National Academy of Design (he was elected an associate in 1829 and a full academician in 1831).[2] He exhibited a wide variety of subjects—history, religious, literary, and landscape—that appealed to the major collectors of the day. In 1829 he married Louisa Ferguson (d. 1845), with whom he had nine children. In 1846 he married Susan Bayard; they had seven children.

In 1834 Weir accepted the post of instructor of drawing at the United States Military Academy at West Point, New York. Despite the demands of teaching, he continued to paint and exhibit, gaining particular fame from the commission about 1836 to paint one of the panels for the U.S. Capitol Rotunda, *The Embarkation of the Pilgrims*. A little-known facet of Weir's career is his activity in church decoration.[3] He retired from teaching in 1876 and moved to Castle Point, Hoboken, New Jersey, where he took a studio and turned his attention to depicting scenes of the nearby waterfront.

Weir relocated to New York City in 1880 and died there in 1889 at the age of eighty-six.[4] Today he is often cited as an early instructor of James McNeill Whistler (1834–1903) and his sons, the artists John Ferguson Weir (1841–1926) and Julian Alden Weir (1852–1919).

1. For Weir's life and career, see Irene Weir, *Robert W. Weir, Artist* (New York: Field-Doubleday, 1947); and William H. Gerdts, *Robert Weir: Artist and Teacher of West Point* (West Point, N.Y.: U.S. Military Academy, 1976).
2. See James T. Callow, "Robert W. Weir and the Sketch Club," in Gerdts, *Weir*, 86–91.
3. This is briefly mentioned in Gerdts, *Weir*, 19.
4. "Obituary: Robert W. Weir," *NYT*, May 3, 1889, 5.

47

Robert W. Weir (1803–1889)

Red Jacket *or* Sagoyewatha

1828

Oil on canvas, 30½ × 20¼ in. (77.5 × 51.4 cm)
Signed and dated lower left: *R. W. Weir. 1828*
Gift of Winthrop Chanler, 1893.1

For color, see page 67

Replete with references to European grand-manner style, Robert W. Weir's full-length portrait of the celebrated Seneca chief Sagoyewatha (known as Red Jacket, ca. 1750–1830) is an unusual and vital image that embodies the ambivalence often experienced by artists as they faced the challenge of interpreting (or constructing) Native American identity.

Red Jacket sat to Weir in the artist's New York studio in 1828, the year after Weir had returned from Europe. The artist had risen rapidly in the cultural life of the city, a fact well demonstrated by the noted personalities whose names are connected with this portrait. One of these was the eminent physician John Wakefield Francis, who was a prominent figure in a number of cultural organizations, including the Sketch Club, where Weir was also a member.[1] Francis recommended that Weir paint the popular Seneca orator, who had won renown campaigning for the retention of tribal territories and customs. A treaty signed in 1784 between the Iroquois Nations and the Americans had forced the Iroquois to cede significant lands to the new government in reparation for their support of the British during the Revolution. Red Jacket himself had served as a runner for the British and was rewarded for his services with a red army jacket, the source of his Anglo name. He eventually switched allegiance, siding with the United States in the War of 1812. Despite ongoing and often bitter tribal infighting, Red Jacket assumed the role of statesman largely on the strength of his powerful oratorical skills. This status was highlighted when he and other important chiefs met with George Washington in Philadelphia in 1792, an occasion commemorated by Washington's gift to him of tokens of

peace: an engraved silver medal, a tomahawk, and a peace pipe.[2]

Red Jacket had refused to have his portrait painted until 1820, when he sat for the little-known Rochester artist John Lee Douglas Mathies (1780–1834).[3] This was followed by bust-length portraits by Henry Inman (1801–1846), Charles Bird King (1785–1862), and George Catlin (1796–1872), all of which lack the emotional intensity of Weir's image. Here the elderly chief stands resolutely, the extent of his seeming determination made all the more powerful by Weir's uncommon decision to show the figure at full length against a stormy sky in a wilderness landscape pinpointed by Niagara Falls (near his tribal homeland). Red Jacket, who likely chose the costume he wears in the portrait, had by then eschewed his red coat in favor of a traditional blue coat trimmed with yellow fringe, decorated with red feathers and sash. As was usually the case, the signature Washington medal and tomahawk were included in the portrait. With one hand resting on his hip and the other gripping the tomahawk propped on a boulder, Red Jacket registers as a direct descendant of Anthony van Dyck's Charles I (*Le Roi à la chasse*, ca. 1635, Musée du Louvre, Paris), in that both images convey the notion of personal sovereignty over the landscape.[4] The wilderness setting assures that the trope of the noble savage remains a strong, Romantic element. Yet the conflation of that stereotype with a traditionally aristocratic portrait format introduces a narrative conflict. Whereas whites may have admired a Native American who embraced certain aspects of European behavior, they were nonetheless confronted by the man's tribal

identity manifested in his pose, which thwarts any attempt by the viewer to go beyond the heroic figure, who functions as a sentinel protecting the lands of his people.

Red Jacket was first exhibited in the 1829 exhibition of the National Academy of Design, listed as owned by the pioneering art collector Samuel Ward. At that time, the portrait and Weir's painting of a Greek youth were each noted by the arts columnist of the *New York Mirror* for "the graceful, but contrasted costume of his native land" and as "two beautiful specimens" of Weir's brush.[5] Thus, although critical response was favorable, the sitter elicited a commonplace, quasi-ethnographic reaction. Even before its display, *Red Jacket* was known to a segment of the public through an engraved reproduction in the *Talisman*, a literary annual established in 1827 by William Cullen Bryant, Robert Sands, and Gulian Verplanck, all of whom (like Weir) were Sketch Club members.[6] The implied exclusivity attached to the portrait was amplified by the fact that the image was accompanied by Fitz-Greene Halleck's poem "Red Jacket." Halleck was also part of the cultural elite represented in the Sketch Club membership and was at the time known as the "American Byron."[7]

In 1831 *Red Jacket* was exhibited again at the National Academy of Design and at the Boston Athenæum. Curiously, Samuel Ward's name is not associated with either showing, and it may be that Ward, who was elected the first president of the New York Temperance Society in 1831, declined to be affiliated with Red Jacket, who, despite widespread admiration for his abilities, was known to have been ravaged by alcohol in his later years. —BDG

1. Francis's account of Red Jacket's sittings is quoted at length in William Dunlap, *A History of the Rise and Progress of the Arts of Design in the United States* (Boston: C. E. Goodspeed, 1918), 3:193.
2. An early and useful biography of Red Jacket is William Stone, *Life and Times of Sa-go-ye-wat-ha or Red Jacket* (New York: Wiley and Putnam, 1841).
3. Portraits of Red Jacket are the subject of Jadviga da Costa Nunes, "Red Jacket: The Man and His Portraits," *American Art Journal* 12, no. 3 (Summer 1980): 5–20.
4. Kent Ahrens has compared the pose of Red Jacket with that of Jonathan Buttal in Thomas Gainsborough's *Blue Boy*. Both paintings, however, owe a debt to the Van Dyck. Ahrens, "The Portraits by Robert W. Weir," *American Art Journal* 6, no. 1 (May 1974): 7.
5. "Fine Arts: The Fourth Annual Exhibition of the National Academy," *NYM*, May 16, 1829, 354.
6. The engraving by George W. Hatch (another Sketch Club member) was published in the *Talisman for 1829* published in New York in 1828, between pages 152 and 153.
7. For Halleck, see James Grant Wilson, *The Life and Letters of Fitz-Greene Halleck* (New York: D. Appleton and Company, 1869).

48

Robert W. Weir (1803–1889)

Saint Nicholas

1837–38

Oil on wood panel, 30 × 24⅜ in. (76.2 × 61.9 cm)
Gift of George A. Zabriskie, 1951.76

For color, see page 39

Saint Nicholas, one of at least six versions of the subject by Robert W. Weir, is representative of the artist's more fully elaborated images of the saint–cum–Christmas elf, who is shown in typically gnomelike guise before a fireplace. Conceived in a manner recalling seventeenth-century Dutch genre paintings, the work relies on an amalgam of Christian, Dutch, and Knickerbocker symbols, ranging from the rosary and the three golden balls above the mantel (attributes of the Christian Saint Nicholas as well as symbols of New York City) to the partially peeled orange (referring to the Dutch House of Orange and the traditional Christmas-stocking filler). The frequency with which Weir addressed this theme attests to the iconic status of the saint in Knickerbocker New York.[1]

The Saint Nicholas legend originated with the life of the fourth-century Nicholas of Myra, whose identity eventually mutated into the traditional patron and protector of children. His winter feast days (Christmas and New Year) gained particularly strong currency in Germany and The Netherlands. Saint Nicholas arrived in the New World with the Dutch Protestants who established New Amsterdam, where the figure retained firm associations with the values of the Dutch settlers. By the time Weir painted his first iteration of the theme in 1837, Saint Nicholas had not only evolved into the popular Santa Claus of Christmas lore but, on a more serious level, had assumed the role of politicized symbol of elitist cultural taste.

An early indication of the political associations lodged in the Saint Nicholas character was the formation of the anti-British Sons of Saint Nicholas in New York in 1773, organized in opposition to the Tory

(pro-British) Society of St. George.[2] The most cogent element in the revival of Saint Nicholas as cultural symbol, however, was the influence of John Pintard, a merchant, philanthropist, and a founder of the New-York Historical Society, in the adoption of the saint as patron for the New-York Historical Society, perhaps as early as 1804, when the Society was founded. A short time later, Washington Irving, one of the Society's early members, published on Saint Nicholas Day, December 6, 1809, *A History of New York from the Beginning of the World to the End of the Dutch Dynasty*, dedicating it to the Society. Irving's fictive, comic history credited Saint Nicholas for the success of the "infant city" and hinted at the concept of the social superiority of colonial Dutch lineage as traced through the rituals associated with the saint. Such sentiments are succinctly presented in Irving's later reference to "that pious ceremony, still religiously observed in all our *ancient families of the right breed*, of hanging up a stocking in the chimney on St. Nicholas eve."[3]

Irving's "history" proved enormously popular, and just under three decades later, Saint Nicholas still commanded cultural attention, galvanized especially by Irving's founding of the Saint Nicholas Society of New York in 1835, the publication of James Kirke Paulding's *The Book of Saint Nicholas: Translated from the Original Dutch of Dominie Nicholas Aegidius Oudenarde* (1836), and "A Visit from St. Nicholas" (now popularly known as "The Night before Christmas") written by Clement C. Moore in 1822 and published in 1837. Weir was part of this second wave of interest in Saint Nicholas inasmuch as he was a celebrated artist-member of the social sphere occupied by Irving, Paulding, and Moore and was also associated with Pintard through their mutual involvement with various organizations, including the New-York Historical Society, which by 1810 was holding annual Saint Nicholas Day festivities.

Weir's purpose in choosing the Saint Nicholas theme was to create a painting that would appeal directly to his circle of associates who were actively engaged in forming the civic and cultural life of New York. Just after finishing his first version of the subject (private collection), he wrote to Gulian Verplanck, saying, "I would like either yourself or Mr. Ward [the banker-collector Samuel Ward] to possess it in order that it might remain with my friends."[4] Ward purchased the work supposedly for the hefty two-hundred-dollar price mentioned in the letter to Verplanck, but not until after it had been shown at the National Academy of Design in 1837. The painting received favorable criticism but was largely interpreted by the press as a representation of the "children's Christmas friend." As Lauretta Dimmick has suggested, Weir's subsequent treatments of the theme were more iconographically complex in order to dispel associations with childish content.[5] Indeed, Weir's frequent return to the theme confirms his awareness of and desire to capitalize on the social exclusivity of the Knickerbocker circle, whose close-knit membership is symbolized in the broken Dutch pipe in the foreground that doubtless refers to the ritual of breaking a pipe over the head of an initiate to the Saint Nicholas Society. The notion of ceremonial custom is amplified by Saint Nicholas's gestures, with a finger of his left hand pointing to his nose (per the imagery of Moore's poem) and his right hand poised in a cryptic sign to an unseen person who witnesses the "jolly old elf" before he disappears up the chimney. Such conspiratorial signs have been interpreted as emblems of loss and nostalgia, since the saint, "in these degenerate days, is very seldom seen."[6] In this light, Weir's *Saint Nicholas* was designed for a select group of men who, in the age of the Jacksonian free market, were determined to preserve the heritage of an older, more ordered way of life. —BDG

1. Lauretta Dimmick, "Robert Weir's Saint Nicholas: A Knickerbocker Icon," *Art Bulletin* 66, no. 3 (September 1984): 465–83.
2. Charles W. Jones, "Knickerbocker Santa Claus," *New-York Historical Society Quarterly Bulletin* 38 (1954): 357–83.
3. Washington Irving, *A History of New-York from the Beginning of the World to the End of the Dutch Dynasty*, author's rev. ed. (New York: G. P. Putnam and Company, 1853), 131.
4. Weir to Gulian Crommelin Verplanck, February 21, 1837, N-YHS.
5. Dimmick, "Weir's Saint Nicholas," 469.
6. "New York in the Olden Times," *NYM*, November 15, 1834, 153, quoted in ibid., 476.

Benjamin West

(1738–1820)

Benjamin West's talent and ambition took him from humble origins to the height of fame in the court of England's King George III.[1] Claimed by America as her first native-born artist to achieve international success, the London-based West inculcated a generation of American painters with the tenets of grand-manner aesthetics, which they transplanted to their homeland on their return.

Born in what is now Delaware County, Pennsylvania, West was the tenth and youngest child of John (an innkeeper) and Sarah Pearson West. West's early penchant for drawing was nurtured by engravings sent to him by a distant cousin, Edward Pennington, of Philadelphia. On a visit to Pennington in 1747 West met the British-born artist William Williams (1727–1791), who is said to have given him guidance. By the early 1750s West was in Philadelphia, painting overmantel decorations and receiving instruction from John Valentine Haidt (1700–1780). At this time he also traveled to nearby counties seeking portrait commissions. When his mother died in 1756, he moved to Philadelphia, where he continued to paint portraits and was informally schooled by the Reverend William Smith, an Anglican priest and social leader. West relocated to New York City in 1859 and, with the proceeds of portrait commissions received over his eleven-month stay there, arranged passage for Europe.

West arrived in Italy in 1760, having left his fiancée, Elizabeth Shewell, in Pennsylvania. Much of his three-year sojourn was spent in Rome, where he received advice from the German Neoclassical painter Anton Raphael Mengs (1728–1779) and entered the English-speaking expatriate community, which included Richard Dalton, the royal librarian to King George III. Dalton convinced West to stop in London on his way back to the colonies. West did so and, finding the cultural atmosphere conducive to his career, remained in England for the rest of his life.

West's rise to fame in London was almost immediate; the three works he showed at the Society of Artists in 1764 inspired critics to call him the "American Raphael." Confident of his prospects, he sent for Shewell, and the two were married in London that year. By then West had expanded his repertoire of subjects and had fully embraced Neoclassicism. In 1768 he was a founding member of the London Royal Academy of Arts and in 1792 succeeded Sir Joshua Reynolds (1723–1792) as the academy's president. West's growing reputation led numerous aspiring American artists to gravitate to his London studio, among them Charles Willson Peale (1791–1827), Gilbert Stuart (1755–1828), William Dunlap, Samuel F. B. Morse, and Rembrandt Peale.[2]

West's place in the social and cultural ground of England reached its zenith with royal appointments: he was made Historical Painter to the King in 1772 and Surveyor of the King's Pictures in 1791. More than sixty of his works entered the royal collection through the king's patronage. Acclaimed as the inventor of the "modern history subject" (based on his 1770 *The Death of General Wolfe*, see fig. 16, p. 81) and instrumental in the shift in British taste from Neoclassicism to Romanticism, West also retained an important place in American culture as a source of national pride and inspiration. He was buried at Saint Paul's Cathedral, London.

1. The basic book on West is Helmut von Erffa and Allen Staley, *The Paintings of Benjamin West* (New Haven: Yale University Press, 1986).
2. For West's influence on American artists, see Dorinda Evans, *Benjamin West and His American Students* (Washington, D.C.: Smithsonian Institution Press, for the National Portrait Gallery, 1980).

Benjamin West (1738–1820)

49

Chryseis Returned to Her Father
ca. 1771

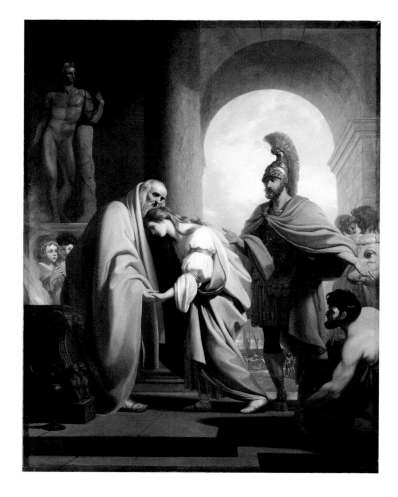

50

Aeneas and Creusa
ca. 1771

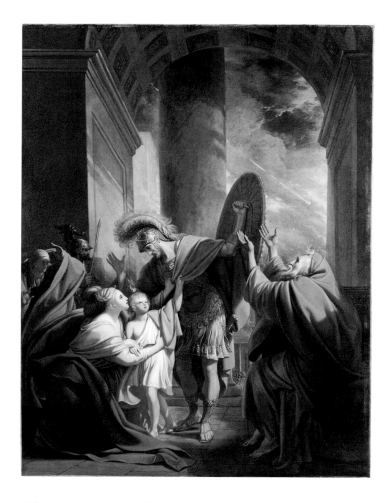

Oil on canvas, 73¼ × 55¼ in. (186.1 × 140.3 cm)
Signed and dated lower left: *B. West / 1771*[?]
Gift of William H. Webb, 1865.1

For color, see page 24

Oil on canvas, 73 × 55 in. (185.4 × 139.7 cm)
Gift of William H. Webb, 1865.2

For color, see page 25

Benjamin West's career entered a critical phase in the early 1780s, a decade marked by his swift rise in the highly competitive art market in London. Traditionally considered a pair, *Chryseis Returned to Her Father* and *Aeneas and Creusa* are believed to have been the paintings West exhibited at the Royal Academy of Arts in 1771 under the titles *The Continence of Scipio* and *Hector Taking Leave of Andromache*, respectively.[1] The confusion about the titles (and, therefore, the subject matter) is thought to have arisen from West's possible failure to provide titles when he sent the paintings to the academy for display, an omission that allowed record keepers there to attach plausible titles based on the narratives suggested by the imagery. The two paintings bring together themes of separation and return expressed in the vernacular of Neoclassical, grand-manner history painting inspired by the works of Homer and Virgil.[2]

The story of Chryseis introduces Homer's epic poem *The Iliad*. The daughter of Chryses, priest of Apollo, Chryseis was taken prisoner by marauding Greek warriors in the ninth year of the siege of Troy. She was given as a gift to the Greek king Agamemnon, who kept her as a prized concubine, ignoring her father's efforts to ransom her. The old priest prayed to Apollo for the return of his daughter. Apollo, who took Agamemnon's resistance as an insult, punished the Greeks with nine days of pestilence before Agamemnon acquiesced and allowed Chryseis to return to her father. West placed the moment of reunion below a statue of the god Apollo, as the helmeted Odysseus delivers the grateful Chryseis into the hands of her elderly father.

The Trojan War also forms the backdrop to *Aeneas and Creusa*, named for the husband and wife whose

story is recounted in Virgil's *The Aeneid*. West again chose a critical moment in the narrative, when Aeneas explains to his wife, Creusa, and son Ascanius the meaning of the omens (including the meteor streaking through the sky) that precipitate their flight from Troy. Ultimately, the unfortunate Creusa dies when she is separated from Aeneas while he carries his crippled father, Anchises (at the right), through the burning city with Ascanius at his side.

The two paintings have remained together since the eighteenth century. The provenance begins with the first documented owner, Francis Thomas Fitzmaurice, third Earl of Kerry, and, with some frustrating gaps, ends when they were given to the New-York Historical Society in 1865 by the New York steamship magnate William Henry Webb.[3] The full extent of Webb's collecting activity is not known, but his taste seems to have led him to contemporary German art; he owned works by Franz Xaver Winterhalter (1803–1873), Wilhelm Camphausen (1818–1885), and Johann Peter Hasenclever (1810–1853).

At the time of their initial display at the Royal Academy, West's Neoclassical renditions of mythological subjects were at the height of artistic fashion and firmly placed him in the cultural mainstream. His reputation as a major proponent of high art persisted for decades, propelled mainly by his position as the president of the Royal Academy, his tenure as Historical Painter to King George III, and by a few key works shown in the United States. However, by the time *Chryseis Returned to Her Father* and *Aeneas and Creusa* were first shown in the United States at the 1864 New York Metropolitan Fair, West was long dead and had been assumed into the

company of the "venerable," whose works "had for years lurked in the seclusion of drawingrooms and private galleries."[4] Indeed, by the 1860s West was lauded primarily for his many kindnesses to younger American artists during their studies in London, not for his art. This opinion was aired forcefully in the *American Whig Review* as early as 1846, when most of his works were regarded as "cold, formal, bloodless and passionless."[5]

It may have seemed fitting, however, for Webb to offer his paintings by West to the art committee for the 1864 Metropolitan Fair, given that the exhibition was organized to benefit the Union cause in which Webb's ships were key elements in the blockade of Southern ports.[6] Shown as "Illustrations from the Iliad," both paintings were thematically consonant with the objectives of the Metropolitan Fair, since their narratives are based on ideas of loyalty, sacrifice, and nobility in the face of conflict. Moreover, the story of Chryseis's release from slavery may have been particularly resonant for the New York audience. —BDG

1. For the persistent confusion over the works' titles, see Helmut von Erffa and Allen Staley, *The Paintings of Benjamin West* (New Haven: Yale University Press, 1986), 246–47, 256–57.
2. Ibid.
3. See "William Henry Webb," *NYT, Illustrated Weekly Magazine*, July 11, 1897, WM2; and "William H. Webb Dead," *NYT*, October 21, 1899, 7.
4. *A Record of the Metropolitan Fair in Aid of the United States Sanitary Commission Held at New York in April 1864* (Cambridge, Mass.: Riverside Press, H. O. Houghton and Company, 1867), 98.
5. "Artists of America," *American Whig Review* 3, no. 5 (May 1846): 519.
6. Webb lent seven paintings to the exhibition. See *Catalogue of the Art Exhibition at the Metropolitan Fair* (New York: John F. Trow, 1864).

William Edward West

(1788–1857)

A painter of portraits and genre subjects inspired by the writings of his friend Washington Irving, William Edward West enjoyed greater success in Europe than he did in his native country.[1] Indeed, his southern upbringing and romantic temperament were compatible with the social habits and taste of English society, factors that stood him in good stead during his London sojourn from 1825 to 1837.

West was born in Lexington, Kentucky, son of the silversmith and inventor Edward West Jr. Both William and his brother may have had some instruction from George (1748–1812) and Mary Beck (d. 1833), and they began their careers as miniature painters. The Becks may have encouraged William to travel in 1808 to Philadelphia, where he is thought to have briefly worked in the studio of Thomas Sully (1783–1872) before establishing his own studio in 1809. West remained in Philadelphia until 1817, then went to New Orleans, Louisiana, and Natchez, Mississippi. There, the occasional portraits he produced echo Sully's fluid style.

In late 1819 West sailed to Europe and, after traveling in France, Switzerland, and Savoy, settled in Florence to study at the Accademia delle Belle Arti. In Florence West ingratiated himself with the American and English expatriate communities. Through the American George Bruen, West received his most important commission, to paint the portrait of the English poet George Gordon Noel, Lord Byron (1822, National Portrait Gallery, Edinburgh), a work that reflects the influence of Sir Thomas Lawrence (1769–1830), who was then resident in Italy.[2] In 1824 West went to Paris, where he opened a studio and entered the circle of Elizabeth Patterson Bonaparte, the American wife of Jerome Bonaparte, whose intimates included the three Caton sisters known as the "American Muses."[3] Washington Irving (whom West may have met as early as 1807) was also in Paris at the time, and the two saw each other frequently. When the Catons shifted their social focus to London in 1825, West followed, bearing letters of introduction from Irving to the painters Gilbert Stuart Newton (1794–1835) and Charles Robert Leslie (1794–1859).

During the first years of his English sojourn, West dined out on the fact that he was the last artist to paint Byron from life. Seemingly less concerned with his art than with social climbing, he went into business with the Caton sisters and began what was probably a romantic liaison with the poet Felicia Hemans. Nevertheless, he also showed regularly in the annual exhibitions of the Royal Academy of Arts, displaying primarily portraits but also several genre paintings illustrating scenes from works by Irving. In 1832 he was made an honorary member of the National Academy of Design. West's lavish lifestyle and relatively small artistic output stretched his finances, and he entered into a disastrous venture with Jacob Perkins (an American banknote engraver who had moved to England in 1819).

A bankrupt West returned to the United States in 1837, determined to pay off his debts. He redoubled his efforts in portraiture and by 1841 was listed in the New York City directory with a studio on Bond Street. As was his habit, he insinuated himself into the society of his patrons and found close friends among the Astor, Schuyler, and Van Rensselaer families in particular. He also remained in contact with Irving, who was then living at Sunnyside, in Tarrytown, New York.

Throughout the last years of his professional life, West depended mainly on the American Art-Union for keeping his art in the public eye. About 1855 he moved to Nashville, where he died in 1857.

1. The major sources on West are Estill Curtis Pennington, *William Edward West, 1788–1857: Kentucky Painter* (Washington, D.C.: National Portrait Gallery, Smithsonian Institution, 1985); and Paul D. Schweizer, "Washington Irving's Friendship with William Edward West and the Impact of His History of New York on John Quidor," *American Art Journal* 17, no. 2 (Spring 1985): 73–88.
2. William Edward West and Estill Curtis Pennington, "Painting Lord Byron: An Account by William Edward West," *Archives of American Art Journal* 24, no. 2 (1984): 17–21, in which West's 1826 article from the London periodical *New Monthly Magazine* is reprinted.
3. The sisters were of the same Caton family as Richard Caton Woodville.

OPPOSITE: CAT. 51, detail

51

William Edward West (1788–1857)

The Confessional

ca. 1845–50

Oil on linen, 35 × 28 in. (88.9 × 71.1 cm)
Gift of Thomas Jefferson Bryan, 1867.287

For color, see page 110

The modern scholar Estill Pennington dates *The Confessional* to about 1845–50, and the image is in keeping with West's later, relatively subdued lifestyle, in which he was described as "quietly mingling little with the younger artists, known and valued by a few friends and dwelling much in the past."[1] His oeuvre is dominated by portraits but also includes a handful of subject pictures, including a few genre scenes based on the stories of his friend Washington Irving, such as *Annette Delarbre* (1831, Munson-Williams-Proctor Arts Institute, Utica, N.Y.). *The Confessional* was said to be one of Irving's favorites among his friend's paintings.[2] However, rather than taking its subject from one of Irving's tales, it may be a personal meditation on the artist's own life.

A young woman in colorful, elegant dress kneels next to a seated elderly man robed in a modest cowl. Her pale skin is stained with a blush—perhaps of shame—as she relates her sins, and he leans toward her as if something she said has caught his attention. They are in a darkened room with hints of Gothic architecture, including the pointed arches on his chair and the window to the right as well as the fluted column that closes off the confined space. The scene is marked by reminders of sacrifice: the flickering candles in the background dimly illuminate what appears to be a painting of the Crucifixion. In the window at the right stands a cross that casts its shadow on the pair.

The artist created a strong distinction between the rich accoutrements of the young woman and the wizened austerity of her confessor. Light hatching on the monk's face, hair, beard, and hands gives them a grizzled appearance, in sharp contrast to the lady's carefully finished porcelain skin and shining tresses. Rather than the sumptuous vestments that a priest would wear on ceremonial occasions, he is garbed in what appears to be a rough robe. The artist's choice of costume for the confessor is somewhat unusual—he may not have been aware that monks cannot hear confession unless they are also ordained priests—and it underscores the importance West placed on showing humility and poverty. In the early nineteenth century, many Americans cast a jaundiced eye on the Catholic Church, with its opposite poles of extravagantly decorated edifices and the poverty and seclusion associated with the cloistered life.[3] In this image West juxtaposed the regrets of a worldly youth with the wisdom of the ascetic in a way that suggests his own journey from his early days as a bon vivant to his later years as a recluse.

The picture became familiar to New Yorkers after it was purchased by the inveterate traveler and collector Thomas Jefferson Bryan. Bryan exhibited hundreds of notable American and European pictures in his Gallery of Christian (meaning Western) Art until its closing in 1857. A companion guidebook to the gallery offered the expected praise for *The Confessional*, calling the effect of the light "brilliant and judiciously managed."[4] —KPO

1. N. P. Dunn, "An Artist of the Past," *Putnam's Monthly* 2 (September 1907): 667.
2. Tuckerman 1867, 201.
3. James Hennesey, *American Catholics: A History of the Catholic Community in the United States* (Oxford: Oxford University Press, 1981), 117–23.
4. Richard Grant White, *Companion Guidebook to the Bryan Gallery of Christian Art* (New York: Baker, Godwin & Co., 1853), 125.

Edwin White

(1817–1877)

Acknowledged by Henry T. Tuckerman as one of the country's "most assiduous" painters, Edwin White drew greater praise from the writer for his "unpretending genre compositions" than he did for the many ambitious history paintings that he produced.[1] White was born in South Hadley, Massachusetts, and reportedly received his first formal training from the portrait painter Philip Hewins (1806–1850) in Hartford, Connecticut.[2] In 1841 he moved to New York City, where he studied with John Rubens Smith (1775–1849) and enrolled in classes at the National Academy of Design. Although White's earliest efforts were portraits, the artist's first notable paintings featured subjects from history and literature. These included imaginary scenes illustrating the lives of Martin Luther and John Milton, some of which were purchased by the American Art-Union. Such subjects bear witness to White's propensity for the European cultural tradition, and, although his career boded success with election to full academic status in the National Academy of Design in 1849, he left for Europe the following year.

White spent the first part of this European sojourn in Paris, where he entered the atelier of François-Édouard Picot (1786–1868). Picot's rigorous technical requirements and preference for historical subject matter are reflected in White's own career, especially in such works as *Murillo Sketching a Beggar Boy* (1864, The New-York Historical Society), one of a series of canvases featuring episodes from the lives of the old masters.[3]

From Paris he went to Düsseldorf, where he studied with the genre specialist Carl Wilhelm Hübner (1814–1879) for approximately two years.

Returning to New York in 1855, White took studio space in rooms above Dechaux's color supply store on Broadway. The market for his art must have been lively, for a contemporaneous writer stated that "[White's] pictures . . . have been distributed among their owners, and but a few remain in his studio."[4] White went back to Europe in 1857, staying until 1859. Later that year, he completed an important commission for the Maryland State Senate Chamber, *Washington Resigning to Congress His Command of the American Army at Annapolis*, a work that debuted to high praise at T. W. Parker & Co. on Broadway.[5] For the next decade, White remained active in the New York area, exhibiting his works mainly at the National Academy of Design, where he was a visiting instructor from 1867 to 1869. In 1867 he served on a committee appointed by the academy to submit suggestions to Congress regarding which artists should be represented at the 1867 Paris Universal Exposition.

White took an extended trip to Europe in 1869, staying primarily in Florence for six years. By 1876 he was back in New York, occupying a studio in the YWCA building, but within a short time he moved to Albany, New York, suffering from declining health. He died in Saratoga Springs, New York, in 1877.

1. Tuckerman 1867, 439.
2. Some biographical information presented here relies on H. W. French, *Art and Artists in Connecticut* (Boston: Lee and Shepard; New York: Charles T. Dillingham, 1879), 94–95; and *Art Journal* 3 (August 1877): 255.
3. See H. Barbara Weinberg, *The Lure of Paris: Nineteenth-Century American Painters and Their French Teachers* (New York: Abbeville Press, 1991), 50.
4. An Old Contributor, "New-York Artists," *Knickerbocker; or New York Monthly Magazine* 48, no. 1 (July 1856): 32.
5. "Edwin White's Historical Painting," *New York Observer and Chronicle*, September 29, 1859, 310.

52

Edwin White (1817–1877)

Olden Times (*also known as* Spinning Flax, Olden Times)

1861

Oil on canvas, 17 × 21 in. (43.2 × 53.3 cm)
Signed and dated lower left: *Edwin White 1861*
The Robert L. Stuart Collection, S-142

For color, see page 169

Olden Times was first shown in December 1861 at the Brooklyn Art Association, where Edwin White's small painting of a solitary, elderly woman at her spinning wheel was listed among the "most admired" of the pictures on display.[1] White had been back from Europe for approximately two years when he executed this painting, which represents a departure from the type of multifigured historical subjects on which his reputation was based. The anonymous figure in a determinedly spare composition offered a distinct contrast to such works as White's more typical *A Morning with Luther* (unlocated), which was also shown at the same exhibition as *Olden Times* and received more commentary, doubtless because of its greater narrative potential.[2]

The reason for White's turn toward a plainer, less dramatic approach is unknown, but it seems clear that he thought *Olden Times* a worthy example of his art, since he submitted it the following year to the National Academy of Design's annual exhibition. Once again the painting was noted, but it generated only minimal commentary. As one critic remarked, the painting was "an admirable *genre* picture of an ancient dame, an ancient kitchen and ancient cooking facilities, of many years ago."[3] By then the work was owned by Robert L. Stuart, who had purchased it just weeks before the opening of the academy exhibition along with another of White's paintings, *Thoughts of the Future* (see fig. 12, p. 168).[4] This double purchase may hold the key to establishing a more complex narrative content for *Olden Times*, inasmuch as it hints that the two paintings should be seen as pendants. Early in his career, White had exhibited a propensity for creating paired works, for example *The Old Age of Milton* and *The Old Age of*

Galileo (both unlocated), which were shown at the National Academy of Design in 1848 and designated "companion pictures."[5] Stuart, too, may have interpreted works in his collection as pairs, as Linda Ferber has speculated in connection with John Frederick Kensett's *View near Cozzen's Hotel*, purchased by Stuart in 1863, and John Ferguson Weir's *View of the Highlands*, made to order for Stuart that year.[6]

In purely visual terms, *Olden Times* and *Thoughts of the Future* (later known as *Thoughts of Liberia, Emancipation*) are ideal candidates for pairing. They share the same measurements, stylistic traits, and umber-toned palettes and feature single figures in austere interiors. Moreover, their general compositional schemes complement each other, with obliquely angled rough-hewn floorboards leading the eye into the heart of a space dominated by an open hearth. The titles of the paintings alone establish a neat opposition of past and future, while other conceptual dialectics are lodged in contrasts of race and gender. In addition, both paintings refer to the printed word. A worn Bible rests on the stool at the left in *Olden Times* (perhaps to signify the role of religious faith in the country's history), while in *Thoughts of the Future*, the newspaper being read by the man and the broadside headed "Hayti" tacked to the door on the left denote contemporaneity.

It is not enough, however, simply to catalogue these sets of opposites, for if the two works are to be regarded as a pair, then a link must be found to establish a unified content. That link appears to be the issue of colonization, registered in *Olden Times* as a distant memory of the nation's colonial roots and in *Thoughts of the Future* as the unsettled status of free blacks during the Civil War, when they were faced with choices involving a future in Haiti, Liberia, or the United States.[7] Although both paintings allude to colonization, the topical issues of the day are more pointedly communicated in *Thoughts of the Future*, which contemporary viewers were likely to associate with the debates spurred by the American Colonization Society's advocacy of the emigration of all blacks from the United States and its territories to Liberia, the 1858 invitation from the Haitian (then spelled Haytien) government to all free Negroes to settle there, or the stance held by abolitionists headed by William Lloyd Garrison against a mass exodus of former slaves.[8]

Without the support of hard evidence, the pendant thesis outlined here must remain speculative. Most problematic is that *Olden Times* is the more ideologically "blank" of the two paintings, while *Thoughts of the Future* conveys the central meaning of these ideas independently. However, the fact that Stuart purchased the paintings on the same day gives sufficient cause to view them as companion pieces. — BDG

1. "Brooklyn Art Association," *NYH*, December 27, 1861, 1.
2. One reviewer ("Brooklyn Art Association," *Brooklyn Eagle*, December 27, 1861, 2) selected *A Morning with Luther* as the "best genre picture" in the exhibition and described it thus: "The great reformer is seated in a listening attitude, while a youth plays upon the organ, and an old cavalier standing [*sic*] near by. Luther's wife and child are at a tapestry frame, and materially aiding to the completeness of the picture as a *genre* production."
3. "The National Academy of Design," *NYT*, April 24, 1862, 2.
4. Both works were acquired on March 29, 1862, for one hundred dollars each. See R. L. Stuart Account Books, New York Public Library, Record Group 2, Lenox Library, Files of Wilberforce Eames, Librarian, Box 25, Folder: "Fine Arts, Stuart Collection," cited in Paul Spencer Sternberger, "Portrait of a Collector and Patron: Robert Leighton Stuart," undated typescript, 13, N-YHS, Museum Department files.
5. "The Fine Arts," *LW* 3, no. 66 (May 6, 1848): 266.
6. Ferber has noted that Kensett's work was indicated as "West Point S & W" in the Stuart account books, while the Weir was recorded as "West Point W & E." Linda S. Ferber, e-mail to the author, January 5, 2010.
7. The reference to flax spinning in the secondary title attached to *Olden Times* may have been intended to contrast the domestic production of linen in colonial times with the international cotton trade supported by slavery in the nineteenth century. Also see Foshay essay in this volume.
8. In describing *Thoughts of the Future*, one review ("The Artists' Reception in Brooklyn," *Independent*, May 27, 1862, 4) confirmed this reading of the painting: "The black philosopher is reading the war news, and wondering what the future has in store for him." (By this time Stuart had purchased both paintings.) It seems safe to assume that White intended viewers to understand the black man to be a freedman because he is able to read. It is not known when or how the painting became known by its later title, *Thoughts of Liberia, Emancipation*.

Worthington Whittredge

(1820–1910)

After starting out as a portrait painter, Worthington Whittredge turned to the landscape subjects on which his reputation as a second-generation Hudson River School painter rests. Born in Springfield, Ohio, Whittredge was raised on his parents' farm.[1] After a brief apprenticeship as a sign painter, he went to Cincinnati, where he was listed as a portrait painter in local directories by 1838 and began exhibiting his work at the Cincinnati Academy of the Fine Arts.

The early 1840s was a period of poor luck and restless travels that took him to such far-flung locales as Indianapolis, Indiana, and Charleston, South Carolina. He returned to Cincinnati and began to concentrate on landscape subjects, taking inspiration from the works of Thomas Cole. His ambitions, however, extended beyond the regional confines of Ohio, and, with the financial help of Cincinnati patrons, he went to Europe, where he would spend the next decade. After first touring Belgium and the Rhineland, he settled temporarily in Paris. Within a short time he went to Düsseldorf, and, although he never formally enrolled in that city's noted academy, he developed firm friendships with members of the faculty (especially the influential German landscape specialists Carl Friedrich Lessing [1808–1880] and Andreas Achenbach [1815–1910]) and other Americans studying there (among them, Albert Bierstadt [1830–1902] and William Stanley Haseltine [1835–1900]). His summers were highlighted by sketching trips in Germany and Switzerland and reached a turning point in 1856, when he, Bierstadt, and Haseltine toured the Italian lake district, proceeding to Florence, and finally to Rome, where he remained until 1859.

After returning to the United States, Whittredge leased a studio in New York's Tenth Street Studio Building in early 1860. He quickly abandoned painting the European landscape subjects that had occupied him for a number of years and refocused his thematic sights on achieving his own niche within the strong market demand for American scenes. In the end, he took his cue from Asher B. Durand's essentially Romantic vision of naturalistically rendered forest interiors. His mounting success was met with election as an associate in the National Academy of Design in 1860 and as a full academician in 1862.

In addition to regular sketching trips to the Catskills, Whittredge traveled to the western territories several times, in 1866, 1870, and 1872. After 1872 he began to incorporate the New England landscape and shorelines into his art, a change reflecting his increasingly frequent summer stays near Tiverton and Newport, Rhode Island. At the same time, he was expanding his activity in professional organizations, especially the National Academy of Design, which he served as president from 1874 to 1876.

A noticeable change in facture and mood occurred in his later landscapes in response to the growing popularity of the Barbizon style and the concomitant decline of the Hudson River School manner. He and his wife (the former Euphemia Foote, whom he had married in 1867) moved to Summit, New Jersey, in 1880. Although he maintained his New York studio until 1900, the art of this period in his career was marked by diminished output and quality. Still, he remained a respected figure among the older members of the cultural community and was honored at a dinner at the Century Association in 1904, in celebration of an exhibition of 125 of his works held there. His 1910 death at home in Summit passed with little notice.

1. For Whittredge's life and art, see Worthington Whittredge, "The Autobiography of Worthington Whittredge, 1820–1910," ed. John I. H. Baur, *Brooklyn Museum Journal* 1 (1942): 7–68; and Anthony F. Janson, *Worthington Whittredge* (New York: Cambridge University Press, 1989).

53

Worthington Whittredge (1820–1910)

The Window (*later known as* A Window, House on Hudson River)
1863

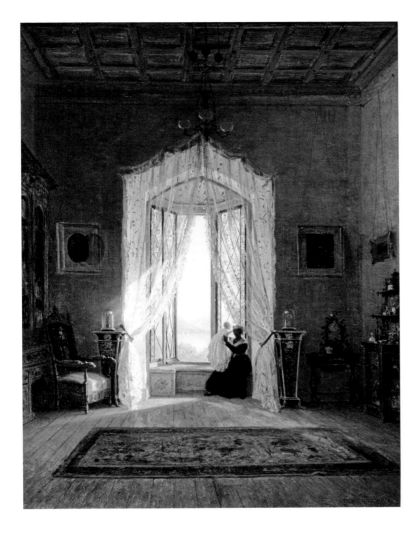

Oil on canvas, 27 × 19½ in. (68.6 × 49.5 cm)
Signed and dated lower right: *W. Whittredge / 1863*
The Robert L. Stuart Collection, S-71

For color, see page 73

Worthington Whittredge returned to the United States in 1859 after having spent ten years in Europe. As he recalled in his autobiography years later, the early 1860s marked a critical juncture in his career, and he resolved to "produce something new and which might claim to be inspired by . . . [his] home surroundings."[1] In addition to devoting himself to painting the American landscape, he created a series of distinctly American domestic interiors from 1862 to 1866, genre paintings that were prefigured by several paintings of Westphalian cottage interiors executed when he was abroad.

The Window undoubtedly fulfilled Whittredge's goal of realigning his art with a more identifiably American content, since it portrays an elegant and clearly American domestic interior in which a black nursemaid holds a white infant at a window overlooking the Hudson River.[2] Yet, for an artist who had already committed himself to a career as a landscape specialist, the painting represents an unusual chapter in Whittredge's development and suggests that his motive for creating it was far from casual. Indeed, by focusing on a black servant in a well-appointed New York home in 1863, it is likely that Whittredge intended this ostensibly benign image to resonate with the painful issues then gripping the divided nation.

The painting was exhibited in the spring of 1863 at the National Academy of Design.[3] Noted by one reviewer as "altogether one of the best interiors ever exhibited in New York," *The Window* received largely descriptive commentary devoted to the room and its furnishings.[4] However, the mere presence of a black person in a painting must surely have prompted

reactions centering on slavery and, more to the point, emancipation. In fact, the painting was on view at the height of the antiemancipation movement in New York City. President Abraham Lincoln's Emancipation Proclamation had gone into effect on January 1, 1863, and, although it affected only slaves behind rebel lines (and therefore had no bearing on Union slave states or Confederate lands under Union army control), it was cause for great celebration in certain quarters throughout the North. Optimism, however, was countered by fears that the North would be flooded with ex-slaves, opposition to government policy of black colonization, and various antiwar factions including the Society for the Diffusion of Political Knowledge, whose membership (including its president, Samuel F. B. Morse) was not in favor of emancipation.[5]

Whittredge's autobiography reveals little about his politics, but his long and strong friendship with the abolitionist Congregational preacher Henry Ward Beecher allows the presumption that he was sympathetic to the abolitionist cause.[6] With the exception of Elizabeth O'Leary, modern scholars have not interpreted *The Window* in terms of social meaning and have, instead, concentrated on the formal challenge the artist set for himself of capturing the effects of the transition from the relatively dark interior space to the bright, sunlit vista beyond.[7] At best, the message contained here is ambiguous inasmuch as the stereotype of the faithful black servant is perpetuated. Thus, although portrayed in a harmonious household environment, the woman remains contained within an economic system that promises no release to the

radiant world beyond the curtained window. Such imagery probably strongly appealed to viewers whose repugnance for slavery was mitigated by fears of social and economic chaos augured by emancipation.

The Window was purchased sometime in 1863 by Robert L. Stuart, who, like Whittredge, was a member of the Century Association and a staunch Presbyterian. Known for his philanthropic activities, Stuart also donated a substantial amount of money to support the Union. That Stuart believed the painting emblematic of Union principles is suggested by the fact that he lent the work to the Brooklyn and Long Island Fair in aid of the United States Sanitary Commission, held at the Brooklyn Academy of Music from February 22 to March 8, 1864, where it was seen with such works as Winslow Homer's *Sharpshooter on Picket Duty* (1863, Portland Museum of Art, Maine) and Eastman Johnson's *Negro Life at the South* (see cat. 24), the latter of which Stuart purchased in 1868. Whittredge's landscape specialty notwithstanding, *The Window* was also displayed at the 1876 Philadelphia Centennial, providing notable contrast to major examples of his landscape output also on view. —BDG

1. Worthington Whittredge, "The Autobiography of Worthington Whittredge, 1820–1910," ed. John I. H. Baur, *Brooklyn Museum Journal* 1 (1942): 42.
2. The house has been tentatively identified as the residence of Louisa Nevins in Riverside, New York. See Anthony F. Janson, *Worthington Whittredge* (New York: Cambridge University Press, 1989), 77.
3. The year before he had shown a related work, *Home on the Hudson* (1862, unlocated), which depicted a similar interior replete with window affording a view of the Hudson Highlands and differed mainly in its inclusion of a woman (presumably the lady of the house) arranging flowers. The dimensions of the two works vary by only a fraction of an inch in height and width.
4. "Visit to the National Academy of Design," *Continental Monthly* 3, no. 6 (June 1863): 717.
5. For a summary of the political divisions in New York during the Civil War, see Edwin G. Burrows and Mike Wallace, *Gotham: A History of New York City to 1898* (New York: Oxford University Press, 1999), 883–905. See also Harold Holzer, ed., *Lincoln and New York* (New York: New-York Historical Society; London: Philip Wilson Publishers, 2009).
6. Whittredge had been close with the Beecher family in Cincinnati, attending Lyman Abbott Beecher's church and frequently visiting the family at home, where he recalled hearing the discussions of slavery that yielded Harriet Beecher Stowe's *Uncle Tom's Cabin*. Later, in Indianapolis, Whittredge lived for a year with Henry Beecher and his wife. Worthington Whittredge Papers, Box 1, "Manuscript of Autobiography," ca. 1905, 23–25, AAA.
7. See Roberta Smith Favis, "Home Again: Worthington Whittredge's Domestic Interiors," *American Art* 9, no. 1 (Spring 1995): 20, in which she links this motif with Whittredge's enclosed forest interiors that open to a light-filled distance. Favis, however, interprets a later work, *Sewing Time* (1865, Museum of Arts and Sciences, Daytona Beach, Fla.), in the context of emancipation. For analysis of the painting in terms of the politics of slavery, see Elizabeth L. O'Leary, *At Beck and Call: The Representation of Domestic Servants in Nineteenth-Century American Painting* (Washington, D.C.: Smithsonian Institution Press, 1996), 151–54. O'Leary suggests a possible link between Whittredge's image and the 1861 publication of Harriet Jacobs's *Incidents in the Life of a Slave Girl Written by Herself*. Jacobs's freedom (she was an escaped slave) had been purchased by the wife of Nathaniel Parker Willis, for whom she worked at Idlewild, the Willises' country home in Cornwall-on-the-Hudson.

Richard Caton Woodville

(1825–1855)

More than ten years after Richard Caton Woodville's death at the age of thirty, Henry T. Tuckerman paid tribute to his art, saying that it was "suggestive of the highest excellence."[1] Although modest in number, Woodville's paintings featuring modern American life were often compared favorably with those of William Sidney Mount, a fact made more remarkable because of Woodville's expatriate existence in Europe.

Woodville was born in Baltimore, Maryland, son of the successful financier William Woodville V.[2] From 1836 to 1841 he received a classical education at Saint Mary's College in Baltimore and then enrolled for a year as a medical student at the University of Maryland. Finding he had no inclination toward medical practice, Woodville adopted the look and behavior of a dandy and spent most of his time drawing portraits of his professors and fellow students. Woodville left university and, against his father's wishes, pursued an independent path toward becoming an artist, sketching inmates at the Baltimore City and County Almshouse and taking advantage of his considerable social connections, which gave him access to highly esteemed local art collections such as that of Robert Gilmor Jr.

In January 1845 Woodville secretly married Mary Theresa Buckler of Baltimore, an event that earned his father's disapproval. The same year Woodville exhibited *Two Figures at a Stove* (1845, private collection) at the National Academy of Design. The vulgar image of two drinkers warming themselves at a stove in a cramped interior may have convinced Woodville's father of his son's talent, but it may also have fed his hopes for evidence of greater refinement in his choice of subject. Paternal displeasure about the artist's marriage and the

direction of his career may account for the senior Woodville's decision to send the errant Richard to Europe for proper training and to relieve the family of embarrassment.

Woodville settled in Düsseldorf, where he remained from 1845 to 1851. After studying at the city's academy for a year, he took private lessons from Carl Ferdinand Sohn (1805–1867). During this period, the artist perfected his technical skills and mastered the tightly finished style associated with the Düsseldorf manner. His meticulous technique limited his output, and the few paintings he completed were sent to the United States, where they were shown and acquired through the American Art-Union and frequently engraved and distributed by Goupil & Co.

In 1849 he separated from his wife (with whom he had two children) and became involved with the artist Antoinette Marie Schnitzler. The couple moved to Paris in the spring of 1851 and, except for Woodville's trip to Baltimore and New York that summer, resided in Paris until moving to London in 1853. By this time, Woodville's main source of income had evaporated with the dissolution of the American Art-Union in 1851, and he began seeking a place in the British market in 1852 by sending a work to London's Royal Academy of Arts, where it received positive critical comment.[3] He eventually married Schnitzler in 1854, but knowledge of the marriage and their child was kept from his Baltimore relatives. Woodville died in London in August 1855, reportedly as a result of an accidental overdose of medicinal morphine. His second child by Marie (the artist Richard Caton Woodville Jr. [1856–1937]) was born the following January.

1. Tuckerman 1867, 408.
2. See Justin Wolff, *Richard Caton Woodville: American Painter, Artful Dodger* (Princeton: Princeton University Press, 2002).
3. The work, now known as *Politics in an Oyster House* (The Walters Art Museum, Baltimore), was illustrated and titled *A New York Communist Advancing an Argument*; "Fine Arts," *Illustrated London News*, no. 571 (July 31, 1852): 84.

54

Richard Caton Woodville (1825–1855)

The Cavalier's Return

1847

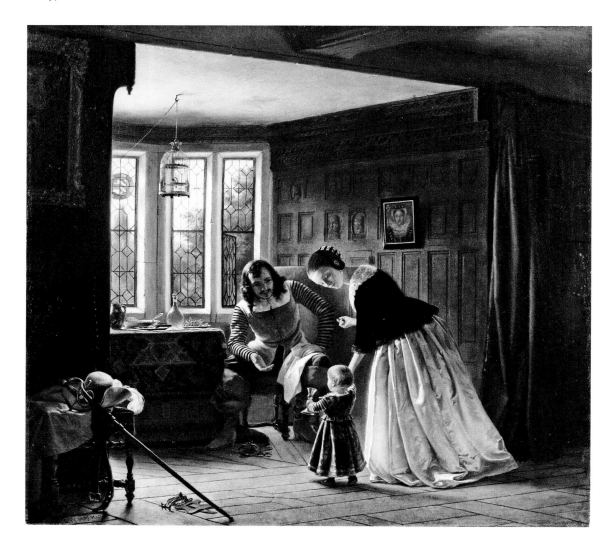

Oil on canvas, 28½ × 30¼ in. (72.4 × 76.8 cm)
Bequest of Kate Warner, 1914.2

For color, see page 51

The Cavalier's Return is one of two paintings by Richard Caton Woodville featuring the theme of the cavalier purchased by the American Art-Union, the principal American outlet for the artist's work after he took up residence in Düsseldorf in 1845.[1] Shown at the Art-Union in 1848, it received considerable attention. According to the *Bulletin of the American Art-Union*, it had "been admired here by thousands."[2]

There is much to admire in the skillfully rendered depiction of a tender, bittersweet moment in English family life as a young wife gently coaxes her toddler toward a welcoming father whose military duty in the service of Charles I had made him a stranger. The quiet domesticity of the setting, rooted in the manner of the seventeenth-century little Dutch masters, represented a marked departure for Woodville, who ordinarily devoted himself to portraying low-life genre subjects focusing on the male-dominated public sphere. The artist's switch to period romance was doubtless inspired by the popularity of history painting at the Düsseldorf academy and, more specifically, by the enormous success of Emanuel Gottlieb Leutze's paintings of Tudor, Stuart, and Cromwellian subjects (for instance, see cat. 28) in America beginning in the 1840s. However, unlike Leutze and other artists who endeavored to reconstruct actual events, Woodville divested his image of specific historic personages and incidents, thereby opening the narrative to encourage a more general interpretation that carried the potential to embrace ideas corresponding to contemporaneous political conditions in much the same way that seventeenth-century Dutch artists inserted coded meanings in ostensibly simple domestic scenes.

Particularly at issue is the relation of the figure of the cavalier to the slavery debates then stirring in the United States. As Wendy Greenhouse has written, "For two decades before the outbreak of the Civil War, Americans drew parallels between the national character types of the hard-nosed northern Yankee and the aristocratic southern gentleman, and their supposed ancestors: the stern English Puritan and the chivalric Cavalier."[3] A fine example of this set of associations is found in a news column in which the author opined,

Most New England men who have talked five minutes with a Virginian, have heard him illustrate the characters of the two races by a reference to their Roundhead and Cavalier origin. Of the Roundhead founders of Massachusetts many were persons of fortune and education, and not a few were of the noble and the gentle blood of England. The settlers of Virginia were Cavaliers of that sort of which Wildrake, in Scott's novel of *Woodstock*, is the type and embodiment. . . . Many were poor gentlemen, broken tradesmen, rakes and libertines, footmen, and others as were much fitter to spoil and ruin a Commonwealth than to help to raise or maintain one.[4]

Such deep-seated regional biases were conveniently employed by both sides in the fiery rhetoric of the slavery debates.

Woodville, a Baltimore native, must have been conscious of the political fences straddled by people living in Maryland, where slavery had strong support despite the fact that the state eventually remained within the Union. Justin Wolff suggests that Woodville created

The Cavalier's Return as a metaphor alluding to the broad social changes then reshaping American family life as well as to his own difficult personal relationships and downplays the possibility that the artist was responding to specific political situations.[5] This seems unlikely, since the contemporaneous press was filled with references to Maryland's history of slave "breeding" by the "reputed sons of the Cavaliers" to compensate for the state's declining agricultural activity.[6] What is more, the tender family scene encompassing ideas of both reunion and separation may implicitly point to a principal abolitionist argument against slavery, inasmuch as the institution cruelly split husbands and wives, parents and children.[7] Divisions between North and South grew wider in the quarrels about emancipation, and, as one writer concluded, "The South will rule, and rule with a rod of iron, until taught that when the Puritan meets the Cavalier in conflict (be it a contest of enterprise, of commerce, of growth, of morals, or of arms), that the stern-souled man will bear the shock in triumph."[8]

Of course, the validity of assigning such content to *The Cavalier's Return* is open to question, since Woodville was abroad when he executed the painting. Yet given that the majority of his paintings were clearly intended to provoke political interpretation, there is little reason to suspect that he would abandon his habitual approach in conceiving this work. Then, too, the painting was slated for an American audience and was acquired by Augustus I. Foster of Wakefield, North Carolina, through the Art-Union. —BDG

1. The second work is *The Game of Chess* (1850, private collection), an engraving of which was reproduced in the *Bulletin of the American Art-Union* 4 (April 1851).
2. *Bulletin of the American Art-Union*, December 1848, 19.
3. Wendy Greenhouse, "Imperiled Ideals: British Historical Heroines in Antebellum American History Painting," in *Redefining American History Painting*, ed. Patricia M. Burnham and Lucretia Hoover Giese (Cambridge: Cambridge University Press, 1995), 272.
4. *Berkshire County (Pittsfield, Mass.) Whig*, July 16, 1846, 2.
5. For a discussion of *The Cavalier's Return*, see Justin Wolff, *Richard Caton Woodville: American Painter, Artful Dodger* (Princeton: Princeton University Press, 2002), 85–91.
6. Theodore Parker, *A Letter to the People of the United States Touching the Matter of Slavery* (Boston: James Munroe and Company, 1848), 36. Parker was a Unitarian minister whose abolitionist views were widely disseminated through publication of his sermons and essays.
7. Parker, ibid., 41, wrote, "[F]or the Negro, the family is all."
8. "From Cassius M. Clay's True American," *Liberator*, February 20, 1846.

George Henry Yewell
(1830–1923)

George Henry Yewell's moderate success as a portraitist and genre painter was mitigated by the peripatetic movements that shaped his life. That, in combination with the fact that he never specialized in a particular subject matter, has contributed to his marginalized position in art historical studies. Nonetheless, his career presents a fascinating pattern, since he emerged from humble midwestern origins to a life of cosmopolitan habits.

Yewell was born in Havre de Grace, Maryland.[1] After his father died about 1830, his mother moved the family to Cincinnati and finally to Iowa City, Iowa. His early artistic inclination manifested itself in a series of caricatures of politicians, which caught the attention of his first major patron, Judge Charles Mason of the Iowa Supreme Court, who made it possible for Yewell to go to New York City in 1851. After studying with Thomas Hicks (1823–1890) at the National Academy of Design, Yewell returned to Iowa City, where he specialized in children's portraits. In 1856 he went to Paris and entered the atelier of Hicks's former master, Thomas Couture (1815–1879). He developed close friendships in Paris with fellow Americans Henry A. Loop (1831–1895), Thomas Satterwhite Noble, and William James Stillman (1828–1901). He remained under Couture's tutelage until 1861, returning to the United States that year and settling in Des Moines, Iowa. For some time he maintained his Iowa activity and simultaneously kept a studio in New York, where he showed his work regularly at the National Academy of Design, to which he was elected an associate in 1861. Throughout this time, Yewell divided his attention between portraiture and genre painting.

In 1867 Yewell left the United States, accompanied by his wife, Mary (whom he married about 1863), and Loop, for what would be nearly eleven years in Europe. With the exception of a trip to Egypt in 1875, he resided mainly in Rome and spent summers in Perugia, near his friend Elihu Vedder (1836–1923). In Europe he developed a keenness for painting architectural subjects and showed several of these at the Paris Salon in 1872 and 1874.

After returning to New York in 1878, Yewell took a studio in the Tenth Street Studio Building from 1879 to 1880 (he would be based there again from 1894 to 1920). He divorced in 1879, and his former wife subsequently married the English portrait painter Edwin Ellis (1841–1895). In 1881 he worked with Francis D. Millet (1846–1912) on Louis Comfort Tiffany's (1848–1933) decorative program for the Veterans' Room of the Seventh Regiment Armory in New York.[2] Thereafter, he devoted most of his time to portraiture, receiving many commissions from political leaders in Iowa. He died at his summer home at Diamond Point, Lake George, New York.[3]

1. Yewell's career has received little attention. The best published sources are the entries in Natalie Spassky et al., *American Paintings in the Metropolitan Museum of Art*, vol. 2, *A Catalogue of Works by Artists Born between 1816 and 1845* (New York: Metropolitan Museum of Art, in association with Princeton University Press, 1985), 330–33; and Dearinger 2004, 599–600, both of which are based on Yewell's papers held at the University of Iowa and on microfilm at the Archives of American Art (reel 2428). Also of value is Alfred A. Guerra, "An Analysis of George Henry Yewell's *Doing Nothing*," unpublished essay, June 2007, N-YHS, Museum Department files.
2. Mary Gay Humphreys, "Decoration and Furniture," *Art Amateur* 4, no. 5 (April 1881): 102.
3. "George H. Yewell, Artist, Dies," *NYT*, September 27, 1923, 7.

55

George Henry Yewell (1830–1923)
Doing Nothing
1852

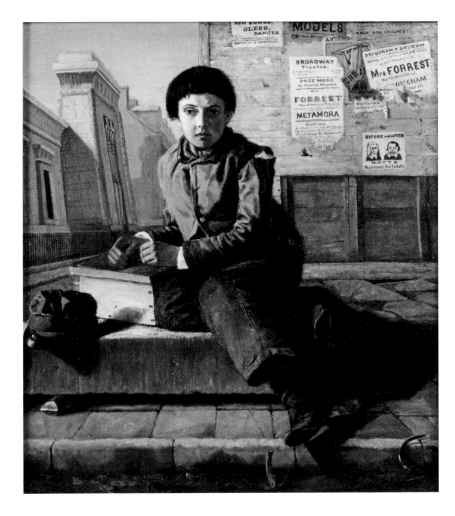

Oil on canvas, 14 × 12 in. (35.6 × 30.5 cm)
Inscribed on reverse in ink: *Geo. H. Yewell Artist /*
 First Picture / Painted 1852
Gift of the Reverend George S. Webster, 1933.8

For color, see page 66

George Henry Yewell's *Doing Nothing*—his debut painting at the National Academy of Design in 1852—is one of a number of midcentury works that formed the thematic subgenre of young protagonists shown on urban streets against a background of posters whose fragments help construct the painting's narrative content. Although many of these "poster paintings" feature newsboys, other identifiable types were occasionally depicted, such as the errand boy portrayed here or the wealthy girl and the poor woman depicted in James Henry Cafferty's *The Sidewalks of New York* (cat. 3).[1] Regardless of the immediate narrative that might be teased from the imagery, the underlying meaning shared by these works is the dawning reality of momentous social changes generated by the country's transition from an agricultural to an urban society. One of the major concerns of the period was the growing number of unsupervised children on city streets, a situation exacerbated by the gradual disappearance of the apprentice system (which was replaced by factories and sweatshops) and the escalating influx of immigrants that destabilized the labor force.[2]

Yewell executed *Doing Nothing* when he was studying with Thomas Hicks (1823–1890) at the National Academy of Design, having enrolled there after arriving in New York in 1851. It was probably through Hicks's good offices that the painting was accepted for display at the academy's 1852 annual, where it received scant critical attention. The painting may have been overlooked because of Yewell's own status as an unknown in the competitive art community and the work's modest size. However, critics may also have been put off by the picture's subject matter, despite the fact

that it was noted by one writer to possess "a pleasing sentiment in a novel direction among our artists."[3]

Yewell's depiction of an errand boy lounging on a city street doubtless registered strongly with viewers whose daily newspaper fare included alarming accounts of crime instigated by youngsters. The boy's furrowed brow suggests that he entertains troubled thoughts, a possibility reinforced by the looming form of New York City's Hall of Detention and Justice (commonly called the Tombs) at the left. The boy's idleness probably made the picture's audience uncomfortable, for the notion of unoccupied youth corresponded with the description of what, in 1849, New York City Police Chief George W. Matsell referred to as the "deplorable and growing evil" manifest on the city's streets. Matsell continued, "I allude to the constantly increasing number of vagrants, idle and vicious children of both sexes, who infest our public thoroughfares, hotels, docks, &c.; children who are growing up in ignorance and profligacy, only destined to a life of misery, shame and crime, and ultimately to a felon's doom."[4]

As Elizabeth Johns has astutely observed, the advertisements posted on the building behind the boy create a subtext anchored in references to reform movements.[5] For instance, a fragment bearing the word "Maine" likely refers to the Maine Law regarding liquor prohibition, and the "Building Association" sign conjures associations with myriad religious and education movements that arose at midcentury designed to improve living—and, therefore, moral—conditions. In pointing out that the sign headed "Models" located at the top of the picture links all the textual fragments into an overall message rooted in social and cultural

oppositions, Johns concludes that the boy's inertia shows that he will enter a life of delinquency.[6] In formal terms, this ominous outcome is strongly forecast by the messenger's body, which inclines toward and, indeed, echoes, the slanted facade of the Tombs.

Projections of the fictive boy's dismal future coincide with the equally dark prospects of the thousands of urban street children of the time, a condition that had spurred the founding of the New York Juvenile Asylum in 1851, the passing of the Truancy Law in 1853, and the formation of the Children's Aid Society by Charles Loring Brace in 1853. This spirit of reform may have brought together Yewell and the Reverend George Sidney Webster, a noted philanthropist, to whom the artist bequeathed the work. Webster was the pastor of the Church of the Covenant, where Yewell was an elder in the congregation.[7] —BDG

1. From the time it entered the New-York Historical Society's collection, the painting was known as *The Bootblack*. Its original title was restored only with the publication of Johns 1991. The identification of the boy as a messenger or errand boy was first proffered by Alfred A. Guerra, "An Analysis of George Henry Yewell's 1852 Painting *Doing Nothing*," June 2007, unpublished essay, N-YHS, Museum Department files. Guerra (11) cites a statement by Yewell in the *Frank Weitenkampf Letters, 1889–1942*, which confirms that the figure represents an errand boy.
2. See Timothy J. Gilfoyle, "Street-Rats and Gutter-Snipes: Child Pickpockets and Street Culture in New York City, 1850–1900," *Journal of Social History* 37, no. 4 (Summer 2004): 853–82. See also a discussion of Frederick R. Spencer's *A Newsboy* (1844, private collection) in Gail E. Husch, *Something Coming: Apocalyptic Expectation and Mid-Nineteenth American Painting* (Hanover, N.H.: University Press of New England, 2000), 34–80.
3. *New York Tribune*, June 7, 1852, cited incompletely in Guerra, "An Analysis," 14.
4. George W. Matsell, *Semi-Annual Report of the Chief of Police from May 1 to October 31, 1849* (New York, 1850), 58, at http://historymatters.gmu.edu/d/6526.
5. The building has been identified by Guerra, "An Analysis," 16, as the New York and New Haven Railroad freight depot and not the New York and Harlem Railroad freight depot as stated in Koke 1982, 3:306.
6. For a discussion of the painting, see Johns 1991, 187–90.
7. The two are among the signatories of a congratulatory letter to a retiring pastor at New York's Brick Church, "Dr. Van Dyke Sent Adieus," *NYT*, January 8, 1900, 10.

Index